Adobe
Photoshop
Lightroom Cla

2018 release

D0131981

CLASSROOM IN A BOOK®

The official training workbook from Adobe

Adobe Photoshop Lightroom Classic CC Classroom in a Book® (2018 release)

Adobe Press is an imprint of Pearson Education, Inc. For the latest on Adobe Press books, go to www.adobepress.com. To report errors, please send a note to errata@peachpit.com. For information regarding permissions, request forms and the appropriate contacts within the Pearson Education Global Rights & Permissions department, please visit www.pearsoned.com/permissions/.

Printed and bound in the United States of America

ISBN-13: 978-0-13-454002-3

ISBN-10: 0-13-454002-6

1 18

WHERE ARE THE LESSON FILES?

Purchase of this Classroom in a Book in any format gives you access to the lesson files you'll need to complete the exercises in the book.

You'll find the files you need on your **Account** page at peachpit.com on the **Registered Products** tab.

1 Go to www.peachpit.com/register.

2 Sign in or create a new account.

3 Enter the ISBN: 9780134540023.

4 Answer the questions as proof of purchase.

5 The lesson files can be accessed through the Registered Products tab on your Account page.

6 Click the Access Bonus Content link below the title of your product to proceed to the download page. Click the lesson file links to download them to your computer.

CONTENTS

PHOTOGRAPHY SHOWCASE: JOHN BATDORFF 80

3 EXPLORING THE LIGHTROOM WORKSPACE 84

5 DEVELOPING BASICS 168

6 ADVANCED EDITING 202

GETTING STARTED

Adobe® Photoshop® Lightroom® Classic CC delivers a complete workflow solution for the digital photographer—from importing, reviewing, organizing, and enhancing images to publishing photos, producing client presentations, creating photo books and web galleries, and outputting high-quality prints.

The user interface is highly intuitive and easy to learn, yet Lightroom has all the power and versatility you'd expect from an Adobe application, using state-of-the-art technologies to manage large volumes of digital photographs and to perform sophisticated image processing tasks.

Whether you're a home user, a professional photographer, a hobbyist, or a business user, Lightroom Classic CC enables you to stay in control of your growing photo library and to produce good-looking pictures and polished presentations for both web and print with ease.

About Classroom in a Book

Adobe Photoshop Lightroom Classic CC Classroom in a Book is part of the official training series for Adobe graphics and publishing software developed with the support of Adobe product experts.

Each lesson in this book consists of a series of self-paced projects that give you hands-on experience using Adobe Photoshop Lightroom Classic CC.

If you're new to Lightroom, you'll learn the fundamental concepts and skills that will help you master the application; if you've used earlier versions of Lightroom, you'll find that this Classroom in a Book® teaches advanced tips and techniques, and covers the many new features and enhancements that Adobe Systems has introduced in the latest version.

What's new in this edition

This edition covers the many new and enhanced features in Adobe Photoshop Lightroom Classic CC, from luminance and color masking that redefine what you can achieve with the local adjustment tools, to new ways to search and filter your source folders as well as your photo library.

You'll also discover enhancements to many of your favorite tools, including a reworked Auto Tone adjustment that uses advanced machine learning, referencing thousands of professionally shot and edited photos to correct an image intelligently, automatically tweaking an even broader range of the Basic panel slider controls.

You'll learn new ways to organize your image library and streamline your workflow by creating collections and collection sets from folders and subfolders, or even from a map pin, and by designating favorite sources.

This edition also includes inspiring showcases from four new guest photographers.

Prerequisites

Before starting on the lessons in this book, make sure that you and your computer are ready by following the tips and instructions on the next few pages.

Requirements on your computer

You'll need about 800 MB of free space on your hard disk for the downloaded lesson files (*see Accessing the Lesson Files and Web Edition on the facing page*) and the work files that you'll create as you work through the exercises.

Required skills

The lessons in this book assume that you have a working knowledge of your computer and its operating system.

Make sure that you know how to use the mouse and the standard menus and commands, and also how to open, save, and close files. Can you scroll (vertically and horizontally) within a window to see content that may not be visible in the displayed area? Do you know how to use context menus, which open when you right-click (Windows) / Control-click (macOS) items?

If you need to review these basic and generic computer skills, see the documentation included with your Microsoft® Windows® or Apple® Mac® OS X software.

Installing Lightroom Classic CC

Before you begin the lessons in *Adobe Photoshop Lightroom Classic CC Classroom in a Book*, make sure that your system is set up correctly and that you've installed the required software and hardware.

You must purchase the Adobe Photoshop Lightroom Classic CC software separately. For system requirements and detailed instructions for downloading, installing, and setting up, see the topics listed on the Get Started link at https://helpx.adobe.com/support/lightroom.html

Online content

Your purchase of this Classroom in a Book includes online materials provided by way of your Account page at peachpit.com. These include:

Lesson Files To work through the projects in this book, you will need to download the lesson files from peachpit.com. You can download the files for individual lessons or it may be possible to download them all in a single file.

Web Edition The Web Edition is an online interactive version of the book, providing an enhanced learning experience. Your Web Edition, which can be accessed from any device with a connection to the Internet, contains:

* The complete text of the book
* Hours of instructional video keyed to the text
* Interactive quizzes

In addition, the Web Edition may be updated when Adobe adds significant feature updates between major Creative Cloud releases. To accommodate the changes, sections of the online book may be updated or new sections may be added.

Accessing the Lesson Files and Web Edition

If you purchased an eBook from peachpit.com or adobepress.com, your Web Edition will automatically appear under the Digital Purchases tab on your Account page. Click the Launch link to access the product. Continue reading to learn how to register your product so that you can access the lesson files.

If you purchased an eBook from a different vendor or you bought a print book, you must register your purchase on peachpit.com in order to access the online content.

You'll start by preparing a folder on your computer to store the downloaded files.

1 Create a new folder named **LRClassicCIB** inside the *username*/My Documents (Windows) or *username*/Documents (macOS) folder on your computer; then, create another folder named **Lessons** inside the new LRClassicCIB folder.

2 Go to www.peachpit.com/register.

3 Sign in or create a new account.

4 Enter the ISBN: 9780134540023.

5 Answer the questions as proof of purchase.

6 The Lesson Files can be accessed through the Registered Products tab on your Account page. Click the Access Bonus Content link below the title of your product to proceed to the download page. Click the lesson file links to download them to the LRClassicCIB \ Lessons folder on your computer.

Note: The sample images are provided for your personal use with this book. You are not authorized to use these files commercially, or to publish or distribute them in any form without written permission from Adobe Systems, Inc. and the individual photographers or other copyright holders.

Tip: This book describes and illustrates Lightroom Classic CC release 7.2; if your software is a later version, check your Account page at peachpit.com for updates.

Note: The Web Edition can be found on the Digital Purchases tab on your Account page. Click the Launch link to access the product.

Understanding Lightroom catalog files

The catalog file stores information about all the photos in your library. It includes the location of the master files, any metadata you've added in the process of organizing your images, and a record of every adjustment or edit you've made. Most users will keep all their photos in a single catalog, which can easily manage thousands of files. Some might want to create separate catalogs for different purposes, such as home photos and business photos. Although you can create multiple catalogs, you can only open one catalog at a time in Lightroom Classic CC.

For the purposes of working with this book, you'll create a new catalog to manage the image files that you'll use in the lessons. This will allow you to leave the default catalog untouched while working through the lessons, and to keep your lesson files together in one easy-to-remember location.

Creating a catalog file for working with this book

When you first launch Lightroom Classic CC, a catalog file named Lightroom Catalog.lrcat is automatically created on your hard disk. This default catalog file is created inside the folder *username*/My Documents/My Pictures/Lightroom (on Windows) or *username*/Pictures/Lightroom (on macOS).

You'll create your new work catalog file inside your LRClassicCIB folder, right beside the Lessons folder containing your downloaded work files.

1 Launch Lightroom Classic CC.

2 From the Lightroom menu bar, choose File > New Catalog.

3 Navigate to the LRClassicCIB folder you created on your hard disk.

4 Type **LRClassicCIB Catalog** in the File Name text box on Windows, or the Save As text box on macOS; then, click Save (Windows) or Create (macOS).

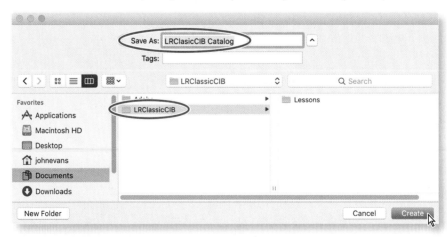

● **Note:** In this book, the forward arrow character (>) is used to denote submenus and commands found in the menu bar at the top of the workspace or in context menus; for example, Menu > Sub-menu > Command.

5 If you see a notification about backing up the current catalog before loading your new catalog, choose your preferred option to dismiss the message.

In order to be sure that you're always aware of which catalog you're working with as you progress through the exercises in this book, you'll now set the preferences so that you'll be prompted to specify your LRClassicCIB catalog each time you launch Lightroom Classic CC.

It is recommended that you keep this preference set as long as you're working through the lessons in this book.

6 Choose Edit > Preferences (Windows) / Lightroom > Preferences (macOS).

7 In the Preferences dialog box, click the General tab. From the Default Catalog menu, choose Prompt Me When Starting Lightroom.

Note: In the remainder of this book, instructions that differ for Macintosh users and those working on Windows systems are given in a compact format as follows; the forward slash character (/) is used to separate equivalent terms and commands for Windows / macOS, in the order shown here.

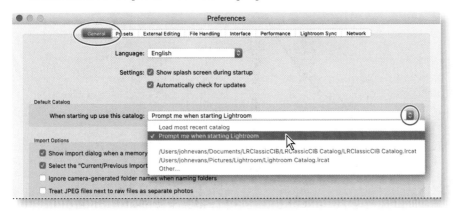

8 Click OK (Windows) / the Close button (⬤) (macOS) to close the Preferences dialog box.

Next time you start Lightroom Classic CC the Select Catalog dialog box will appear, giving you the opportunity to make sure that your LRClassicCIB Catalog is selected before Lightroom launches.

Tip: Even if you've set Lightroom to load the most recent catalog by default, you can open the Select Catalog dialog box by holding down the Clrl+Alt / Control+Option keys immediately after you launch Lightroom.

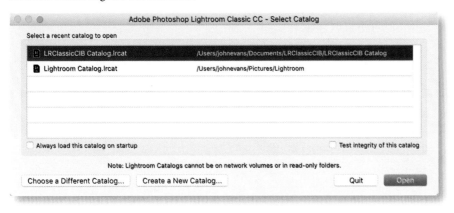

Getting ready to go mobile

Adobe Photoshop Lightroom Classic CC is integrated through Adobe Creative Cloud with Lightroom CC for mobile and Lightroom CC for Web, enabling you to sync photo collections between your desktop computer and a companion app on your mobile device, so that you can review, organize, and even edit your photos anywhere, anytime, and then share them online.

Whether you're working in Lightroom Classic CC on your desktop or Lightroom CC on your handheld device, any modifications made to a synced collection or the photos it contains will be updated on the other device. Lightroom CC syncs high resolution Smart Previews to your mobile device, rather than your original photos. At a small fraction of the original file size, these Smart Previews won't take long to sync, or use up all your storage space, which means that you can even work with raw images while you're away from your desktop computer.

Edits you make on the mobile device are synced back to the full-size originals in your Lightroom Classic CC catalog. Photos captured on your handheld device and added to a synced Collection are downloaded to your desktop at full size. You can share your photos from your device to social media or via Lightroom CC for Web.

1 The first step is to download and install Lightroom CC on your mobile device. You can download the app free from iTunes or the Apple App Store (for iPad and iPhone), or from Google play (for Android), on a trial basis; then, choose a subscription plan later.

2 Once you've installed Lightroom CC on your handheld device, see the section "Taking your collections on the road" in Lesson 4, "Managing Your Photo Library" for details on getting started with Lightroom CC.

Editing photos in Lightroom CC is covered in Lesson 5, "Developing Basics."

Sharing collections from Lightroom CC via Lightroom CC for Web is explained in Lesson 10, "Publishing Your Photos."

Subscription to Lightroom CC for mobile is free with either a full Creative Cloud subscription, or the Photography Bundle. For subscription details, go to https://www.adobe.com/creativecloud/plans.html

Getting help

Help is available from several sources, each one useful to you in different circumstances:

Module-specific Tips

The first time you enter any of the Lightroom Classic CC modules, you'll see module-specific tips that will help you get started by identifying the components of the Lightroom Classic CC workspace and stepping you through the workflow.

You can dismiss the tips if you wish, by clicking the Close button (x) in the upper right corner of the floating tips window. You can call up the module tips at any time by choosing Help > [*Module name*] Tips.

In the Help menu you can also access a list of keyboard shortcuts applicable to the current module.

Navigating Help in the application

The complete user documentation for Adobe Photoshop Lightroom Classic CC is available from the Help menu.

1 Choose Help > Lightroom Classic CC Help, or press the F1 key on your keyboard. Lightroom takes you to the online Help landing page. To search for a particular topic in the online Help, use the search bar at the upper right of the page. Enter a search term and press Enter/Return.

2 For quick access to Help documentation specific to the module in which you are working, press Ctrl+Alt+/ on Windows, or Command+Option+/ on macOS.

3 Press Ctrl+/ on Windows, or Command+/ on macOS to see a list of keyboard shortcuts for the current module.

Note: You need to be connected to the Internet to view Help in Lightroom.

Accessing Help and Support on the web

You can access Lightroom Classic CC Help, tutorials, support, and other useful resources on the web, even if Lightroom Classic CC is not currently running.

- If the application is running, choose Help > Lightroom Classic CC Online.
- If Lightroom Classic CC is not currently running, point your default web browser to https://helpx.adobe.com/support/lightroom.html where you can find and browse Lightroom Classic CC content on adobe.com.

Additional resources

Adobe Photoshop Lightroom Classic CC Classroom in a Book is not intended to replace the documentation that comes with the application, or to be a comprehensive reference for every feature. Only the commands and options used in the lessons are explained in this book. For comprehensive information about program features and tutorials, please refer to these resources:

Adobe Photoshop Lightroom Classic CC Help and Support
You can search and browse Help and Support content from Adobe at
https://helpx.adobe.com/support/lightroom.html

Adobe Forums
Tap into peer-to-peer discussions, advice, and questions and answers on Adobe products at https://forums.adobe.com/welcome

Adobe Creative Cloud Learn
For inspiration, key techniques, cross-product workflows, and updates on new features, go to https://helpx.adobe.com/lightroom/tutorials.html

Adobe Photoshop Lightroom Classic CC product home page
https://www.adobe.com/products/photoshop-lightroom-classic.html

Adobe Create Magazine
https://create.adobe.com offers articles on design and design issues, a gallery showcasing the work of top-notch designers, tutorials, and more.

1

A QUICK TOUR OF LIGHTROOM CLASSIC CC

Lesson overview

This lesson begins with a brief look behind the scenes that will show you how Lightroom Classic CC makes it so easy to navigate, search, and manage your ever-growing image library and frees you to work on your photos without fear of damaging the original files.

The exercises that follow provide a hands-on introduction to Lightroom Classic CC, familiarizing you with the workspace as they guide you through a typical workflow:

- Bringing photos into Lightroom Classic CC

- Reviewing and comparing photos

- Sorting and organizing your image library

- Adjusting and enhancing photos

- Sharing your work

 You'll probably need between one and two hours to complete this lesson. If you haven't already done so, log in to your peachpit.com account to download the lesson files for this chapter, or follow the instructions under "Accessing the Lesson Files and Web Edition" in the Getting Started section at the beginning of this book.

Note: The downloaded lesson images won't appear in Lightroom until you've imported them into the library catalog file; you'll do that in the exercise "Importing photos," after the overview that begins this lesson.

Whether you're a home or business user, a hobbyist or a professional, Lightroom Classic CC delivers a complete desktop-based workflow solution for the digital photographer. In this lesson, you'll get an overview of how Lightroom Classic CC works; then, take it for a test drive to familiarize yourself with the workspace, panels, tools and controls.

Understanding how Lightroom works

Working with Lightroom Classic CC will be easier and more productive if you have an overview of how Lightroom works—and how it differs from other image processing applications in the way it handles digital images.

About catalog files

In order to work with a photo in Lightroom Classic CC you must first bring it into your library catalog by importing it. It's important to understand that when you do this, Lightroom does not actually import the photo itself but simply creates a new entry in the *catalog file* to record the location of the image file on your computer hard disk, or even on external storage media. The catalog file is central to the way Lightroom Classic CC works: once an image has been registered in the catalog file as part of your Lightroom library, any operation you perform on the photo in Lightroom will be recorded in its catalog entry. Whenever you tag the image, assign it a rating or flag, group it with other photos in a collection, edit it, or publish it online, your actions are recorded in the catalog file.

A single catalog can easily manage thousands of files, but you're free to create as many catalogs as you wish and switch between them, should that better suit the way you prefer to work; for example, you may wish to use different catalogs to separate your personal photo library from your professional work.

Managing the photos in your catalog

Lightroom Classic CC helps you to make a start on organizing your photos from the moment you click the Import button; you can choose to add photos to your catalog without moving the image files from their current locations (the option illustrated below), copy them to a new location leaving the originals intact, or move them and delete the originals to avoid duplicating files. If you choose to copy or move your files during the import process, you can either have Lightroom replicate the folder structure in which they are currently stored, consolidate them into a single folder, or reorganize them into subfolders based on capture date.

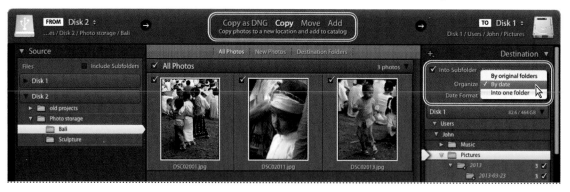

You can also have Lightroom Classic CC rename your image files during import, create backup duplicates, attach keywords and other metadata, and even apply developing presets—all before you've opened a single image!

Note: You'll learn more about setting up import options in Lesson 2, "Bringing Your Photos into Lightroom."

Once your photos are imported into the catalog you can work on them individually or in batches in the Lightroom Classic CC Library module, where you can attach keywords and captions, flag images for attention, assign ratings and map locations, tag faces, and create virtual groupings. Lightroom stores all of this information about each of your photos in the catalog file, making it quick and easy to find the photos you want, wherever the image files are located.

Managing files and folders

If you wish to rename or move an image file that you've already imported into your catalog or a folder containing photos from your Lightroom Classic CC library, you should always do so from within Lightroom so that the changes can be tracked by the catalog file. If you make these changes in Windows Explorer or the macOS Finder, Lightroom will report the renamed or moved file as missing and you may be asked to reestablish the link so that the catalog file can be updated.

Non-destructive editing

Storing information about your images in a central catalog file makes it easy to navigate, search, and manage your growing photo library, but perhaps the greatest advantage of this arrangement is that it allows for *non-destructive editing*. When you modify or edit a photo, Lightroom makes a record of each step you take in the catalog file, rather than saving changes directly back to the source file, as do other image processing applications such as Photoshop or Photoshop Elements. Lightroom effectively saves your changes only as a set of editing instructions attached to the photo's catalog entry, leaving the original image file untouched.

Non-destructive editing not only frees you to experiment with your photos without fear of losing information from the original files, but also makes Lightroom a very flexible and forgiving editing environment. All of your edits remain "live," so you can return at any time to undo, redo, or tweak any modification that you've made; Lightroom applies your edits permanently only to output copies.

Editing photos in another application

Should you wish to edit an image from your catalog using an external image processing application, you should always launch the process from within Lightroom so that Lightroom can keep track of changes made to the file. For a JPEG, TIFF, or PSD image, you have the option to edit the original file or a copy—either with or without the adjustments that you've already applied in Lightroom. For other file formats, you can edit a copy to which your Lightroom adjustments have already been applied. The edited copy will automatically be added to your Lightroom Classic CC catalog.

Tip: You can specify your favorite external editors in the External Editing preferences; your choices will appear in the Photo > Edit In menu. If you have Photoshop installed on your computer, it will be listed by default.

The Lightroom Classic CC workspace

The Lightroom Classic CC workspace is divided into six main panels. At center stage is the work area, flanked by the left and right panel groups. Above the work area and the left and right panel groups, the top panel displays an identity plate at the left and presents the Module Picker to the right. Immediately below the work area is the Toolbar, and below that, across the bottom of the workspace, the Filmstrip.

Note: The illustration at the right shows the macOS version of Lightroom. On Windows, the workspace is the same except for minor differences between the two operating systems; on Windows, for example, the menu bar is located under the title bar, whereas on macOS it's anchored at the top of the screen.

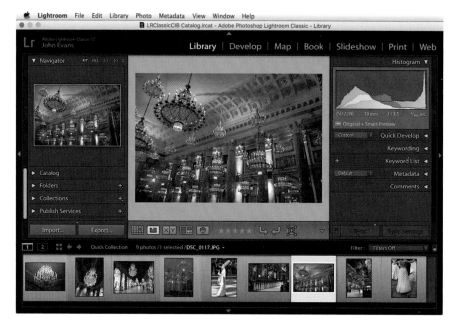

The basic arrangement of the panels is identical in all of the seven Lightroom Classic CC workspace *modules*. Only the contents of the panels vary from module to module, to address the specific requirements of each working mode.

The top panel

The top panel displays an identity plate on the left and the Module Picker on the right. The identity plate can be customized to feature your own company name or logo and will be temporarily replaced by a progress bar whenever Lightroom is performing a background process. You'll use the Module Picker to move between the different workspace modules by clicking their names. The name of the currently active module is always highlighted in the Module Picker.

The work area

Tip: The first time you enter any of the Lightroom modules, you'll see module tips that will help you get started by identifying the components of the Lightroom workspace and stepping you through the workflow. Dismiss the tips by clicking the Close button. To reactivate the tips for any module, choose [*Module name*] Tips from the Help menu.

At center-stage below the Module Picker is the main preview and working area. This is where you select, review, sort, compare, and apply adjustments to your

images, and where you preview the work in progress. From module to module, the work area offers different viewing options, allowing you to see either multiple images or a single photo at a range of magnification levels, and to preview your book designs, slideshow presentations, web galleries, and print layouts.

The Toolbar

Across the bottom of the work area is the Toolbar, which offers a different set of tools and controls for each of the Lightroom Classic CC modules. You can customize the Toolbar for each module independently to suit your working habits, choosing from a variety of tools and controls for switching viewing modes, setting ratings, flags, or labels, adding text, and navigating through preview pages. You can show or hide individual controls, or hide the Toolbar altogether until you need it.

▶ **Tip:** If you don't see the Toolbar across the bottom of the work area, choose View > Show Toolbar, or press the T key.

The illustration below shows the Toolbar for the Library module, with the view mode buttons at the left, and a selection of task-specific tools and controls that can be customized by choosing from the menu at the far right of the Toolbar.

Tools and controls that are currently visible in the Toolbar have a check mark beside their names in the Select Toolbar Content menu. The order of the tools and controls from left to right in the Toolbar corresponds to their order from top to bottom in the menu. Most of the options presented in the Toolbar are also available as menu commands or keyboard shortcuts.

The Filmstrip

The Filmstrip gives you access to all of the images in your catalog at any stage in your workflow; whichever module or viewing mode you're working with, you can use the Filmstrip to quickly navigate through a selection of images, or to switch between different sets of images without returning to the Library.

▶ **Tip:** If you don't see the Filmstrip across the base of the workspace, choose Show Filmstrip from the Window > Panels menu, or press the F6 key.

You can work directly with the thumbnails in the Filmstrip—just as you do in the Library module's Grid view—to assign ratings, flags and color labels, apply meta-data and developing presets, and rotate, move, or delete photos.

By default, the Filmstrip displays the same set of images as the Grid view in the Library module; it can show every image in the library, the contents of a selected source folder or collection, or a selection filtered by a range of search criteria.

The side panels

The content of the side panel groups changes as you switch between the workspace modules. As a general rule, you'll use the panels in the left group to navigate, preview, find and select items, and panels in the right group to edit or customize the settings for your selection.

In the Library Module for example, you'll use the panels below the Navigator preview in the left group (Catalog, Folders, Collections, and Publish Services) to locate and group the images you want to work with or share, and the panels below the Histogram panel in the right panel group (Quick Develop, Keywording, Keyword List, Metadata, and Comments) to apply changes to your selection.

In the Develop Module, you can choose from develop presets on the left, and fine-tune their settings on the right (*see illustrations below, left*). In the Slideshow, Print and Web Modules (*see illustrations below, right*), you'll select a layout template on the left, and customize its appearance on the right.

Left panel - Develop module Right panel - Develop module Left panel - Web module Right panel - Web module

Customizing the workspace

You can easily modify the layout of the flexible Lightroom Classic CC workspace to suit the way you prefer to work on any particular task in your workflow, freeing-up screen space as you need it and keeping your favorite tools and controls at your fingertips. Lightroom remembers your customized workspace layout for each module independently, so that the workspace is automatically rearranged to suit the way you like to work for each stage in your workflow as you move between modules.

Click in the outer margin at the top, sides, and bottom of the workspace, or use the commands and shortcuts listed in the Window > Panels menu, to show and hide any of the panels that surround the work area. Right-click / Control-click in the side and bottom margins to access a context menu, where you can even set the side panels or the Filmstrip to show and hide in response to your pointer movements, so that information, tools and controls will appear only when you need them.

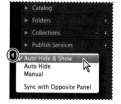

Simply drag to adjust the width of the side panel groups or the height of the Filmstrip panel; you might choose to increase the width of the left panel group to enlarge the navigator preview, maximize the right panel group to give you finer manual control when working with the adjustment sliders, or minimize the Filmstrip to make more space in the work area for a portrait-format image.

Within the left and right groups, you can expand or collapse any of the panels by clicking the triangle beside its name. Right-click / Control-click any panel header to access a context menu where you can hide panels you seldom use, creating more space for those you access more often, or reduce clutter by choosing Solo Mode, so that all the panels other than the one you're working with close automatically.

Select options from the View > Grid View Style and View > View Options menus to customize the appearance of the thumbnail image cells in the Grid view. You can choose to have the thumbnails displayed in either compact or expanded cells, and specify how much information about the images will be shown for each view style.

Tip: To choose from a more limited set of display options for the thumbnails in the Filmstrip, right-click / Control-click inside the Filmstrip and choose View Options from the context menu.

If you use a second monitor, click the Second Window button (■2), located at the upper left of the Filmstrip, to set up an additional view that is independent of the module and view mode on your main monitor. Use the view picker at the top of secondary display, or choose from the Second Window button's context menu, to customize the view and the way it responds to your actions in the main workspace.

The Lightroom Classic CC modules

Lightroom Classic CC has seven modules: Library, Develop, Map, Book, Slideshow, Print, and Web. Each module offers a specialized set of tools tailored to a different phase of your workflow: the Library for importing, organizing and publishing your photos, the Develop module for correcting, adjusting and enhancing images, and specialized modules for creating stylish presentations for screen, print, or web.

Use the Module Picker, or the commands and keyboard shortcuts listed in the Window menu to move effortlessly between modules as you work.

Library | Develop | Map | **Book** | Slideshow | Print | Web

The Lightroom Classic CC workflow

The modular Lightroom Classic CC interface makes it easy to manage every stage of your workflow, from image acquisition to finished output:

- **Import** The Lightroom Classic CC workflow begins in the Library module, where you can acquire images from your hard disk or Creative Cloud library, import them from storage media or another application, download them from a camera, extract frames from video, and even bypass your camera's memory card and shoot photos directly into your Lightroom catalog.

- **Organize** You can set the options in the Import dialog box to apply a basic level of organization to your catalog at import by attaching keywords and other metadata to your photos in batches. Once the photos have been added to your catalog, you'll use the Library and Map modules to manage them—to tag, sort, and search your image library and create collections to group your photos.

> **Tip:** If you wish to process your images further in your favorite pixel-based editor as part of your workflow, you can launch an external application from inside the Library or the Develop module and Lightroom will keep track of the changes that you make.

- **Process** You'll crop, adjust, correct, retouch, and apply effects to your images in the Develop module.

- **Create** In the Book, Slideshow, Print and Web modules, you can put together polished presentations and layouts to showcase your photos.

- **Output** Some output operations—such as exporting your edited images in a variety of digital file formats or sharing them as e-mail attachments—are not tied to any specific module and are always accessible via menu commands. The Book, Slideshow, Print and Web modules each have their own output options and export controls. The Library module hosts the Publish Services panel for sharing your images online.

In the exercises to follow, you'll step through a typical workflow as you familiarize yourself with the Lightroom Classic CC workspace.

Importing photos

You can import photos into your Lightroom Classic CC library from your hard disk, your Creative Cloud library, your camera or memory card reader, or from external storage media. During the import process you can choose from many options to help you manage and organize your files. For the purposes of this Quick Tour we'll ignore most of these advanced options; Lesson 2, "Importing," will go into more detail.

Before you start on the exercises, make sure you've set up the LRClassicCIB folder for your lesson files and created the LRClassicCIB Catalog file to manage them, as described in "Accessing the Lesson Files and Web Edition" and "Creating a catalog file for working with this book" in the Getting Started chapter at the beginning of this book.

If you haven't already done so, log in to your peachpit.com account to download the lesson files for this chapter, or follow the instructions under "Accessing the Lesson Files and Web Edition" in the chapter "Getting Started."

1 Start Lightroom Classic CC. In the Select Catalog dialog box, make sure that the file LRClassicCIB Catalog.lrcat is selected in the list of recently opened catalogs, and then click Open.

2 Lightroom Classic CC will open in the screen mode and workspace module that were active when you last quit. If necessary, switch to the Library module by clicking Library in the Module Picker at the top of the workspace.

3 Choose File > Import Photos And Video. If the Import dialog box appears in compact mode, as shown in the illustration below, click the Show More Options button at the lower left of the dialog box to access all of the options available in the expanded Import dialog box.

▶ **Tip:** If you can't see the Module Picker, choose Window > Panels > Show Module Picker, or press the F5 key. Note that on macOS the function keys are assigned to specific operating system functions by default and may not work as expected in Lightroom. If you find this to be the case, either press the fn key (not available on all keyboard layouts) together with the F5 key, or change the keyboard behavior in the system preferences.

The layout of the header bar of the Import screen reflects the steps in the import process: working from left to right, first specify the source location of the files you wish to import; next, select the appropriate type of import, and then designate a destination (for Copy and Move imports) and set batch processing options.

4 In the Source panel at the left of the expanded Import dialog box, navigate to the Lessons folder inside the LRClassicCIB folder on your hard disk.

5 Select the Lesson 1 folder. Ensure that all of the images in the Lesson 1 folder are checked for import.

6 In the import options just above the thumbnail previews, select Add so that the imported photos will be added to your catalog without being moved or copied.

7 In the File Handling panel at the right of the expanded Import dialog box, choose Minimal from the Build Previews menu. Disable the Build Smart Previews option and ensure that Don't Import Suspected Duplicates is activated.

8 In the Apply During Import panel, choose None from both the Develop Settings menu and the Metadata menu, and then type **Lesson 1, Europe** (including the comma) in the Keywords text box. Make sure that your import is set up as shown in the illustration below, and then click Import.

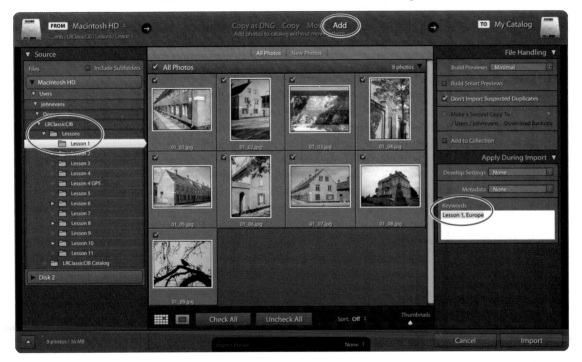

Thumbnails of the Lesson 1 images appear in the Grid view of the Library module and also in the Filmstrip at the bottom of the workspace. If you don't see the Filmstrip, press the F6 key or choose Window > Panels > Show Filmstrip.

Reviewing and organizing

When you're working with a library that contains many images, you need to be able to find exactly what you're looking for quickly. Lightroom Classic CC delivers numerous tools that will make organizing and finding your files easy and enjoyable.

You should make it a working habit to go through a few cycles of reviewing and organizing your files each time you import a new batch. Investing a little time in this way can save you a lot of effort later, making it much quicker and easier to retrieve the photos you want when you need to work with them.

You've already taken the first step towards structuring your catalog by tagging the lesson images with the keyword "Lesson 1" as they were imported.

Tagging photos with keywords is perhaps the most intuitive and versatile way to organize your catalog, because it lets you sort and search your library based on whatever words you choose to associate with your images, making it easy to find the files you need, regardless of how they are named or where they are located.

About keywords

Keyword are labels (such as "Sculpture" or "New York") that you can attach to your images to make them easy to find and organize. Shared keywords create virtual groupings within your library, linking photos by association, although the image files may actually be stored in many separate locations.

There's no need to painstakingly sort your photos into subject-specific folders or rename files according to their content; simply assign one or more keywords to your images and you can easily retrieve them by searching your library using the Metadata and Text filters located in the Filter bar across the top of the work area.

You can use keywords to sort your photos into photographic categories, organize them according to content by tagging them with the names of people, places, activities or events, or associate them by season, color, or even mood; your imagination is the only limit.

Attach multiple keywords to your images to make retrieving the pictures you want even easier; you could quickly find all the photos that you've tagged with the keyword Sculpture, and then narrow the search to return only those that are also tagged New York. The more tags you attach to your photos, the more chances you have of finding exactly the right image when you need it.

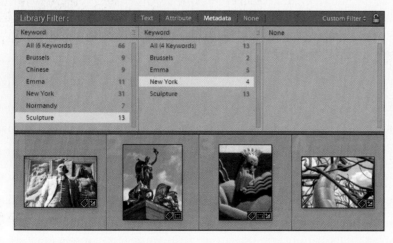

For more on working with keywords, see Lesson 4, "Managing Your Photo Library."

Working in slideshow mode

As a convenient way to review the images you've just imported, you can now sit back and enjoy an impromptu slideshow:

Note: The slideshow plays according to the settings current in the Slideshow module and will repeat until you press the Esc key to return to the Library.

1 Check the Catalog panel (below the Navigator pre-view in the left panel group) to make sure that the Grid view is displaying the images from the previous import. Choose Window > Impromptu Slideshow or press Ctrl+Enter / Command+Return to launch a full-screen slideshow. Press the spacebar to pause and resume playback.

Even while the slideshow is playing, you can start organizing your catalog by using keyboard shortcuts to rank your photos with star ratings, flag images as picks or rejects, or attach color labels. This makes the impromptu slideshow a great first-pass review: you can quickly mark your images, and then use a search filter to isolate the shots you want to work with once you return to the Library.

Tip: Whenever you use your keyboard to mark a photo in the impromptu slideshow, the rating, flag, or label you assign appears briefly in the lower left corner of the screen to confirm your action.

2 To quickly assign a rating to the image that's currently displayed in your slideshow, press a number between 1 (for 1 star) and 5 (for 5 stars) on your keyboard. To remove the rating, press 0. You can attach only one rating to each photo; assigning a new rating will replace the old one. For the purposes of this exercise, mark three or four images with either 3, 4, or 5 stars.

Rating stars are displayed under the thumbnail images in all of the Library module views and in the Filmstrip, as shown in the illustration above.

3 Press the P key on your keyboard to flag the image currently displayed in your slideshow as a pick (⚐), press the X key to flag it as a reject (⚑), or press the U key to remove any flags. Flag several of the Lesson 1 images as picks, and mark at least one as a reject.

You can choose to display flags, along with other information, in the image cells in the Library views and in the Filmstrip. Images flagged as rejects appear grayed out, while those marked as picks are indicated by a white border.

Use color labels to mark photos for specific purposes or projects. You might use a red label for images you intend to crop, green for those that need correction, or blue to identify photos you wish to use in a particular presentation. To help you remember the meaning of your labels, you can assign your own names to the colors by choosing Metadata > Color Label Set > Edit. You can create several label sets, and switch between them as needed. You could customize one set for working in the Library module and another to suit your workflow in the Develop module.

4 To assign a color label to the image currently displayed in your slideshow, use the number keys. Press 6 on your keyboard to assign a red color label, press 7 for yellow, 8 for green, or 9 for blue. There's no keyboard shortcut to assign a purple color label. To remove a color label simply press the same number again. Assign different colored labels to several of the images, and then remove one.

In the Library module's Grid View, and in the Filmstrip, a photo with a color label will be framed in that color when it's selected, and surrounded by a tinted image cell background when it's not, as shown in the illustration at the right.

If you prefer, you can change the view options so that color labels will appear only under the thumbnail images in the Grid view. You'll learn about customizing view options and more about assigning ratings, flags, and color labels, using both menu commands and the Toolbar controls, in Lesson 4, "Managing Your Photo Library."

5 Press the Esc key to stop the slideshow and return to the Library module.

In the Library, you can use the Filter bar above the thumbnail grid to search your images by text or metadata, and then refine your search by filtering for one or more of the searchable attributes—flag status, edits, rating, label color, or file type—so that only those photos you want are displayed in the Grid view and the Filmstrip.

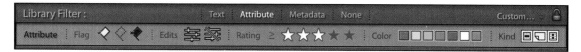

6 If the Filter bar is not already visible above the work area, open it by choosing View > Show Filter Bar. Click the Attribute filter. Click the fourth star, and choose Rating Is Greater Than Or Equal To from the Rating menu. Lightroom will now display only those photos with at least a 4 star rating.

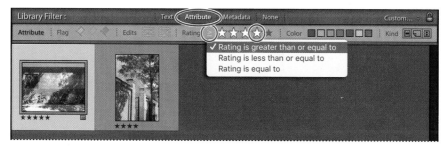

7 Experiment a little with the attribute filters. Try searching different star ratings; then varied combinations of ratings, flags, and labels.

When you're working with only a few images—as you are in this lesson—rating, flagging, and filtering seems unnecessary, but as your photo library grows to contain more and more photos you'll find these tools invaluable. The objective of this step in your workflow is to organize your images so that you can retrieve them easily for processing in the Develop, Slideshow, Print, and Web modules.

Creating a collection

Once you've searched your library by keywords or text, and then filtered out the unwanted images using the attributes filters, you can group the resultant group of photos as a *collection*, so that you can easily retrieve the same selection at any time without repeating the search. You can choose between several types of collections:

- The Quick Collection: a temporary holding collection in the Catalog panel, where you can assemble a selection of images.

- A "standard" Collection: a permanent grouping listed in the Collections panel.

- A Smart Collection: a selection of images automatically filtered from your library according to whatever criteria you specify.

- A Publish Collection: a selection of images intended for publishing that will be listed in the Publish Services panel. A Publish Collection will keep track of images you've published, enabling you to check at a glance whether the versions you're sharing are up-to-date.

For this exercise, you'll create a standard Collection.

1 If the star rating filter is still active in the Grid view, clear this setting by choosing Library > Filter by Rating > Reset This Filter, or simply click None in the Filter bar above the Grid view to disable all active filters.

2 Ensure that Previous Import is selected in the Catalog panel. Choose View > Sort > File Name; the Grid view and the Filmstrip should display all nine images.

● **Note:** A selected image is highlighted in the Grid view and the Filmstrip by a narrow white border (or a colored border if the image has a color label) and a lighter cell background color. If more than one photo is selected, the active photo is shown with an even lighter background. Some commands will affect only the active photo while others affect all selected photos.

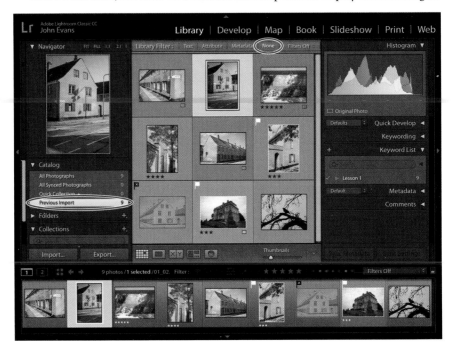

When you next import images, the Previous Import folder will be updated and you'll no longer be able to isolate this particular group of images by choosing from the entries in the Catalog panel. In this case, you could still retrieve your selection by working with the Folders panel or searching the Lesson 1 tag, but it would not be so easy to retrieve a group of photos (such as the results of a complex search) that didn't share a keyword or were spread across separate folders.

The solution is to create a collection, a virtual grouping that will be permanently listed in the Collections panel, so you'll be able to call up the same set of images at any time with a single click.

Tip: Collections can be nested. For example, you could create a Portfolio collection, and then create nested collections for Portraits, Scenic, Product Shots, Black & White, etc. Each time you import an outstanding new image, add it to one of these collections to slowly build up your portfolio.

3 Choose Edit > Select All; then choose Library > New Collection. In the Create Collection dialog box, type **Copenhagen Color** as the collection name. Under Location, leave the option Inside A Collection Set disabled. Under Collection Options, ensure that Include Selected Photos is activated, and the other options disabled; then, click Create.

Your new collection is now listed in the Collections panel. The listing includes an image count showing that the Copenhagen Color collection contains nine photos.

Rearranging and deleting images in a collection

While you're working with the images in the Previous Import folder or the All Photographs folder—source locations listed in the Catalog panel—the order of the photos in the Grid view and in the Filmstrip is fixed; the thumbnails are either ordered by capture time (the default) or by your choice of various other criteria from the sort menu in the Toolbar, such as file name, rating, or the order in which the photos were imported into your catalog.

If the image source is a single folder without subfolders, or a collection, however, you're free to rearrange the order of images in the Grid view and the Filmstrip, and even remove them from the working view without deleting them from the catalog.

1 If your new collection is not already selected in the Collections panel, click to select it now. Choose Edit > Select None.

2 In the Filmstrip, Ctrl-click / Command-click to select the fourth and sixth images (two portrait-format photos) and drag the selection over the dividing line between the first and second thumbnails in the Filmstrip. Release the mouse button when the black insertion line appears.

Tip: You need to drag the thumbnail of one of your selected images, rather than the image cell frame.

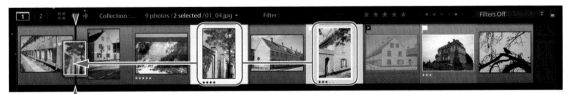

The selected photos snap to their new positions in the Grid view and the Filmstrip.

3 Deselect the photos by clicking an empty area in the main work area. Click to select the first thumbnail in the Grid view and drag it over the border between the fourth and fifth images. Release the mouse button when the black insertion line appears. In the Toolbar, the Sort criteria has changed to Custom Order.

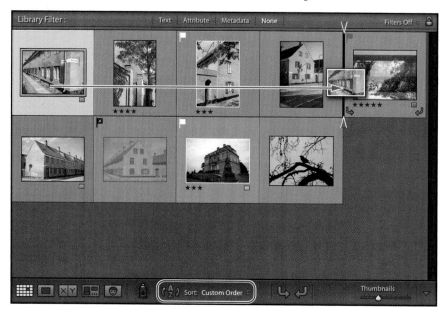

4 Choose Edit > Select None. Shift-click to select the last two thumbnails in the Grid view. Right-click / Control-click either of the selected images and choose Remove From Collection from the context menu.

In the Collections panel (and in the header bar of the Filmstrip) the image count shows that the new collection now contains only 7 images.

Although you've removed photos from the collection, they have not been deleted from your catalog. The Previous Import and All Photographs folders in the Catalog panel still contain all nine images. A collection contains only links to the files in your catalog; deleting a link does not affect the file in the catalog.

You can include a single image in any number of collections—each collection will then contain its own link to the same file. If you apply a modification to a photo in a collection, the modification will be visible in each folder and collection that references the same photo. This is because Lightroom stores only one entry for each image file in its library catalog, and a record of all modifications is associated with that entry; any collection including that image links to the same catalog entry, and therefore displays the photo with all edits applied. Although the original image file itself remains untouched, its catalog entry has changed to include your modifications. For more information on collections, please refer to the section "Using collections to organize images" in Lesson 4.

▶ **Tip:** Should you wish to edit the same image differently in two collections, you'll first need to make a virtual copy—an additional catalog entry for the image—for inclusion in the second collection. You'll learn about this in Lesson 6, "Advanced Editing."

Comparing photos side by side

Often you'll have two or more similar photos that you'd like to compare side by side. The Library module features a Compare view for exactly this purpose.

1 If you have any images selected in the Grid view, choose Edit > Select None. Select the first two images in the Filmstrip, and then click the Compare View button (![xy]) in the Toolbar to switch to the Compare view. Alternately, choose View > Compare, or press C on your keyboard.

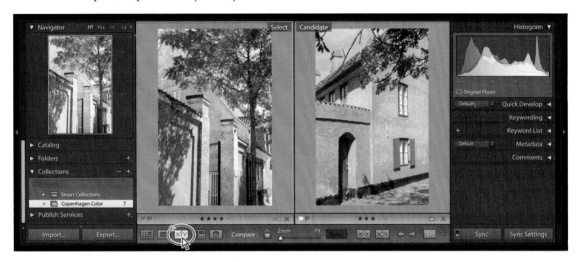

2 The Select pane is active by default. In the Filmstrip, click on the third photo to replace the current Select image. Press the right arrow key on your keyboard repeatedly to cycle the Candidate pane to the sixth photo.

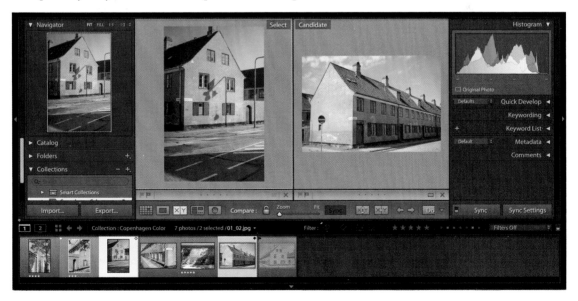

3　Press the Tab key on your keyboard, and then press F5 to hide the side and top panels so that your photos can be displayed at a larger size in the Compare view.

4　Click the Swap button (⧉) in the Toolbar below the Candidate image to swap the Candidate and Select images; then, use the right arrow key to compare the new Select photo with the next candidate from the collection.

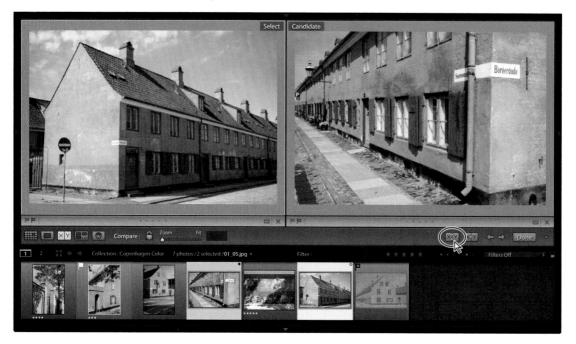

5　When you've made your choice, click the Done button at the right end of the Toolbar. The Select image will appear in the single-image Loupe view.

Comparing several photos

The Survey view lets you compare several photos at the same time and narrow your selection until only the best photo remains. Even while you're working in the Compare and Survey views, you can continue to organize your photos using menu commands and the Toolbar to assign ratings, flags, and color labels. If necessary, use the Content menu at the right of the Toolbar to show the controls you need.

1　Choose Edit > Select None. In the Filmstrip, Ctrl-click / Command-click any three of the landscape-format photos, and then click Survey view (⊞⋯) in the Toolbar. Alternatively, choose View > Survey, or press N on your keyboard.

The Survey view will display all the selected images; the more images you select the smaller the individual preview images in the Survey view. You can make more room for the images you're reviewing by hiding the Filmstrip and side panel groups as necessary. However, it may be helpful to show the right panel group where you can examine a histogram and metadata for the active photo, apply Quick Develop

adjustments, and add keywords, titles, and captions. The active image is indicated by a thin white border; to activate a different photo, you can either click its thumbnail in the Filmstrip or click the image directly in the work area.

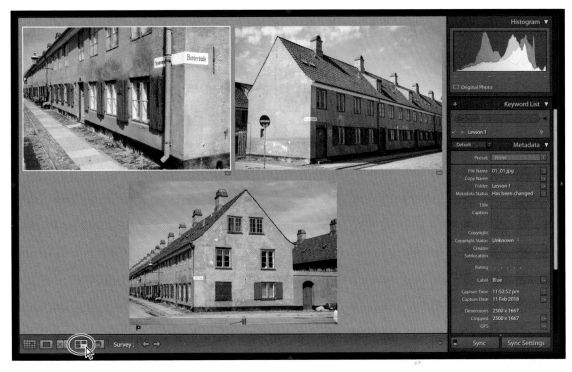

2 Drag any of the images to reposition it in the Survey view. The other images will be shuffled automatically to accommodate your action.

3 As you move the pointer over each of the images, a Deselect Photo icon (❎) appears in the lower right corner. Click this icon to remove a photo from the selection in the Survey view.

As you eliminate candidates the photos remaining in the Survey view are progressively resized and shuffled to fill the space available in the work area. When you eliminate a photo from the Survey view, the image is simply dropped from the selection, not removed from the collection.

Tip: If you eliminate a photo accidentally, choose Edit > Undo to return it to the survey selection, or Ctrl-click / Command-click the image in the Filmstrip. You can easily add a photo to the selection in the same way.

4 Eliminate another photo from the Survey so that your selection is narrowed down to a single image, and then press E on your keyboard to switch to the single-image Loupe view.

5 Press Shift+Tab (twice if necessary) to show all the workspace panels. Press G on your keyboard to return to the Grid view. Choose Edit > Select None.

Developing and editing

The next step in the Lightroom workflow is to process your images, whether you wish to improve them technically by correcting color, tonal balance, and distortion, or enhance them creatively using customizable develop presets and effects.

You can start without even leaving the Library module, where the Quick Develop panel offers simple controls for basic color correction and tonal adjustment, and a choice of preset crop and develop settings. For a finer degree of control, the Develop module offers an extended suite of sophisticated image processing tools, in a more comprehensive and convenient editing environment.

Using Quick Develop in the Library module

In this exercise you'll quickly improve the color and tonal balance of an image, and then tweak the results with the controls in the Quick Develop panel.

1 In the Catalog panel, click the Previous Import folder so that you can see all nine of the lesson images.

> **Tip:** If the Filmstrip is not visible, choose Window > Panels > Show Filmstrip or press F6 on your keyboard.

2 In the Filmstrip or the Grid view, hold the pointer over the photo of the chateau under an overcast sky to see the file name and basic image details displayed in a tooltip. Click the thumbnail to select it; the file name is also displayed in the status bar above the thumbnails in the Filmstrip.

3 Double-click the selected image in the Filmstrip to see it enlarged in Loupe view. If necessary, expand the Histogram and Quick Develop panels in the right panel group by clicking the arrows beside the panel names.

> **Tip:** To make more space for the image in Loupe view, use the commands in the Window > Panels menu to hide the left panels, the Module Picker, and the Filmstrip. Commands for showing and hiding the Toolbar and Filter bar are listed in the View menu.

As you can see from both the image preview and the curve in the Histogram panel, this photo does not have a balanced tonal distribution; everything but the sky is significantly under-exposed and lacking in mid-tone contrast, giving it a dull, flat look.

4 Watch the tone distribution curve shift in the Histogram panel as you click the Auto Tone Control button in the Quick Develop panel.

Although the automatic adjustment hasn't done a perfect job with this particular photo, there is substantial improvement; a lot of tone and color detail has been recovered from the overcast glare as well as the darker shadows. These changes are reflected in the histogram curve, which no longer shows such a pronounced spike in the upper highlights and now has far more information through the mid-tone range. However, while the tonal balance has improved, the overall effect is still dull.

▶ **Tip:** Click back and forth between the Reset All button at the bottom of the Quick Develop panel and the Auto Tone Control button to assess the results in the Loupe view.

5 Click the triangle to the right of the Auto Tone button to expand the Tone Control pane. Click the second button (the left-facing single arrow) once for the Exposure control and twice for Highlights. Click the right-most button once for Contrast, Whites, Blacks, and Vibrance, and twice each for Shadows and Clarity.

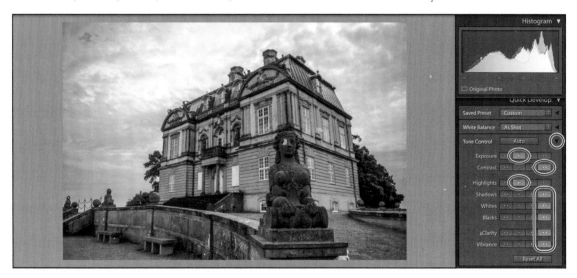

The histogram now shows an even more balanced tonal spread, with less glare and far more depth and definition in the mid-tones. The adjusted image has more detail than the original in both the brightest-lit and most shadowed areas, and the overall contrast and color are much improved.

Working in the Develop module

The controls in the Quick Develop panel let you change settings but don't indicate absolute values for the adjustments you make to your images.

In our example there is no way to tell which parameters were modified by the Auto Tone adjustment, or by how much they were shifted. For finer control, and a more comprehensive editing environment, you need to move to the Develop module.

1 Keeping the image from the previous exercise selected, switch to the Develop module now by doing one of the following:

 • Click Develop in the Module Picker at the top of the workspace.

 • Choose Window > Develop.

 • Press Ctrl+Alt+2 / Command+Option+2.

2 If necessary, expand the History panel in the left panel group and the Basic panel in the right panel group by clicking the white triangle beside each panel's name. Collapse any other panels that are currently open, except the Navigator on the left and the Histogram at the right. Press F6 to hide the Filmstrip.

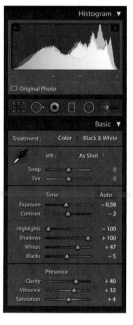

The History panel not only lists every modification you've made to a photo—even Quick Develop adjustments made in the Library module—but also enables you to return the image to any of its previous states.

The most recent Clarity adjustment you applied is at the top of the History list. The entry at the bottom of the list, records the date and time of import. Clicking this entry will revert the photo to its original state. As you move the pointer over each entry, the Navigator displays a preview of the image at that stage of development.

The Basic panel displays numerical values for the adjustment settings that were unavailable in the Quick Edit panel. For our image in its most recent state, the Exposure is set to -0.58, Contrast is set to -2; Highlights, Shadows, Whites, Blacks, Clarity, Vibrance, and Saturation are set to -100, +100, +47, -5, +40, +32, and +4, respectively. Don't be concerned if your settings differ fractionally.

3 In the History panel, click the entry for the first modification you made to this photo: the Auto Tone adjustment: Inspect the settings in the Basic panel.

For this image, clicking Auto Tone modified all the settings in the Tone and Presence panes, but applying Auto Tone to another photo may effect fewer settings and produce very different adjustment values.

4 Click the top entry in the History list to return the photo to its most recent state.

5 In the Toolbar (View > Show Toolbar), click the small triangle to the right of the Before/After button and choose Before/After Top/Bottom from the menu.

Tip: If you don't see the Before/After button in the Toolbar, click the triangle at the right of the Toolbar and activate Before And After in the Toolbar content menu.

By comparing the Before and After images, you can see how much you've improved the photo with just a few clicks.

Now let's look at how much difference your manual Quick Develop adjustments made after applying Auto Tone.

6 Leaving the most recent Clarity adjustment activated in the History panel, right-click / Control-click the entry for the Auto Tone adjustment and choose Copy History Step Settings To Before from the context menu.

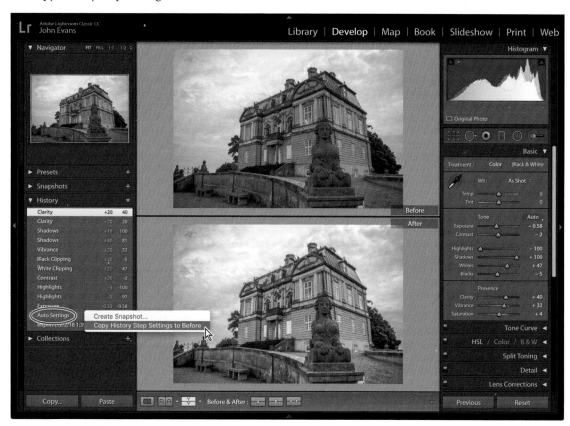

There's much more to learn about the correction and adjustment tools in the Develop module, but we'll leave that for later. For now you'll straighten this slightly tilted photo, and then crop it.

Straightening and cropping an image

1. Press D on your keyboard to activate the Loupe view in the Develop module.

2. Click the Crop Overlay Tool (▦), located just below the Histogram in the right panel group. The Crop Overlay Tool enables you to both crop and straighten an image.

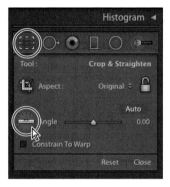

3. When the Crop Overlay Tool is active, a pane with tool-specific controls opens below the tool buttons. Click the Straighten tool (⊜). The pointer changes to a crosshairs cursor, and the spirit level icon follows your movement across the image preview.

4. With the Straighten tool, drag a line that follows an edge of the widest part of the plinth supporting the statue in the foreground. Release the mouse button; the image is rotated so that your line becomes horizontal and the Straighten tool returns to its place in the Crop Overlay Tool controls. If you are not satisfied with the result, undo the step (Ctrl+Z / Command+Z) and try again; the text box beside the Straighten tool slider should indicate a rotation of close to 1.5 degrees.

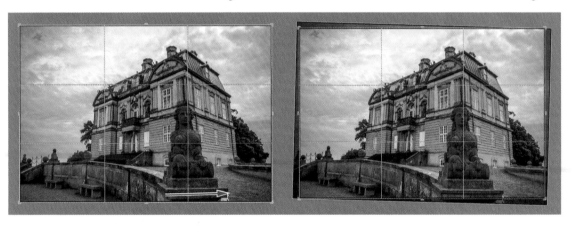

▶ **Tip:** To maintain the original aspect ratio of an image when you crop it manually, make sure that Original is selected from the cropping Aspect menu and that the aspect ratio is locked.

Lightroom has overlaid a cropping rectangle on the straightened photo, automatically positioned to achieve as large a crop as possible with the original aspect ratio while trimming away the angled edges.

If you wished to adjust the crop, you could drag any of the eight handles on the cropping rectangle. To assist with manual cropping, you can choose from a variety of grid overlays in the Tools > Crop Guide Overlay menu, or hide the grid by choosing Tools > Tool Overlay > Never Show.

5. When you're done, apply the crop by clicking the Crop Overlay tool, the Close button at the lower right of the tool controls, or the Done button in the Toolbar. You can reactivate and adjust the crop at any time by clicking the crop tool.

Adjusting lighting and tonal balance

In the previous project, you used the simplified Quick Develop tone controls to tweak the tonal range of a photo shot in difficult lighting conditions. This time you'll work in the Basic panel to rescue a photo that may at first seem beyond redemption.

1 Remaining in the Develop module, press F6 and F7 (or use the Window > Panels menu) to show the Filmstrip and hide the left panels. In the Filmstrip, click to select the photo 01_09.jpg.

This image is a very difficult case; captured in low light on an gloomy day, and back-lit by a flat, overcast sky, the photo is badly underexposed. There is so little detail in the bird and branches that, at first glance, they appear to be mere silhouettes.

2 In the histogram above the right panels, it's easy to see that the tonal distribution is uneven: data is clumped at both ends of the curve, with an obvious deficiency of information through most of the shadows and mid-tones range, and none at all in the upper highlights and whites.

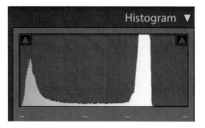

3 In the Basic panel, click the Auto adjustment button at the top of the Tone pane, noting the effect on the histogram curve as well as the image in the work area.

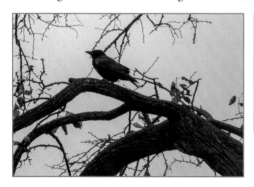

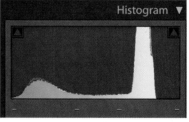

As a whole, the tone distribution curve has shifted to the right; the image is somewhat brighter, but it still looks dull and lifeless. The automatic adjustment has spread the peak formerly in the shadows range of the histogram into the lower mid-tones, bringing out more detail in the bird and branches; however, the central trough is little improved, so the photo still lacks mid-tone contrast. Although it has shifted towards the upper highlights, the truncated peak at the right of the curve is still the dominant feature, reflecting the flat, almost monotone look of the sky.

4 Inspect the controls in the Basic panel. The Auto Tone adjustment has affected all six of the settings in the Tone pane, as well as the Vibrance and Saturation settings in the Presence pane.

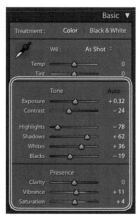

As the automatic adjustment has moved this photo in the right direction, you can now use these settings as a starting point, and then make manual adjustments to tweak the tonal balance, as you did with the simplified Quick Develop controls in the previous exercise.

5 Watch the change in the histogram as well as the photo as you move the Contrast slider to the left, or type in the text box, to reduce the value to **-100**.

Reducing the Contrast may seem counter-intuitive but, as you can see, it has effectively drawn image data inwards from the ends of the histogram curve toward the center, reducing the tonal range most affected by the trough. At this point, the photo may actually look worse for the reduction in contrast, but the extreme tonal deficiencies in this image will require some adjustments that are equally extreme, and reducing the Contrast will help limit the damage.

6 Increase the Highlights and Blacks values to **0**, and Clarity to **+100**. Set a value of **+50** for both Vibrance and Saturation.

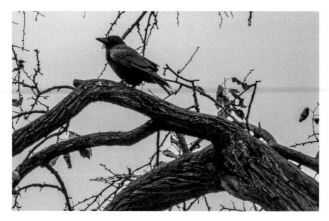

The Clarity and Vibrance settings affect the image as a whole, rather than a specific tonal range. Increasing the Clarity adds depth and definition by heightening the local contrast between adjacent areas in the image. The Vibrance control affects the color saturation in a non-linear manner, boosting less saturated colors more than bolder areas.

And now, it's time for a dirty trick. Increasing the Whites value significantly will push the right end of the curve off the end of the graph, causing most of the sky to be "clipped" to pure white. In purist, technical terms this is not an acceptable result, but for our hard-case image the sky is already so devoid of color and detail that we can trade the barely noticeable loss against improvement elsewhere.

7 Use the slider to increase the Whites value slowly to **+100**. Watch the change in both the photo and the histogram curve when the value exceeds **+80**.

8 Press F7, or use the Window > panels menu, to show the left panels. In the History panel, click back and forth between the current state at the top of the list, the Import state at the bottom, and the Auto Tone entry just above it, comparing the changes in the histogram as well as the results in the Loupe view. When you're done, leave the image open in Loupe view for the next exercise.

Original photo Auto Tone Auto Tone with manual adjustments

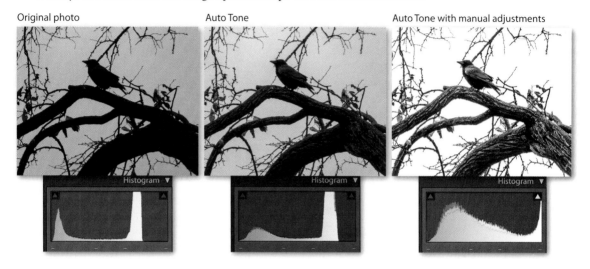

Creating effects with the Radial Filter tool

You can use the Radial Filter tool to create off-center custom vignettes, amongst other effects, by applying local adjustments to a selected area in an image through a feathered (soft-edged) elliptical mask.

Unlike the centered post-crop vignette in the Effects panel, you can place the center of your Radial Filter adjustment anywhere in the photo, focusing attention on whichever part of the image you choose.

By default, your local adjustments are applied to the area outside the adjustable ellipse, leaving the inside unaffected, but the Radial Filter's Invert option enables you to reverse the focus of the filter.

By applying multiple Radial Filter adjustments, you can treat the inside and outside areas differently, highlight more than one area in the same image, or create an asymmetrical vignette, as illustrated here.

You can experiment with adding custom vignettes to your own photos later. In this exercise, you'll learn how to work with the Radial Filter tool as you set up a more complex effect that will hopefully add a little color and atmosphere to our problem photo, which is still less than exciting.

You'll start by setting up a combination of adjustments that will be applied to the photograph through your first Radial Filter mask.

1 Click to activate the Radial Filter tool—the fifth of the editing tools located right below the Histogram in the right panel group.

When the Radial Filter tool is activated, its own pane of image adjustment controls appears immediately below the tool bar.

> **Tip:** Make sure the color swatch at the bottom of the local adjustments pane shows a black X on a white background (no color selected). If this is not the case, click the swatch and reduce the Saturation setting to 0.

2 Set the Temperature to **-25**. Reduce the Exposure setting to **-2.25**, increase the Contrast to **45**, and decrease the Highlights to **-100**. Set the Shadows and Clarity values to **60** and **-50** respectively. Make sure that the Feather control is set to the default value of **50** and the Invert option is disabled.

3 Hold down the Shift key to constrain the new mask to a circle, and then drag in the Loupe view with the Radial Filter tool's cross-hairs cursor, starting from a point at the back of the bird's neck. When you've created a circle positioned and scaled as shown in the illustration at the right, release the mouse button, and then the Shift key.

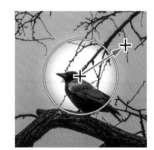

Once established, the active Radial Filter adjustment is displayed with a circular *pin* at its center and four square control handles around its circumference. Whenever the tool is activated, you can select an existing filter for editing by clicking its central pin, reposition it by dragging the pin, and resize the adjustment area or change its shape by dragging any of the square control handles.

At present, the Radial Filter adjustments are applied evenly across the unmasked parts of the image like an overlay, but you can set up the Range Mask control so the adjustments will be applied mainly to the sky, "behind" the branches and the bird.

4 Click the double arrows beside Range Mask, right below the Feather control, and choose Luminance from the menu. Drag the left-hand slider of the Range control to set a luminance range value of **10/100**.

> **Tip:** If the colors you see on-screen differ significantly from those illustrated, consider calibrating your display. See Windows / macOS help for instructions. Slighter differences may be a result of conversion from RGB to CMYK color for printing.

5 Hold Ctrl+Alt / Command+Option and click the pin to duplicate the filter. As you can see, duplicating the radial filter has doubled the effect on the image; you should keep it in mind that the effects of overlapping filters are cumulative.

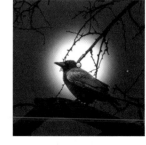

6 Activate the Invert option below the local adjustment controls. The same adjustments are now being applied both inside and outside the feathered mask, so that the entire image is affected evenly.

7 With your second Radial Filter adjustment still selected and active, change the Temperature and Tint values to **25** and **15** respectively. Set the Exposure to **1.30**, and the Contrast, Highlights, and Shadows to a common value of **-100**. Increase the Clarity setting to **100**, Saturation to **45**, and Sharpness to **100**. The new settings are applied inside the inverted mask.

8 Hold down the Shift key to constrain the shape of the filter as you drag the bottom control handle downwards. Enlarge the circle as shown in the illustration at the left, below. Be sure to release the mouse button before you release the Shift key. Drag the control handle on the left side of the circle (without the Shift key) until it lies just outside the left edge of the image, as shown on the right, below. The mask is enlarged horizontally, from its center.

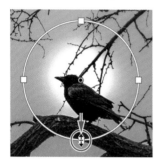 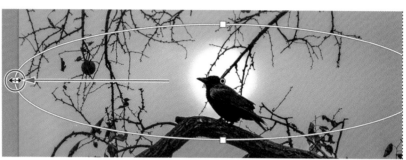

9 Hold Ctrl+Alt / Command+Option and drag the pin to duplicate the active filter and reposition it as shown at the left, below; then, without holding the Shift key, drag the control handles at the top and left of the ellipse to enlarge the Radial Filter adjustment as illustrated at the right, below.

> **Tip:** Radial Filter adjustments scale from the center by default. Hold down Alt / Option to scale from one side.

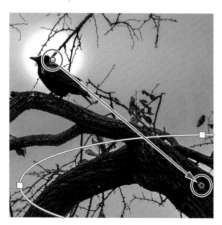 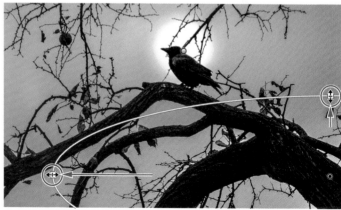

10 Drag the central pin for the active Radial Filter to the left to center the ellipse horizontally, while maintaining its distance from the lower edge of the image. Set both the Temperature and Tint values to **33**, increase the Exposure to **1.60**, and reduce the Clarity and Sharpness to **0** and **50** respectively. You can leave the rest of the settings as they are.

The Radial Filter tool includes a Brush mode, which enables you to add to, or subtract from, the area affected by the filter by painting directly onto the image.

You'll add a finishing touch to this image by using the Radial Filter in Brush mode to restore some color and definition to the bird.

10 Keeping the Radial Filter tool active, press Ctrl / Command together with the Plus sign key (+) twice; then, hold down the spacebar and drag the image to center the bird in the workspace.

11 Click the Radial Filter pin at the back of the bird's head to activate it; then, click Brush in the Radial Filter's Mask picker.

12 In the Brush options at the bottom of the Radial Filter controls, set the brush to Erase mode and activate Auto Mask. Set the brush Size to **5**, and the Feather value to **10**.

13 Click well within the outline of the bird and drag to paint out the effects of the Radial filter. Start by working around the outline. With the Auto Mask option activated, you won't need to be overly careful; the brush will detect the edges.

14 Click the Radial Filter tool below the Histogram to disable the tool and hide the local adjustment pins from view; then press Ctrl / Command together with the Minus sign key (-) twice to fit the image to the work area.

Sharing your work by e-mail

Now that you've edited and enhanced your photos, the final step in your workflow is to present them to your client, share them with friends and family, or publish them for the world to see on a photo-sharing website or in your own interactive web gallery. In Lightroom Classic CC, it takes only minutes to create a sophisticated photo book or slideshow, customize a print layout, publish your photos online, or generate a stylish interactive gallery ready to be uploaded directly to your web server from within Lightroom.

Lesson 7, "Creating a Photo Book," Lesson 8, "Creating a Slideshow," Lesson 9, "Printing Images," and Lesson 10, "Publishing your Photos," will provide much more detail on the many Lightroom Classic CC tools and features that make it simple to create professional-looking presentations, layouts, and galleries to showcase your photos. In this exercise, you'll learn how you can attach your finished images to an e-mail without leaving Lightroom Classic CC.

1 Press Ctrl+D / Command+D or choose Edit > Select None. In the Filmstrip, Ctrl-click / Command-click to select the images 01_08.jpg and 01_09.jpg—the two photos that you've edited in the course of this lesson.

2 Choose File > Email Photos.

Lightroom automatically detects the default e-mail application on your computer and opens a dialog box where you can set up the address, subject, and e-mail account for your message, and specify the size and quality of the attached images.

● **Note:** For Windows users: if you have not specified a default e-mail application in Windows, the sequence of dialog boxes you see may differ slightly from that described and illustrated here (from macOS). The process is basically the same, but you may need to refer to steps 8, 9, and 10 to set up an e-mail account before returning to this step.

3 Click Address to open your Lightroom address book. Click New Address; then, enter a contact name and e-mail address and click OK.

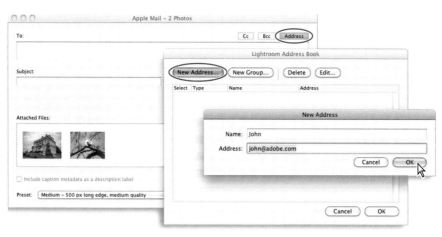

4 In the Lightroom Address Book dialog box, you can specify as many recipients for your message as you wish. For now, select the entry for your new contact by clicking the associated check box, and then click OK.

5 Now type a subject line for your e-mail.

6 Choose from the image size and quality options in the Preset menu.

7 If you intend to use your default e-mail application, you're ready to click Send and add a text message in a standard e-mail window.

8 If you'd prefer to connect directly to a web-based mail service, you need to set up an account. In the From menu, choose Go To Email Account Manager.

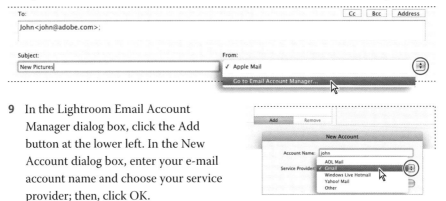

9 In the Lightroom Email Account Manager dialog box, click the Add button at the lower left. In the New Account dialog box, enter your e-mail account name and choose your service provider; then, click OK.

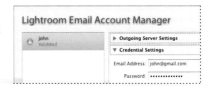

10 Enter your e-mail address and password under Credential Settings in the Lightroom Email Account Manager dialog box, and then click Validate.

Lightroom uses your credential settings to verify your account online. In the Lightroom Email Account Manager dialog box, a green light indicates that your web-based e-mail account is now accessible by Lightroom.

11 Click Done to close the Email Account Manager. Type a message in the text box above the thumbnails of your attached images, change the font, text size, and text color if you wish, and then click Send.

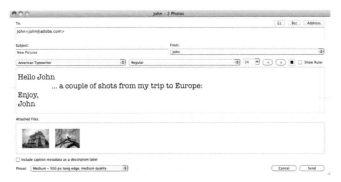

Review questions

1 What is non-destructive editing?

2 What are the seven Lightroom workspace modules and how do they relate to your workflow?

3 How can you increase the viewing area without resizing the application window?

4 What advantage is there to grouping images in a collection, rather than by keyword?

5 Why is it recommended to create a special collection for each book, slideshow, print, or web project?

Review answers

1 Whatever modifications you make to an image in your library—cropping, rotation, corrections, retouching, or effects—Lightroom records the editing information only in the catalog file. The original image data remains unchanged.

2 The Lightroom workflow begins in the Library module: a hub where you'll import, organize, sort, and search your photos, manage your growing catalog, and keep track of the images you publish. You can leverage GPS metadata to organize your photos by location in the Map module. Move to the Develop module for a comprehensive editing environment with all the tools you need to correct, retouch, and enhance digital images and ready them for output. The Book, Slideshow, Print and Web modules each provide a range of stylish preset templates together with a suite of powerful, intuitive controls to help you customize them so that you can quickly create sophisticated layouts and presentations to share and showcase your work in its best light.

3 You can hide any of the panels and panel groups surrounding the work area. The working view automatically expands into the space available. The work area is the only part of the Lightroom workspace that you cannot hide from view.

4 The difference between grouping images in a collection and applying shared keywords is that, in a collection, you can change the order of the photos displayed in the Grid view and the Filmstrip, and easily remove an image from the group.

5 In a collection, you can change the order in which your images are displayed, which affects their placement in your project or layout. Images that are not included in a collection are displayed in a fixed order reflecting your choice of sorting criteria, such as capture date, file name, or star rating.

2 BRINGING PHOTOS INTO LIGHTROOM CLASSIC CC

Lesson overview

Lightroom Classic CC allows a great deal of flexibility in importing photos; you can download images directly from a camera, import them from your hard disk or storage media, or transfer them between catalogs on separate computers. During the import process you can organize folders, add keywords and metadata to make your photos easier to find, make backup copies, and even apply editing presets.

This lesson will familiarize you with the many options available to you as you add more photos to your Lightroom Classic CC library:

- Importing images from a camera or card reader
- Importing images from a hard disk or removable media
- Evaluating images before importing
- Organizing, renaming, and processing images automatically
- Initiating backup strategies
- Setting up automatic importing and creating import presets
- Acquiring images from other catalogs and applications
- Setting viewing options in the Library module

 You'll probably need between one and two hours to complete this lesson. If you haven't already done so, log in to your peachpit.com account to download the lesson files for this chapter, or follow the instructions under "Accessing the Lesson Files and Web Edition" in the Getting Started section at the beginning of this book.

Lightroom Classic CC helps you to begin organizing and managing your growing photo library from the moment you click the Import button; you can make backups, create and organize folders, inspect images at high magnification, and add keywords and other metadata that will save you hours sorting and searching your image library later—and all this before your photos even reach your catalog!

Getting started

Before you begin, make sure you've set up the LRClassicCIB folder for your lesson files and created the LRClassicCIB Catalog file to manage them, as described in "Accessing the Lesson Files and Web Edition" and "Creating a catalog file for working with this book" in the Getting Started chapter at the start of this book.

If you haven't already done so, download the Lesson 2 folder from your Account page at www.peachpit.com to the LRClassicCIB \ Lessons folder, as detailed in the section "Accessing the Lesson Files and Web Edition" in "Getting Started."

1 Start Lightroom Classic CC. In the Select Catalog dialog, make sure that LRClassicCIB Catalog.lrcat is selected, and then click Open.

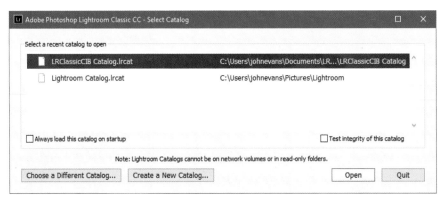

▶ **Tip:** If you can't see the Module Picker, choose Window > Panels > Show Module Picker, or press the F5 key. If you're working on macOS, you may need to press the fn key together with the F5 key, or change the function key behavior in the system preferences.

2 Lightroom Classic CC will open in the screen mode and workspace module that were active when you last quit. If necessary, switch to the Library module by clicking Library in the Module Picker at the top of the workspace.

The import process

Lightroom Classic CC allows a great deal of flexibility in the import process. You can download images directly from a digital camera or card reader, import them from your hard disk or external storage media, and transfer them from another Lightroom catalog or from other applications. Import at the click of a button, use a menu command, or simply drag and drop. You can set Lightroom to launch the import process as soon as you connect your camera, or import automatically whenever you move files into a specified folder. Wherever you're acquiring photos from, you'll be working with the Import dialog box, so we'll begin there.

You have the option to use the Import dialog box in either a compact or expanded mode, providing flexibility in the process from the very beginning. The top panel of the Import dialog box, common to both modes, presents the basic steps in the import process, arranged from left to right: choose an import source, specify how Lightroom is to handle the files you're importing, and then—if you choose to copy or move the source files—set up an import destination.

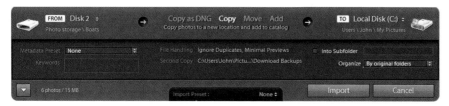

In expanded mode, the Import dialog box looks and works like the Lightroom Classic CC workspace modules. The Source panel at the left provides easy access to your files on any available drive. The Preview pane displays images from the source selection as thumbnails in Grid view or enlarged in Loupe view. Depending on the type of import, the right panel group offers a Destination panel that mirrors the Source panel, and a suite of controls for processing your images as they're imported.

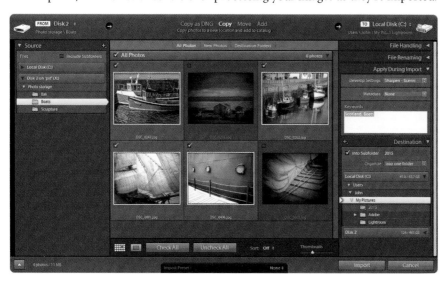

Importing photos from a digital camera

If you have a digital camera or a memory card reader at hand, you can step through this exercise using your own photos. If not, you can simply read through the steps and study the illustrations—most of the information in this exercise is equally applicable to importing from other sources.

The first step is to configure the Lightroom preferences so that the import process is triggered automatically whenever you connect your camera or a memory card to your computer.

1 Choose Edit > Preferences (Windows) / Lightroom > Preferences (macOS). In the Preferences dialog box, click the General tab. Under Import Options, activate the option Show Import Dialog When A Memory Card Is Detected by clicking the checkbox.

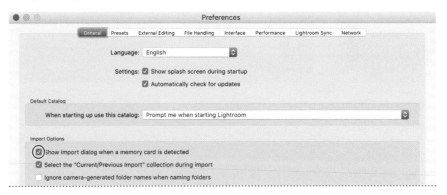

Some cameras generate folder names on the memory card. If you don't find these folder names helpful for organizing your images, activate the option Ignore Camera-Generated Folder Names When Naming Folders. You'll learn more about folder naming options later in this lesson.

If your camera records Raw images, it may also generate a JPEG version of each photo. If you wish to import both files, activate the option Treat JPEG Files Next To Raw Files As Separate Photos; otherwise, Lightroom will display only the Raw images in the Import Photos dialog box.

2 Click OK / the Close button (⊜) to close the Preferences dialog box.

3 Connect your digital camera or card reader to your computer, following the manufacturer's instructions.

4 This step may vary depending on your operating system and the image management software on your computer:

- On Windows, if the AutoPlay dialog box or settings pane appears, select the option to open image files in Lightroom Classic CC. If you wish, you can set this option as the default.

- If you have more than one Adobe image management application—such as Adobe Bridge—installed on your computer and the Adobe Downloader dialog box appears, click Cancel.

- If the Import dialog box appears, continue to step 5.

- If the Import dialog box does not appear, choose File > Import Photos And Video, or click the Import button below the left panel group.

● **Note:** You'll find more options relating to the creation of DNG files during import on the File Handling preferences tab, but for the purposes of this exercise, you can ignore those settings. For more detailed information on DNG files, see the section "About file formats," later in this lesson.

5 If the Import dialog box appears in compact mode, click the Show More Options button at the lower left of the dialog box to see all the options in the expanded Import dialog box.

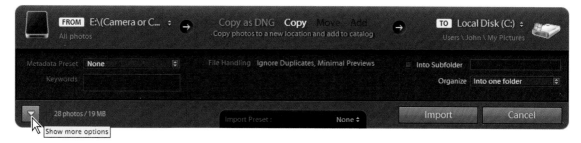

The top panel of the Import dialog box—which is visible in both the compact and expanded modes—presents the three basic steps in the import process, arranged from left to right:

- Selecting the source location of the images you wish to add to your catalog.

- Specifying the way you want Lightroom to handle the files you're importing.

- Designating the destination to which the image files will be copied and choosing any develop presets, keywords, or other metadata that you would like applied to your photos as they are added to your catalog.

Your camera or memory card is now shown as the import source in the FROM area at the left of the top panel and under Devices in the Source panel at the left of the Import dialog box.

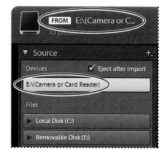

Depending on your computer setup, it's possible that your camera's memory card will be recognized as a removable storage disk. If this is the case, you may see some differences in the options available in the Import dialog box, but these differences will not affect the actions you'll take in the remainder of this exercise.

6 If your memory card is listed as a removable disk—rather than a device—in the Source panel, click to select it from the Files list and make sure that the Include Subfolders option is activated.

7 From the import type options in the center of the top panel, choose Copy, so that the photos will be copied from your camera to your hard disk, and then added to your catalog, leaving the original files on your camera's memory card.

Lightroom displays a brief description of the action that will be taken for whichever option is currently selected, as shown in the illustration below.

8 Move your pointer over each of the options shown in the bar across the top of the Preview pane to see a tool tip describing the option. For this exercise, leave the default All Photos option selected. Don't click the Import button yet.

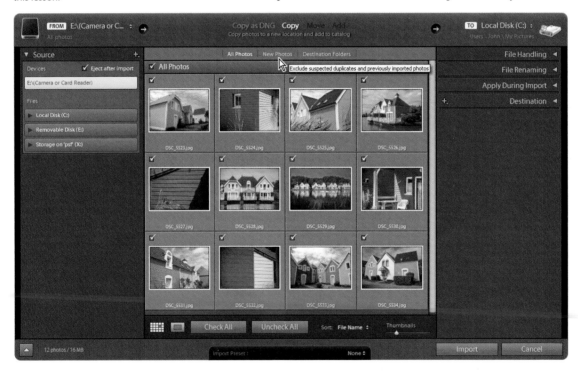

A check mark in the top left corner of an image cell indicates that the photo will be imported. By default, all the photos on your memory card will be check-marked for import; you can exclude an image from the selection to be imported by clicking its checkbox to remove the check mark.

You can select multiple images, and then change all of their check marks simultaneously. To select a contiguous range of images, select the first image in the range by clicking the thumbnail or the surrounding image cell, then hold down the Shift key and select the last image in the series. To select individual additional photos, Ctrl-click / Command-click their thumbnails. Click the check mark of any image in a multiple selection to change the import status for the entire selection.

When you import photos from your hard disk or from external storage media, the Import dialog box offers you the option to add them to your catalog without moving them from their current locations. This is possible because Lightroom does not actually import the image files themselves; it only adds entries to the library catalog to record their locations. For this kind of import, there's no need to specify a destination folder. However, because memory cards are expected to be erased and reused, an image on your camera doesn't have a very permanent address. For this reason, you're not offered the Add or Move options when you import from a camera—Lightroom expects to copy your photos from your camera to a more permanent location before it adds their addresses to the library catalog.

Therefore, the next step in the process of importing from a camera is to specify a destination folder to which your photos should be copied. This is the time to give some thought to how you intend to organize your photos on your computer hard disk. For now, leave the Import Photos dialog box open; you'll choose a destination folder and deal with the rest of the import options in the following exercises.

Organizing your copied photos in folders

Although there's no technical reason why you can't choose a different destination folder for each import, it will be much easier to keep your hard disk organized if you create a single folder to contain all the images that are associated with a particular catalog. Within this folder you can create a new subfolder for each batch of images downloaded from your camera or copied from other external media.

Before beginning the lessons in this book, you created a folder named LRClassicCIB inside your *[username]*/My Documents (Windows) or *[username]*/ Documents (macOS) folder on your computer. This folder already contains subfolders for your LRClassicCIB Catalog file and for the image files used for the lessons in this book. For the purposes of this exercise, you'll create another subfolder inside the LRClassicCIB folder as the destination for the images that you import from your camera's memory card:

1 In the right panel group of the Import dialog box, collapse the File Handling, File Renaming, and Apply During Import panels; then, expand the Destination panel.

2 In the Destination panel, navigate to and select your LRClassicCIB folder; then, click the Create New Folder button () at the left of the Destination panel header and choose Create New Folder from the menu.

3 In the Browse For Folder / Create New Folder dialog box, navigate to and select your LRClassicCIB folder, if it's not already selected. Click the Make New Folder / New Folder button, type **Imported From Camera** as the name for your new folder, and then press Enter (Windows) / click Create (macOS).

4 Make sure the new Imported From Camera folder is selected in the Browse For Folder / Create New Folder dialog box, and then click Select Folder / Choose. Note that the new folder is now listed, and selected, in the Destination panel.

The name of the new destination folder also appears in the TO area at the right of the top panel of the Import dialog box.

The Organize menu, near the top of the Destination panel, offers various options to help you organize your photos into folders as you copy them onto your hard disk:

- **Into One Folder** With the current settings, the images would be copied into the new Imported From Camera folder. You could then use the Into Subfolder option to create a new subfolder for each import.

Note: If your memory card has been recognized as a removable disk, you may also see the Organize option By Original Folders; this option will be discussed later in this lesson.

- **By Date:** *[Date Format]* The remaining options are all variations on organizing your photos by capture date. Your images would be copied into the Imported From Camera folder and placed into one or more subfolders, depending on your choice of date format. Choosing the date format "2015/01/11," for example, would result in one folder per year, containing one folder per month, containing one folder per day for each capture date, as shown in the illustration at the right.

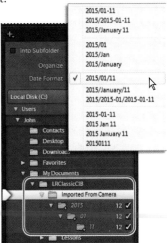

You should think about which system of folder organization best suits your needs before you begin to import photos from your camera, and then maintain that system for all your camera imports.

5 For the purposes of this exercise, choose the option Into One Folder from the Organize menu.

6 Click the Into Subfolder checkbox and type **Lesson 2 Import** in the adjacent text box as the name for the new subfolder.

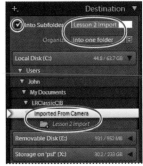

About file formats

Camera raw formats Camera raw file formats contain unprocessed data from a digital camera's sensor. Most camera manufacturers save image data in a proprietary camera format. Lightroom reads the data from most cameras and processes it into a full-color photo. You can use the controls in the Develop module to process and interpret the raw image data for your photo. For a list of supported cameras and camera raw formats, see https://helpx.adobe.com/photoshop/camera-raw.html.

Digital Negative format (DNG) The Digital Negative (DNG) file format is a publicly available archival format for raw files generated by digital cameras. DNG addresses the lack of an open standard for raw files created by individual camera models, ensuring that photographers will be able to access their files in the future. You can convert proprietary raw files to DNG in Lightroom. For more information about the Digital Negative (DNG) file format, visit https://helpx.adobe.com/photoshop/digital-negative.html.

TIFF format Tagged-Image File Format (TIFF, TIF) is used to exchange files between applications and computer platforms. TIFF is a flexible bitmap image format supported by virtually all paint, image-editing, and page-layout applications. Also, virtually all desktop scanners can produce TIFF images. Lightroom supports large documents saved in TIFF format (up to 65,000 pixels per side). However, most other applications, including older versions of Photoshop (pre-Photoshop CS), do not support documents with file sizes greater than 2 GB. The TIFF format provides greater compression and industry compatibility than Photoshop format (PSD), and is the recommended format for exchanging files between Lightroom and Photoshop. In Lightroom, you can export TIFF image files with a bit depth of 8 bits or 16 bits per channel.

JPEG format Joint Photographic Experts Group (JPEG) format is commonly used to display photographs and other continuous-tone images in web photo galleries, slide shows, presentations, and other online services. JPEG retains all color information in an RGB image but compresses file size by selectively discarding data. A JPEG image is automatically decompressed when opened. In most cases, the Best Quality setting produces a result indistinguishable from the original.

Photoshop format (PSD) Photoshop format (PSD) is the standard Photoshop file format. To import and work with a multi-layered PSD file in Lightroom, the file must be saved in Photoshop with the Maximize PSD and PSB File Compatibility option activated. You'll find this option in the Photoshop file handling preferences. Lightroom saves PSD files with a bit depth or 8 bits or 16 bits per channel.

PNG files Lightroom imports PNG files but transparency is not supported; it will appear white.

CMYK files Lightroom imports CMYK files but edits and output are performed in the RGB color space.

Video files Lightroom will import video files from most digital cameras. You can tag, rate, filter and include video files in collections and slideshows. Video files can be trimmed, and also edited with most of the Quick Edit controls. Click the camera icon on the video file's thumbnail to launch an external viewer such as QuickTime or Windows Media Player.

File format exceptions Lightroom does not support the following types of files: Adobe Illustrator® files; Nikon scanner NEF files; files with dimensions greater than 65,000 pixels per side or larger than 512 megapixels.

Note: To import photos from a scanner, use your scanner's software to scan to TIFF or DNG format.

Creating import presets

When you import photos on a regular basis, you'll probably find that you're setting up the same configurations of options over and over. Lightroom Classic CC enables you to streamline your import workflow by saving your preferred settings as import presets. To create an import preset, set up your import in the expanded Import dialog box, and then choose Save Current Sett ings As New Preset from the Import Preset menu below the Preview pane.

Type a descriptive name for your new preset, and then click Create.

Your new preset will include all of your current settings: the source, import type (Copy as DNG, Copy, Move, or Add), file handling and renaming options, develop and metadata presets, keywords, and destination. You might set up one preset to move photos from a single folder on your hard disk into dated subfolders, and another to create a single folder of renamed black-and-white copies. Create separate import presets tailored to the characteristics of different cameras, so you can quickly apply your favorite noise reduction, lens correction and camera calibration settings during the import process, saving yourself time in the Develop module later.

Using the Import dialog box in compact mode

Once you've created the presets you need, you can speed up the process even more by using the Import dialog box in compact mode, where you can use your import preset as a starting point, and then change the source, metadata, keywords, and destination settings as required.

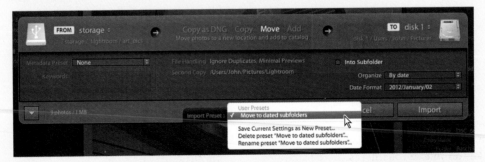

Backup strategies

Your next choice is whether or not to make backup copies of the images from your camera at the same time as Lightroom creates primary copies in the location you've just specified and adds them to the library catalog. It's a good idea to create backup copies on a separate hard disk or on external storage media so you don't lose your images should your hard disk fail or in case you accidentally delete them.

1 In the right panel group of the Import Photos dialog box, expand the File Handling panel and activate the option Make A Second Copy To by clicking the checkbox.

2 Click the small triangle to the right and select Choose Folder to specify a destination for your backup copies.

3 In the Browse For Folder / Choose Folder dialog box, navigate to the folder in which you wish to store the backup copies of your images, and then click OK / Choose.

The purpose of this backup is mainly as a precaution against loss of data due to disk failure or human error during the import process; it's not meant to replace the standard backup procedure you have in place—or should have in place—for the files on your hard disk.

It's worthwhile to archive each photo shoot by burning your images to a DVD, which you can store separately. This will also help you organize your image library in Lightroom Classic CC because you'll feel more secure trimming your collection down to the best images knowing that you have a backup before you press Delete.

Renaming files as they are imported

The cryptic file names created by digital cameras are not particularly helpful when it comes to sorting and searching your photo library. Lightroom can help by renaming your images for you as they are imported. You can choose from a list of predefined naming options, or create your own customized naming templates.

1 In the right panel group of the Import dialog box, expand the File Renaming panel and activate Rename Files. Choose Custom Name - Sequence from the Template menu and type a descriptive name in the Custom Text box, and then press the Tab key on your keyboard. A sample name at the bottom of the File Renaming panel shows how your settings will be applied for the first image imported.

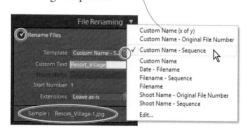

Tip: An option you should consider, if it's supported by your camera, is to set the camera to generate file names with unique sequence numbers. When you clear your memory card, or change memory cards, your camera will continue to generate unique sequence numbers rather than start counting from one again. This way, the images you import into your library will always have unique file names.

You can enter a number other than 1 in the Start Number text box; this is useful if you're importing more than one batch of images from the same series.

2 Click the small triangle to the right of the Custom Text box; your new text has been added to a list of recently entered names. You can choose from this list if you import another batch of files that belong in the same series. This not only saves time and effort but helps you ensure that subsequent batches are named identically. Should you wish to clear the list, choose Clear List from the menu.

3 Choose Custom Name (x of y) from the Template menu. Note that the sample name at the bottom of the File Renaming panel is updated to reflect the change.

4 Choose Edit from the Template menu to open the Filename Template Editor.

In the Filename Template Editor dialog box you can set up a filename template that makes use of metadata information stored in your image files—such as file names, capture dates, or ISO settings—adding automatically generated sequence numbers and any custom text you specify. A filename template includes placeholders—or *tokens*—that will be replaced by actual values during the renaming process. A token is framed by curly brackets on Windows and highlighted in blue on macOS.

You could rename your photos Resort_Village-April 27, 2013-01, and so on, by setting up a filename template with a custom text token, a date token, and a 2-digit sequence number token, separated by typed hyphens, as shown in the illustration at the right. After closing the Filename Template Editor you could type **Cottages** over the words Resort_Village in the Custom Text box; the word "Cottages" would then replace the custom text token in the filename. The capture date from the images' metadata and the sequence number will be added automatically.

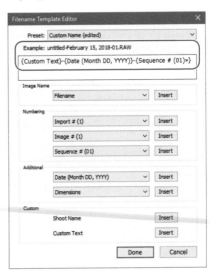

Tip: For more information on using the Filename Template Editor please refer to Lightroom Help.

5 Click Cancel to close the Filename Template Editor without making any changes.

Despite all of the options available for renaming your images during the import process, there's only so much information you can squeeze into a single file name. It might be better to take a minimal approach to renaming your photos and instead take advantage of the other file management capabilities of Lightroom Classic CC. Metadata and keywords are far more powerful and versatile tools for organizing and searching your image library.

You'll learn about working with metadata and keywords in the following exercises and in Lesson 4, "Managing Your Photo Library."

You have now completed this exercise on importing photos from a digital camera or a memory card. You'll learn about the other options that are available in the Import dialog box in the exercises to follow.

6 For now, click Import if you wish to bring your photos into the LRClassicCIB catalog, or Cancel to close the Import dialog box without importing any images.

Importing images from a hard disk

When you import photos from your hard disk or from external storage media, Lightroom Classic CC offers you more options for organizing your image files than are available when importing from a camera.

If you wish, you can still choose to copy your images to a new location during the import process as you did in the previous exercise, but you also have the option to add them to your catalog without moving them from their current locations. You might choose to do this if the images you wish to import are already well organized in a folder hierarchy.

For images that are already located on your hard disk you have an extra option: to *move* them to a new location, removing them from the original location at the same time. This option might appeal if the images on your hard disk are not already organized in a satisfactory manner.

1 To import the images for this exercise from your computer hard disk, either choose File > Import Photos And Video, press Ctrl+Shift+I / Command+Shift+I, or click the Import button below the left panel group in the Library module.

● **Note:** The same commands apply for importing images from a CD, DVD, or other external storage media.

2 In the Source panel at the left of the Import dialog box, navigate to the Lessons folder inside the LRClassicCIB folder on your hard disk. Select the Lesson 2 folder and click the checkbox at the top right of the Source panel to activate the Include Subfolders option.

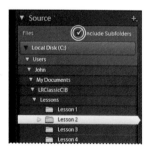

An image count in the lower left corner of the Import dialog box shows that the Lesson 2 folder and its subfolders contain a total of 28 photos with a combined file size of 87 MB.

3 From the import type options in the center of the top panel, choose Add so that your photos will be added to your catalog without being moved—an option that is not available when importing images from a camera. Do not click Import yet!

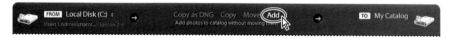

4 Use the scrollbar at the right of the Preview pane to view all of the images in the Lesson 2 folder and its subfolders. Drag the Thumbnail slider below the Preview pane to the left to reduce the size of the thumbnails so that you can see as many of the images as possible in the Preview pane.

5 In the Source panel, disable the Include Subfolders option. The Preview pane now displays only the nine images in the Lesson 2 root folder and the image count in the lower left corner of the Import dialog box reads: 9 photos / 44 MB.

In the next exercise, you'll apply keywords and other metadata to these images to make them easier to organize once you've added them to your catalog. For now, you can review the import type options above the Preview pane.

6 Click each of the import type options in turn, from left to right:

• Choose the option Copy As DNG to have Lightroom make copies of your images in DNG (Digital Negative) file format, which will be stored in a new location, and then added to your catalog. Collapse all of the panels in the right panel group. For the Copy As DNG, Copy, and Move options, the right panel group offers the same suite of panels—File Handling, File Renaming, Apply During Import, and Destination.

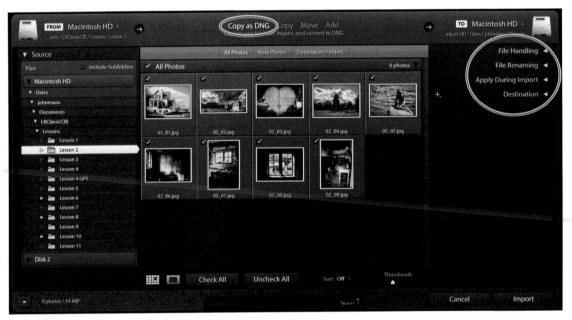

• Choose the option Copy to have Lightroom create copies of your images in a new location, and then add them to your catalog, leaving the originals in their current locations. You can set a destination for your copies in the Destination panel, as you did in the previous exercise. Expand the Destination panel and click the Organize menu. When you use either the Copy As DNG, Copy, or Move options to import images from your hard disk

or from external storage media, the Organize menu offers you the option to copy your photos into a single folder, into subfolders based on the capture dates, or into a folder structure that replicates the original arrangement.

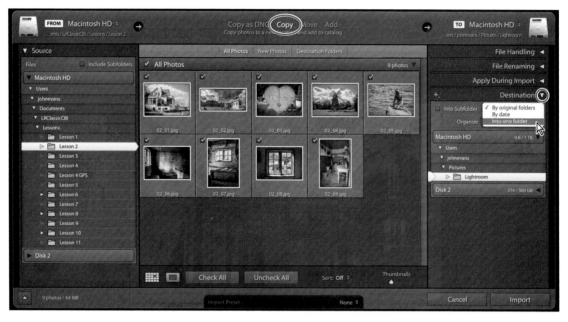

- Choose the option Move to have the images moved to a new location on your hard disk, arranged in whatever folder structure you choose from the Organize menu, and then deleted from their original locations.

- Choose Add to have Lightroom add the images to your catalog without moving or copying them from their current locations, or altering the folder structure in which they are stored. Note that for the Add option, the right panel group offers only the File Handling and Apply During Import panels; you cannot rename the original source images during import, and there's no need to specify a destination because the files will remain where they are. Expand the File Handling and Apply During Import panels to see the options available.

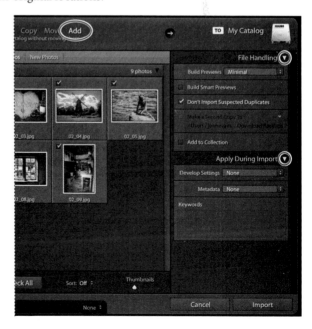

Applying metadata

Lightroom uses the metadata information attached to image files to enable you to quickly find and organize your photos. You can search your image library and filter the results by keyword, creation date, flag status, color label, shooting settings, or any combination of a wide range of other criteria. You can also choose specific information about your images from this metadata and have Lightroom display it as a text overlay applied to each image in a slideshow, web gallery, or print layout. Some metadata is automatically generated by your camera when you take a photo. You can also add your own information as part of the import process, making it even easier to locate and organize your images on your own terms.

1 In the Apply During Import panel, choose New from the Metadata menu.

2 In the New Metadata Preset dialog box, type a descriptive name for these nine photos in the Preset Name box (we used the country name "Denmark"); then, enter metadata information that is applicable to the images as a group, such as labels or copyright information. You can customize the metadata for each individual image after import, adding information such as titles and captions.

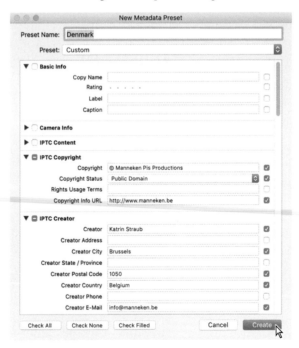

3 Click Create to close the New Metadata Preset dialog box, and then confirm that your new metadata preset is selected in the Metadata menu.

You can edit your metadata presets by choosing Edit Presets from the Metadata menu in the Apply During Import panel. In the Edit Metadata Presets dialog box you can edit, rename, or delete presets, or save modified settings as a new preset.

4 In the Apply During Import panel, choose None from the Develop Settings
 menu and type **Lesson 2, Europe** in the Keywords text box.

5 In the File Handling panel, choose Minimal from the Build Previews menu.
 Check that your settings are the same as those shown in the illustration below,
 and then click Import.

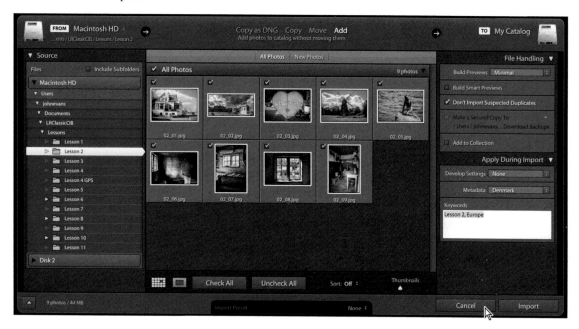

The nine photos from the Lesson 2 folder are imported into your library catalog
and thumbnails of the images appear in the Grid view and the Filmstrip in the
Library module.

6 Right-click / Control-click any of the images in the Grid view and choose
 Go To Folder In Library from the context menu.

In the Folders panel in the left panel group, the Lesson 2
folder is highlighted and the image count indicates that it
contains 9 photos.

7 Right-click / Control-click the Lesson 2 folder in the Folders
 panel, and then choose Show In Explorer / Show In Finder
 from the context menu.

8 The Lessons folder opens in a Windows Explorer / Finder window, with the
 Lesson 2 folder highlighted. Leave the Windows Explorer / Finder window open
 for use in the next exercise.

Importing via drag and drop

Perhaps the easiest way to add photos to your image library is to simply drag a selection of files—or even an entire folder—directly into Lightroom Classic CC.

1 The Windows Explorer / Finder window showing your Lesson 2 folder should still be open from the previous exercise. Position the window so that you can see the Grid view in the Lightroom Classic CC workspace behind it.

2 Open your Lesson 2 folder, if necessary, and then drag the Batch1 folder from the Windows Explorer / Finder window onto the Grid view.

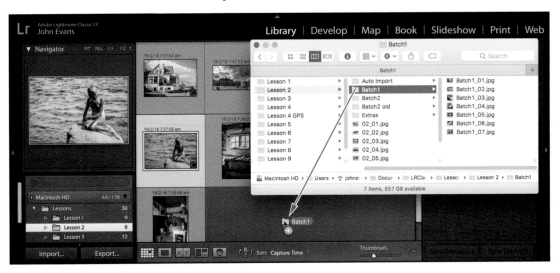

In the Import dialog box, the Batch1 subfolder is now selected in the Source panel and the seven photos it contains are displayed in the Preview pane.

3 In the Apply During Import panel, choose None from the Metadata menu and type **Lesson 2, Architecture** in the Keywords box. Don't click Import just yet.

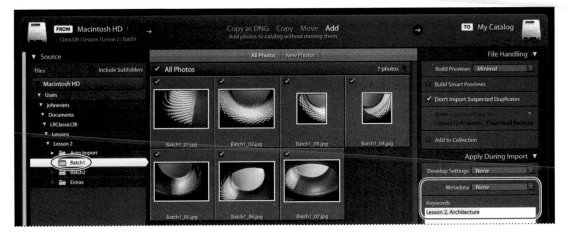

Evaluating photos before importing

Lightroom Classic CC makes it easier to decide which of your photos you wish to import by providing an enlarged Loupe view in the Import dialog box; you can examine each image in detail so that you can choose between similar images or exclude a photo that is out of focus.

1 Double-click any of the thumbnails to see the photo in Loupe view, or select the thumbnail and click the Loupe view button () below the preview pane; the image is enlarged to fit the preview area and the pointer becomes a magnifying glass cursor (⊕). Depending on the size of your display and / or the application window, you may first see a Zoom Out cursor.

2 If necessary, click the image again to further magnify the image to a zoom ratio of 1:1. Use the Zoom slider below the preview pane to see even more detail. Drag the enlarged image in the preview pane to pan the view so that you can inspect portions of the photo that are not currently visible.

While you're examining the photo in Loupe view, you can check-mark the image for import or un-check it to exclude it by clicking the Include In Import check box below the preview pane. Alternatively, press the P key to check-mark the photo, the X key to un-check it, or the Tilde key (~) to toggle between the two states.

Note: The P, X, and Tilde (~) keyboard shortcuts are disabled at magnification levels higher than 1:1.

3 Click the enlarged preview to return to the Fit view where the entire image is visible. Double-click the image, or click either the Loupe view button or the Grid view button beside it to return to the thumbnail display.

4 For the purposes of this exercise, un-check one of the images to exclude it, and then click Import.

Tip: If your Lesson 2 folder in the Folders panel shows a different image count to that shown in the illustration at the right, uncheck the option Show Photos In Subfolders in the Library menu.

5 In the Folders panel, click the triangle beside the Lesson 2 folder, if necessary, to see the listing for the Batch1 subfolder inside it.

Both the Batch1 subfolder and the Previous Import listing in the Catalog panel show an image count of 6 and the six recently imported photos are displayed in the Grid view and the Filmstrip.

6 Switch back to Windows Explorer / the Finder and drag the Batch1 folder onto the Grid view in the Library module again.

In the Import dialog box, the six photos that are already registered in the catalog are dimmed and unavailable for import. Clicking New Photos above the Preview pane would remove them from view entirely.

7 Type **Lesson 2, Architecture** in the Keywords box, and then click Import to add the remaining Batch1 photo to your library catalog.

8 In the Folders panel, the Batch1 folder now shows an image count of 7; click the Batch1 folder to see all seven photos in the Grid view and the Filmstrip.

Importing and viewing video

Lightroom Classic CC will import many common digital video files from digital still cameras, including AVI, MOV, MP4, and AVCHD. Choose File > Import Photos And Video or click the Import button in the Library module; then, set up your import in the Import dialog box, just as you would for photos.

In the Library module Grid view, you can scrub backwards and forwards in your video clips by simply moving the mouse over the thumbnails, making it easy to select the clip you want. Double-click a thumbnail to preview the video in Loupe view; drag the circular current time indicator in the playback control bar to scrub through the video manually.

Setting distinctive thumbnail images (poster frames) for your videos can make it easier to find the clip you want in the Grid view. Move the current time indicator to the frame you want; then, click the Frame button (⬜) in the control bar and choose Set Poster Frame. Choose Capture Frame from the same menu to convert the current frame to a JPEG image that will be stacked with the clip. To shorten a video clip, click the Trim Video button (⚙). The playback control bar expands to display a time-line view of the clip where you can drag the start and end markers to trim the clip as desired.

Importing to a specific folder

From within the Library module, you can import photos directly to a folder in the Folders panel without needing to specify a destination in the Import dialog box.

1 In the Folders panel, right-click / Control-click the Batch1 folder and choose Import To This Folder from the context menu.

2 In the Import dialog box, click Select A Source at the left of the top panel, just above the Source panel, and then choose the path to the Lesson 2 folder from the list of recent sources in the menu.

3 In the Source panel, the folder path expands automatically. Inside the Lesson 2 folder, select the subfolder Extras, which contains two photos. In the top panel, choose Move from the import type options to move the photos from the Extras folder to the destination folder and add them to your catalog. Check that your previous settings are still active in the Apply During Import panel. You may need to re-type **Lesson 2, Architecture** in the Keywords box.

4 Expand the Destination panel, if necessary. You can see that the Batch1 folder has been automatically selected as the destination to which the photos will be moved from the Extras folder. At the top of the Destination panel, choose Into One Folder from the Organize menu; then, click Import. Thumbnails of the two new images appear in the Grid view and the Filmstrip in the Library module.

5 In the Folders panel, the Batch1 folder now shows an image count of 9. Click the Batch1 folder to see all nine images together in the Grid view and the Filmstrip.

6 In the Folders panel, right-click / Control-click the Lesson 2 folder and choose Show In Explorer / Show In Finder from the context menu. In the Windows Explorer / Finder window, open the Extras folder inside the Lesson 2 folder; the two image files have been removed and the Extras folder is now empty.

Importing from other catalogs

If you work on a laptop while you're on location and need to merge your new photos with the Lightroom Classic CC library on your desktop computer, or if you work in a situation where more than one person will be using the same images in Lightroom on different computers, you can move photos from one computer to another using the Export As Catalog and Import From Catalog commands. Your images will be transferred with all of your edits, adjustments, and settings in place—including any keywords or other metadata you may have added.

Lesson 11, "Making Backups and Exporting Photos," will discuss exporting photos as a catalog; for this lesson you'll import photos from a catalog that you'll find in the Batch2 subfolder inside the Lesson 2 folder on your hard disk.

1 Choose File > Import From Another Catalog.

2 Navigate to and open your Lessons > Lesson 2 > Batch2 folder, select the file Batch2Catalog.lrcat, and then click Open / Choose.

3 In the Import From Catalog dialog box, click the Show Preview check box in the lower left corner. Choose Add New Photos To Catalog Without Moving from the File Handling menu, and then click Import.

▶ **Tip:** The Don't Import New Photos option in the File Handling menu is useful when you've exported images from one computer, edited them on a second computer, and then wish to import the changes without importing new images from the second catalog.

The newly imported photos are displayed in the Grid view and the Filmstrip. In the Grid view, all three image cells are marked with the Photo Is Missing badge (), which is shown highlighted in the illustration below.

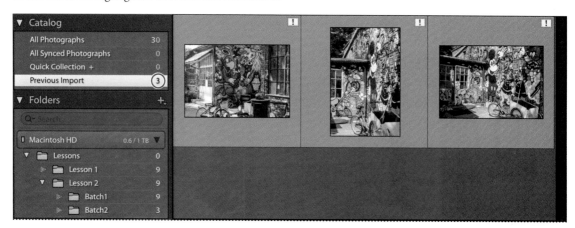

4 Select the first image; the photo's missing status is also indicated in the Histogram panel. Click the badge on the image cell; then, click Locate. Navigate to the folder Lesson 2 / Batch2 / Images, select the missing photo, and then click Select. Lightroom will automatically locate the other missing files inside the same folder. In the Folders panel; the Batch2 / Images folder is now listed.

5 In the Folders panel, you may now also see a missing folder, dimmed and marked with a question mark badge. If you see the missing folder (the folder in which Lightroom expected to find the images from the Batch2 catalog), right-click / Command-click the listing and choose Remove from the menu.

6 Select one of the images in the Grid. Inspect the Keywording panel at the right; the tags Europe and Lesson 2 have already been applied. You could add keywords to images individually or as a group. Expand the Collections panel if necessary. Select all three images and drag them to the Copenhagen Color collection you created in Lesson 1.

7 Expand the Metadata panel in the right panel group. If necessary, collapse the other panels in the group or scroll down so that you can see the contents of the Metadata panel. Note that these images already include the metadata from the Denmark preset. In the Metadata panel, you can edit or add to the metadata.

The imported images have also been edited. Lightroom records every editing operation performed on an image in the library catalog file. When images are exported as a catalog their entire edit history is exported with them.

8 Select one of the images in the Grid view, and then switch to the Develop module. If necessary, expand the History panel. Move the pointer over the Import entry at the bottom of the History list; the Navigator preview shows the image in its un-edited state. Click your way up through each of the subsequent entries to follow the developing steps as you return to the edited version.

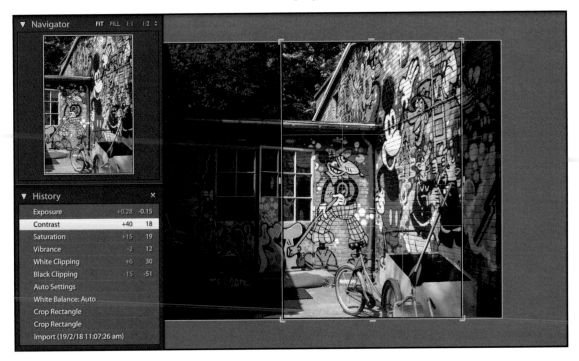

9 Switch back to the Library module in readiness for the next exercise.

Importing a Photoshop Elements catalog

Lightroom Classic CC makes it easy to import photographs and video from Photoshop Elements 6 and later on Windows, and from Photoshop Elements 9 and later on macOS.

The media files from your Photoshop Elements catalog are imported complete with keywords, ratings, and labels—even your stacks are preserved. Version sets from Photoshop Elements are converted to stacks in Lightroom Classic CC, and your albums become collections.

1 In the Lightroom Classic CC Library module, choose File > Import A Photoshop Elements Catalog.

Lightroom searches your computer for Photoshop Elements catalogs and displays the most recently opened catalog in the Import Photos From Photoshop Elements dialog box.

2 If you wish to import a Photoshop Elements catalog other than that selected by default, choose from the pop-up menu.

3 Click Import to merge the photo library and all catalog information from your Photoshop Elements catalog to your Lightroom Classic CC catalog.

If you're migrating from Photoshop Elements to Lightroom Classic CC, or intend to use the two applications together, refer to the Adobe tutorial "Get started with Lightroom Classic CC and Photoshop for Photoshop Elements users" for useful tips and info:

helpx.adobe.com/lightroom/how-to/photography-plan-photoshop-elements.html

Importing from a watched folder

Designating a folder on your hard disk as a *watched folder* can be a very convenient way to automate the import process. Once you've nominated a folder that is to be watched, Lightroom will detect any photos that are placed or saved into it, then automatically move them to a specified location and add them to the catalog. You can even have Lightroom rename the files and add metadata in the process.

1 Choose File > Auto Import > Auto Import Settings. In the Auto Import Settings dialog box, click the first Choose button to designate a watched folder. Navigate to your Lessons \ Lesson 2 folder. Open the Auto Import folder and select the subfolder named Watched Folder; then, click Select Folder / Choose.

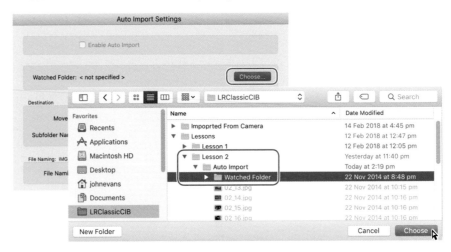

Tip: Once you've set a watched folder, you can activate or disable Auto Import at any time, without opening the Auto Import Settings dialog box, by choosing File > Auto Import > Enable Auto Import. A check mark beside this menu command indicates that the Auto Import feature is currently enabled.

2 Now that you have designated a watched folder, you can click the checkbox at the top of the Auto Import Settings dialog box to enable Auto Import.

3 Click the second Choose button under Destination to specify a folder to which Lightroom will move your photos when adding them to the library catalog. Navigate to and select the Lesson 2 folder, and then click Select Folder / Choose. Type **Batch3** in the Subfolder Name text box.

4 Choose Filename from the File Naming menu. Under Information, type **Lesson 2, Color** in the Keywords text box. Choose None from the Develop Settings and Metadata menus and Minimal from the Initial Previews menu. Click OK to close the Auto Import Settings dialog box.

5 Switch to Windows Explorer / the Finder and navigate to the Lesson 2 folder. Note that as yet there is no Batch3 subfolder. Open the folder Auto Import and drag the seven image files inside to the Watched Folder.

When Lightroom has finished importing, you'll see the newly created Batch3 folder inside the Lesson 2 folder. The Watched Folder is empty once more and the seven lesson images have been moved into the Batch3 folder.

6 Return to Lightroom Classic CC; the Batch3 folder is listed in the Folders panel and the newly imported photos are displayed in the Grid view and the Filmstrip.

You can now import images into your Lightroom Classic CC library by simply dragging them onto the watched folder. This makes importing photos directly from a camera or card reader even easier; there's no need to attend to a dialog box and yet your images can be renamed and have custom metadata added automatically.

Specifying initial previews when importing

As photos are imported, Lightroom can immediately display a photo's embedded preview, or display higher-quality previews as the program renders them. You can choose the rendered size and quality for previews using the Standard Preview Size and Preview Quality menus on the File Handling tab of the Catalog Settings (choose Edit > Catalog Settings / Lightroom > Catalog Settings). Please keep in mind that embedded previews are created on-the-fly by cameras and are not color managed therefore they don't match the interpretation of the camera raw files made by Lightroom. Previews rendered by Lightroom are color managed.

In the Import Photos dialog box, choose one of the four Build Previews options:

- **Minimal** displays images using the smallest previews embedded in the photos, Lightroom renders standard-size previews as and when needed.

- **Embedded & Sidecar** displays the largest possible preview available from the camera; slower than a Minimal preview but faster than a standard preview.

- **Standard** displays previews as Lightroom renders them. Standard-size previews use the ProPhoto RGB color space.

- **1:1** displays a 1 to 1 view of the actual pixels.

You can also choose to build Smart Previews during the import process. Smart Previews are compressed, high-resolution previews that allow you to work on your photos, even when the originals are offline. They support editing at high magnification, though they are a fraction of the size of the source files. Generating Smart Previews for a large import takes time, but adds a lot of flexibility to your workflow.

Tethered shooting

Many modern digital cameras support tethered shooting, a process where you connect—or tether—your digital camera to your computer and save images to the computer's hard disk rather than to the camera's memory card. With tethered shooting you can view a photo on your computer screen immediately after you shoot it—a vastly different experience from seeing it on your camera's LCD screen.

▶ **Tip:** Please refer to Lightroom Classic CC Help to see a list of cameras currently supported for integrated tethered shooting, .

For a range of DSLR cameras including many models from Canon and Nikon, you can capture photographs directly into Lightroom Classic CC without the need for any third-party software. If your camera allows tethered shooting, but is not on the list of models supported by Lightroom Classic CC, you can still capture images into your Lightroom Classic CC library using either the image capture software associated with the camera or any of a number of third-party software solutions.

You can have Lightroom name the photos, add metadata, apply developing settings, and organize them in your library then and there. If necessary, you can adjust your camera settings (white balance, exposure, focus, depth of field, and others), or even change cameras, before taking the next shot. The better the quality of the captured image the less time you'll need to spend adjusting it later.

Tethered shooting with a supported camera

Note: Depending on your camera model and the operating system your computer uses, you may also need to install the necessary drivers for your camera.

1 Connect your camera to the computer.

2 In the Library module, choose File > Tethered Capture > Start Tethered Capture.

3 In the Tethered Capture Settings dialog box, type a name for your shooting session. Lightroom will create a folder with this name inside the destination folder of your choice; this session folder will appear in the Folders panel.

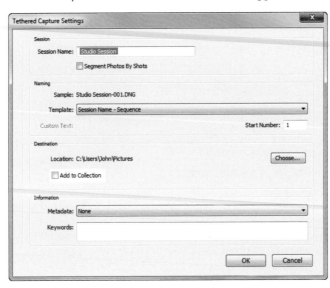

4 Choose a naming scheme for your shots, select a destination folder, and specify any metadata or keywords that you want Lightroom to apply as the newly captured images are imported.

5 Click OK to close the Tethered Capture Settings dialog box. The tethered capture control bar appears.

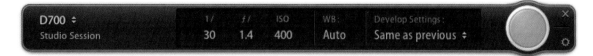

The control bar displays the model name of the connected camera, the name you entered for the shooting session, and the current camera settings. You can choose from a wide range of Develop presets in the Develop Settings menu at the right. You can trigger the shot with your camera's shutter button, by clicking the large circular button at the right of the control bar, or by pressing F12 on your keyboard.

As you shoot, the images captured will appear in both the Grid view and the Filmstrip. To see each captured photo as large as possible, use the Loupe view and hide unwanted panels—as shown in the illustration below—or chose Window > Screen Mode > Full Screen And Hide Panels.

▶ **Tip:** To collapse the control bar to just the shutter button, hold down the Alt / Option key and click the close button at the upper right. Repeat to expand the control bar again.

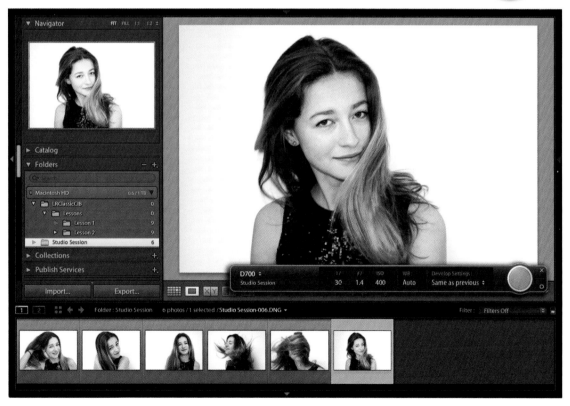

Tethered shooting with other cameras

▶ **Tip:** To find out about third-party image capture software compatible with your camera, search "tethered shooting" on the Internet or in Adobe Community Help.

If your camera allows tethered shooting, but is not on the list of models for which the process is integrated in Lightroom Classic CC, you can still capture images into your Lightroom Classic CC library by using the image capture software associated with your camera—or a third-party software solution—to save your photos to a watched folder. Lightroom will remove the images from the watched folder and add them to your catalog as soon as it detects them.

1 Choose File > Auto Import > Auto Import Settings. In the Auto Import Settings dialog box, click the first Choose button to choose a watched folder. Once you've designated a folder to be watched, you can click the checkbox at the top of the Auto Import Settings dialog box to enable Auto Import.

2 Click the second Choose button under Destination to specify a folder to which Lightroom will save your photos in the process of adding them to the library catalog. Type a name for your photo shoot in the Subfolder Name text box; Lightroom will create this subfolder inside the designated destination folder.

3 Choose a naming option for your images from the File Naming menu. Under Information, you can choose a metadata preset and enter any keywords that you wish Lightroom to apply as your newly captured images are imported. If you wish, you can also choose a developing preset and specify a preview option. Click OK to close the Auto Import Settings dialog box.

4 Use your camera's image capture software to designate your new watched folder as the destination to which the camera will save your photos.

By way of an example, this illustration shows the download and metadata options from the Camera Control component of Nikon's Capture NX software.

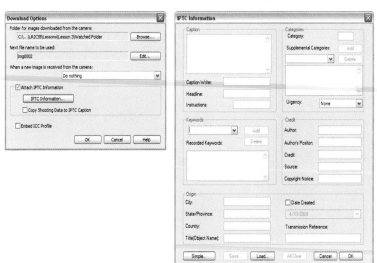

5 Before you begin shooting, make sure that you are in the Library module. In the Folders panel, select the subfolder you created for your tethered shoot in step 2, so that your newly captured photos will be displayed as they are imported.

Viewing imported photos in the work area

Tip: If more dir

In the Library module, the main display area—the work area—in the center of the application window is where you select, sort, search, review and compare images. The Library module work area offers a choice of view modes to suit a range of tasks, from organizing your photos to choosing between similar shots.

1 If you're not already in the Library module, switch to it now.

Depending on your workspace setup in the Library module, you may see the Filter bar across the top of the work area. You can use filters to limit the images that are displayed in the Grid view and the Filmstrip so that you'll see only those photos with a specified rating, flag status, or containing particular metadata content.

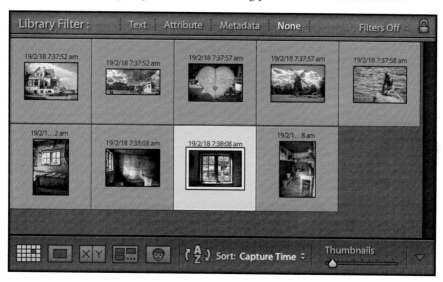

Note: You'll learn more about using the Filter bar controls in Lesson 4, "Managing Your Photo Library."

The Toolbar, located at the bottom of the work area, is common to all the workspace modules but contains different tools and controls for each.

2 If the Filter bar is not already visible at the top of the work area, show it by pressing the backslash character (\) on your keyboard or by activating the menu option View > Show Filter Bar. Press backslash again or disable the menu option View > Show Filter Bar to hide it.

3 If the Toolbar is not already visible, press T to show it. Press T again to hide it. Switch to the Develop module. If the Toolbar is not already visible, press T to show it. Switch back to the Library Module. In the Library module the Toolbar is still hidden; Lightroom remembers your Toolbar setting for each module independently. Press T to show the Toolbar in the Library module.

4 Double-click an image in Grid view to switch to Loupe view. The Loupe view is available in both the Library and Develop modules, but the controls available in the Loupe view Toolbar differ for each of these modules.

5 To hide or show individual tools, click the white arrow at the right end of the
 Toolbar and choose their names from the pop-up menu. Tools that are currently
 visible in the Toolbar have a checkmark in front of their names.

Setting Grid and Loupe view options

You can choose from the many options in the Library View Options dialog box to
customize the information Lightroom Classic CC displays for each image in the
Grid and Loupe views. For the Loupe view overlay and thumbnail tooltips you can
activate two sets of options; then, use a keyboard shortcut to switch between them.

1 Press G to switch to Grid view in the Library module.

2 Choose View > View Options. The Library View Options dialog box appears
 with the Grid View tab already selected. Position the Library View Options
 dialog box so you can see some of the images in the Grid view.

3 At the top of the Grid View tab, un-check Show Grid Extras. This disables most
 of the other options.

4 The only options still available are Tint Grid Cells With Label Colors and
 Show Image Info Tooltips. If they're not already activated, click the checkboxes
 for both of these options. As this lesson's images have not yet been assigned
 color labels, activating the first option has no visible effect in the Grid view.
 Right-click / Control-click any image—you can do this while the Library View
 Options dialog box is open—and choose a color from the Set Color Label menu.

In the Grid view and the Filmstrip, a color-labeled image that is currently selected will show a thin colored frame around the thumbnail; a color-labeled image that is not selected has a tinted cell background.

5 Position the pointer over a thumbnail in the Grid view or the Filmstrip; a tooltip appears. In macOS you'll need to click anywhere in the Lightroom Classic CC workspace window to bring it to the front before you can see the tooltips.

By default, the tooltip will display the file name, capture date and time, and the cropped dimensions. You can specify the information to be displayed in the tooltip by choosing from the Loupe View options.

6 On macOS, if the Library View Options dialog box is now hidden behind the main application window, press Command+J to bring it back to the front.

7 Activate the Show Grid Extras option and choose Compact Cells from the menu beside it. Experiment with each setting to see its effect in the Grid view display. Activate and disable the settings for Options, Cell Icons, and Compact Cell Extras. Position the pointer over the various icons in the image cells to see tooltips with additional information.

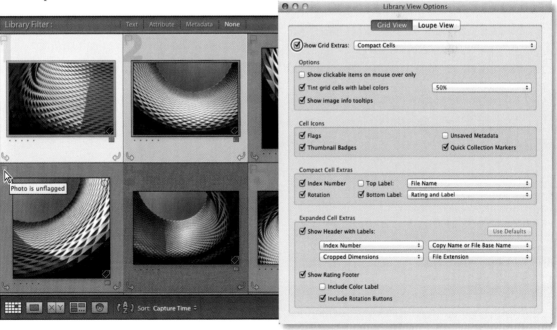

8 Under Compact Cell Extras, click the Top Label menu to see the long list of choices available. For some choices, such as Title or Caption, nothing will be displayed until you add the relevant information to the image's metadata.

9 Now choose Expanded Cells from the Show Grid Extras menu. Experiment with the Expanded Cell Extras options to see the effects in the Grid view. Click any of the Show Header With Labels menus to see the many choices available to customize the information that is displayed in the cell headers.

10 Click the Loupe View tab. The work area switches to Loupe view so you can preview the changes you'll make in the Library View Options dialog box.

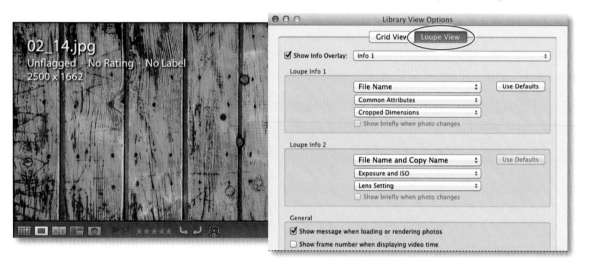

Note: When you choose an information item such as Capture Date And Time, those details are drawn from the image metadata. If the image's metadata does not contain the specified information, nothing will be displayed for that item. For both the Grid and Loupe view options you can choose the information item Common Attributes, which will display the flag status, star rating and color label for each image.

For the Loupe view, you can activate the Show Info Overlay option to display image information in the top left corner of the view. Choose items from the menus in Loupe Info 1 and Loupe Info 2 to create two different sets of information, and then choose either set from the Show Info Overlay menu.

You can reset either group to its default state by clicking the Use Defaults button. Activate the Show Briefly When Photo Changes option to show the info overlay for only a few seconds when a new image is displayed in the Loupe view. Activate the Show Message When Loading Or Rendering Photos option to display a notification in the lower part of the view while the image preview is updated.

11 Click the Close button (x) / (⬤) to close the Library View Options dialog box.

12 You can choose which of the two information sets will be displayed by choosing an option from the View > Loupe Info menu, or by pressing the I key to cycle the info overlay through Loupe Info 1, Loupe Info 2, and its disabled state.

13 Switch to the Grid view. From the View > Grid View Style menu you can choose whether or not to display additional information, using either the Compact Cells layout or the Expanded Cells layout. Press the J key to cycle through the different cell layouts.

Review questions

1 When would you choose to copy imported images to a new location on your hard disk and when would you want to add them to your library catalog without moving them?

2 What is DNG?

3 When would you use the Import dialog box in compact mode?

4 How can you transfer photos between Lightroom libraries on separate computers?

5 How can you specify the information displayed for images in the Grid and Loupe views?

Review answers

1 You don't have the option to import photos from a camera at their current location; Lightroom needs to record a location for each file in the library catalog, and as memory cards are expected to be erased and reused the images need first to be copied to a more permanent location. Copying or moving images might also be useful when you want Lightroom to organize the files into a more ordered folder hierarchy during the import process. Images that are already arranged in a useful way on the hard disk or removable media can be added to the library catalog in their current locations.

2 The Digital Negative (DNG) file format is a publicly available archival format intended to address the lack of an open standard for raw files generated by cameras. Converting raw files to DNG in Lightroom will help ensure that you'll be able to access your raw files in the future even if the original proprietary format is no longer supported.

3 Once you've created import presets to suit your workflow, you can speed up the import process by using the Import dialog box in compact mode. Use your import preset as a starting point, and then modify the settings as required.

4 On one computer, export the images from Lightroom Classic CC as a catalog file. On the other computer, choose File > Import From Another Catalog to import the photos into the Lightroom library together with their develop settings and metadata.

5 You can choose from the many options in the Library View Options dialog box (View > View Options) to customize the information Lightroom Classic CC displays for each image in the Grid and Loupe views. For the Loupe view and thumbnail tooltips you can define two sets of options and then press the I key to switch between them. From the View > Grid View Style menu you can switch between Compact or Expanded Cells and activate or disable the display of information for either style.

PHOTOGRAPHY SHOWCASE
JOHN BATDORFF

"I think the best images are created to stand on their own, superseding the photographer's eye."

My natural curiosity comes from years of working in our family's small town newspaper. Over the years I have found myself traveling more in an effort to better understand the world around me. It's during these moments of observation that I try to reconcile what I see with who I am. It is this process that continues to drive my creativity.

Over the years I've become naturally drawn to black and white images. For me, when an image is stripped of its color it becomes vulnerable and the composition becomes the cornerstone for the message. It's that sort of honesty that I look for in my images and in myself. I think the best images are created to stand on their own, superseding the photographer's eye. While my style is ever evolving, without dispute my journalism foundation runs deep and continues to bolster my curious nature.

John Batdorff is an award-winning landscape and travel photographer and a nationally recognized authority on black and white photography. When John's not teaching workshops or writing books he can be found wandering the streets looking for his next image.

http://johnbatdorff.com

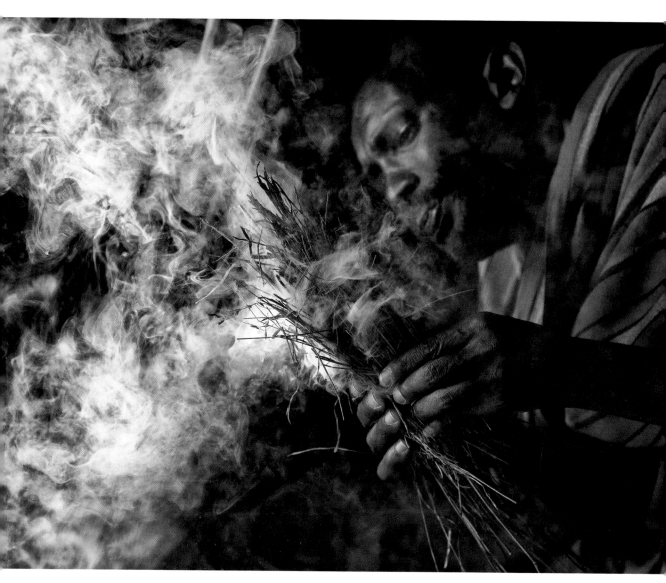

SMOKE, 2011

THE SWEEPER, 2010

UNGUARDED, 2011

EYES OF JAIPUR, 2010

HIS MAJESTY, 2011

3 EXPLORING THE LIGHTROOM WORKSPACE

Lesson overview

Whether you prefer to use menu commands and keyboard shortcuts or buttons and sliders, whether you use a single monitor or two—you can set up the flexible Lightroom Classic CC workspace to suit the way *you* work. Customize each module so you always have your favorite tools and controls at hand, arranged just the way you like them.

In this lesson you'll explore the Library module and a variety of view modes, tools, and techniques for reviewing your images and navigating your catalog. In the process, you'll become familiar with the interface elements and skills that are common to all the workspace modules:

- Adjusting the workspace layout
- Working with the different views and screen modes
- Using keyboard shortcuts
- Comparing, flagging, and deleting photos
- Assembling groups of images using the Quick Collection
- Using the Navigator panel and the Filmstrip
- Working with a second display

 You'll probably need between one and two hours to complete this lesson. If you haven't already done so, log in to your peachpit.com account to download the lesson files for this chapter, or follow the instructions under "Accessing the Lesson Files and Web Edition" in the Getting Started section at the beginning of this book.

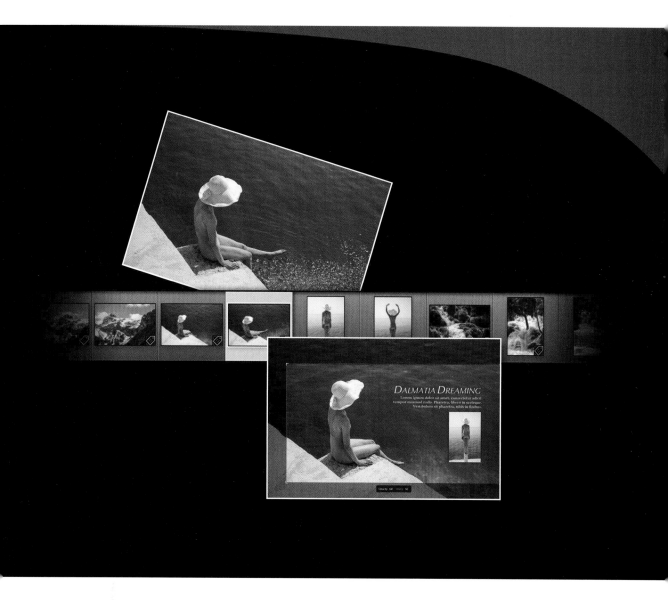

Make working with Lightroom Classic CC even more pleasurable, and ultimately more productive, by personalizing the workspace so that you always have your favorite tools and controls at hand. Lightroom Classic CC streamlines your workflow, allowing you to move effortlessly between screen modes and working views and freeing you up to spend less time in front of the computer and more time behind the lens.

Getting started

Note: This lesson assumes that you already have a basic working familiarity with the Lightroom Classic CC workspace. If you need more background information, refer to Lightroom Classic CC Help, or review the previous lessons.

Before you begin, make sure you've set up the LRClassicCIB folder for your lesson files and created the LRClassicCIB Catalog file to manage them, as described in "Accessing the Lesson Files and Web Edition" and "Creating a catalog file for working with this book" in the Getting Started chapter at the start of this book.

If you haven't already done so, download the Lesson 3 folder from your Account page at www.peachpit.com to the LRClassicCIB \ Lessons folder, as detailed in "Accessing the Lesson Files and Web Edition" in the chapter "Getting Started."

1 Start Lightroom Classic CC.

2 In the Adobe Photoshop Lightroom Classic CC - Select Catalog dialog box, make sure the file LRClassicCIB Catalog.lrcat is selected under Select A Recent Catalog To Open, and then click Open.

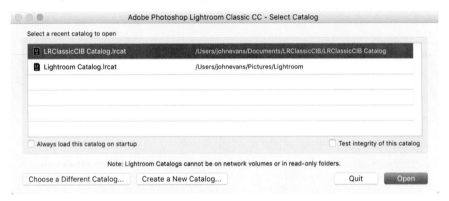

Tip: If you can't see the Module Picker, choose Window > Panels > Show Module Picker, or press the F5 key. If you're working on Mac OS, you may need to press the fn key together with the F5 key, or change the function key behavior in the system preferences.

3 Lightroom Classic CC will open in the screen mode and workspace module that were active when you last quit. If necessary, switch to the Library module by clicking Library in the Module Picker at the top of the workspace.

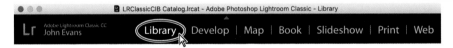

Importing images into the library

The first step is to import the images for this lesson into the Lightroom library.

1 In the Library module, click the Import button below the left panel group.

2 If the Import dialog box appears in compact mode, click the Show More Options button at the lower left of the dialog box to see all the options in the expanded Import dialog box.

3 Under Source at the left of the expanded Import dialog box, locate and select your LRClassicCIB \ Lessons \ Lesson 3 folder. Ensure that all twelve images in the Lesson 3 folder are checked for import.

4 In the import options above the thumbnail previews, select Add so that the imported photos will be added to your catalog without being moved or copied. Under File Handling at the right of the expanded Import dialog box, choose Minimal from the Build Previews menu and ensure that the Don't Import Suspected Duplicates option is activated. Under Apply During Import, choose None from both the Develop Settings menu and the Metadata menu and type **Lesson 3, Europe** in the Keywords text box. Make sure that your import is set up as shown in the illustration below, and then click Import.

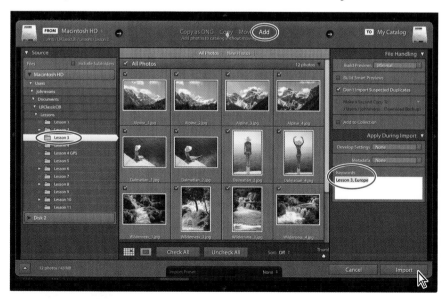

> **Tip:** The first time you enter any of the Lightroom Classic CC modules, you'll see tips that will help you get started by identifying the components of the workspace and stepping you through the workflow. Dismiss the tips by clicking the Close button.
> To reactivate the tips for any module, choose [*Module name*] Tips from the Help menu.

The twelve images are imported from the Lesson 3 folder and now appear in both the Grid view of the Library module and in the Filmstrip across the bottom of the Lightroom Classic CC workspace.

Viewing and managing your images

The Library module is where every Lightroom Classic CC workflow begins; whether you're importing new images, or finding a photo that's already in your catalog. The Library module offers a variety of viewing modes and an array of tools and controls to help you evaluate, sort, and group your photos. During import, you applied common keywords to the selection of images as a whole; now, even as you review your newly imported photos for the first time, you can begin to add more structure to your catalog, flagging picks and rejects and assigning ratings, tags, and labels.

Lightroom's search and filter features will enable you to leverage this metadata that you attach to your photos; you can search and sort the images in your library by any attribute or association, and then create Collections to group them, making it easy to retrieve exactly the photos you want, no matter how extensive your catalog.

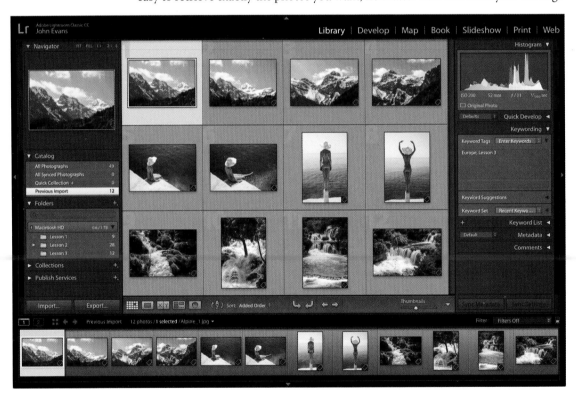

In the Library module's left panel group you'll find panels where you can access and manage the folders and collections containing your photos. The right panel group presents controls for adjusting your images and working with keywords and metadata. Above the work area is the Filter bar, where you can set up a custom search. The Toolbar below the work area provides easy access to your choice of tools and controls and the Filmstrip presents the images in the selected source folder, no matter which view is active in the work area.

Adjusting the workspace layout

You can customize the layout of the flexible Lightroom Classic CC workspace to suit the way you prefer to work on any task in your workflow, freeing-up screen space as you need it and keeping your favorite controls at your fingertips. In the next five exercises you'll learn how to modify the workspace on the fly and use the various screen display modes: skills that are applicable to any of the Lightroom modules.

Resizing panels

When you need more space for the task at hand, you can quickly alter the workspace layout by adjusting the width of the side panel groups and the height of the Filmstrip panel, or by simply hiding any of these elements.

1 Move the pointer over the right edge of the left panel group; the cursor changes to a horizontal double arrow (↔). Drag to the right and release the mouse button when the panel group has reached its maximum width.

The central work area contracts to accommodate the expanded panel group. You might use this arrangement to maximize the Navigator preview.

2 Click Develop in the Module Picker to switch to the Develop module. You'll notice that the left panel group returns to the width it was when you last used the Develop module.

Lightroom Classic CC remembers your customized workspace layout for each module independently, so that the workspace is automatically rearranged to suit the way you like to work for each stage in your workflow as you move between modules.

3 Press Alt+Ctrl+Up Arrow / Option+Command+Up Arrow to return quickly to the previous module.

4 In the Library module, drag the right edge of the left panel group to return the group to its minimum width.

5 Move the pointer over the top edge of the Filmstrip panel; the cursor changes to a double-arrow (↕). Drag the top edge of the Filmstrip down as far as it will go.

The work area expands to fill the available space. This arrangement keeps the Filmstrip visible while increasing the space available for the Grid view when you're selecting photos, or for reviewing images in the Loupe, Compare and Survey views.

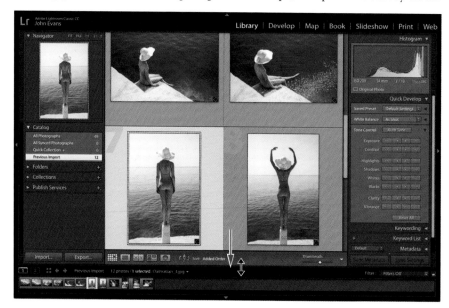

Note: You can't change the size of the top panel, but you can hide or reveal it just like the side panel groups and the Filmstrip. You'll learn about showing and hiding panels in the next exercise.

6 Switch to the Develop module. The Filmstrip remains unchanged as you move between modules. Whichever module you switch to, the Filmstrip will remain at its current height until you resize it.

Note: For the side panel groups, double-clicking the border will produce a different result. This is discussed in the next section, "Showing and hiding panels or panel groups."

7 Move the pointer over the top edge of the Filmstrip panel; the pointer changes to a vertical double-arrow cursor. Double-click the top edge of the Filmstrip to reset the panel to its previous height; then switch back to the Library module.

8 Drag the top border of the Filmstrip to its maximum height. The thumbnails in the Filmstrip are enlarged and, if necessary, a scroll bar appears along the bottom of the Filmstrip. Scroll to view all the thumbnails; then, double-click the top edge of the Filmstrip with the vertical double-arrow cursor to reset the panel to its previous height.

Showing and hiding panels or panel groups

By adjusting the size of the side panel groups and the Filmstrip, you can allocate more space for the controls you access most frequently and reduce the prominence of features you use less often. Once you've set up the workspace as you like it, you can maximize your working view as needed by temporarily hiding any, or all of the surrounding panels.

1 To hide the left panel group, click the Show / Hide Panel Group arrow (◀) in the left margin of the workspace window. The panel group disappears and the arrow icon is reversed to face right.

2 Click the reversed Show / Hide Panel Group arrow (▶) to reinstate the left panel group.

▶ **Tip:** You don't need to be accurate clicking the Show / Hide Panel Group arrows. In fact, you can click anywhere in the outer margins of the workspace to hide and show panels.

You can use the arrows in the top, right, and bottom margins of the workspace to show and hide the top panel, the right panel group, and the Filmstrip.

3 Disable the menu option Window > Panels > Show Left Module Panels or press the F7 key to hide the left panel group. To show the group again, press F7 or choose Window > Panels > Show Left Module Panels. Disable the menu option Window > Panels > Show Right Module Panels or press the F8 key to hide the right panel group. To show the group again, press F8 or choose Window > Panels > Show Right Module Panels.

4 Disable the menu option Window > Panels > Show Module Picker or press the F5 key to hide the top panel. To show it again, press F5 or choose Window > Panels > Show Module Picker. To hide the Filmstrip, press the F6 key or disable the menu option Window > Panels > Show Filmstrip. To show it again, press F6 or choose Window > Panels > Show Filmstrip.

5 To hide or show both side panel groups at once, press the Tab key or choose Window > Panels > Toggle Side Panels. To hide or show the top panel and the Filmstrip as well as the side panel groups, press Shift+Tab, or choose Window > Panels > Toggle All Panels.

▶ **Tip:** On macOS, some function keys are assigned to specific operating system functions by default. If pressing a function key in Lightroom Classic CC does not work as expected, either press the fn key (not available on all keyboard layouts) together with the respective function key, or change the keyboard behavior in the system preferences.

Lightroom Classic CC offers options that make the workspace even more flexible and convenient by showing and hiding panels or panel groups automatically in response to your movements with the pointer, so that information, tools and controls will appear only when you need them.

6 Right-click / Control-click the Show / Hide Panel Group arrow (◀) in the left margin of the workspace. Choose Auto Hide & Show from the context menu.

7 Hide the left panel group by clicking the Show / Hide Panel Group arrow (◀); then, move the pointer over the arrow in the left margin of the workspace. The left panels automatically slide into view, partly covering the work area. You can click to select catalogs, folders, and collections; the left panel group will remain visible as long as the pointer remains over it. Move the pointer outside the left panel group and it will disappear again. To show or hide the left panels independently of the current settings, press the F7 key.

8 Right-click / Control-click the Show / Hide Panel Group arrow (◀) in the left margin of the workspace window and choose Auto Hide from the context menu. Now the panel group disappears when you are done with it and does not reappear when you move the pointer into the workspace margin. To show the left panel group again, click in the workspace margin, or press the F7 key.

9 To turn off automatic show and hide for this panel, right-click / Control-click the Show / Hide Panel Group arrow (◀) in the left margin of the workspace and choose Manual from the context menu.

10 To reset the left panel group to its default behavior, activate Auto Hide & Show in the context menu. If either of the left or right panel groups is still hidden, press the F7 key or the F8 key respectively, to show it again.

Lightroom remembers your panel layout for each module independently, including your choice of show and hide options. The options you choose for the Filmstrip and the top panel, however, remain unchanged as you move between modules.

Expanding and collapsing panels

Up to this point in our lesson, we've dealt with the left and right panels only as groups. Now you'll learn to work with the individual panels within the groups.

1 If you are not already in the Library module, switch to it now. Create more space to work with the side panel groups by hiding both the top panel and the Filmstrip. *(See step 4 in the previous exercise.)*

In the Library module, the left panel group contains the Navigator, Catalog, Folders, Collections, and Publish Services panels. Each panel within a group can be *expanded* to show its content or *collapsed* so that only the panel header is visible. A triangle next to the panel name indicates whether a panel is expanded or collapsed.

▶ **Tip:** You don't need to be accurate when you click the triangle. Clicking anywhere in the panel header will do, as long as you don't click any other control that might be located there, such as the Plus icon (+) in the header of the Collections panel.

2 To expand a collapsed panel, click the triangle beside its name; the triangle turns downward and the panel expands to show its content. Click the triangle again to collapse the panel.

Folders within a panel—such as the Smart Collections folder in the Collections panel—can also be expanded and collapsed by clicking the triangle next to the folder name.

3 Open the Window > Panels menu; panels that are currently expanded and fully visible in the panel group show a check mark in front of their names. Choose any of the panels from that menu and toggle its display status.

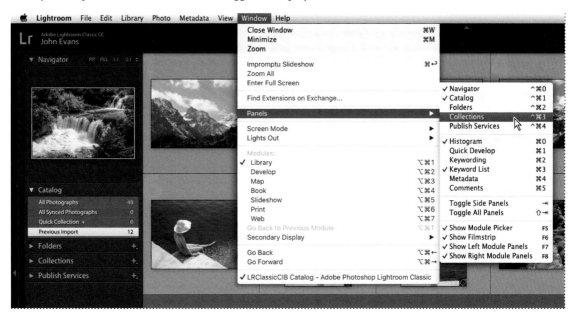

4 In the Window > Panels menu, look at the keyboard shortcuts for expanding and collapsing the individual panels.

For the panels in the left group, the keyboard shortcuts begin with Ctrl+Shift / Control+Command followed by a number. The panels are numbered from the top down, so you press Ctrl+Shift+0 / Control+Command+0 for the Navigator panel, Ctrl+Shift+1 / Control+Command+1 for the Catalog panel, and so on.

For the panels in the right group, the keyboard shortcuts begin with Ctrl / Command followed by a number. Press Ctrl+0 / Command+0 to collapse the Histogram panel. Press the same keyboard shortcut again to expand it. These keyboard shortcuts may be assigned to different panels in another module, but this shouldn't be too confusing if you remember that, whatever module you're in, the panels are always numbered from the top of the group, starting at 0.

Using keyboard shortcuts is a great way to streamline your workflow, so it's well worthwhile to note the shortcuts listed beside the menu commands you use.

5 Press Ctrl+/ (Windows) or Command+/ (Mac OS) to see a list of all the keyboard shortcuts for the currently active module. When you're done, click anywhere on the list to dismiss it.

With one click, you can expand and collapse all panels other than the topmost in each group, or have all the panels other than the top panel in the group and the one you're working with close automatically. The top panel in each group has a special role and is not affected by these commands.

6 To collapse all panels in either of the side groups, right-click / Control-click the header of any panel other than the top panel in the group, and then choose Collapse All from the context menu. If the top panel is already expanded, it will stay open.

7 To expand all the panels in either group, right-click / Control-click the header of any panel—other than the top panel in each group—and choose Expand All from the context menu. Once again, the top panel remains unaffected.

Tip: Alt-click or Option-click the header of any panel to quickly activate or disable the Solo mode.

8 To collapse all the panels in a group other than the one you're working with, right-click / Control-click the header of any panel—other than the top panel in the group—and choose Solo mode from the context menu. Only one panel will remain expanded. The triangles beside the panel names change from solid to dotted when Solo mode is activated. Click the header of a collapsed panel to expand it. The previously expanded panel collapses automatically.

Hiding and showing panels

If you use some panels in a group less often than others, you can hide them from view to create more space to expand the panels you use most frequently.

1 To show or hide an individual panel, choose it from the same context menu. Panels that are currently visible have checkmarks in front of their names.

2 To show all of the panels that are currently hidden in either of the side panel groups, right-click / Control-click the header of any panel other than the top panel in the group and choose Show All from the context menu.

You can't access the panel group context menu by right-clicking / Control-clicking the headers of the Navigator or Histogram panels; if you've hidden all of the panels other than the topmost in either side group, you can make the panel you want visible again by choosing its name from the Window > Panels submenu.

Toggling screen modes

Whichever of the Lightroom Classic CC modules you're working in, you can choose between several *screen modes* to suit the way you prefer to work. In the default mode the workspace appears inside an application window that you can resize and position on your screen. If you prefer, you can expand the workspace to fill the screen, either with or without the menu bar, or switch to a full-screen preview to see the photo you're working on without any distracting workspace elements.

1 Choose Window > Screen Mode > Normal to ensure you're in the default mode.

In Normal screen mode, the Lightroom Classic CC workspace appears inside an application window. You can resize and reposition the application window just as you are used to doing with other applications.

2 Move the pointer over any edge or corner of the application window. When the pointer changes to a horizontal, vertical, or diagonal double-arrow (⤢), drag to reduce the size of the application window.

3 On Windows, click the Maximize button (▣), located at the right of the title bar; on Mac OS, click the green Zoom button (⬤) at the left of the title bar.

The application window expands to fill the entire screen, though the title bar remains visible. While the window is maximized, it's no longer possible to resize it as you did in step 2, or reposition it by dragging the title bar.

4 Click the Restore Down button (▣) / the green Zoom button (⬤) to restore to the window to the size you established in step 2.

5 Choose Window > Screen Mode > Full Screen; the workspace fills the entire screen. The menu bar is hidden, as is the Task Bar on Windows, or the Dock on Mac OS. Move the pointer to the top edge of the screen to see the menu bar. Choose Window > Screen Mode > Full Screen And Hide Panels. Alternatively, use the keyboard shortcut Shift+Ctrl+F / Shift+Command+F.

The Full Screen And Hide Panels mode is a good choice to quickly maximize the space available for the main work area, whether you're working with the thumbnail grid or a single image in the Loupe view. You can still access any of the hidden panels when needed—using either keyboard shortcuts or your mouse—without changing the view. You'll learn more about showing and hiding panels later in this lesson.

6 Press Shift+F repeatedly, or choose Window > Screen Mode > Next Screen Mode, to cycle through the working modes. As you switch between the screen modes, you'll notice that the panels around the work area remain hidden. To reveal all panels, press Shift+Tab once or twice. Press T to show the Toolbar.

7 Press the F key to see a full-screen preview of the selected image at the highest magnification possible, without the distraction of workspace elements; then, press Alt+Ctrl+F / Option+Command+F to return to Normal screen mode.

Switching views

In each Lightroom Classic CC module you have a different choice of working views to suit the various phases of your workflow. You can switch between viewing modes as you work by choosing from the View menu, by using the keyboard shortcuts listed there, or by clicking a view mode button in the Toolbar below the work area.

In the Library, you can move between several viewing modes. Press the G key or click the Grid view button (▦) in the Toolbar to see thumbnails of your images while you search, apply flags, ratings and labels, or create collections. Use the keyboard shortcut E or click the Loupe view button (▣) to inspect a single photo at a range of magnifications. Press C or click the Compare view button (XY) to see two images side by side. Click the Survey view button (▦) in the Toolbar or use the keyboard shortcut N to evaluate several images at once. The Toolbar displays a different set of controls for each view mode. For the purposes of this lesson, we'll ignore the fifth view button in the Toolbar, which is used in the process of tagging faces in your photos; you'll learn about using the People view in Lesson 4.

1 If you're not already in the Grid view, click the Grid view button (▦). Adjust the size of the thumbnails to your liking by dragging the Thumbnails slider.

2 Click the triangle at the right end of the Toolbar and ensure that View Modes is activated in the tools menu. If you're working on a small screen, you can disable any of the other options except Thumbnail size for this lesson.

Note: The order of the tools and controls from top to bottom in the menu corresponds to their order from left to right in the Toolbar.

Tools and controls that are currently visible in the Toolbar have a check mark beside their names in the menu.

3 Review the section "Setting Grid and Loupe view options"—the last exercise in Lesson 2—and specify which items of information you would like to see displayed with each photo in the Grid view image cells.

Working in Loupe view

The Loupe view displays a single photo, at a wide range of zoom levels. In the Develop module, where high magnification enables fine editing, the Loupe view is the default; in the Library module, you'll use it while evaluating and sorting your images. You can use the Navigator panel to set the level of magnification, and also to find your way around a zoomed image that's mostly out of frame. Like the Loupe view, you'll find the Navigator panel in both the Library and Develop modules.

1　In the Grid view or the Filmstrip, select a cascade or a mountain, and then click the Loupe view button (▦) in the Toolbar, or press the E key. Alternatively, simply double-click the thumbnail in the Grid view or the Filmstrip.

Tip: In the Library View Options dialog box, activate Show Info Overlay if you wish to display text details overlaid on your image in the Loupe view. By default, the Loupe view info overlay is disabled.

2　If necessary, expand the Navigator panel at the top of the left panel group.

The zoom controls in the top right corner of the Navigator panel in the left panel group enable you to switch quickly between preset magnification levels. You can choose from Fit, Fill, 1:1, or choose another option from a menu of ten zoom ratios.

You can toggle between zoom levels by choosing View > Toggle Zoom View, by pressing Z on your keyboard, or simply by clicking the photo in the work area. To better understand what happens when you use the Toggle Zoom View command (or click the enlarged image) you should be aware that the magnification controls are organized into two groups: Fit and Fill make up one group, while the numerical zoom ratio settings are in the other. The Toggle Zoom View command toggles the Loupe view between whichever magnification levels were last used in each group.

3 Click Fit in the zoom controls in the top right corner of the Navigator panel. Now click the 1:1 control. Choose View > Toggle Zoom View, or press Z. The zoom setting reverts to Fit. Press the Z key; the zoom setting reverts to 1:1.

4 Click Fill in the zoom controls, and then choose 2:1 from the menu at the far right of the Navigator panel header.

5 Click the image in the Loupe view. The zoom setting reverts to Fill. The difference between zooming this way and using the Toggle Zoom View command is that the zoomed view will now be centered on the area you clicked. Press Z to zoom to 2:1.

When you're working at such a high level of magnification, the Navigator helps you to move around in the image quickly and easily.

6 Click anywhere in the Navigator preview and the zoomed view will be centered on that point. While the view is magnified, the white rectangle overlaid on the Navigator preview indicates the area currently displayed in the Loupe view. Drag the rectangle to pan the zoomed view; then, watch the rectangle move as you drag the image in the Loupe view.

7 Using keystrokes to navigate an image can be helpful when you wish to inspect the entire image in close detail. Press the Home key (fn+Left Arrow) to position the zoom rectangle at the upper left of the image; then press the Page Down key (fn+Down Arrow) repeatedly to scroll through the magnified image one section at a time. When you reach the bottom of the photo the zoom rectangle jumps to the top of the next column. To start in the lower right corner of the image, press the End key (fn+Right Arrow); then use the Page Up key (fn+Up Arrow).

8 Show the Filmstrip; then, select another photo with the same orientation and click in the Navigator preview to move the zoom rectangle to a different part of the image. Return to the previous image; the zoom rectangle returns to its previous position for that photo. Choose View > Lock Zoom Position, and then repeat the first part of this step; the position of the zoom rectangle is now synchronized. This can be useful when comparing detail across similar photos.

9 In the View menu, un-check the Lock Zoom Position option to disable it. Click Fit in the header of the Navigator panel.

The zoom controls and the Navigator panel work the same way for the Loupe view in both the Library and Develop modules.

Using the Loupe view overlays

When you're working in Loupe view in the Library, the Develop module, or during a tethered capture session, you can choose to show configurable overlays that can be useful for setting up a layout, aligning elements, or making transformations.

1 Select any image in the Filmstrip. Press Shift+Tab to hide all panels, maximizing the Loupe view. Choose View > Loupe Overlay and check both Grid and Guides. To show and hide the guides, toggle Show in the same submenu.

2 Hold down the Ctrl / Command key to show controls for customizing the layout grid and guides. Drag over the Size and Opacity values at the top of the view to change the appearance of the Grid overlay. Drag the pin at the intersection of the Guides overlay to reposition it.

The Layout Image option for the Loupe overlay can be useful when you're choosing a photo—or purpose-shooting one in tethered capture mode—that's intended for use in a printed layout, a web page design, or a title screen for a slideshow.

You can create a layout sketch in PNG format, with a transparent background, and then choose View > Loupe overlay > Choose Layout Image. To resize a layout overlay, or change the opacity of the overlay or the matte that shades the parts of your photo that fall outside its borders, hold down the Ctrl / Command key and drag the corners of the bounding box or scrub over the values at the bottom of the view.

3 To show or hide the Loupe overlay, press Ctrl+Alt / Command+Option together with the O (for Oscar) key. When you're done, leave the overlay hidden.

4 Press Shift+Tab to show all the Library workspace panels.

Comparing photos

As the name suggests, the Compare view is ideal for examining and evaluating images side by side.

1 Press F5 and F7, or click the white arrows at the top and left edges of the workspace to hide the Module Picker and the left panels. In the Filmstrip, select any pair of similar photos: then, click the Compare View button (⊠Y) in the Toolbar.

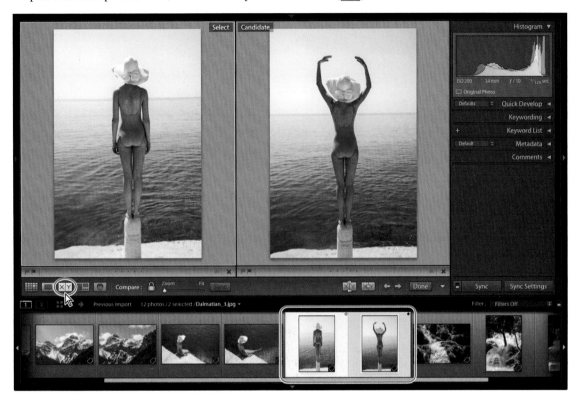

The first image that you selected becomes the *Select* image, which is displayed in the left pane of the Compare view; the image displayed in the right pane is called the *Candidate*. In the Filmstrip, the Select image is marked with a white, or rather, un-filled diamond icon in the upper right corner of the image cell, whereas the Candidate image is indicated by a solid diamond.

To use the Compare view to make a choice from a group of more than two photos, select your favored choice first to place it as the Select image, and then add the other photos to the selection. Click the Select Previous Photo and Select Next Photo buttons (⇐ ⇒) in the Toolbar or press the left and right arrow keys on your keyboard to move between the selected candidates. Should you decide that the current Candidate is better than the Select image, you can reverse their positions by clicking the Swap button (⊠Y) in the Toolbar.

2 To compare fine detail in the images, zoom in by dragging the Zoom slider in the Toolbar. You'll notice that the images are zoomed together. Drag either of the images in the Compare view and the images move in unison. The closed lock icon to the left of the Zoom slider indicates that the view focus of the two images is locked.

In some situations, this may prove to be inconvenient; for instance, with photos of the same subject shot at different zoom levels, or differently composed.

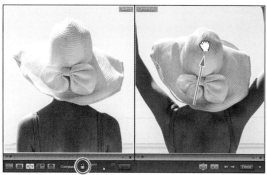

3 To pan the Select and Candidate images independently, click the view focus lock icon to unlink them; then, drag either image to pan the view.

A thin white line surrounds whichever photo in the Compare view is currently the active image: the image that will be affected by the Zoom slider or the controls in the right panel group.

4 Click the photo without the thin white border to make it active; then alter the zoom ratio.

5 Press Shift+Tab twice to show all panels. Click the lock icon to re-link the views, and then choose Fit from the zoom picker at the top of the Navigator.

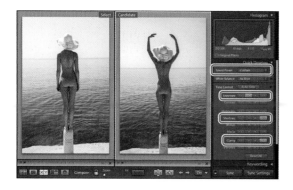

6 Change the active image—the image to which your edits will be applied—by clicking the photo without the white border; then, expand the Quick Develop panel. From the Saved Preset menu at the top of the Quick Develop panel, choose a developing preset that suits the photo you're working with (we chose Direct Positive from the Lightroom Color Presets category). In the Tone Control pane, experiment with a few of the adjustment buttons to improve the image.

Using the controls in the Quick Develop panel while you're working in Compare view can be a helpful aid in making a choice between images. Although the Select image in our example is better exposed for skin tones, the Candidate image, with the Direct Positive effect, is perhaps more atmospheric. Applying a develop preset or making Quick Develop adjustments can help you to assess how a candidate image will look once it's edited and adjusted. You can then either undo your Quick Develop operations and move to the Develop module to edit the image with greater precision, or even use the modifications you've already made as a starting point.

Using Survey view to narrow a selection

The last of the four viewing modes in the Library module, the Survey View lets you see multiple images together on one screen, and then refine your selection by dropping one photo after another from the view.

1 Make sure the Previous Import folder is selected as the image source in the Catalog panel. In the Filmstrip, select the four alpine shots, or the waterfalls. Click the Survey view button (▨) in the Toolbar, or press the N key. Press F5, or click the arrow at the top edge of the workspace, to hide the Module Picker.

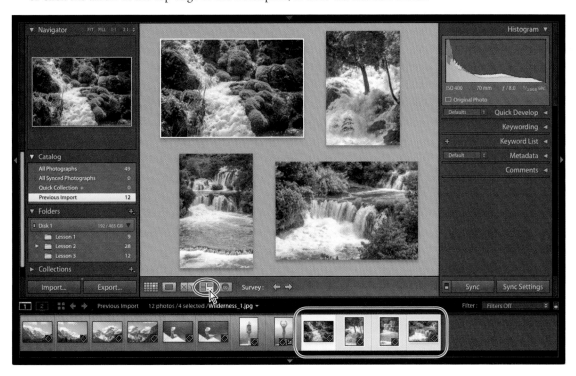

2 Navigate between the images by pressing the arrow keys on your keyboard or click the Select Previous Photo and Select Next Photo buttons (⇐⇒) in the Toolbar. The active image is surrounded by a thin white border.

3 Position the pointer over the image you like least; then, click the Deselect Photo icon (☒) in the lower right corner of the thumbnail to drop this photo from the Survey view selection.

As you eliminate candidates, the remaining photos are progressively resized and shuffled to fill the space available in the work area.

> **Tip:** If you have eliminated a photo accidentally, choose Edit > Undo to return it to the selection, or simply Ctrl-click / Command-click its thumbnail in the Filmstrip. You can easily add a new photo to the selection in the Survey view in the same way.

Dropping a photo from the Survey view doesn't delete it from its folder or remove it from the catalog; the dropped image is still visible in the Filmstrip—it has simply been deselected. You can see that the images that are still displayed in the Survey view are also the only ones that remain selected in the Filmstrip.

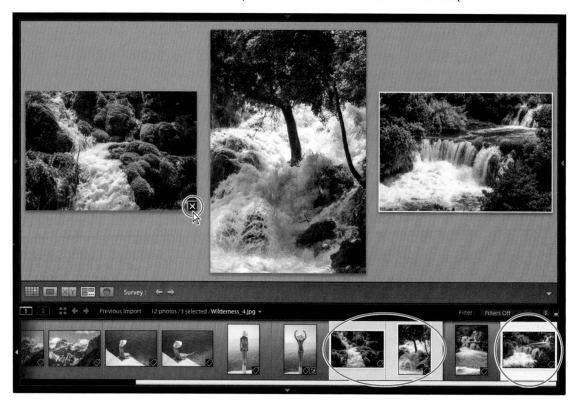

4 Continue to eliminate photos from the Survey view. For the purposes of this exercise, deselect all but one favorite. Keep the last image selected in the Survey view for the next exercise.

Flagging and deleting images

Now that you've narrowed down a selection of images to one favorite in the Survey view, you can mark your choice with a flag.

Flagging images as either picks or rejects as you review them is an effective way to quickly sort your work; flag status is one of the criteria by which you can filter your photo library. You can also quickly remove images flagged as rejects from your catalog using a menu command or keyboard shortcut.

A white flag denotes a pick (⚑), a black one with an x marks a reject (⚑), and a neutral grey flag indicates that an image has not been flagged (⚑).

1 Still in the Survey view, move the pointer over the remaining photo to see the flag icons just below the lower left corner. The grayed icons indicate that the image is not yet flagged. Click the flag to the left. The flag turns white, which marks this image as a pick. In the Filmstrip, you can see that the thumbnail now displays a white flag in the upper left of the image cell.

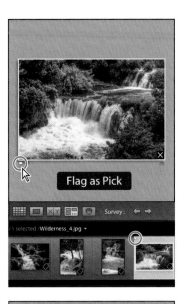

▶ **Tip:** Press the P key on your keyboard to flag a selected image as a pick (⬜), the X key to flag it as a reject (☒), or the U key to remove any flags.

2 Select a different waterfall image in the Filmstrip, and then press the X key. The black reject flag icon appears at the lower left corner of the image in the Survey view and at the upper left of the thumbnail in the Filmstrip. The thumbnail of the rejected image is dimmed in the Filmstrip.

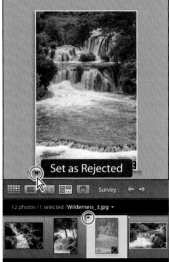

3 Choose Photo > Delete Rejected Photos or press Ctrl+Backspace / Command+Delete; then, click Remove to remove the rejected photo from your catalog without also deleting the master file from your hard disk.

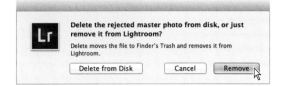

Having been removed from the Lightroom library catalog file, the rejected image is no longer visible in the Filmstrip.

4 Press the G key or click the Grid view icon in the Toolbar to see all the remaining images as thumbnails in the Grid view.

Grouping images in the Quick Collection

A collection is a convenient way to keep a group of photos together in your catalog, even when the image files are actually located in different folders on your hard disk. You can create a new collection for a particular presentation or use collections to group your images by category or any other association. Your collections are always available from the Collections panel where you can access them quickly.

The Quick Collection is a temporary holding collection: a convenient place to group images as you review and sort your new imports, or while you assemble a selection of photos drawn from different folders in your catalog.

In the Grid view or the Filmstrip, you can add images to the Quick Collection with a single click—and remove them just as easily. Your images will stay in the Quick Collection until you're ready to convert it to a more permanent grouping that will be listed in the Collections panel. You can access the Quick Collection from the Catalog panel so that you can return to work with the same selection of images at any time.

Moving images into or out of the Quick Collection

1 Expand the Catalog panel in the left panel group, if necessary, to see the listing for the Quick Collection.

2 In the Grid view or the Filmstrip, select the image Alpine_1.jpg, and then Shift-click Alpine_4.jpg to select all four photos of snow-covered mountains.

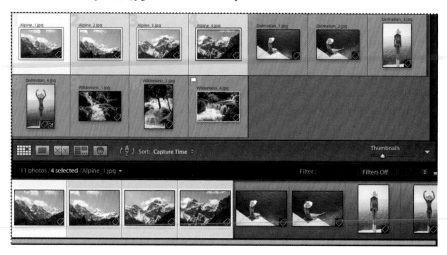

3 To add the selected photos to the Quick Collection, press the B key or choose Photo > Add To Quick Collection.

In the Catalog panel, the image count beside the Quick Collection indicates that it now contains four images. If you have activated the Show Quick Collection Markers option in the Library View Options dialog box, each of the four images is marked with a gray dot in the upper right corner of its thumbnail in the Grid view. The same markers are also shown in the Filmstrip unless the thumbnail size is too small.

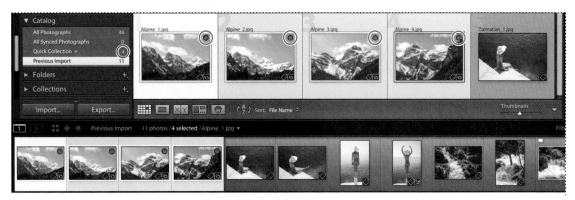

You can remove all of the selected photos from the Quick Collection by simply clicking the marker on one of the thumbnails or by pressing the B key.

4 For this exercise, you'll remove only the second image, Alpine_2.jpg, from the Quick Collection. First, deselect the other three images; then, with only the image Alpine_2.jpg selected, press the B key. The image count for your Quick Collection has been reduced to three.

Converting and clearing the Quick Collection

1 Click the Quick Collection entry in the Catalog panel. The Grid view now displays only three images. Until you clear the Quick Collection, you can easily return to this group of images to review your selection.

Tip: If you don't see the Quick Collection marker when you move your pointer over a thumbnail, make sure that Show Extras is activated in the View > Grid View Style menu. Choose View > View Options and activate Quick Collection Markers under Cell Icons in the Library View Options dialog box.

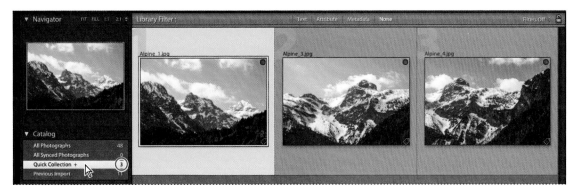

Now that you've refined your selection you can move your grouped images to a more permanent Collection.

2 Choose File > Save Quick Collection.

3 In the Save Quick Collection dialog box, type **Scenic Collection** in the Collection Name box. Activate the option Clear Quick Collection After Saving, and then click Save.

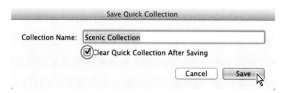

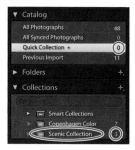

4 In the Catalog panel, you can see that the Quick Collection has been cleared; it now has an image count of 0. If necessary, expand the Collections panel so that you can see the listing for your new collection, which displays an image count of 3.

5 In the Folders panel, click the Lesson 3 folder. The grid view once more shows all the lesson images, including those in your new collection.

Designating a target collection

By default, the Quick Collection is designated as the *target collection;* this status is indicated by the plus sign (+) that follows the Quick Collection's name in the Catalog panel. The target collection is that collection to which a selected image is moved when you press the B key or click the circular marker in the upper right corner of the thumbnail, as you did in the previous exercise.

You can designate a collection of your own as the target collection so that you can use the same convenient techniques to add and remove photos quickly and easily.

1 Right-click / Control-click the entry for your new Scenic Collection in the Collections panel, and then choose Set As Target Collection from the context menu. The name of your collection is now followed by a plus sign (+).

2 Click the Previous Import folder in the Catalog panel; then, Control-click / Command-click to select the waterfall photos in the Grid view or the Filmstrip.

3 Open the Collections panel and watch as you press the B key on your keyboard; the image count for the Scenic Collection increases as the selected images are added.

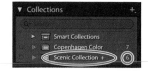

4 Right-click / Control-click the Quick Collection in the Catalog panel and choose Set As Target Collection from the context menu. The Quick Collection once again displays the plus sign (+).

Working with the Filmstrip

No matter which module or view you're working in, the Filmstrip across the bottom of the Lightroom Classic CC workspace provides constant access to the images in your selected folder or collection.

As with the Grid view, you can quickly navigate through your images in the Filmstrip using the arrow keys on your keyboard. If there are more images than will fit in the Filmstrip you can either use the scroll bar below the thumbnails, drag the Filmstrip by the top edge of the thumbnail frame, or click the shaded thumbnails at either end to access photos that are currently out of view.

Across the top of the Filmstrip, Lightroom Classic CC provides a convenient set of controls to help streamline your workflow.

At the far left you'll find buttons for working with two displays, with pop-up menus that enable you to set the viewing mode for each display independently.

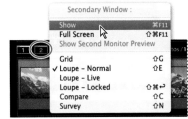

To the right of these buttons is the Grid view button, and arrow buttons for navigating between the different folders and collections you've recently been viewing.

Next is the Filmstrip Source Indicator, where you can see at a glance which folder or collection you're viewing, how many photos it contains, how many images are currently selected, and the name of the active image or the photo that is currently under your pointer in the Filmstrip. Click the Source Indicator to see a menu listing all the image sources that you've accessed recently.

At the right of the Filmstrip header are the Filter controls, which we'll look at later in this lesson.

Hiding the Filmstrip and adjusting its size

You can show and hide the Filmstrip and adjust its size, as you can with the side panel groups, to make more screen space available for the image you're working on.

1 Click the triangle in the lower border of the workspace window to hide and show the Filmstrip. Right-click / Control-click the triangle to set the automatic show and hide options.

2 Position the pointer over the top edge of the Filmstrip; the cursor becomes a double arrow. Drag the top edge of the Filmstrip up or down to enlarge or reduce the thumbnails. The narrower you make the Filmstrip the more thumbnails it can display.

Using filters in the Filmstrip

With so few photos in the Lesson 3 folder it's not difficult to see all the images at once in the Filmstrip. However, when you're working with a folder containing many images it can be inconvenient to scroll the Filmstrip looking for the photos you want to work with.

You can use the Filmstrip filters to narrow down the images displayed in the Filmstrip to only those that share a specified flag status, rating, color label, or any combination of these attributes.

1 In the Filmstrip you can see that one of the images in the Lesson 3 folder displays the white Pick flag that you assigned in a previous exercise. If you don't see the flag, right-click / Control-click anywhere in the Filmstrip and activate the context menu option View Options > Show Ratings And Picks. Examine the other options available in the Filmstrip context menu. Many of the commands apply to the image or images currently selected; others affect the Filmstrip itself.

2 From the Filter menu at the top right of the Filmstrip, choose Flagged. Only the image with the white flag is displayed in the Filmstrip.

3 The white flag icon is now highlighted among the Filter controls in the top bar of the Filmstrip. Click the word Filter at the left of the flag icons to see the attribute filter options displayed as buttons in the Filmstrip header.

You can activate or disable any of the filters you saw in the Filter menu by clicking the respective Filter buttons. You can set up a combination of filters and save it as a custom preset by choosing Save Current Settings As New Preset from the menu.

4 Click the white flag button to deactivate the active filter or choose Filters Off from the menu to disable all filters. The Filmstrip once more displays all the images in the folder. Click the word Filter again to hide the filter buttons.

You'll learn more about using filters in Lesson 4, "Managing Your Photo Library."

Changing the sorting order of the thumbnails

Use the Sort Direction control and the Sort Criteria menu in the Toolbar to change the display order of the thumbnail images in the Grid view and the Filmstrip.

1 If the sorting controls are not currently visible in the Toolbar, choose Sorting from the tools menu at the right of the Toolbar.

2 Choose Pick from the Sort Criteria menu.

The thumbnails are rearranged in both the Grid view and the Filmstrip to display the image with the white Pick flag first.

3 Click the Sort Direction control (▓) to reverse the sorting direction of the thumbnails. The image with the white Pick flag now appears last in the order.

When you've grouped images in a Collection, you can manually rearrange their order however you wish. This can be particularly useful when you're creating a presentation such as a slideshow or web gallery, or putting together a print layout, as the images will be placed in the template according to their sort order.

4 Expand the Collections panel and click the Scenic Collection that you created earlier in this lesson. Choose File Name from the Sort Criteria menu.

5 In the Filmstrip, drag the second image to the right and release the mouse button when you see a black insertion bar appear between the third and fourth thumbnails.

▶ **Tip:** You can also change the order of the photos in a collection by dragging the thumbnail images in the Grid view.

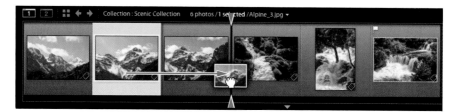

The image snaps to its new location in both the Filmstrip and the Grid view. The new sorting order is also apparent in the Toolbar; your manual sorting order has been saved and is now listed as Custom Order in the Sort Criteria menu.

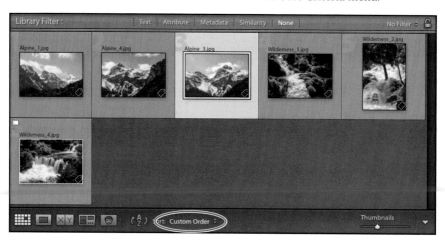

6 Choose File Name from the Sort menu; then return to your manual sorting by choosing Custom Order.

Using a secondary display

If you have a second monitor connected to your computer, you can use it to display an additional view that is independent of the module and view mode currently active on your main monitor. You can choose to have the secondary view displayed in its own window that can be resized and repositioned, or have it fill your second screen. Use the view picker at the top of secondary display to switch between Grid, Loupe, Compare, Survey, and Slideshow views.

If you have only one monitor connected to your computer, you can open the additional display in a floating window that you can resize and reposition as you work.

1 To open a separate window—whether you're using one or two monitors—click the Second Window button (...), located at the upper left of the Filmstrip.

Tip: You can use keyboard shortcuts to change the view in the secondary display— Shift+G for Grid, Shift+E for Loupe, Shift+C for Compare, and Shift+N for Survey. If the second window is not already open, you can use these keyboard shortcuts to quickly open it in the desired viewing mode.

2 In the top panel of the secondary display, click Grid or press Shift+G.

3 Use the Thumbnails slider in the lower right corner of the secondary display to change the size of the thumbnail images. Use the scrollbar on the right side, if necessary, to scroll to the end of the Grid view.

Although it's possible for the secondary display to show a different enlarged photo from the main window, the Grid view in the secondary display always shows the same images as the Grid view and the Filmstrip in the main window.

The source indicator and menu at the left of the secondary display's lower panel work the same way they do in the Filmstrip, and the top and bottom panels can be hidden and shown, just as they can in the main window.

4 Click to select any thumbnail in the grid, and then click Loupe in the view picker at the left of the top panel in the secondary display. Check the picker at the right of the top panel to make sure that Normal mode is active.

When the secondary display is in Normal mode, the Loupe view displays the active image from the Grid view and the Filmstrip in the main display.

Note: If your secondary display is open in a window rather than on a second screen, you may need to change the focus for any keyboard input by clicking inside the main window or on its title bar.

5 Use the left and right arrow keys on your keyboard to select either the previous or next photo in the series. The new selection becomes the active image and the secondary display is updated accordingly.

6 Click Live in the mode picker at the right of the secondary display's top panel.

In Live mode, the secondary display shows the image that is currently under your pointer in the main window—whether that image is a thumbnail in the Filmstrip or the Grid view, or enlarged in the Loupe, Compare, or Survey view.

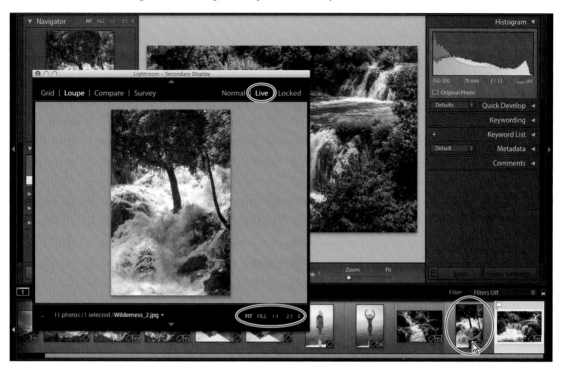

You can set a different zoom level for the secondary display by choosing from the picker at the lower right of the secondary window.

7 Select an image in the Filmstrip; then, switch the secondary window to Locked mode by clicking Locked in the mode picker at the right of the top panel. The current image will now remain fixed in the secondary display until you return to Normal or Live mode—regardless of the image displayed in the main window.

8 Change the zoom level for the secondary display by choosing from the picker at the right of the lower panel: click Fit, Fill, or 1:1, or choose a zoom ratio from the menu at the far right.

9 Drag the zoomed image to reposition it in the secondary window, and then click the image to return to the previous zoom level.

10 (Optional) Right-click / Control-click the image to choose a different background color or texture from the context menu. These settings will apply to the secondary display independently of the options chosen for the main window.

11 Choose Compare from the view picker at the left of the secondary window's top panel. In the main window, select two or more images—either in the Grid view or in the Filmstrip.

12 The image in the left pane of the Compare view is the *Select* image; the image in the right pane is the *Candidate*. To change the candidate photo, make sure the Candidate pane is active; then, click the Select Previous Photo button (⬅) or the Select Next Photo button (➡). If you have more than two images selected, only images from the selection are considered as candidates. To replace the Select image with the current Candidate, click the Make Select button (⬍).

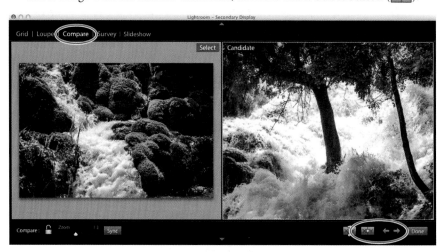

13 In the main window, select three or more images—either in the Grid view or in the Filmstrip, and then click Survey in the top panel of the second window. Use the Survey view to compare more than two images at once. To remove an image from the Survey view, move the pointer over the unwanted image and click the Deselect Photo button (✖) that appears in the lower right corner of the image.

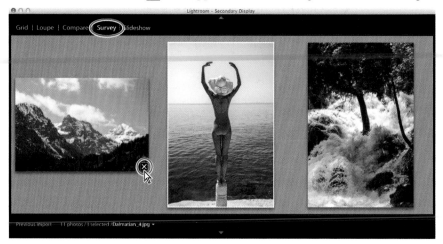

14 Click to un-check Show in the Window > Secondary Display menu, or click the Close button (✖ Windows) / (⬤ Mac OS) to close the secondary display.

Review questions

1 Name the four working views in the Library module, and explain how they're used.

2 What is the Navigator?

3 How do you use the Quick Collection?

4 What is the target collection?

Review answers

1 Press the G key or click the Grid view button (⊞) in the Toolbar to see thumbnails of your images while you search, apply flags, ratings and labels, or create collections. Use the keyboard shortcut E or click the Loupe view button (▣) to inspect a single photo at a range of magnifications. Press C or click the Compare view button (☒Y) to see two images side by side. Click the Survey view button (▦) in the Toolbar or use the keyboard shortcut N to evaluate several images at once or refine a selection.

2 The Navigator is an interactive full image preview that helps you move around easily within a zoomed image in Loupe view. Click or drag in the Navigator preview to reposition the view while a white rectangle indicates the portion of the magnified image that is currently visible in the workspace. The Navigator panel also contains controls for setting the zoom levels for the Loupe view. Click the image in Loupe view to switch between the last two zoom levels set in the Navigator panel.

3 To create a Quick Collection, select one or more images and then press the B key or choose Photo > Add To Quick Collection. The Quick Collection is a temporary holding area; you can continue to add—or remove—images until you are ready to save the grouping as a more permanent Collection. You'll find the Quick Collection listed in the Catalog panel.

4 The target collection is the collection to which a selected image will be moved when you press the B key or click the circular marker in the upper right corner of the thumbnail. By default, the Quick Collection is designated as the target collection; this status is indicated by the plus sign (+) that follows the Quick Collection's name in the Catalog panel. You can designate a collection of your own as the target collection so that you can use the same convenient techniques to add and remove photos quickly.

PHOTOGRAPHY SHOWCASE
JULIEANNE KOST

"Photographers are artists—we see things in ways no one else does. Now, more than ever we must realize that our individual vision is what matters the most; it hasn't "all been done before," because your image will be made through your eye, telling your story, with your voice."

With the constant over-stimulation that many of us experience on a daily basis, I find that the search to include only what is most important to the story while eliminating the rest helps me to compartmentalize and make sense of what I see and experience (even if it's only a partial view)—organizing elements within a frame allows me to focus on what is meaningful to me, without being overwhelmed. In my photography, I am guiding people to look at what I saw—both by my point of view, and by the way I process my images. I'm more interested in conveying the feeling of my experience than trying to accurately represent the subject or location.

My relationship with Lightroom and Photoshop has constantly evolved over the years. Look at the masters in any field and you'll see a beautiful relationship between the tool and the creativity. As our tools evolve, so will the work that we create with them. Innovations in technology offer additional opportunities and methods for making art— if I limit myself to the tools that I already know, I might be limiting my potential both intellectually as well as aesthetically.

Blogs.adobe.com/jkost

Jkost.net

instagram.com/jkost/

NEW HAMPSHIRE, 2010

AIRLIE BEACH, 2015

ICELAND, 2010

FROM THE OBJECTS OF IMPORTANCE SERIES, 2013

4 MANAGING YOUR PHOTO LIBRARY

Lesson overview

As your photo library grows larger, it will become increasingly important to organize your files so that they can be easily found. Lightroom Classic CC offers options for organizing your images before you even click the Import button—and even more once they're in your catalog. Manage folders and files without leaving the Library module; then apply keywords, flags, ratings, and labels, and group photos in convenient collections, regardless of where they're stored.

This lesson will familiarize you with the tools and techniques you'll use to organize, manage, and search your photo library:

- Working with a folder structure
- Understanding Collections
- Working with keywords, flags, ratings, and labels
- Tagging faces in the People view
- Organizing images by location in the Map module
- Editing Metadata and using the Painter tool
- Finding and filtering files

 You'll probably need between one and two hours to complete this lesson. If you haven't already done so, log in to your peachpit.com account to download the lesson files for this chapter, or follow the instructions under "Accessing the Lesson Files and Web Edition" in the Getting Started section at the beginning of this book.

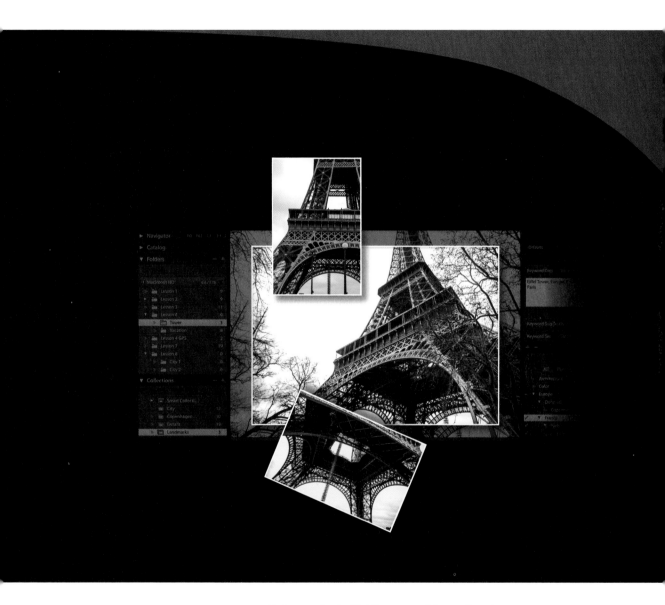

Lightroom Classic CC delivers powerful, versatile tools to help you organize your image library. Use people tags, keywords, flags, labels, ratings, and even GPS location data to sort your images, and group them into virtual collections by any association you choose. Make fast, sophisticated searches, based on practically limitless combinations of criteria, that will put the photos you want at your fingertips.

Getting started

● **Note:** This lesson
assumes that you
already have a basic
working familiarity with
the Lightroom Classic CC
workspace. If you need
more background
information, refer to
Lightroom Classic CC
Help, or review the
previous lessons.

Before you begin, make sure you've set up the LRClassicCIB folder for your lesson
files and created the LRClassicCIB Catalog file to manage them, as described
in "Accessing the Lesson Files and Web Edition" and "Creating a catalog file for
working with this book" in the Getting Started chapter at the start of this book.

If you haven't already done so, download the Lesson 4, and Lesson 4 GPS fold-
ers from your Account page at www.peachpit.com to the LRClassicCIB \ Lessons
folder, (*see "Accessing the Lesson Files and Web Edition" in the chapter "Getting
Started."*)

1 Start Lightroom Classic CC.

2 In the Adobe Photoshop Lightroom Classic CC - Select Catalog dialog box,
 make sure the file LRClassicCIB Catalog.lrcat is selected under Select A Recent
 Catalog To Open, and then click Open.

▶ **Tip:** The first time
you enter any of the
Lightroom Classic CC
modules, you'll see
module tips that will
help you get started by
identifying the compo-
nents of the workspace
and stepping you
through the workflow.
Dismiss the tips by click-
ing the Close button.
To reactivate the tips
for any module, choose
[*Module name*] Tips
from the Help menu.

3 Lightroom Classic CC will open in the screen mode and workspace module that
 were active when you last quit. If necessary, switch to the Library module by
 clicking Library in the Module Picker at the top of the workspace.

Importing images into the library

The first step is to import the images for this lesson into the Lightroom library.

1 In the Library module, click the Import
 button below the left panel group.

2 If the Import dialog box appears in compact mode, click the Show More
 Options button at the lower left of the dialog box to see all the options in the
 expanded Import dialog box.

3 Under Source at the left of the expanded Import dialog box, locate and select
 your LRClassicCIB \ Lessons \ Lesson 4 folder. Ensure that all twelve images
 from the Lesson 4 folder are checked for import.

4 In the import options picker above the thumbnail previews, select Add so
 that the imported photos will be added to your catalog without being moved
 or copied. Under File Handling at the right of the Import dialog box, choose
 Minimal from the Build Previews menu and ensure that the Don't Import
 Suspected Duplicates option is activated. Under Apply During Import, choose
 None from both the Develop Settings menu and the Metadata menu, and type
 Lesson 4, Europe in the Keywords text box. Make sure that your import is set
 up as shown in the illustration below, and then click Import.

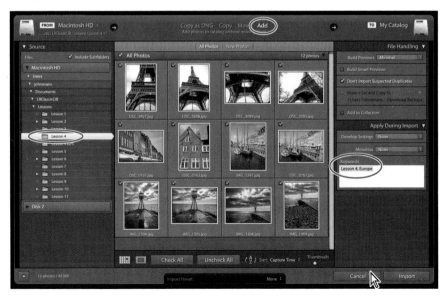

The twelve images are imported from the Lesson 4 folder and now appear in both
the Grid view of the Library module and in the Filmstrip across the bottom of the
Lightroom Classic CC workspace.

Organizing folders

Each time you import an image, Lightroom creates a new catalog entry to record the file's address and lists the folder in which it is stored—and the volume that contains that folder—in the Folders panel in the left panel group.

In the Folders panel, you can organize your photo library at the most basic level by rearranging files and folders on your hard disk without ever leaving the Lightroom Classic CC workspace; you can create or delete folders at the click of a button and move files and folders by simply dragging them.

When you use the Folders panel to move a photo between folders, Lightroom will delete the image file from its original location and update the library catalog with the file's new address. Lightroom maintains a single catalog entry for each photo you import, so a master image cannot be duplicated in separate folders or added to the catalog twice.

Creating subfolders

In this exercise you'll use the Folders panel to begin organizing the photos in the Lesson 4 folder into categories by separating them into subfolders. You'll use two methods of creating a subfolder.

1 Click the Lesson 4 folder in the Folders panel; then, Ctrl-click / Command-click to select the four images of the Eiffel Tower in the Grid view.

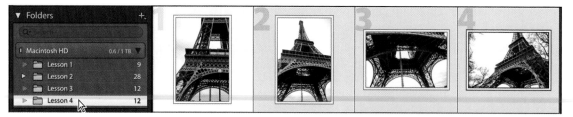

Tip: From the 2018 release of Lightroom Classic CC, you can now mark those folders you work with frequently as Favorites, making it easy to assess them quickly via the Favorite Sources menu in the header of the Filmstrip. Simply right-click / Control-click a folder in the Folders panel and choose Mark Favorite; the folder icon will be marked with a star at the lower right.

2 In the Folders panel header, click the Create New Folder button (⊕) and choose Add Subfolder from the menu. Make sure the Show Photos In Subfolders option is activated.

3 In the Create Folder dialog box, type **Architecture** as the name for the new subfolder, activate the option Include Selected Photos, and then click Create.

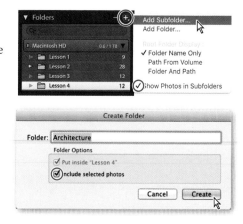

4 In the Folders panel, expand the Lesson 4 folder to see the Architecture folder nested inside. The image count for the new subfolder shows that it contains the four images that you selected in step 1.

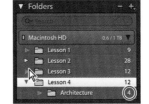

5 With the Lesson 4 folder still selected in the Folders panel, select the remaining eight images.

6 Right-click / Control-click the Lesson 4 folder and choose Create Folder inside "Lesson 4" from the context menu. Type **Vacation** as the folder name, activate the Include Selected Photos option, and then click Create. Click the Vacation subfolder to see the eight images you selected in step 5.

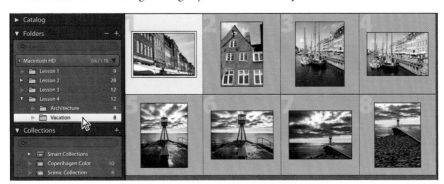

> **Tip:** As your catalog grows, the Folders panel can become more and more difficult to navigate. Managing your folders may help to an extent, but when you need to find a folder quickly, you can type its name in the Folders panel search box, right below the panel header.

Making changes to a folder's content

When you rearrange files and folders in the Folders panel the changes are also made on your hard disk. Inversely, the Folders panel needs to be updated to reflect any changes you make to the location, name, or contents of a folder from outside the Lightroom Classic CC workspace. In this exercise you'll experience this first hand by deleting an image in Windows Explorer / the Finder.

1 Click the Lesson 4 folder in the Folders panel. Right-click / Ctrl-click any of the photos of the Eiffel Tower in the Grid view or the Filmstrip, and then choose Show In Explorer /Show In Finder from the context menu.

> **Tip:** To rename a folder in the Folders panel, right-click / Control-click its name and choose Rename from the context menu. Be aware that when you rename a folder in the Folders panel, the change affects the folder on the hard disk.

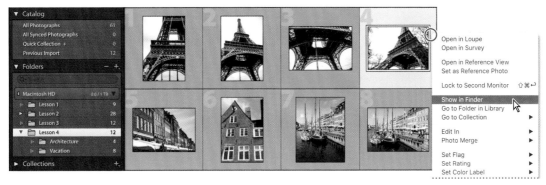

2 The Explorer / Finder window opens. Note the Architecture and Vacation subfolders inside the Lesson 4 folder. Right-click / Ctrl-click the image file DSC_3899.jpg inside the Lesson 4 folder and choose Delete / Move To Trash from the context menu.

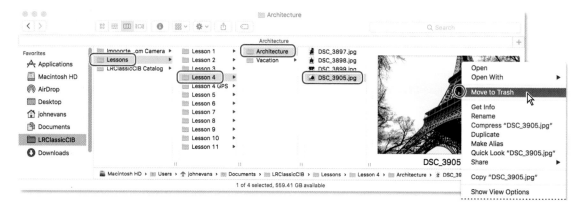

3 Switch back to Lightroom Classic CC. In the Grid view, the thumbnail of the image that you deleted in the Explorer / Finder window now has an alert badge in the upper right corner of its grid cell. This indicates that there is still an entry for the image in the library catalog but the link to the original file is broken. When the image is selected, the missing photo alert also appears below the Histogram.

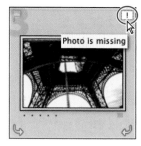

4 Click the missing photo badge. A dialog box opens offering you the option to locate the missing file and reestablish its link to the catalog. Click Cancel.

As you deleted the file intentionally you should now remove it from the library catalog. You can remove a missing photo from your catalog by selecting its thumbnail in the Grid view or the Filmstrip and pressing Alt+Backspace / Option+Delete or by choosing Photo > Remove Photo From Catalog. Don't remove the photo from the catalog yet—if you've done so already, choose Edit > Undo Remove Photo From Catalog. In the next exercise you'll learn a different technique for updating the catalog by synchronizing folders.

Synchronizing folders

When you synchronize the folders in the Lightroom Classic CC catalog with the folders on your hard disk you have the option to remove catalog entries for files that have been deleted, import photos that have been added to your folders, or scan for files with updated metadata.

You can specify which folders and subfolders will be synchronized and which new images you want added to your library.

1 Make sure that the Lesson 4 folder is still selected in the Folders panel.

2 Choose Library > Synchronize Folder.

3 In the Synchronize Folder "Lesson 4" dialog box, the import options are unavailable, indicating that there have been no new photos added to the Lesson 4 folder. Activate the option Remove Missing Photos From Catalog (1), disable Scan For Metadata Updates, and then click Synchronize.

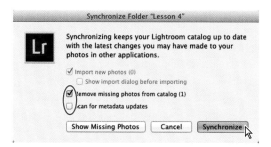

Tip: The Import New Photos option in the Synchronize Folders dialog box automatically imports any files that have been added to a folder without yet having been added to your image library. Optionally, activate Show Import Dialog Before Importing to choose which of those files you wish to import. Activate the Scan For Metadata Updates option to check for files with metadata modified in another application.

The missing image is removed from your catalog and its thumbnail is no longer displayed in the Grid view; all the remaining links between your library catalog and the Lesson 4 folder on your hard disk have been restored.

Using collections to organize images

Although an organized system of folders provides a good foundation for your photo library, grouping images into collections is a far more efficient and flexible way to classify your images—and offers many more options when you need to find them.

A collection is like a *virtual* folder: a grouping of photos from your library based on your own associations rather than on the actual location of the files. A collection may contain images drawn from any number of separate folders on your hard disk. Inversely, a single master image can be included in any number of collections; the same photo might appear in a collection of images with architectural content, a compilation of shots with an Autumn theme, a collection you've assembled for a client presentation, and another created for a vacation slideshow. Grouping images as collections in your library doesn't affect the files and folders on your hard disk, and removing a photo from a collection won't remove it from the library catalog.

Note: Once you've grouped a selection of photos as a collection you can rearrange them in the Grid view or the Filmstrip, changing the order in which they will appear in a presentation or a print layout. Your customized sorting order will be saved with the collection.

There are three basic types of collection: Collections, Smart Collections and the Quick Collection. Any collection can also be part of an Output Collection—a collection that is created automatically when you save a print layout or a creative project such as a photo book or web gallery, linking a set of images to a particular project template, together with all of your customized settings. Any collection can also become a Publish collection, which automatically keeps track of images that you've shared via an online service, or be synced to Lightroom CC on your mobile device via Adobe Creative Cloud.

Tip: You'll learn more about Publish collections in Lesson 10, "Publishing Your Photos." Syncing collections is discussed a little later in this lesson.

The Quick Collection

Note: If the Thumbnail Badges option is activated in the Library View Options, a photo that is included in a collection of any kind displays the collection badge () in the lower right of its thumbnail.

Photo is in collection

Click the badge to see a menu listing the collections in which the image is included. Select a collection from the list to designate that collection as the image source folder.

The Quick Collection is a temporary holding collection; a convenient place to assemble a group of images while you gather photos from different folders. You can access the Quick Collection from the Catalog panel so that you can easily return to work with the same selection of images at any time. Your images will stay in the Quick Collection until you are ready to convert your selection to a permanent collection that will then be listed in the Collections panel.

You can create as many collections and smart collections as you wish, but there is only one Quick Collection; if there is already a selection of images in the Quick Collection, you'll need to convert it to a standard collection, and then clear the Quick Collection before you can use it to assemble a new grouping. To create a new collection for images that are currently in the Quick Collection, right-click / Control-click the Quick Collection folder in the Catalog panel and choose Save Quick Collection from the context menu.

If the Quick Collection Markers option is enabled in the View Options for the Grid view, a circular marker appears in the top right corner of a thumbnail in the Grid view or the Filmstrip when you move your pointer over the image cell. You can add the image to the Quick Collection by clicking this marker.

Once the photo is added to the Quick Collection the marker becomes a solid grey circle. Click the solid marker to remove the image from the Quick Collection. You can select multiple images and perform the same operations for the whole group by clicking the Quick Collection marker on any of the selected thumbnails.

You can also add a selected image or group of images to the Quick Collection by pressing the B key or choosing Photo > Add To Quick Collection, or remove a selected image or group of images from the Quick Collection by pressing the B key again or choosing Photo > Remove From Quick Collection.

Collections

You can create as many permanent collections as you wish. Use a collection to collate the images you need for a particular project or to group photos by subject or any other association.

When you create a collection of images for a slideshow or a web page, all the work you do on your presentation will be saved with the collection in the catalog file. In fact, the catalog entry for a single collection can incorporate your settings from the Develop module, a slide layout and playback options from the Slideshow module, designs you set up in the Book and Web modules, and a page layout modified

in the Print module. Output collections for print jobs will also include your color management and printer settings.

To create a collection, choose Library > New Collection. Alternatively, click the New Collection button (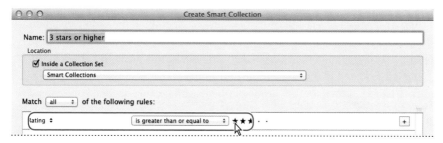) in the header of the Collections panel and choose Create Collection from the menu. Enter a name for the collection and click Create. Your new collection will be listed in the Collections panel; you can then simply drag photos onto the listing in the Collections panel to add them to the collection.

Note: Remember that a single photo can be included in any number of collections, although the master image file is located in only one folder in your library. For this reason, grouping your images in collections is a far more versatile organizational method than sorting them into categorized folders.

Smart collections

A smart collection searches the metadata attached to your photos and gathers together all those images in your library that meet a specified set of criteria. Any newly imported photo that matches the criteria you've set up for a smart collection will be added to that collection automatically.

You can create a Smart Collection by choosing Library > New Smart Collection, and then specify the search criteria for your smart collection by choosing options from the menus in the Create Smart Collection dialog box.

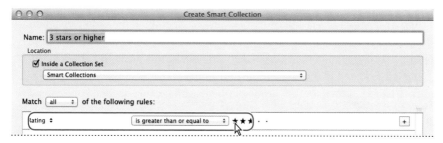

You can add more search criteria by clicking the + button to the right of any of the rules. Hold down the Alt / Option key and click the Plus button (+) to refine a rule. In the illustration below a second rule has been added to search for images containing "Europe" in any searchable text, and then a refined rule has been added to search for images which were either captured or edited this year.

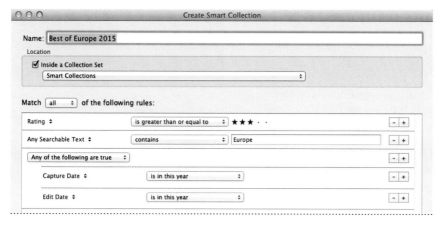

Taking your collections on the road

Lightroom Classic CC enables you to sync photo collections between your desktop computer and your mobile devices so that you can access, organize, edit, and share your photos anywhere, anytime. Whether you're working in Lightroom on your desktop or on your iPad, iPhone, or Android device, any changes you make to photos in a synced collection will be automatically updated on the other device.

Setting up to go mobile

Lightroom CC will let you sync from only one catalog, so you can start by creating a personal catalog rather than syncing your LRClassicCIB Catalog.

1 If you already have a personal catalog, load it now; if you have not already established a personal catalog, do so now (File > New Catalog).

There are no lesson images provided for this section; you'll need to import a selection of your own photos. Lightroom Classic CC syncs designated collections from your desktop catalog, rather than individual images or folders, so you'll also need to create at least one collection to work with.

2 Import the photos you'd like to sync. Make a selection in the Grid view; then, click the plus sign (+) at the right of the Collections panel header and choose Create Collection. In the Create Collection dialog box, make sure the option Include Selected Photos is checked and all the other options are disabled; then, click Create. Select another group of photos and create a second collection.

3 Install Lightroom CC for mobile on your device. You can download the app free from iTunes or the Apple App Store (iPad and iPhone), or from Google play (Android), on a trial basis; then, choose a subscription plan later if necessary.

Syncing photos from Lightroom Classic CC

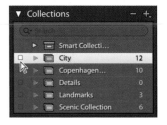

● **Note:** This exercise assumes that you have already signed in to Lightroom Classic CC with your Adobe ID. If you have not yet signed in, you'll need to do so before you begin; choose Help > Sign In.

1 Move the pointer over your name in the identity plate at the upper left of the workspace. Click the small white triangle to open the Activity Center menu, and then choose Sync With Lightroom CC.

2 In the Collections panel, click the empty checkbox at the left of the name of one of your new collections to sync it to Lightroom CC. If the Share Your Synced Collections tip appears, dismiss it for now.

3 A syncing progress notification appears at the upper left; in the Collections panel, the empty checkbox is replaced by a two-way arrow icon indicating that the collection is synced. Repeat the process for your other collection(s).

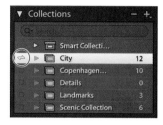

Tip: You can disable syncing for a mobile collection by clicking the two-way arrow sync icon next to the name of the collection in the Collections panel or by right-clicking / Control-clicking the collection and un-checking Sync With Lightroom CC in the context menu.

You can also sync an existing collection by right-clicking / Control-clicking the collection name and choosing Sync With Lightroom CC from the context menu. When you create a new collection with syncing activated, you'll find a Sync With Lightroom CC option in the Create Collection dialog box.

4 Expand the Catalog panel, if necessary; a new All Synced Photographs entry in the Catalog panel shows an image count for your synced photos. In the Grid view, the thumbnails of synced photos show a two-way arrow badge in the upper right corner of the image cell.

Viewing synced photos on your mobile device

1 On your mobile device, tap the Lightroom CC app icon; then, sign in to Lightroom CC for mobile with your Adobe ID, Facebook, or Google.

The first screen you'll see is the Albums view, which lists the collections you've synced from your desktop, as well as those you may create in Lightroom CC mobile, and also offers an All Photos view where you can browse all your synced images.

2 Tap with two fingers to show extra information about the albums in the list.

You can create a new album by tapping the plus-sign icon (+) at the right of the Albums header, or set options for an album by tapping the three dots (…) at the right of its list entry. Album options include adding photos from your device's camera roll, enabling Auto Add so that new photos captured with your device will be added automatically, and various management and sharing options.

3 In the Albums view, tap All Photos to see all of your synced photos. Tap the three dots (...) at the right of the header and choose Grid View > Segmented.

4 Tap the Back button (<) at the upper left to return to the Albums view. Tap one of your synced albums to see its contents in Grid view. Tap the three dots (...) to access view actions and settings; then, try the sorting options. Tap the Grid view with two fingers to cycle metadata information for each photo in the album.

Note: You'll learn about editing your photos in Lightroom CC for mobile in Lesson 5, Developing Basics, and how to share collections via Lightroom CC on the web in Lesson 10, Publishing Your Photos.

5 On your desktop computer, choose File > Open Recent > LRClassicCIB Catalog.

Stacking images

Another effective way of organizing images within a folder or collection is by creating stacks.

Stacks are ideal for reducing clutter in the Grid view—and the number of thumbnails you need to scroll through in the Filmstrip—by grouping similar or related photos so that only the top image in each stack is displayed. You can stack a selection of images of the same subject, a series of photos shot to test different camera settings, or action shots taken using burst mode or auto-bracketing.

A stack can be identified in the Grid view and the Filmstrip by an icon representing a stack of photos, together with an image count, in the upper left corner of the thumbnail.

You can expand or collapse the stack by clicking the stack icon; rearrange the order of the photos within the stack or specify which image appears at the top either by choosing commands from the Photo > Stacking menu or by using keyboard shortcuts.

When you're working with a folder containing hundreds of photos from the same shoot, you can have Lightroom stack the images automatically based on capture time; you can specify the time interval between stacks so that your shots are grouped in a way that reflects the flow of the shoot.

To create a stack, select two or more images in the Grid view or the Filmstrip, and then choose Photo > Stacking > Group Into Stack.

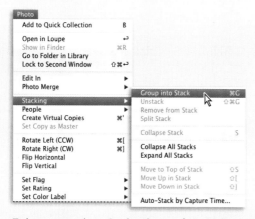

To learn more about Stacks, please refer to Lightroom Classic CC Help.

Applying keyword tags

Perhaps the most direct way to mark your photos so that they're easier to find later is by tagging them with keywords—text metadata attached to the image files to categorize them by subject or association.

For example, the image in the illustration at the right could be tagged with the keywords Vacation, Copenhagen, and Seaside, and could therefore be located by searching for any combination of one or more of those tags. If the Thumbnail Badges option is activated in the Library View Options dialog box, photos with keyword tags are identified by a keywords badge (🔳) at the lower right of the thumbnail.

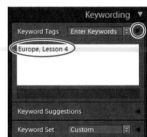

Photo has keywords

You can apply keywords to your photos individually or tag an entire series of images with shared metadata in one operation, thereby linking them by association and making them easier to access amongst all the photos that make up your library. Keywords added to images in Lightroom can be read by Adobe applications such as Bridge, Photoshop, and Photoshop Elements, and by other applications that support XMP metadata.

Viewing keyword tags

Because you applied keyword tags to the images for this lesson during the import process, the thumbnails in the Grid view and the Filmstrip are all marked with the keywords badge. Let's review the keywords you already attached to these photos.

1 Make sure that you are still in the Grid view, and then select the Lesson 4 folder in the Folders panel.

▶ **Tip:** Clicking the keyword badge of an image in Grid view will automatically expand the Keywording panel.

2 Show the right panel group, if necessary; then, expand the Keywording panel. Expand the Keyword Tags pane at the top of the panel. By selecting each thumbnail in the Grid view in turn you can confirm that all of the images in the Lesson 4 folder share the keywords "Lesson 4" and "Europe."

3 Select any one of the photos in the Lesson 4 folder. In the Keyword Tags pane at the top of the Keywording pane, select the text "Lesson 4" and press the Backspace key on your keyboard to delete it.

4 Click anywhere in the Grid view, and then choose Edit > Select All or press Ctrl+A / Command+A to select all the Lesson 4 photos. In the Keyword Tags pane, the keyword "Lesson 4" is now marked with an asterisk to indicate that this tag is not shared by every image in the selection.

5 Expand the Keyword List panel.

In the Keyword List, a check mark in front of the keyword "Europe" indicates that this tag is shared by every image in the selection, while the tag "Lesson 4" is marked with a dash—indicating that it attached to some, but not all, of the selected images. The image count to the right of the Lesson 4 tag shows that it is shared by only ten of the eleven images.

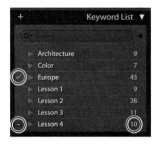

▶ **Tip:** You can apply an existing keyword tag to selected images by clicking the tag in the Keyword Suggestions pane in the Keywording panel. To remove a tag from a selected photo or photos, either delete the word from the Keyword Tags pane in the Keywording panel, or click the checkbox to disable that keyword in the Keyword List panel.

6 With all eleven images still selected, click the dash mark in front of the Lesson 4 tag to reinstate the deleted tag; a check mark replaces the dash and the image count for the Lesson 4 keyword increases to 11.

Adding keyword tags

You already added keywords to your images during the process of importing them into your Lightroom library. Once the images have been added to your Lightroom library, you can add more keywords by using the Keywording panel.

1 In the Folders panel, select the Vacation subfolder inside the Lesson 4 folder, and then choose Edit > Select All or press Ctrl+A / Command+A.

2 In the Keywording panel, click in the grey text box right above the Keyword Suggestions pane and type **Copenhagen, Denmark**. Make sure to separate the words with a comma as shown in the illustration at the right, below.

● **Note:** Always use a comma to separate keywords; words separated by a space (Copenhagen Denmark) or by a period (Copenhagen. Denmark) will be treated as a single keyword.

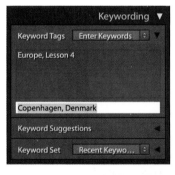

3 Press Enter / Return. The new keywords are listed in alphabetical order in the Keywording panel and in the Keyword List.

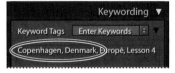

4 In the Folders panel, select the Lesson 4 folder, and then choose Edit > Invert Selection to select all the images other than the eight in the Vacation folder.

5 In the Keywording panel, click in the text box below the Keyword Tags pane and type **France**. Press Enter / Return.

6 Choose Edit > Select None or press Ctrl+D / Command+D on your keyboard.

Working with keyword sets and nesting keywords

▶ **Tip:** Keyword sets are a convenient way to have the keywords you need at hand as you work on different collections in your library. A single keyword tag may be included in any number of keyword sets. If you don't see the Lightroom presets in the Keyword Set menu, open the Lightroom Preferences and click the Presets tab. In the Lightroom Defaults options, click Restore Keyword Set Presets.

You can use the Keyword Set pane in the Keywording panel to work with *keyword sets*; groups of keywords compiled for a particular purpose. You could create a set of keywords for a specific project, another set for a special occasion, and one for your friends and family. Lightroom Classic CC provides three basic keyword set presets. You can use these sets as they are or as starting points for creating sets of your own.

1 Expand the Keyword Set pane in the Keywording panel, if necessary, and then choose Wedding Photography from the Keyword Set menu. You can see that the keywords in the set would indeed be helpful in organizing the shots from a big event. Look at the categories covered by the other Lightroom keyword sets. You can use these as templates for your own keyword sets by editing them to suit your needs and saving your changes as a new preset.

Grouping your keywords in Keyword Sets is one way to keep your keywords organized; another handy technique is to nest related tags in a keywords hierarchy.

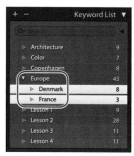

2 Ctrl-click / Command-click to select the keywords "Denmark" and "France" in the Keyword List panel; then, drag the selected tags onto the keyword "Europe." The Europe expands automatically to show the Denmark and France tags nested inside.

3 In the keyword list, drag the Copenhagen tag onto the keyword "Denmark." The Denmark tag expands to show the nested Copenhagen tag.

4 Right-click / Control-click the keyword "France" and choose Create Keyword Tag Inside "France" from the context menu.

5 In the Keyword Name text box, type **Paris**. Make sure the first three Keyword Tag Options are activated as shown in the illustration below; then, click Create.

Include On Export Includes the keyword tag when your photos are exported.

Export Containing Keywords Includes the parent tag when your photos are exported.

Export Synonyms Includes any synonyms associated with the keyword tag when your photos are exported.

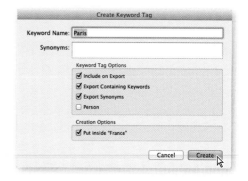

6 Expand the France tag; then, right-click / Control-click the keyword "Paris" and choose Create Keyword Tag Inside "Paris" from the menu. Type **Eiffel Tower**; then, click Create. Expand the Paris tag to show all the tags in the hierarchy.

7 In the Folders panel, select the Lesson 4 \ Architecture folder, and then choose Edit > Select All or press Ctrl+A / Command+A. Drag the Paris and Eiffel Tower tags from the Keyword List onto any of the selected images in the Grid view.

In the Keyword List, check marks in front of the new Paris and Eiffel Tower tags, and the image count to the right of each entry, indicate that both keyword tags have been applied to all three selected photos.

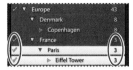

8 In the Folders panel, select the Lesson 2 folder. If you see more than nine images in the Grid view, disable the menu option Library > Show Photos In Subfolders. Choose Edit > Select All or press Ctrl+A / Command+A. Move the pointer over the Denmark tag in the Keyword List, and then click the empty check box to the left. Press Ctrl+D / Command+D or choose Edit > Select None; then, select all but the four farmhouse interiors. Drag the keyword "Copenhagen" onto any of the five selected images.

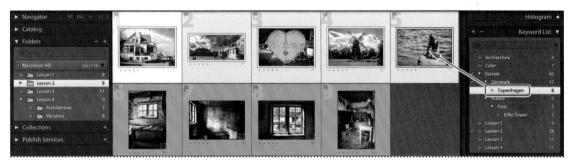

9 In the Folders panel, select the Lesson 1 folder. Select all nine images and drag the Denmark tag from the Keyword list onto any of the selected photos.

Searching by keywords

Once you've taken the time to organize your images by adding keywords and other metadata such as ratings, flags, and labels, it will be easy to set up sophisticated and detailed filters to find exactly the photo you're looking for.

For now, we'll look at some techniques for finding the photos in your library by searching (or filtering) for keywords alone.

1 Choose Library > Show Photos In Subfolders. In the left panel group, collapse other panels if necessary, so that you can clearly see the contents of the Catalog and Folders Panels. In the Folders panel, select the Lesson 4 folder, and then choose Edit > Select None or press Ctrl+D / Command+D.

2 Use the Thumbnails slider in the Toolbar to reduce the size of the thumbnails to the minimum, so that you'll be able to see as many images as possible in the Grid view. If the Filter Bar is not already visible above the Grid view, choose View > Show Filter Bar, or press the Backslash key (\).

> **Tip:** If you find that you cannot have two panels open at the same time in either of the side panel groups, right-click / Control-click the header of any panel in the group and disable the Solo Mode option in the context menu.

3 In the right panel group, collapse other panels if necessary, so that you can see the contents of the expanded Keyword List panel.

4 In the Keyword List panel, move your pointer over the entry for the keyword "Europe," and then click the white arrow that appears to the right of the image count. Press Ctrl+D / Command+D or choose Edit > Select None.

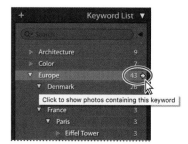

In the left panel group, All Photographs is now selected in the Catalog panel, indicating that your entire catalog has been searched for photos with the Europe tag.

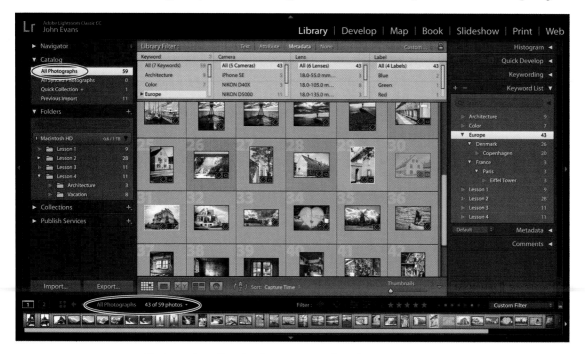

▶ **Tip:** To transfer lists of keywords between computers or share them with colleagues who are also working in Lightroom, use the Export Keywords and Import Keywords commands, which you'll find in the Metadata menu.

The Metadata filter has been activated in the Filter bar at the top of the work area, and the Grid view now displays only those images in your library that are tagged with the keyword "Europe."

5 In the Keyword column at the left of the Metadata filter pane, expand the Europe entry; then, click the nested Denmark tag.

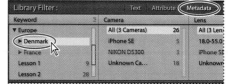

The images in the Grid view are filtered so that only the 26 photos with the Denmark tag are still visible. Now you'll use a different technique to narrow the search further.

6 Click Text in the Filter Picker in the Filter bar at the top of the work area. In the Text filter bar, choose Any Searchable Field from the first menu and Contains from the second menu, noting the options available in each menu; then type **Copenhagen** in the text box at the right and press Enter.

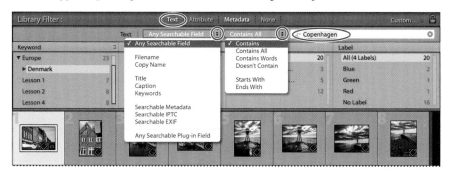

▶ **Tip:** You can use the lock button at the right end of the Filter bar to keep your current filter settings active when you choose a different image source from the Catalog, Folders, or Collections panels.

Only twenty photos are still visible in the Grid view—not only those tagged with the Copenhagen keyword, but also those from the Copenhagen Color collection you created in Lesson 1. Of course, the true power of the Library filters only comes into play when you set up more complex filters based on a combination of criteria, but this exercise should have given you at least a glimpse of the possibilities.

7 In the center of the filter bar, click None in the filter picker to deactivate the combined Text and Metadata filter. In the Folders panel, select the Lesson 4 folder, and then choose Edit > Select None or press Ctrl+D / Command+D.

Using flags and ratings

The Attribute filters in the Filter bar allow you to search and sort your images according to attributes such as flags and ratings.

When you choose Attribute from the Library Filter options in the Filter bar, the Filter bar expands to display controls for sorting your images by flag status, edit status, star rating, color label, copy status, or any combination of these attributes.

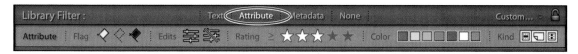

Flagging images

Assigning flags to sort the good images from the rejects can be a good way to begin organizing a group of photos. An image can be flagged as a pick (⚐), a reject (⌧), or left unflagged (⚐).

1 Choose Attribute from the picker in the Filter bar. The Filter bar expands to show the Attribute filter controls.

▶ **Tip:** In the Grid and Loupe views, you'll find tools for adding ratings, flags, and color labels in the Toolbar. In the Compare and Survey views you can change these attributes using the controls beneath the images. You can also flag, rate, or color label a selected image by using the Set Flag, Set Rating, or Set Color Label commands in the Photo menu.

2 If the Toolbar is not already visible below the Grid view, press the T key. Click the triangle at the right side of the Toolbar and activate the Flagging tool in the menu to show the Flag As Pick and Set As Rejected buttons in the Toolbar.

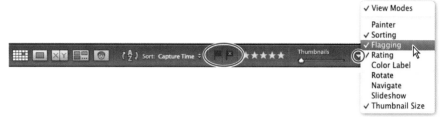

3 In the Folders panel, select the Vacation subfolder inside the Lesson 4 folder.

4 In the Grid view, select a favorite from this group of photos captured on vacation in Copenhagen. If the Flags option is activated in the Library View Options dialog box, a grey (un-filled) flag icon in the upper left corner of the image cell indicates that this photo is not flagged. If necessary, hold the pointer over the image cell to see the flag, or disable the option Show Clickable Items On Mouse Over Only in the Library View Options dialog box.

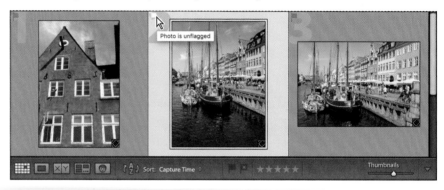

5 To change the flag status to Flagged, you can either click the flag badge in the image cell or the Flag As Pick button (⚐) in the Toolbar. Note that the photo is now marked with a white flag icon in the upper left corner of the image cell.

6 Click the white flag button in the Attribute Filter bar. The Grid view displays only the image that you just flagged. The view is now filtered to display only flagged images from the Vacation folder.

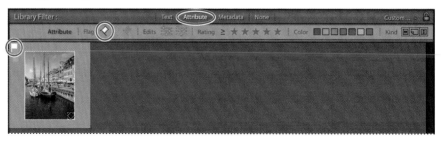

Lightroom Classic CC offers a variety of ways to flag a photo. To flag a photo as a pick, choose Photo > Set Flag > Flagged or press the P key on your keyboard. Click the flag icon at the top left corner of the image cell to toggle between Unflagged and Pick status. To flag an image as a reject, choose Photo > Set Flag > Rejected, press the X key, or Alt-click / Option-click the flag icon in the corner of the image cell. To remove a flag from an image, choose Photo > Set Flag > Unflagged or press the U key. To set any flag status for an image, right-click / Control-click the flag icon in the corner of the image cell and choose Flagged, Unflagged, or Rejected from the menu.

Tip: You can use the Library > Refine Photos command to sort your photos quickly on the basis of their flagging status. Choose Library > Refine Photos, and then click Refine in the Refine Photos dialog box; any unflagged photos are flagged as rejects and the picks are reset to unflagged status.

7 Click the grey flag button (the flag in the center) in the Attribute Filter bar. The Grid view now displays any photos flagged as Picks and all unflagged photos, so once again we see all of the images in the Vacation folder.

8 In the Filter bar, click None to disable the Attribute filters.

Assigning ratings

A quick and easy way to sort your images as you review and evaluate them is to assign each photo a rating on a scale from one to five stars.

1 In the Grid view, select another of the photos in the Vacation folder.

2 Press the 3 key on your keyboard. The message "Set Rating to 3" appears briefly and the photo is now marked with three stars in the lower left of its image cell.

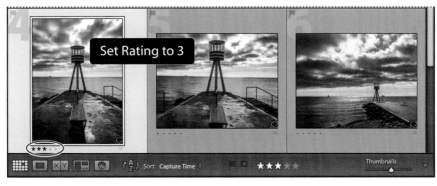

Tip: If you don't see the star rating in the image cell, choose View > View Options and make sure Rating And Label is activated in the image cell display options.

3 If necessary, click the triangle at the right of the Toolbar and make sure that the Rating controls are activated in the menu. The stars in the Toolbar reflect the rating you just applied to the selected image.

4 In the Folders panel, select the Architecture folder, and then use the same technique to assign a rating of three or more stars to one of the Eiffel Tower images. Click in the Folders panel to reset the Vacation folder as the image source.

It's easy to change the rating for a selected image; simply press another key between 1 and 5 to apply a new rating or press the 0 key to remove the rating altogether. Alternatively, you can click the stars in the Toolbar to change the rating, or click the highest star in the current rating to remove it.

Tip: You can also assign ratings in the Metadata panel, by choosing from the Photo > Set Rating menu, or by choosing from the Set Rating submenu in the context menu when you right-click / Control-click a photo's thumbnail.

Working with color labels

Color labeling can be a very versatile tool for organizing your workflow. Unlike flags and ratings, color labels have no predefined meanings; you can attach your own meaning to each color and customize separate label sets for specific tasks.

While setting up a print job you might assign the red label to images you wish to proof, a blue label to those that need retouching, or a green label to mark images as approved. For another project, you might use the different colors to indicate levels of urgency.

Applying color labels

You can use the colored buttons in the Toolbar to assign color labels to your images. If you don't see the color label buttons, click the triangle at the right of the Toolbar and choose Color Label from the menu. You can also click the color label icon displayed in a photo's image cell (a small grey rectangle, for an unlabeled image) and choose from the menu. Alternatively, choose Photo > Set Color Label and choose from the menu; you'll notice that four of the five color labels have keyboard shortcuts.

To see—and set—color labels in the Grid view image cells, choose View > View Options or right-click / Control-click any of the thumbnails and choose View Options from the context menu to open the Library View Options dialog box. On the Grid View tab in the Library View Options dialog box, activate Show Grid Extras. In the Compact Cell Extras options, you can choose Label or Rating And Label from either the Bottom Label or Top Label menus. In the Expanded Cell Extras options, activate the Include Color Label checkbox.

Editing color labels and using color label sets

You can rename the color labels to suit your own purposes and create separate label sets tailored to different parts of your workflow. The Lightroom default options in the Photo > Set Color Label menu are Red, Yellow, Green, Blue, Purple, and None. You can change the color label set by choosing Metadata > Color Label Set, and then choosing either the Bridge or Lightroom default sets, or the Review Status set.

The Review Status label set gives you an idea of how you might assign your own label names to help you keep organized. The options in the Review Status set are To Delete, Color Correction Needed, Good To Use, Retouching Needed, To Print, and None.

You can use this label set as it is or as a starting point for creating your own sets. To open the Edit Color Label Set dialog box, choose Metadata > Color Label Set > Edit. You can enter your own name for each color, and then choose Save Current Settings As New Preset from the Presets menu.

Searching by color label

In the Filter bar, click Attribute to see the Attribute filter controls. You can limit your search to a single color label by clicking just one button, or activate more than one button at once. To disable an active color label button, simply click it again. You can use the color label search buttons together with other Attribute filters, or to refine a Text or Metadata search.

The Attribute filters, including the color label filters, are also available in the bar above the thumbnails in the Filmstrip.

Adding metadata

You can leverage the metadata information attached to the image files to help you organize and manage your photo library. Much of the metadata, such as capture date, exposure time, focal length and other camera settings, is generated by your camera, but you can also add your own metadata to make it easier to search and sort your catalog. In fact, you did just that when you applied keywords, ratings, and color labels to your images. In addition, Lightroom supports the information standards evolved by the International Press Telecommunications Council (IPTC), which includes entries for descriptions, keywords, categories, credits, and origins.

You can use the Metadata panel in the right panel group to inspect or edit the metadata attached to a selected image.

1 In the Grid view, select another photo from the Vacation folder.

2 Expand the Metadata panel. If necessary, hide the Filmstrip or collapse the other panels in the right panel group so that you can see as much of the Metadata panel as possible. Choose Default from the Metadata Set menu in the header of the Metadata panel.

Even the default metadata set exposes a great deal of information about the image. Although most of this metadata was generated by the camera, some of it can be very useful in sorting your photos; you could filter images by capture date, search for shots taken with a particular lens, or easily separate photos taken on different cameras. However, the default set displays only a subset of an image's metadata.

3 Choose EXIF And IPTC from the Metadata Set menu in header of the Metadata panel. Scroll down in the Metadata panel to get an idea of the kinds of information that can be applied to an image.

4 For the purposes of this exercise, you can choose Quick Describe from the Metadata Set menu.

In the Quick Describe metadata set, the Metadata panel shows the File-name, Copy Name (for a virtual copy), Folder, Rating, and some EXIF and IPTC metadata. You can use the Metadata panel to add a title and caption to a photo, attach a copyright notice, provide details about the photographer and the location where the photo was shot, and also change the star rating.

5 Click in the Metadata panel to assign the image a rating of three or more stars; then, type **Nyhavn 1** in the Title text box and press Enter / Return.

 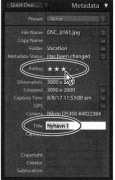

6 Control-click / Command-click any of the other seven vacation photos to add it to the selection. In the Metadata panel you can see that the folder name, dimensions and the camera model are shared by both files; items not shared by both images now show the entry <mixed>. Changes made to any of the items in the metadata panel, even those with mixed values, will affect both of the selected images. This is a convenient way to edit items such as copyright details for a whole batch of selected images at the same time.

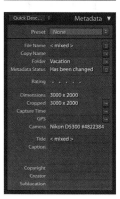

Storage of metadata

File information is stored using the Extensible Metadata Platform (XMP) standard. XMP is built on XML. In the case of camera raw files that have a proprietary file format, XMP isn't written into the original files. To avoid file corruption, XMP metadata is stored in a separate file called a sidecar file. For all other file formats supported by Lightroom (JPEG, TIFF, PSD, and DNG), XMP metadata is written into the files in the location specified for that data.

XMP facilitates the exchange of metadata between Adobe applications and across publishing workflows. For example, you can save metadata from one file as a template, and then import the metadata into other files. Metadata that is stored in other formats, such as EXIF, IPTC (IIM), and TIFF, is synchronized and described with XMP so that it can be more easily viewed and managed. To find out more about Metadata, please refer to Lightroom Classic CC Help.

—From Lightroom Classic CC Help

Tagging faces in the People view

Undoubtedly, your growing photo library will include many photos of your family, friends, and colleagues. Lightroom Classic CC makes it quick and easy to tag the people that mean the most to you, taking much of the work out of sorting and organizing what probably amounts to a large portion of your catalog, and making it even easier to retrieve exactthe photos you're looking for.

Face recognition automatically finds the people in your photos and makes it simple for you to tag them; the more faces you tag, the more Lightroom Classic CC learns to recognize the people you've named, automatically tagging their faces whenever they appear in new photos.

There are no lesson images provided for this exercise, so the first thing you need to do is to import some of your own photos.

1 Use either the Import button, or the drag and drop method you learned in Lesson 2, to import a good selection of photos featuring the faces of people you know. Make sure you have a mix of single-person images and groups of various sizes, with plenty of overlap—and at least a few strangers' faces.

Tip: If any of the photos you import has embedded GPS information, the Enable Address Lookup dialog will open. Click Enable.

By default, face recognition is disabled; the next step is have Lightroom analyze your photos and build an index of those images that include faces.

2 In the Catalog panel, change the image source from Previous Import to All Photographs, so that Lightroom Classic CC will index the entire catalog. Press Control+D / Command+D or choose Edit > Select None.

3 Show the toolbar, if necessary (T), and click the People button.

4 Lightroom displays a message screen welcoming you to the People view. Click Start Finding Faces In Entire Catalog. A progress bar appears at the upper left of the workspace and the Activity Center menu opens, with a tip showing you where you can turn face recognition off and on. Wait for the indexing process to complete before moving on.

The work area is now in People view mode. Lightroom Classic CC stacks similar faces for tagging, with an image count for each stack; the default sorting order is alphabetical but, as none of the faces are yet tagged, they are arranged by stack size. At this point, all the faces are listed in the Unnamed People category.

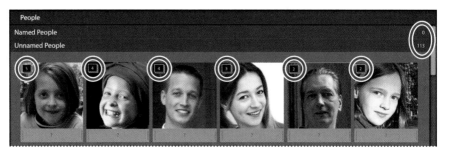

5 Click the stack badge on a people stack to expand it. Multiple-select all of the photos in the stack that belong together; then, click the question mark below a selected thumbnail, type the person's name and press Enter / Return.

Lightroom moves the selected photos into the Named People category, and the image counts in both category headers are updated.

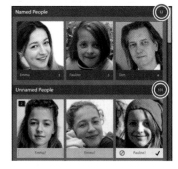

▶ **Tip:** You can also add photos to the Named People groups by simply dragging them directly from the Unnamed People pane.

6 Repeat the process for two or three more unnamed stacks. Already, Lightroom is learning from your input, suggesting more photos that may belong with those you've named. Move the pointer over a suggested name to confirm or dismiss the suggestion.

7 Continue until you've named at least five or six people, and tagged several photos for each; then double-click one of the faces in the Named People stack to enter the Single Person view, where the upper division is now labeled as the Confirmed category, showing all the photos tagged with the selected name. Below, the Similar category displays only the suggested matches for this face.

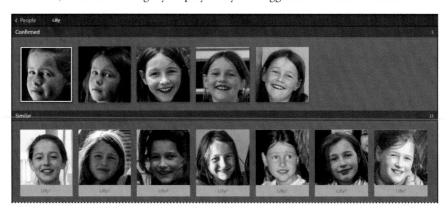

8 Add as many photos as you can to the group in the Single Person view; then, when you're done, click "< People" at the left of the Confirmed header to return to the People view.

9 Repeat the process for all your named people, alternating between the People and Single Person views until the only untagged photos that remain are people you don't know, or image fragments incorrectly identified as faces. Remove these from the Unnamed People list by moving the pointer over each and clicking the X icon that appears at the left of the label.

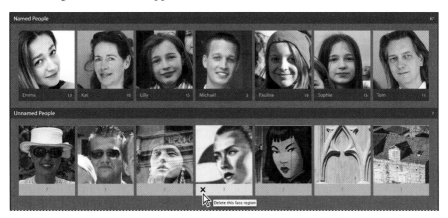

10 Click the Grid view button in the toolbar; then double-click a photo with multiple people to see it enlarged in the Loupe view. Click the Draw Face Region button (■) in the toolbar to see the People tags attached to the image. When you find a face that has not been identified by face recognition, you can use the Draw Face Region tool to drag a box around it, and then enter a name.

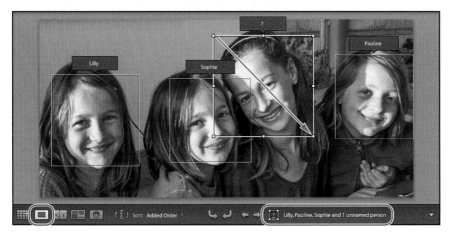

▶ **Tip:** You can quickly isolate your People tags in the Keyword List panel by expanding the filter options at the top of the list of keywords and clicking People.

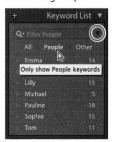

11 Inspect the Keyword List panel to see your new People tags listed with your other keywords. You can use the Keyword List panel or the Text and Metadata filters to search for People tags, just as you'd do for any other keyword.

Organizing photos by location

Note: You need to be online to make use of the Map module.

In the Map module, Lightroom Classic CC enables you to leverage geotagging technology so that you can see exactly where your photos were captured on a Google map, and search and filter the images in your library by location.

Photos that were captured with a camera or phone that records GPS coordinates will appear on the map automatically. You can easily add location metadata to images captured without GPS information by dragging them directly onto the map from the Filmstrip, or by having Lightroom match their capture times to a tracklog exported from a mobile device.

1 In the Library module, click the Import button below the left panel group.

Tip: If GPS address lookup has not yet been enabled for your catalog, you may see a dialog box asking you to authorize Lightroom Classic CC to exchange GPS location information with Google Maps. Click Enable, then click away from the pop-up notification to dismiss it.

2 Under Source at the left of the Import dialog box, navigate to the folder LRClassicCIB \ Lessons \ Lesson 4 GPS. Make sure that both images in the folder are checked for import. Set the import options above the thumbnails to Add, type **Lesson 4, GPS** in the Keywords text box, and then click Import.

3 In the Grid view or the Filmstrip, select the image DSC_0449.jpg—a sculpture commemorating Emily, Washington, and John Roebling, the designers and builders of the Brooklyn Bridge.

4 Click Map in the module picker.

Working in the Map module

Lightroom has automatically plotted the selected photo's location by reading the GPS metadata embedded in the image file; the location is marked by a yellow pin.

Tip: If you don't see the Map Info overlay at the upper right, and the Map Key explaining the color-coding of location pins, choose Show Map Info and Show Map Key from the View Menu.

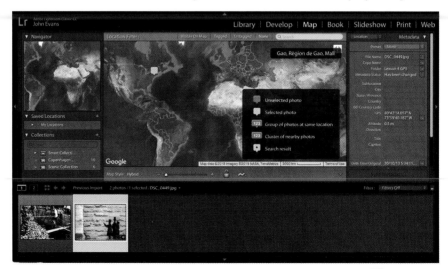

Note: What you see on screen may differ from this illustration, depending on the map style and zoom depth set when you last used the Map module.

1 Dismiss the Map Key by clicking the Close button (x) at the upper right, or by un-checking Show Map Key in the View menu. Right-click / Control-click the map pin and choose Zoom In to focus the map view on that location.

The Navigator panel at the left shows an overview map, with a white rectangle indicating the area visible in the main map view. The Toolbar below the map view offers a Map Style menu, a Zoom slider, and buttons for locking pins and loading GPS tracklogs. The Metadata panel at the right displays embedded location information.

2 Click repeatedly on the Zoom In (+) button at the right of the slider in the Toolbar, until you can see Lower Manhattan and the Brooklyn Bridge. In the Map Style menu, select each of the six styles in turn, then set your preference.

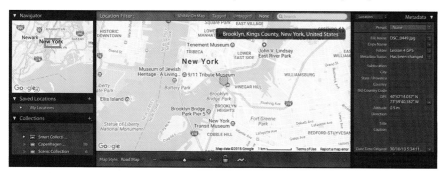

You can drag the map in the main view to reposition it, or move the map's focus by dragging the white-bordered box in the Navigator. Hold down the Alt / Option key and drag a rectangle in the main map view to zoom in to that area.

The Location Filter bar above the map lets you highlight just those photos captured at locations currently visible on the map or filter for tagged or untagged shots.

3 Click each of the four filters in the Location Filter bar in turn, noting the effect on which images are displayed in the Filmstrip.

In the Filmstrip and the Library module's Grid view, images that have been tagged with a GPS location are marked with a location marker badge (▣).

Photo has GPS coordinates

▶ **Tip:** Click the location marker badge on a thumbnail in the Library module's Grid view or the Filmstrip to zoom in to the image's location in Map view.

Geotagging images captured without GPS data

Even if your camera does not record GPS data, the Map module makes it easy to tag your photos with map locations.

1 In the header of the Filmstrip, click the white arrow to the right of the name of the currently selected image and choose Folder - Lesson 4 from the Recent Sources list in the menu. Select the three photos of the Eiffel Tower.

2 In the search box in the Filter bar, type **Eiffel Tower**; then, press Enter / Return.

The map is redrawn and the new location is marked with a Search Result marker.

▶ **Tip:** To check if a photo selected in the Library has GPS metadata, choose the Location preset in the Metadata panel; then, look for coordinates in the GPS field.

3 Clear the Search Result marker by clicking the X button at the right of the text search box in the Location Filter bar.

4 Right-click / Control-click the found location on the map and choose Add GPS Coordinates To Selected Photos.

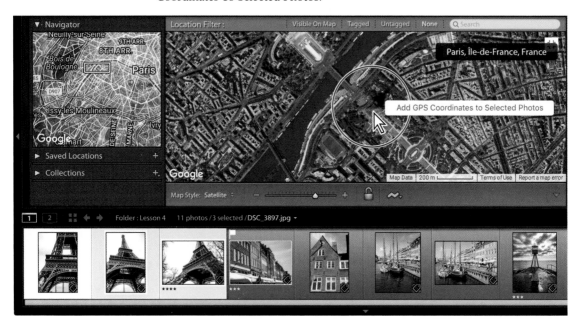

5 Choose Edit > Select None. Move the pointer over the marker pin on the map to see a preview of the photos captured at that location. Click the marker pin to select the photos attached to that location. Click the white arrows at the sides of the preview thumbnail to cycle through the other images mapped to this location, and then click away from the preview to close it.

6 Right-click / Control-click the map pin and choose Create Collection. Type **Landmarks** as the name for the new collection; then, disable all check box options and click Create.

The new collection appears in the Collections panel, with an image count of 3.

7 In the header of the Filmstrip, click the arrow to the right of the image source information and choose Previous Import from the source menu. Select the image NY_Marathon.jpg in readiness for the next exercise.

Adding locations using GPS tracklogs

Although your camera may not record GPS data, many mobile devices such as phones can export a tracklog that records your location over a given period of time. You can import this information, and then have Lightroom tag your photos automatically by matching their capture times to the locations recorded in the tracklog.

▶ Tip: Lightroom can work with tracklogs exported in GPX format. If your device doesn't export in GPX format, you can use GPS Babel to convert its output.

1 Click the GPS Tracklogs button (⌇) in the Toolbar and choose Load Tracklog, or choose Map > Tracklog > Load Tracklog. In the Import Track File dialog box, navigate to your LRClassicCIB \ Lessons \ Lesson 4 GPS folder; then, select the file NY_Marathon.gpx and click Open / Choose. Click the small white arrow at the right of the Track date information and choose All Tracks from the menu.

The map is updated to a view of New York, with the recorded GPS track shown as either a blue or yellow line on the map, depending on your choice of map style.

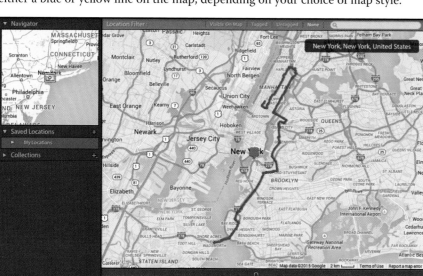

This tracklog was generated by a sports watch that was set to a different time zone than the camera used to capture our lesson photo, so you may need to offset the times recorded. The offset will depend on the time zone setting on your computer.

2 Click the GPS Tracklogs button (⌇) in the Toolbar and choose Set Time Zone Offset, or choose the same command from the Map > Tracklog menu. Use the slider in the Offset Time Zone dialog box, or type a number in the adjacent text box, to shift the starting time for the tracklog to 11:27 AM; then, click OK.

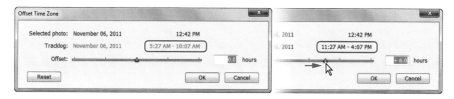

3 Set the map to a style other than Satellite. Select the image NY_Marathon.jpg in the Filmstrip, and then choose Map > Tracklog > Auto-Tag Photos.

Lightroom matches the capture time of the selected image to the corresponding location on the marathon route recorded by the tracklog.

4 Move the pointer over the new marker pin on the map—or double-click the marker—to see a preview of the tagged image.

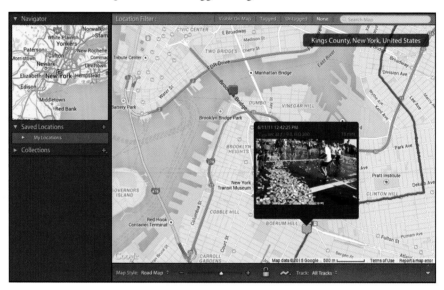

5 Zoom into the map close enough to read the street names around the new marker pin. As you can see, the photo was taken near the corner of 4th Avenue and Dean Street. Click Library in the module picker at the top of the workspace and double-click the New York marathon thumbnail in the Grid view to enter Loupe view. Zoom into the upper right corner of the image; the street sign confirms that the photo has been correctly placed.

6 Click Map in the module picker to return to the Map module.

Saving map locations

In the Saved Locations panel, you can save a list of your favorite places, making it easy to locate and organize a selection of related images. You could create a saved map location to encompass a cluster of places that you visited during a particular vacation, or to mark a single location that you used for a photo shoot for a client.

1 Zoom out in the map view until you can see all of the GPS track.

2 Expand the Saved Locations panel, if necessary; then, click the Create New Preset button (**+**) at the right of the header.

3 In the New Location dialog box, type **New York Marathon** as the location name. Under Options, set the Radius value to **9.5** miles; then, click Create.

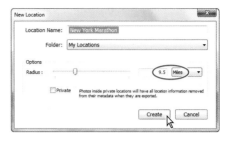

Your new listing appears in the Saved Locations panel; the image count shows that there are two tagged images that fall within the specified radius.

On the map, the saved location has a center pin that can be repositioned, and a second pin on the border for increasing or decreasing the radius of the target area.

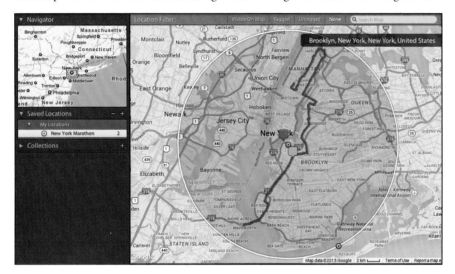

Selecting or deselecting a location in the Saved Locations panel shows and hides the circular location overlay, and makes the location active for editing. To add photos to a saved location, you can either drag them directly from the Filmstrip onto the location's entry in the Saved Locations panel, or select the images in the Filmstrip and click the check box to the left of the location name.

Click the white arrow button that appears to the right of the location name when you move your pointer over the location in the Saved Locations panel to move to that saved location on the map. To edit a location, right-click / Control-click its entry in the Saved Locations panel and choose Location Options from the menu.

Once your photos are tagged with locations, you can search your library using the filter picker and search box in the Location Filter bar above the map, the Saved Locations panel, and the Library Metadata filters set to GPS Data or GPS Location.

4 Click Library in the module picker to return to the Library module.

▶ **Tip:** Marking a saved location as Private in the New Location and Edit Location dialog boxes ensures that the GPS information will always be removed when photos from that location are exported or shared, without deleting the location from the images in your catalog. This is useful for protecting your privacy at locations such as your home address. For photos that are not in a saved location, you can choose to omit GPS metadata when you set up an export. For more detail, see Lesson 11.

Using the Painter tool

Of all the tools Lightroom Classic CC provides to help you organize your growing image library, the Painter tool () is the most flexible. By simply dragging across your images in the Grid view with the Painter tool you can "spray on" keywords, metadata, labels, ratings, and flags—and even apply developing settings, rotate your photos, or add them to the Quick Collection.

When you pick the Painter tool up from its well in the Toolbar, the Paint menu appears beside the empty tool well. From the Paint menu you can choose which settings or attributes you wish to apply to your images. Once you've made your choice the appropriate controls appear to the right of the Paint menu.

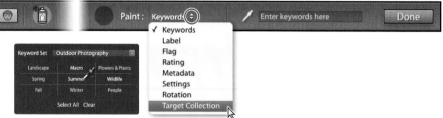

▶ **Tip:** In Keywords mode, the Painter tool can apply entire keyword sets, or any selection from your favorite set. With the Painter tool in Keywords mode, press the Shift key to activate the eyedropper and access the Keyword Set picker.

In this exercise you'll use the Painter tool to mark images with a color label.

1 Click the Vacation folder in the Folders panel. If necessary, press G to switch to the Grid view; then, make sure that none of the images are currently selected. If you don't see the Painter tool in the Toolbar, click the triangle at the right side of the Toolbar and choose Painter from the tools menu.

2 Click the Painter tool to pick it up from its well in the Toolbar and choose Label from the Paint menu beside it; then, click the red color label button.

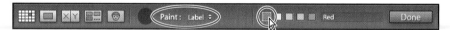

3 The Painter tool is now "loaded." Move the pointer over any of the thumbnails in the Grid view and a red spray can icon appears.

4 Click the thumbnail in the Grid view and the Painter tool applies the red label. Whether you see the color as a tint in the image cell depends on your Library View Options settings, and whether the image is currently selected (our example is not). If you don't see the red color label marker (circled in the illustration at the right), choose View > Grid View Style > Show Extras.

5 Move the pointer back over the same thumbnail, and then hold down the Alt / Option key and; the cursor changes from the Painter tool spray can to an eraser. Click the thumbnail with the eraser cursor and the red color label is removed.

6 Release the Alt / Option key and click the image once more—but this time drag the spray can across several photos to apply the red color tag to multiple images with one stroke. Hold down the Alt / Option key again, and then remove the label from all but one of the photos.

7 Click Done at the right side of the Toolbar, or click the Painter tool's empty well, to drop the Painter tool and return the Toolbar to its normal state.

Finding and filtering files

Now that you're familiar with the different techniques for categorizing and marking your photos, it's time to see some results. Next you'll look at how easy it is to search and sort your images once they've been prepared in this way. You can now filter your images by rating or label or search for specific keywords, GPS locations and other metadata. There are numerous ways to find the images you need, but one of the most convenient is to use the Filter bar across the top of the Grid view.

Using the Filter bar to find photos

1 If you don't see the Filter bar above the Grid view, press the backslash key (\) or choose View > Show Filter Bar. In the Folders panel, select the Lesson 4 folder. If you don't see all eleven photos, choose Library > Show Photos In Subfolders.

The Filter bar picker contains three filter types: Text, Attribute, and Metadata; choose any of these and the Filter bar will expand to display the settings and controls you'll use to set up a filtered search. You can either use the different filters separately or combine them for a more sophisticated search.

Use the Text filter to search any text attached to your images, including filenames, keywords, captions, and the EXIF and IPTC metadata. The Attribute filter searches your photos by flag status, star rating, color label, or copy status. The Metadata filter enables you to set up to eight columns of criteria to refine your search; choose from the menu at the right end of a column header to add or remove a column.

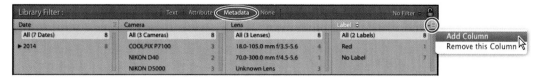

2 If the Text or Metadata filters are active, click None to disable them. Click Attribute to activate the Attribute filters. If any of the flag filters is still active from the previous exercise, click the highlighted flag in the Filter bar to disable it, or choose Library > Filter By Flag > Reset This Filter.

3 In the Rating controls, click the third star to search for any image with a rating of three stars or higher.

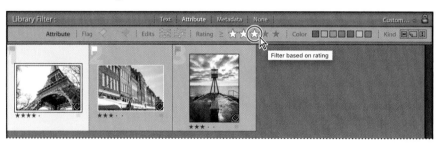

The grid view displays only the three images to which you've applied a star rating.

4 There are many options for refining your search. Click Text in the header of the Filter bar to add an additional filter. In the Text filter bar, open the first menu to see the search target options. You can narrow the search to Filename, Copy Name, Title, Caption, Keywords, or searchable IPTC and EXIF metadata, but for this exercise you can choose Any Searchable Field as the search target. Click the second menu and choose Contains All.

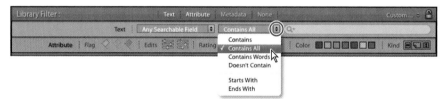

5 In the search text box, type **France**. Your narrowed search returns only one image in the Grid view.

6 In the Rating controls, click the third star to disable the current Rating filter or choose Library > Filter By Rating > Reset This Filter. Click Attribute in the header of the Filter bar to close the Attribute filter controls.

▶ **Tip:** In the search text box, add an exclamation mark (!) before any word to exclude it from the results. Add a plus sign (+) before any word to apply the "Starting With" rule only to that word. Add a plus sign (+) after a word to apply the "Ending With" rule only to that word.

7 In the Text filter bar, clear the search term "France" by clicking the x icon at the right of the text box, and then type **Europe**.

The Grid view now displays all eleven of the photos in the Lesson 4 folder.

8 In the search text box, type a space after the word Europe, and then type **!Copenhagen** (note the exclamation mark). The search is narrowed to find those images in the Lesson 4 folder with searchable text that contains the word Europe, but does not contain the word Copenhagen. The Grid view now displays three photos. Leave the Text filter set as it is for the next exercise.

Using the Metadata filter

1 Click Metadata in the header of the Filter bar to open the Metadata filter pane. Choose Default Columns from the menu at the far right of the Filter bar header.

2 Click Date in the header of the first column to see the wide range of search criteria from which you can choose for each of up to eight columns. Choose Aspect Ratio from the menu as the criteria for the first column, and then choose Landscape from the Aspect Ratio options in the column. The selection in the Grid view is narrowed to the single image with a horizontal format.

3 Click Text in the header of the Filter bar to disable the Text filter. This search returns five photos from the Lesson 4 folder. In the Aspect Ratio column, click Portrait to find the other six Lesson 4 images.

4 Click to close the lock icon at the right of the Filter bar header to lock the current filter so that it remains active when you change the image source for the search.

5 Click the All Photographs listing in the Catalog panel. The Grid view now displays every portrait format image in your catalog.

As you can see, there are endless possibilities for combining filters to find just the image you're looking for.

6 Click None in the Filter bar to disable all filters. Click the Lesson 4 folder in the Folders panel.

Using the filters in the Filmstrip

The Attribute filter controls are also available in the header of the Filmstrip. As in the Filter bar the Filter Presets menu lists filter presets and offers the option to save your filter settings as a custom preset, which will then be added to the menu.

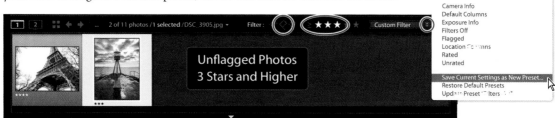

The Default Columns preset opens the four default columns of the Metadata search options: Date, Camera, Lens, and Label. Choose Filters Off to turn off all filters and collapse the Filter bar. Select the Flagged preset to display photos with a Pick flag. Use the Location Columns preset to filter photos by their Country, State/Province, City, and Location metadata. The Rated filter preset displays any photos that match the current star rating criteria. Choose Unrated to see all the photos without a star rating or Used and Unused to see which pictures have been included in projects.

▶ **Tip:** If you don't see any filter presets in the presets menu, open Lightroom Preferences and click Restore Library Filter Presets under Lightroom Defaults on the Presets tab.

1 Choose Flagged from the Filter Presets menu at the top right of the Filmstrip. The Attribute filter bar opens above the Grid view. The Grid view and the Filmstrip show only one photo that you flagged as a pick in a previous exercise.

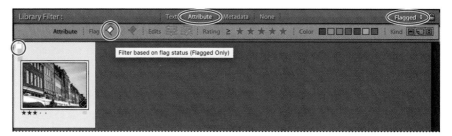

2 Click the white flag icon in the header of the Filmstrip to disable the current filter, and then click the red color label button. If you don't see the color label buttons in the header of the Filmstrip, click the word Filter to the left of the flag buttons. The Attribute filter settings change in the Filter bar above the Grid view and both the Grid view and the filmstrip display only the image that you labeled with the Painter tool.

Tip: To save time and effort setting up searches, save your filter settings as a new preset. Specify criteria for any combination of Text, Attribute, and Metadata filters. Then choose Save Current Settings As New Preset from the Custom Filter menu in the Filter bar or the Filmstrip.

3 To disable all filters and display all the images in the Lesson 4 folder, choose Filters Off from the Filter Presets menu or click the switch at the far right of the Filmstrip's header.

Reconnecting missing files and folders

Remember that when you import a photo into your library, Lightroom adds the image file's name and address to the library catalog file, and displays an entry for the folder in which the photo is stored in the Folders panel.

If you rename or move a photo—or a folder—while you're outside the Lightroom Classic CC workspace the link to the catalog will be broken and Lightroom may no longer be able to locate the image file.

Lightroom Classic CC will alert you to the problem by marking the thumbnail of the missing photo—or the entry for the missing folder in the Folders panel—with a question mark icon.

1 In the Grid view, select one of the Copenhagen vacation photos; then right-click / Control-click the image and choose Show In Explorer / Show In Finder from the context menu.

2 In the Explorer / Finder window, change the name of the selected file to **Copenhagen.jpg**. Change the name of the Architecture folder inside the Lesson 4 folder to **Tower**.

3 Back in the Grid view in Lightroom Classic CC, you'll notice the missing file alert icon in the upper right corner of the selected image cell (and also just below the Histogram). Click the icon; then click Locate in the dialog box.

4 Locate and select the renamed file and then click Select.

When you've merely moved, rather than renamed files, you can activate the Find Nearby Missing Photos option in the Locate file dialog box and Lightroom will find any other missing photos in the same folder automatically.

5 Click Confirm to verify that Copenhagen.jpg is the correct file despite the changed name. You have now reestablished the link to your renamed file; the missing file icon no longer appears in its image cell.

6 In the Folders panel, the Architecture folder is now dimmed and marked with a question mark icon. Right-click / Control-click the missing folder; you *could* choose Find Missing Folder from the context menu, and then locate the renamed folder as you did for the missing file, but we'll take this opportunity to look at a different method instead.

7 Choose Library > Find All Missing Photos. A new temporary collection named Missing Photographs is created in the Catalog panel. The new collection is automatically selected and the three photos from the Architecture folder appear in the Grid view.

Select each image in turn; the missing photo icon appears on each image cell.

8 Click the missing photo icon on any of the images in the Grid view and follow the same steps you used previously. Navigate to the renamed folder, and then locate the selected file. This time, activate the Find Nearby Missing Photos option in the Locate file dialog box and Lightroom will find the other missing photos in the folder automatically. Click Select.

9 The renamed folder is now listed in the Folders panel. Although the missing Architecture folder is still listed in the Folders panel, it now shows an image count of 0. Right-click / Control-click the empty folder and choose Remove from the menu.

10 If the Missing Photographs folder in the Catalog panel is not removed automatically, right-click / Control-click the listing and choose Remove This Temporary Collection from the context menu.

This concludes the lesson on organizing your image library. You've learned about structuring your folders, sorting and grouping images into collections, and a variety of methods for tagging and marking your photos to make them easier to find by applying a range of search filters.

However, it's worth discussing a final step that is invaluable in managing your growing library of photos: perform regular catalog backups. The library catalog contains not only your entire image database but also all the preview images and metadata, together with records of your collections and all your settings from the Develop, Slideshow, Web and Print modules. It is as important to make backups of your catalog as it is to keep copies of your image files. You'll learn more about backing-up your library in Lesson 11, "Making Backups and Exporting Photos."

Before you move on to the next lesson, take a moment to refresh some of what you've learned by reading through the review on the next page.

Review questions

1 What is a Smart Collection?

2 Why would you create a Stack?

3 What are keyword tags?

4 What are the three modes in the Filter bar?

5 How can you search for images by location?

Review answers

1 A Smart collection can be configured to search the library for images that meet specified criteria. Smart collections stay up-to-date by automatically adding any newly imported photos that meet the criteria you've specified.

2 Stacks can be used to group similar photos and thereby reduce the number of thumbnails displayed at one time in the Grid view and the Filmstrip. Only the top image in a stack appears in the thumbnail display but the stack can be expanded and contracted by clicking the thumbnail.

3 Keyword tags are text added to the metadata of an image to describe its content or classify it in one way or another. Shared keywords link images by subject, date, or some other association. Keywords help to locate, identify, and sort photos in the catalog. Like other metadata, keyword tags are stored either in the photo file or (in the case of proprietary camera raw files) in XMP sidecar files. Keywords applied in Lightroom Classic CC can be read by Adobe applications such as Bridge, Photoshop, or Photoshop Elements, and by other applications that support XMP metadata.

4 The Filter bar offers three filter groups: Text, Attribute, and Metadata filters. Using combinations of these filters you can search the image library for metadata text, filter searches by flag, copy status, rating, or label, and specify a broad range of customizable metadata search criteria.

5 Once your photos are tagged with locations, you can search your library from the Map module by using the Location Filter bar above the map and the Saved Locations panel. In the Library you can use the Metadata filters, set to GPS Data or GPS Location.

PHOTOGRAPHY SHOWCASE
DAVID FROHLICH

"I take pictures because words could never express how truly wonderful nature is—and not everyone has the opportunity, or takes the time, to experience it as I do."

To portray wildlife in its fullest expression and successfully capture its inner beauty, you need to understand the behavior of the animals you're working with. You have to put yourself on their level, where you can be face to face.

All living beings can be equally beautiful if seen from the right perspective; it's up to the photographer to find that perfect angle and to capture the tiny details that most people would overlook.

I spend a great deal of time observing an animal thoroughly and learning its habits before ever picking up my camera. I want to be sure just what type of shot will best portray my subject's "personality," and I'm always looking for a perspective that will show off it's most interesting features in a unique, engaging, and artistic way.

I want to show people that there is so much more to animals than they'd think, and that each is highly adapted to its place in the world and absolutely perfect in its own way. I hope that my work will inspire others to learn more about wildlife, gain a deeper appreciation for it, and treasure it as I do.

www.flickr.com/photos/157037508@N08/

HYPNOTIC STARE - KEELED SLUG SNAKE

TWILIGHT - ASIAN VINE SNAKE

LISTENING TO SILENCE - FALSE VAMPIRE BAT

STANDING ITS GROUND - SIAMESE SPITTING COBRA

HIDING IN PLAIN SIGHT - ARABIAN SAND VIPER

ALIEN BEAUTY - ORCHID MANTIS

MORNING SUN - ROCK HYRAX

5 DEVELOPING BASICS

Lesson overview

Lightroom delivers an extensive suite of powerful, yet easy-to-use developing tools to help you make the most of your photos with a minimum of effort, whether they're incorrectly exposed, shot at an angle, poorly composed, or even spoiled by extraneous objects.

This lesson introduces you to a range of basic editing options in both the Library and Develop modules, from automatic adjustments and develop presets to cropping, straightening and retouching tools. Along the way you'll pick up a little background knowledge in digital imaging as you become familiar with some basic techniques:

- Quick developing in the Library module
- Applying Develop presets
- Working with video
- Understanding previews and Process Versions
- Cropping and rotating images
- Removing unwanted objects and retouching blemishes
- Editing in Lightroom CC for mobile

 You'll probably need between one and two hours to complete this lesson. If you haven't already done so, log in to your peachpit.com account to download the lesson files for this chapter, or follow the instructions under "Accessing the Lesson Files and Web Edition" in the Getting Started section at the beginning of this book.

Now that you've imported your photos and organized your catalog, you can jump right in and begin editing them with a range of options from one-click automatic adjustments to specialized retouching tools. You can experiment with any of these, secure in the knowledge that, thanks to Lightroom's non-destructive editing, the modifications you make while you're learning won't alter your master files.

Getting started

● **Note:** This lesson assumes that you already have a basic working familiarity with the Lightroom Classic CC workspace. If you need more background information, refer to Lightroom Classic CC Help, or review the previous lessons.

Before you begin, make sure you've set up the LRClassicCIB folder for your lesson files and created the LRClassicCIB Catalog file to manage them, as described in "Accessing the Lesson Files and Web Edition" and "Creating a catalog file for working with this book" in the Getting Started chapter at the start of this book.

If you haven't already done so, download the Lesson 5 folder from your Account page at www.peachpit.com to the LRClassicCIB \ Lessons folder, as detailed in "Accessing the Lesson Files and Web Edition" in the chapter "Getting Started."

1 Start Lightroom Classic CC.

2 In the Adobe Photoshop Lightroom Classic CC - Select Catalog dialog box, make sure the file LRClassicCIB Catalog.lrcat is selected under Select A Recent Catalog To Open, and then click Open.

▶ **Tip:** If you can't see the Module Picker, choose Window > Panels > Show Module Picker, or press the F5 key. If you're working on Mac OS, you may need to press the fn key together with the F5 key, or change the function key behavior in the system preferences.

3 Lightroom Classic CC will open in the screen mode and workspace module that were active when you last quit. If necessary, switch to the Library module by clicking Library in the Module Picker at the top of the workspace.

Importing images into the library

The first step is to import the images for this lesson into the Lightroom library.

1 In the Library module, click the Import button below the left panel group.

2 If the Import dialog box appears in compact mode, click the Show More Options button at the lower left of the dialog box to see all the options in the expanded Import dialog box.

3 Under Source at the left of the expanded Import dialog box, locate and select your LRClassicCIB \ Lessons \ Lesson 5 folder. Ensure that all seven photos and the video in the Lesson 5 folder are checked for import.

4 In the import options above the thumbnail previews, select Add so that the imported media will be added to your catalog without being moved or copied. Under File Handling at the right of the expanded Import dialog box, choose Minimal from the Build Previews menu and ensure that the Don't Import Suspected Duplicates option is activated. Under Apply During Import, choose None from both the Develop Settings menu and the Metadata menu and type **Lesson 5, Develop** in the Keywords text box. Make sure that your import is set up as shown in the illustration below, and then click Import.

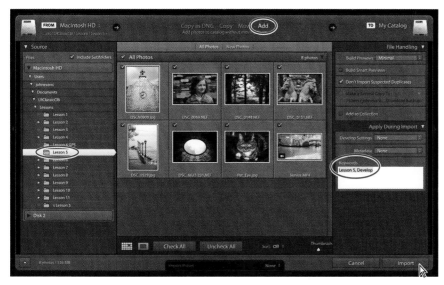

The eight media files are imported from the Lesson 5 folder and now appear in both the Grid view of the Library module and in the Filmstrip across the bottom of the Lightroom workspace.

▶ **Tip:** The first time you enter any of the Lightroom Classic CC modules, you'll see tips that will help you get started by identifying the components of the workspace and stepping you through the workflow. Dismiss the tips by clicking the Close button. To reactivate the tips for any module, choose [*Module name*] Tips from the Help menu.

Quick developing in the Library module

Tip: You can make a multiple selection in the Grid view or the Filmstrip and apply a develop preset, a new crop ratio, or any of the other Quick Develop adjustments, to all of the selected photos at once.

The Library module's Quick Develop panel offers an array of simple controls that let you quickly apply developing presets to your images, correct tone and color, sharpen, and even crop photos—without ever switching to the Develop module.

1 In the Grid view, double-click the RAW image DSC_0148.NEF, a photo of a forested shore in Denmark. Expand the Quick Develop panel, if necessary.

Shot from the shade of the trees, this image is effectively back-lit by light reflected off the water—notoriously difficult conditions for achieving a good overall exposure.

2 Expand the Tone Control pane and click the Auto button.

Auto Tone has had the most noticeable effect in the shadowed areas, revealing detail hidden in the tree trunks and foliage, but has also brightened the image overall, while recovering tone and color detail from the overexposed glare on the water.

The photo still has a slightly cool color cast, giving the sunlit areas a muted, dull look. You can correct this kind of color imbalance by adjusting an image's *white balance*.

3 In the Quick Develop panel, expand the White Balance pane. Try each of the settings in the White Balance presets menu, noting the effects in the Loupe view. When you're done, choose the Shade white balance preset.

Your white balance adjustment has reduced the overall cool cast, warming up the colors of the foliage and the sandy path, making the photo appear brighter and sunnier, even without making appreciable changes to its tonal distribution.

Adjusting the white balance can mean making some very subjective choices; in this case, opting for a sunnier look overall has made the water less blue. With some selective editing, this could be corrected, but for this exercise we'll leave it as is.

If you wish to stay fairly close to a photo's original look, start with the As Shot preset, and then fine-tune the Temperature and Tint. If you feel that the white balance was set incorrectly at the time of capture—perhaps as a result of artificial lighting—or if you wish to achieve a specific effect, use an appropriate preset as a starting point.

Next, you'll use the manual tone controls to fine-tune the tonal balance, enhancing detail in the shadows and recovering color and detail in the overexposed water.

4 If necessary, expand the Tone Control pane by clicking the triangle to the right of the Auto button. Click once on the third button (›) for Exposure, twice on the first button (‹‹) for Highlights, twice on the right-most buttons (››) for both Shadows and Clarity, and once on the first button (‹‹) for Blacks. In the White Balance pane, click twice on the second button (‹) for Temperature.

If you lose track of your adjustments, you can reset any control by simply clicking its name. To revert the image to its original state, click the Reset All button.

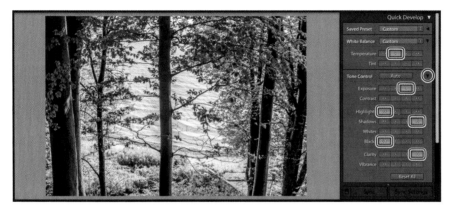

The highlights and temperature adjustments retrieved more detail and color in the water, while the shadows adjustment increased definition in the darker areas. The increased clarity helps to counteract the tonal flattening that can result from applying significant highlights and shadows adjustments together.

Increasing the Clarity emphasizes *local contrast* between adjacent areas of light and dark, without boosting contrast across the entire image, which would result in darkening of shadowed areas and brightening of highlights.

The Quick Develop panel also provides access to over fifty Develop presets, from emulated lens filters to creative effects. Develop presets apply different combinations of develop settings to an image with a single click. You can even save your own settings as custom presets that will be listed in the Saved Preset menu.

▶ **Tip:** To see clearly how your adjustments have improved this photo, click Reset All at the bottom of the Quick Develop panel; then, press Ctrl+Z / Command+Z to restore the improvements.

5 Experiment with one or two presets from each category in the menu at the top of the Quick Develop panel. Many presets are applied to the image in its original state, overriding your corrections; use the Shadows control to quickly assess a preset that appears too dark. Undo each adjustment and preset before applying the next, so that you can return the image to its corrected state when you're done.

Color Presets > Yesteryear B&W Presets > B&W Contrast Low B&W Toned Presets > Split Tone 2

Quick and easy video editing

Many digital cameras enable photographers to capture video as well as still images, but for those of us who haven't learned to use video editing software, those videos end up languishing, forgotten and neglected, in dark corners on our hard disks.

Lightroom lets you import your videos, dust them off, catalog and organize them alongside your photos, make simple edits and grab still frames—even share them to Facebook or Flickr—and you can do it all without ever leaving the Library module.

You can import video in many common file formats used by digital still cameras, including AVI, MOV, MPG, MP4, and AVCHD, in exactly the same way that you import photos; in fact, you did just that at the beginning of this lesson.

1 Press the G key or click the Grid view button (▦) in the Toolbar. If you're working with very small thumbnails, use the Thumbnails slider in the Toolbar to make them a little larger.

2 Locate the video file Venice.MP4; then, move the pointer slowly from left to right, and then back again over the thumbnail (or better still, just below it) to scrub forwards and backwards through the video.

The horizontal position of your pointer relative to the width of the thumbnail preview corresponds roughly to the location of the current frame in the video clip.

3 Double-click the thumbnail to see the video in Loupe view; drag the circular current time indicator along the playback control bar to scrub through the video. Click the Play button at the left of the control bar to play the clip.

Trimming video clips

In the Loupe view, you can improve a video by snipping off a slow start or a shaky ending; the video file on your hard disk remains intact, but when you play the clip in Lightroom—or export it—the video will be trimmed to show only the real action.

1 Click the Trim Video button (⬡). The playback control bar expands to display a series of key frames from the video, representing a time-line or film-strip view of the clip. You can lengthen the expanded control bar by dragging either end.

2 Watch the time count at the left end of the control bar as you drag the current time indicator to the first frame in the 12th second; then, drag the end marker in from the right end of the time-line to meet the current time indicator.

3 Click the Play button at the center of the control bar to view the trimmed clip.

Setting video thumbnails and grabbing still frames

Setting a distinctive poster frame (thumbnail image) for a video clip can make it easier to locate in the Grid view or the Filmstrip.

1 Make sure that you can see the video clip's thumbnail in the Filmstrip. In the Loupe view, move the current time indicator to the frame you want; then, click the Frame button (▣) at the right end of the control bar. Watch the video thumbnail in the Filmstrip as you choose Set Poster Frame.

2 Find a frame that you like; then, click the Frame button and choose Capture Frame to capture and save the current frame as a JPEG image that will be stacked with the clip.

Editing video in the Quick Develop panel

When you're working with video, several of the Quick Develop controls are disabled. Although you can access all of the developing presets in the Saved Preset menu, only the supported settings within each preset will be applied.

▶ **Tip:** Presets in the Lightroom Video Presets category are tailored for video; they do not incorporate any unsupported operations.

1 With the same frame still open in the Loupe view, choose the Video Color Pop preset from the Lightroom Video Presets category in the Saved Preset menu.

2 Click Auto in the Tone Control pane to correct the slightly de-saturated, overexposed look.

3 Click the right-most buttons for Contrast and Whites, twice each. To see the effect in motion, scrub through the clip by dragging the current time indicator, or click the Play button in the control bar.

As imported Video Color Pop preset, plus
 Auto Tone, Contrast, and Whites

Previews in a nutshell

The issue of previews in Lightroom can be confusing, and much of the information on the subject may seem dauntingly technical, but the concept is really quite simple. *Every* image you see in Lightroom is a preview—from the thumbnails in the Grid view and the Filmstrip to the Develop module Loupe view at its highest zoom ratio. Lightroom extracts some previews from the images themselves, and generates others on the fly; some are used temporarily and then discarded, and others stored.

In the Import, Preferences, and Catalog Settings dialog boxes, you can set up a range of options relating to previews—but basically, you can go ahead and successfully import, organize, and edit your photos without ever changing any of the defaults. The whole process is quite automatic; all of those options are only offered so that, if you choose, you can configure preview handling to improve performance or save disk space. For more information on doing just that, please refer to Lightroom Help.

In Lightroom Classic CC, Smart Previews are the exception to this simplified summary; they are created on-demand for your convenience, rather than generated automatically to Lightroom's operating requirements.

In Lightoom CC, Smart Previews play a more pivotal role; for the sake of space and speed, only Smart Previews of the photos you sync to Lightroom CC are downloaded to your mobile device for editing.

Working with Smart Previews

Smart Previews allow you to edit off-line images, and then Lightroom will automatically update the originals when they come back on-line—ideal for working on your laptop when you're away from home. Likewise, your Smart Previews are automatically updated with any adjustments you make when the originals are on-line, so they'll always be up-to-date for the next time you take a trip.

Smart Previews are a lightweight file type, based on the lossy DNG format—at around 5% of the size of the original raw files, they're also a great way to free up disk space. You can have Lightroom build Smart Previews at import by activating that option in the Import dialog box, invoke the Build Smart Previews command from the Library > Previews menu for a multiple selection, or generate one Smart Preview at a time by clicking the Smart Preview status indicator at the bottom of the Histogram panel when you have an original photo open in the Loupe view.

Viewing an original photo that has no Smart Preview

Viewing an original photo that has a Smart Preview

Viewing a Smart Preview; the original file is off-line

For a multiple selection of images in the Grid view, the Smart Preview status indicator shows a breakdown of the selected files.

The Develop module

Although the Library module's Quick Develop panel offers access to many basic image editing options, you'll work in the Develop module to make more detailed adjustments and modifications to your photos. The Develop module is a comprehensive editing environment, presenting all the tools you'll need to correct and enhance your images in a single workspace. The controls are simple enough for a beginner to use, and yet have the depth and power required by the advanced user.

The Develop module offers two viewing modes: the Loupe view, where you can focus on a single image, and the Before/After view, which has several layout options that make it easy to compare the original and edited versions of a photo. The Toolbar across the bottom of the work area presents buttons for switching between the views and a slightly different suite of controls for each viewing mode.

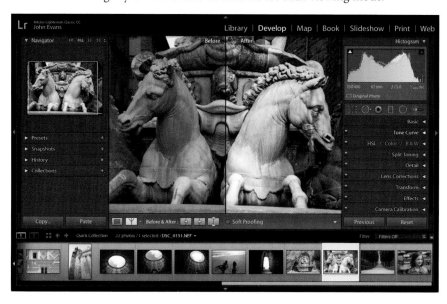

The tools and controls in the Develop module's right panel group are arranged from top to bottom in the order in which they would ordinarily be used: a layout that guides you intuitively through the editing workflow.

The left panel group contains the Navigator panel, which can be collapsed but not hidden, and any combination of the Presets, Snapshots, History, and Collections panels, which can be shown or hidden to suit the way you prefer to work.

At the top of the left panel group, the Navigator panel helps you find your way around a zoomed image, and lets you preview the effects of developing presets before you apply them. You can also use the Navigator to review past stages in an image's developing history. At the right of the Navigator's header is a zoom picker for setting the magnification level in the working views.

The Navigator can be collapsed, but not hidden.

While the History panel keeps track of every modification made to the image, including Quick Edit adjustments made in the Library module, you can use the Snapshots panel to record important stages in a photo's development, so you can return to a key state quickly and easily, without searching through the history list.

At the top of the right panel group is the Histogram panel. Immediately below the Histogram is an array of tools for cropping, removing image flaws, applying local adjustments through graduated or radial masks, and painting develop settings directly onto an image selectively. Clicking any of these tools expands a tool options pane with controls and settings for that tool.

Below these editing tools is the Basic panel: your starting point for color correction and tonal adjustments. In many cases this may be the only panel you need to achieve the result you want. The remaining panels offer specialized tools for various image enhancement tasks.

For example, you can use the Tone Curve panel to fine-tune the distribution of the tonal range and increase mid-tone contrast. Use the controls in the Detail panel to sharpen an image and reduce noise.

It's not intended that you use every tool on every photo. In many circumstance you may make only a few slight adjustments to an image; however, when you wish to polish a special photo—or if you need to work with shots captured at less than ideal camera settings—the Develop module gives you all the control you need.

In the next exercise you'll use the first of the tools in the strip below the Histogram.

Cropping and rotating images

The Crop Overlay tool makes it simple to improve your composition, crop away unwanted edge detail, and even straighten your image.

1 Select the raw image DSC_0151.NEF in the Grid view or Filmstrip and switch to the Develop module (press the D key or choose View > Go To Develop).

2 Hide the Filmstrip and the left panel group to enlarge the work area; you'll find keyboard shortcuts for showing and hiding any or all of the workspace panels listed beside the commands in the Window > Panels menu. If you're not already in the Loupe view, press the D key, or click the Loupe view button (▣) in the Toolbar. If you don't see the Toolbar, press the T key.

3 Click the Crop Overlay tool ()button just below the Histogram panel, or press R. A crop overlay rectangle appears on the image in the Loupe view and a control pane for the Crop Overlay tool opens above the Basic panel.

4 From the Aspect menu, choose Original. If the lock button shows an open lock icon, click to close the lock; this will constrain the aspect ratio.

The Crop & Straighten pane also contains the Straighten tool, which lets you mark a horizontal or vertical element in a tilted photo as a reference around which the image will be straightened automatically. As there is no reliable straight-line reference in our lesson photo, we'll rotate it manually instead.

5 In the Loupe view, drag outside the crop rectangle to rotate the image. Release the mouse button when the blue-gray stone fountain-rim across the bottom of the photo is aligned with the grid.

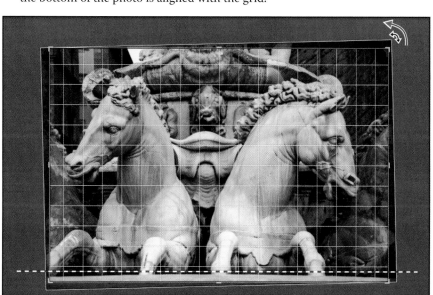

Whether you use the Straighten tool or rotate the photo manually, Lightroom will automatically trim the angled edges of the rotated photo when you commit the crop by clicking the Crop Overlay tool or double-clicking the image in the Loupe view. Lightroom will find the largest crop possible with the specified aspect ratio. Changing or unlocking the aspect ratio can minimize the amount of the photo that will be trimmed away.

6 Drag the lower right handle of the crop overlay rectangle upwards and to the left. As you drag, the image moves so that the cropped portion is always centered in the Loupe view. Release the mouse button when the lower edge of the crop rectangle is clear of the curved fountain rim, as shown below.

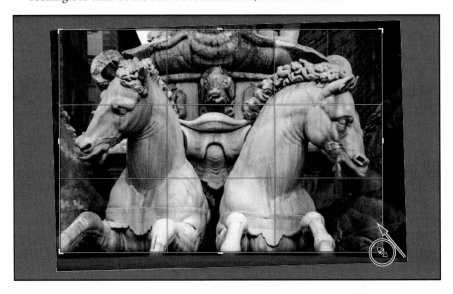

7 Click inside the crop overlay rectangle and drag the image. You'll notice that you can't drag the photo downwards or to the right because the image will move only until its edge touches the border of the cropping rectangle. Position the photo so that the horses' noses have the same amount of clearance on each side.

8 To exit cropping mode, press the R key or click the Crop Overlay tool button again. The cropped and straightened image is displayed in the Loupe view.

▶ **Tip:** Thanks to non-destructive editing, you can return at any time and adjust your crop—or the angle of the photo—by simply reactivating the Crop Overlay tool. The crop becomes "live"—the trimmed portions of the image become visible once more and you can rotate the photo or resize and reposition the cropping rectangle as you wish.

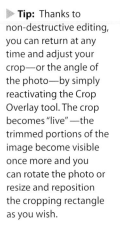

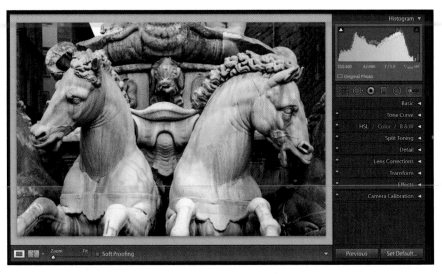

Removing unwanted objects

The impact of a photo can easily be spoiled by an unwanted object in the frame. In the modern world, it's often difficult to photograph even a remote landscape without capturing a fence, power lines, satellite dishes, or litter, if not a tourist or two—mundane clutter that can reduce the drama of an otherwise perfect shot.

In this exercise, we'll look at the latest enhancements to the Spot Removal tool, free-form brushed spots and connect-the-dots lines, which make it even easier to paint an extraneous element out of a photo.

1 Staying in the Develop module, click the white triangles at the left and bottom edges of the workspace window to show the left panel group and the Filmstrip. In the Filmstrip, select the image DSCN0909.jpg.

2 Choose 1:1 from the zoom picker in the header of the Navigator panel. Drag the white view area overlay in the Navigator preview, so that the Loupe view shows the TV antenna, the sky between the antenna and the bell, and a slice of the empty grey image canvas at the right. If you're working on a small screen and are unable to arrange this view at 1:1, click the small white triangles to the right of the picker and choose from the menu to reduce the zoom level to 1:2.

3 Click to activate the Spot Removal tool—the second tool in the strip below the Histogram panel. In the tool options pane right below the tool strip, click Heal to set the Spot Removal tool to healing mode. Set the brush size to 70, the Feather value to 50, and Opacity to 100.

▶ **Tip:** Healing mode is usually the best option for areas such as skin or sky, with graduated colors and no regular pattern or texture.

4 Position the cross-hairs at the center of the Spot Removal tool cursor over the point where the television antenna appears to touch the stone wall. Click and drag away from the wall along the arm of the antenna, making sure to paint over the lighter crosspieces on the underside. Drag your stroke outside the edge of the photo; then, double back to cover the crosspieces on the top side of the arm. Watch as you release the mouse button; Lightroom analyzes the detail around your brush stroke and automatically finds a likely source area to sample. The sample area chosen by the Spot Removal tool will vary depending on the placement, shape, and direction of your target stroke. Don't worry, at this stage, if your result is misplaced or blurred.

As you can see in the illustration at the bottom of the last page, our brush spot produced a less than ideal result; the cloned sample is misaligned with the edge of the wall and has introduced another part of the antenna into the target area.

If you're not satisfied with the automatic result, you can right-click / Control-click either of the brush spot marker pins and choose Select New Source from the context menu, or move either area by dragging its adjustment pin, as you'll do in the following steps.

5 Press H, or move the pointer away from the preview image to hide the brush spot overlays while you examine the result of the preceding step. Press H again, or move the pointer back over the preview image, to show the overlays.

Note: Brush spots can be moved or made more or less opaque or soft-edged, but once drawn, they can not be scaled or reshaped.

6 Drag the source area slowly along the edge of the wall until you find a sample that blends seamlessly into the target area. If you see blurring or strange color artefacts, try including more or less of the stone wall inside the source area's outline.

7 Paint over the remainder of the antenna with a single "scribble" stroke, taking care to cover all the finer components of the antenna and include the image border. As you build up the target area, be sure to overlap the loops of your stroke so that the antenna doesn't show through the feathered edges.

Tip: When an object that's more complex, or less isolated, than the antenna in our example proves hard to remove, try using more strokes or vary the direction, brush size and mode.

8 To change the automatically selected source, right-click / Control-click either marker pin and choose Select New Source from the context menu, or drag the source area by its pin.

9 Click the Spot Removal tool in the strip below the Histogram, or press Q to disable the tool and hide the spot overlays.

10 Reactivate the Spot Removal tool and move the pointer over the Loupe view; the target marker pin for your spot overlay becomes visible once more. Move the pointer over the pin to see the outlines of the brush spot; then, click the pin to select and activate the adjustment. Leave the Spot Removal tool active.

Thanks to Lightroom's non-destructive editing, you can reactivate a Spot Removal adjustment at any time and tweak it by moving the target or source, changing the mode, or adjusting the opacity and feathering.

About white balance

In order to correctly display the full range of color information recorded in an image file, it's critical to balance the distribution of color in the photo—that is, to correct the photo's *white balance*.

This is achieved by shifting the image's *white point*: the neutral point around which the colors in the image are distributed on the two axes of temperature (blue to red, visualized in the illustration at the right as a curved axis) and tint (green to magenta).

An image's white point reflects the lighting conditions in which the photo was captured. Different types of artificial lighting have different white points; they produce light that is dominated by one color or deficient in another. Weather conditions also have an effect on the white balance.

The higher the red component in the lighting, the warmer the colors in the photo will appear; the higher the blue component, the cooler the image, so movement along this axis defines the photo's color *temperature*, while the term *tint* refers to shifts in the direction of green or magenta.

The sensors in a digital camera record the amount of red, green, and blue light that is reflected from an object. Under pure white lighting, an object that is a color-neutral gray, black, or white reflects all color components of the light source equally.

If the light source is not pure white but has a predominant green component for example (typical of fluorescent lighting), a higher amount of green will be reflected. Unless the composition of the light source is known—and the *white balance* or *white point* is corrected accordingly—even objects that should appear color-neutral will have a green color cast.

When shooting in auto white balance mode, your camera attempts to estimate the composition of the light source from the color information measured by the sensors. Although modern cameras are doing better at automatically analyzing lighting and setting the white balance to meet conditions, the technology is not infallible; it's preferable—if your camera supports it—to use your camera to measure the white point of the light source before shooting. This is usually done by photographing a white or neutral, light gray object in the same lighting conditions as the intended subject.

Together with the color information collected by the camera sensors, Raw images also contain "As Shot" white balance information; a record of the white point determined automatically by the camera at the moment of capture. Lightroom can use this information to correctly interpret the recorded color data for a given light source. The recorded white point information is used as a calibration point in reference to which the colors in the image will be shifted to correct the white balance.

(continues on next page)

About white balance (continued)

You can use the White Balance Selector tool, located in the top left corner of the Basic panel, to correct the white balance in your photo. Click to sample an area in your photo that you know should appear on screen as a light neutral gray; Lightroom will use the sampled information to determine the point around which the image can be calibrated and set the image's white balance accordingly.

As you move the White Balance Selector tool across the image you will see a magnified view of the pixels under the eyedropper cursor and RGB values for the central target pixel. To avoid too radical a color shift, try to click a pixel where the red, green, and blue values are as close as possible. Do not use white or a very light color (such as a spectral highlight) as the neutral target; in a very bright pixel, one or more of the color components might already have been clipped.

Color temperature is defined with reference to a concept known as *black-body radiation* theory. When heated, a black-body will first start glowing red, then orange, yellow, white, and finally blue-white. A color's temperature is the temperature—in kelvin (K)—to which a black-body must be heated to emit that particular color. Zero K corresponds to −273.15 °C or −459.67 °F and an increment of one unit kelvin is equivalent to an increment of one degree Celsius.

What we generally refer to as a warm color (with a higher red component) actually has a lower color temperature (in kelvin) than what we would call a cool color (with a higher blue component). The color temperature of a visually warm scene lit by candlelight is about 1,500 K. In bright daylight you would measure around 5,500 K and light from an overcast sky results in a color temperature in the photo of about 6,000 to 7,000 K.

The Temperature slider adjusts the color temperature (in kelvin) of the designated white point, from low at the left side of the range to high on the right side. Moving the Temp slider to the left reduces the color temperature of the white point. In consequence, the colors in the image are interpreted as having a higher color temperature relative to the adjusted white point and are shifted towards blue. The colors displayed in the track of the Temp slider control indicate the effect a change in that direction will have on the image. Moving the slider to the left will increase the blue in the image, moving the slider to the right will make the image look more yellow and red.

The Tint slider works in the same way. For example, to remove a green cast in an image you would move the Tint slider to the right, away from the green displayed inside the slider control. This increases the green component in the white point so the colors in the image are interpreted as less green relative to the adjusted white point.

Adjusting the Temp and Tint sliders corresponds to shifting the white point within the color gamut.

Removing posts, wires, and cables

Power lines, which are often starkly visible against the sky, are a commonly encountered form of unwanted visual clutter in a photograph. In this part of the exercise, you'll practice a quick and easy technique for removing electrical wires—and other man-made, linear obstructions such as sign posts and fences—that takes advantage of the latest enhancement to the Spot Removal tool.

1 Staying in the Develop module, select the image DSC_0529.jpg in the Filmstrip.

2 Use the zoom picker in the header of the Navigator panel and the white view area overlay in the Navigator preview to set up the Loupe view so that you can focus on the power line between the tree and the right side of the photo. Make sure your view includes a little of the gray image canvas outside the right edge.

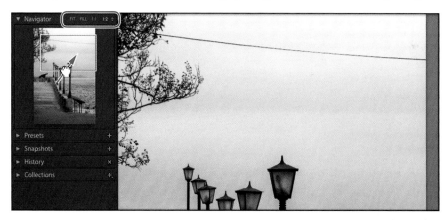

3 If it's not already active, click to activate the Spot Removal tool in the tool strip below the Histogram panel. In the tool options pane right below the tool strip, make sure that the Spot Removal tool is set to healing mode. Set the brush size to 40, the Feather value to 25, and the Opacity level to 100 percent.

4 Position the cross-hairs of the Spot Removal tool cursor over the point where the wire intersects the right edge of the photo. Click once; then, hold down the Shift key and click again about one third of the way along the wire towards the tree, taking care to center the cross-hairs on the line. Keep your finger on the Shift key as you click at the two-thirds mark, and again at the point just before the wire enters the branches of the tree. Release the Shift key.

Tip: This technique enables you to draw straight lines with precision, so that you can set the Spot Removal tool to a very small brush size and still achieve a perfect result with ease.

5 Check the left end of your stroke; if you're not satisfied with the automatic results, right-click / Control-click either of the marker pins and choose Select New Source from the context menu, or drag the source area by its pin.

In situations like this, where it's difficult to see the white borders of your linear spot adjustments against a light background, you can toggle the Visualize Spots view in the Toolbar for a clearer view as you reposition the source area manually.

Tip: To see the spots in Visualize Spots mode, move the ponter over the preview image. Use the Visualize Spots slider to change the amount of image detail visible in the black and white preview.

6 Pan the view so that you can see the left edge of the photo. Press the Esc key to deactivate your first spot removal stroke. Set the Spot Removal tool to Clone mode; then, work from left to right over the wire as it passes through the branches of the tree, making four or five short freehand strokes.

Retouching spots

The Spot Removal tool can also be used to create *circle spot* adjustments, which are ideal for fixing image flaws such as the unsightly spots or blurs often caused by water droplets or dust on the camera lens, especially in photos captured outdoors or in harsh lighting conditions. In this exercise however, you'll use circle spots to improve a portrait photo by retouching blemishes on the subject's skin.

1 If necessary, press F6 or use the Window > Panels menu to show the Filmstrip. Click to select the image DSC_0069.NEF; then, hide the Filmstrip. Press T if you don't see the Toolbar across the bottom of the Loupe view. In the header of the Navigator panel, make sure that the zoom level is set to 1:1 or 1:2; then, hide the left panel group.

2 Hold down the space bar on your keyboard and drag the photo in the work area to center the Loupe view on the young girl's face.

3 The Spot Removal tool should still be active from the previous exercise; set the tool to Heal mode. Set the Size, Feather, and Opacity values to 75, 0, and 100.

In Clone mode, the Spot Removal tool replaces the target area with an exact copy of the source—ideal for dealing with regular patterns or textures. Use the Heal mode for areas with smooth color transitions such as skin or sky, and for fine, random textures like sand or lawn. In Heal mode, the Spot Removal tool matches color and tone to blend the sample into the target area, rather than replacing it.

4 Center the cross-hairs just below and to the right of the darkest part of the red blemish on the girl's cheek; then click—but don't drag. Lightroom automatically locates a sample source. Keep the pointer over the image. On your screen you should see something similar to the illustration at the right, below; the bolder circle marks the sample area, linked by an arrow to the target area—the lighter white circle with the central cross-hairs.

▶ **Tip:** Depending on exactly where you clicked, the automatic source area you see on screen may differ from the illustration.

● **Note:** Unlike *brush spots* created by dragging in the image with the Spot Removal tool, one-click *circle spots* do not have marker pins. Clicking inside either the target or source circle will select it for adjustment with the size and opacity sliders.

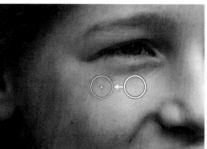

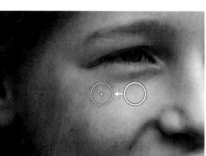

5 The automatically selected sample may sometimes include unwanted detail or create repetition in the target area. To try a different source, press the forward slash (/) key or right-click / Control-click either of the circles and choose Select New Source. If the source circle doesn't move far, repeat the command.

▶ **Tip:** To cancel and remove an active spot correction, simply press Backspace / Delete.

▶ Tip: For portrait retouching, removing this blemish falls just within the limits of what's achievable with a single circle spot. For difficult cases, try using two or three overlapping circle spots, or use one or more shaped brush spots instead.

6 Click inside the target circle to select it. Move the pointer over the edge of the circle and drag outwards from the target circle's center to enlarge both circles together. Release the mouse button to see the target area's outline; then, tweak the circle until it's the same size as that in the illustration at the left, below. Drag the source circle to touch the target area as shown below at the right.

▶ Tip: The best way to evaluate the success of the spot removal process (and many other editing operations) is to inspect the photo at full size by clicking 1:1 in the header of the Navigator panel to set a pixel-for-pixel zoom ratio for the Loupe view.

7 To blend the source sample more subtly with the target, use the slider in the tool options pane to reduce the opacity for the selected spot to 60%. Press H to hide the circle overlays while you assess the blend; then, show the overlays again and drag either of the circles as needed to improve the results. Press Q to deselect the current adjustment; then press Q again to reactivate the Spot Removal tool.

Although this young lady's skin really needs no further retouching, we have one more circle spot technique to try; this time, rather than let Lightroom select the sample automatically, you'll specify the target and source in one stroke.

8 Position the cross-hairs over the tiny spot on the girl's chin. Press the left bracket key ([) repeatedly to reduce the brush size until the Size value in the tool options pane is approximately 50. Hold the Ctrl / Command key and drag from the target to find a source that blends well; then, release the mouse button.

9 Examine the options in the Tool Overlay menu in the Toolbar below the Loupe view. The default setting, Auto, shows the Spot Removal tool overlays only while the pointer remains over the photo. Change the setting to Always.

● Note: You can still select, move, scale, adjust or delete Spot Removal adjustments in Visualize Spots mode. The Visualize Spots mode is also very useful for quickly finding spots caused by dust or fibers on the lens or sensors; adjust the threshold slider to make any such artifacts stand out.

10 The white Spot Removal tool overlays can be difficult to see against light-colored or "busy" areas in a photo, especially when they are not selected. In the Toolbar, activate the Visualize Spots check box; then, use the slider to reduce the image detail enough to see the white overlays clearly. A selected spot adjustment shows both source and target overlays; inactive spots show a source area only when you move the pointer over them.

11 Disable Visualize Spots, reset the Tool Overlay to Auto, and then click Done to deactivate the Spot Removal tool. Click the Before & After view button ([Y][Y]) in the Toolbar to admire your handiwork; then, return to the Loupe view.

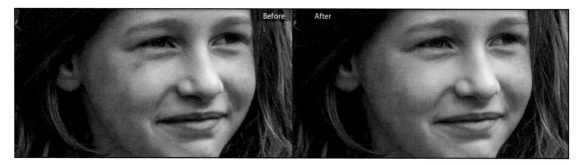

Fixing flash effects in pets' eyes

Portraits shot with flash are often marred by the *red eye effect* caused by reflection from the subject's retinas. As every pet owner knows, flash photos of animals can also be spoiled; though the reflection from pets' eyes is more often green, yellow, or white, and will not respond to the Red Eye Correction tool. In Lighroom Classic CC, you can simply switch the Red Eye Correction tool to the Pet Eye mode.

1 In the Filmstrip, select the image Pet_Eye.jpg. Choose 1:1 from the zoom picker in the header of the Navigator panel; then, click to activate the Red Eye Correction tool—the third tool in the strip below the Histogram panel. In the tool options pane below the tool strip, set the tool to Pet Eye mode.

2 Drag from the center of either pupil until the cursor markers are just a little outside the outline of the eye; then release the mouse button. Lightroom fills the pupil with black, adding a catchlight (specular highlight) by default. Use the slider in the tool options pane to tweak the pupil size, if necessary. For the second eye, simply click at the center; the cursor size is already set.

3 Drag the outer border of the red eye adjustment area to make the correction more, or less, elliptical. Drag the inner circle to reposition the catchlight.

Understanding process versions

Lightroom has regularly updated the Camera Raw technology used to analyze, process and render images, allowing for finer control over color, tone and detail, with fewer artifacts. Taken as a whole, this technology constitutes the *process version*.

Lightroom 1 and 2 used PV1 (2003); Lightroom 3 introduced PV2 (2010). Process Version 3 (2012) was applied to photos edited for the first time in Lightroom 4 or later, adding improved sharpening and noise reduction and adaptive tone mapping that enabled new controls for finer control of exposure, shadows and highlights.

Lightroom Classic CC introduces Process Version 4, which incorporates the power and accuracy of PV3 and adds support for exciting new tools such as color and tone range masking that adds a new dimension to local editing, and the new CC-based Auto Tone feature, which intelligently analyzes your images to find the best solution.

As in previous versions, Lightroom Classic CC gives you the option to either update an image edited in an earlier process version, or leave it as is and use the old editing controls to avoid modifying the existing adjustments.

Updating the process version

In this exercise, you'll update the process version for a raw image that was edited in Process Version 2. Even if you've never used a previous version of Lightroom, this exercise serves as an introduction to the enhanced Develop controls.

1 In the Grid view or the Filmstrip, select the raw image DSC_6622.NEF; then, click Develop in the module picker at the top of the workspace.

In the Develop module, a lightning-bolt marker in the lower right corner of the Histogram panel indicates that the image was not edited with the current process version. Hold the pointer over the marker to see which process version was used.

Tip: If you don't see the right panels, press F8 or choose Window > Panels > Show Right Module Panels.

2 Click the lightning bolt marker. In the Update Process Version dialog box, activate the option Review Changes Via Before/After; then, click Update.

3 If necessary, expand the Basic panel in the right panel group. Watch the Histogram and the Basic panel settings as you undo and redo the update by pressing Ctrl+Z / Command+Z, and then Shift+Ctrl+Z / Shift+Command+Z. When you're done, make sure you return the image to its updated state.

Note: You can also update the process version from the Settings > Process submenu; however, using this command will apply the default or most recently used settings without giving you access to the update options dialog.

There is little change in the histogram curve or the preview, but in the Basic panel, the old develop settings are mapped to a new set of controls (*see illustration below*).

Our lesson image was pre-edited in Process Version 2; the Auto Tone adjustment was applied, and the Recovery slider was manually increased to the maximum setting (somewhat similar to a reduction in the current Highlights control).

4 To demonstrate the enhanced developing controls in Process Version 4, click the Auto button in the Basic panel's Tone pane and reduce Highlights to **-100**.

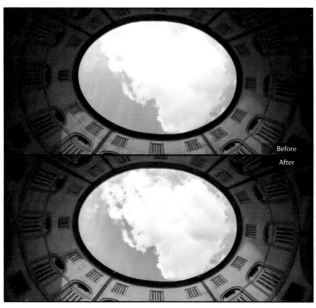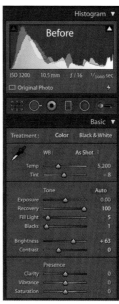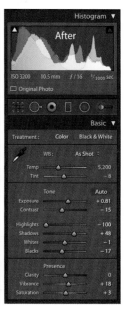

In Process Versions 3 and 4, the Exposure control combines elements of both the Exposure and Brightness settings from earlier versions. The new Exposure control works more like camera exposure; boosting midtones without clipping highlights.

The Highlights and Shadows controls replace Recovery and Fill Light, enabling you to bring out more detail from the darkest and brightest parts of your photos; the new controls target their respective tonal ranges more effectively, without affecting the rest of the image; your Highlights and Shadows adjustments won't overlap, so there's less chance of color shifts and other artifacts. The Whites and Blacks controls correct clipping at the ends of the histogram. In Process Versions 3 and 4 the Clarity adjustment produces a more natural look, with less likelihood of halo effects.

Tip: For some photos, updating the process version may result in significant changes; update your images one at a time until you're familiar with the new processes. Use a Before & After view while you tweak develop settings to match the look of the photo before it was updated.

The upgrade from Process Version 1 or 2 must be performed manually, as you did in this exercise. If you're working with an image edited in Process Version 3, you can either make the conversion manually, or it will be initiated automatically as soon as you apply the enhanced Auto Tone adjustment or any of the local adjustment tools that incorporate the new range masking feature. For an image edited in Process Version 1 or 2, the Auto Tone button simply produces a PV 1 or 2 result without updating the process version; the local adjustment tools will present a narrower selection of editing controls and do not incorporate range masking.

5 Return to the Loupe view and click to activate the Radial Filter tool, right below the Histogram. Adjustment controls for the Radial Filter open below the tool strip. In the Radial Filter tool controls pane, make sure that the Mask mode is set to New.

6 In the Radial Filter controls pane, set the Temperature to **-20**, Exposure to **-0.5**, and Contrast, Highlights, and Shadows to **25**, **-50**, and **-25** respectively. Below the sliders, set the Feather amount to **0** and check the Invert option to activate it.

7 Starting at the center of the sky area, dragging outwards to create an ellipse that surrounds it completely. For the purposes of this demonstration, you can make the filter way to big; you'll use the Range Masking feature to constrain the effect.

8 Click the word Off beside Range Mask at the bottom of the Radial Filter controls and choose Color from the menu. Pick up the eyedropper and drag a marquee in the preview image to include as many shades of blue and white as possible. Be careful not to include any part of the building; your radial adjustment will be constrained to the colors that you sample.

9 Click the Radial Filter tool to deactivate it; then, choose Settings > Process > Version 3 (2012); range masking is not supported in this process version, so your radial adjustment is no longer constrained to the sky area. Reactivate the Radial Filter tool; then click the adjustment pin on the image preview to make it "live" once again. Watch the lightning bolt icon at the lower right of the histogram as you reinstate the Color Range Mask; the photo is automatically updated to the current process version.

 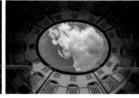

| Process Version 2 | Process Version 4 | Radial Filter adjustment | Color range masking applied |

10 Deactivate the Radial Filter tool and return to the Library module

Editing in another application

You can open a photo from your Lightroom catalog in an external image editing application from within both the Library and Develop modules. Lightroom gives you the option to edit either the original image or a copy—either with or without the edits and adjustments you've already applied in Lightroom.

Lightroom will automatically update the catalog entry for an original file edited in another application; a copy edited externally will be imported to the catalog automatically and grouped in a stack with the original image.

If you have Photoshop installed on your computer, it will be preselected as the default external editor, but in the External Editing preferences you can specify an additional application that will be also listed in the Photo > Edit In menu.

If you like to work with several image editing applications, you can create multiple external editor presets, or even set up several presets for the same application, each with differing file type, naming, and photo handling settings suited to specific editing tasks.

If your external editor is Photoshop CS4 or later, Lightroom lists additional commands in the Photo > Edit In menu. You can open an image in Photoshop as a Smart Object, open multiple shots as layers in a single file (ideal for photo-composites), merge a series of photos into a panorama, or produce a HDR (High Dynamic Range) image by merging several differently exposed pictures of the same subject.

Editing photos in Lightroom CC for mobile

Whether you're working with your photos in Lightroom Classic CC on your desktop or in Lightroom CC on your handheld device, any modifications made to a synced collection, or to the photos it contains, will be updated on the other device.

Lightroom CC syncs high resolution Smart Previews—rather than the original, full-size image files—to your phone or tablet. At a small fraction of the original file size, these Smart Previews won't take long to sync or use up all your storage space, which means that you can even work with raw images while you're away from your desktop computer. Despite their small size, Smart Previews are to all intents and purposes, visually indistinguishable from the original images.

Edits you make on the mobile device are synced back to the full-size originals in your Lightroom catalog as needed. Photos captured on your handheld device and added to a synced collection are downloaded to your desktop at their full file size.

1 In Lightroom Classic CC, choose File > Open Recent and launch the personal catalog for which you enabled syncing in Lesson 4; then, click the arrow beside your name in the upper left corner of the workspace to make sure that syncing is still activated.

2 On your mobile device, tap the Lightroom CC app icon and sign in with your Adobe ID. In the Albums view, tap an album to open it in the Grid view; then, tap a photo in the Grid view to see it enlarged in the single-image Loupe view.

Note: This exercise shows Lightroom CC running on an iPad; on a smart phone, some of the screen layouts and controls will be a little different from the way they are described and illustrated here. Controls and options presented at the right of the tablet screen may appear at the bottom on a phone and, rather than a Done button, you may find a checkmark to commit your changes, and so on.

3 If you see the Edits pane beside the enlarged photo in Loupe view, tap the photo or the Edits button to collapse the Edits pane and focus on the image. Tap with two fingers to cycle through views with and without overlays showing image metadata details or a histogram.

4 Tap the Edits button (), and then each of the four buttons that are grouped with it, to show or hide (from top to bottom):

- The Edits pane, with separate tabs for Light, Color, Effects, Detail, and Optics.
- The Presets pane, with Color, Creative, B&W, and Components categories.
- The Crop & Rotate controls, including aspect presets and the Straighten tool.
- The Selective Edits pane, with the local adjustment tools and their controls.
- The Paste Settings From Previous button with related options.

5 To apply an adjustment in Loupe view, open the Edits pane, choose from the listed adjustment categories, and then use the sliders.

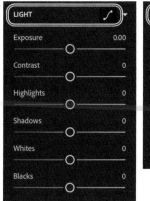

6 To select and edit a different photo from the collection without returning to the Grid view, tap a thumbnail in the scrolling filmstrip below the image preview on the Edits screen. To show or hide the filmstrip, tap the button at the lower right.

7 Use the buttons at the upper right to undo or redo your last edit.

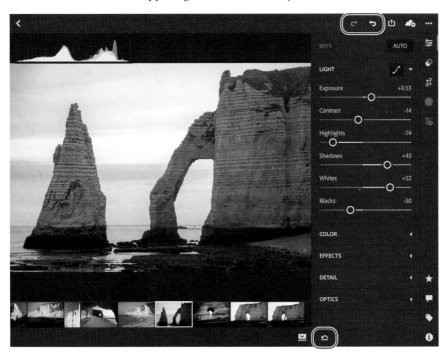

8 To apply a develop preset, tap the Presets button (![icon]), choose a category, and tap the thumbnail preview for the desired preset; then, click Done. To crop or straighten an image, click the Crop & Rotate button (![icon]); then drag the corners of the cropping rectangle or the graduated rotation wheel below the image preview. Click Done to commit the changes.

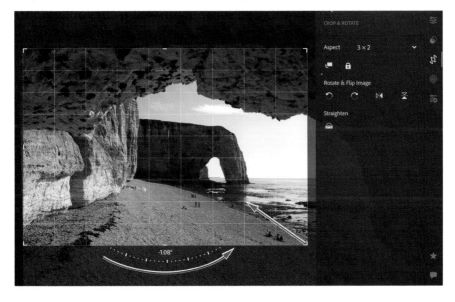

In the Crop & Rotate pane, you'll find a menu of aspect presets and controls for cropping a landscape image to a portrait orientation or vice versa, locking the aspect ratio, and rotating or flipping a photo, as well as an automatic straightening tool.

9 To edit part of an image without affecting other areas, tap the Selective Edits button (⬤). Tap the **+** icon at the upper left to choose a local adjustment tool. Apply the tool; then, choose an adjustment category and make your adjustments. When you're satisfied with the results, click Done.

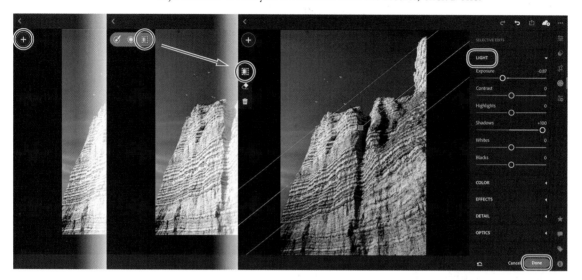

10 To undo more than just your last edit, tap the Reset button at the lower left of the Edits pane. Choose Adjustments to undo lighting and color edits and develop presets, maintaining your cropping and rotation settings. Choose All to revert all modifications made to the image in Lightroom; choose To Import to reset all changes made on this device, or To Open to reset all edits performed in this editing session.

11 Return to Lightroom on your desktop and check for the changes you made. When you're done, choose File > Open Recent > LRClassicCIB Catalog.lrcat.

Congratulations; you've completed this lesson on developing basics. You've picked up some important technical background about white balance, screen previews, and process versions, while practicing with some of the tools for correcting common image problems in both the Library and Develop modules. You've also made a start on working with your synced photos on your mobile device.

You worked with retouching tools to heal skin blemishes and correct flash effects in eyes, and to improve a composition by removing extraneous objects, and you used a local adjustment tool to edit just part of an image selectively.

You'll learn more about adjusting and developing images in the next lesson, but before you move on, take a moment to refresh some of what you've learned by reading through the review on the next page.

Review questions

1 What is a Smart Preview?

2 What is the meaning of the term *white balance*?

3 How can you straighten a crooked photo?

4 What is the difference between the Clone and Heal modes for the Spot Removal tool?

5 How does a Spot Removal tool *brush spot* differ from a *circle spot*?

Review answers

1 A Smart Preview is a high-resolution preview with a file size around 5% of the original raw file. Smart Previews enable you to edit images that are off-line, even at high magnification; Lightroom automatically updates the originals when they come back on-line. Smart Previews make it possible to edit even the largest files in Lightroom mobile.

2 An image's white balance reflects the light source when the picture was taken. Different types of artificial lighting and weather conditions can produce light that is dominated by one color or deficient in another, resulting in images with a color cast. White balance correction is the process of "re-calibrating" the spread of colors in an image in order to remove the color cast or tint.

3 You can straighten a tilted image by dragging to rotate the cropping rectangle, or use the Straighten tool (⬤), which lets you mark a horizontal or vertical element in a tilted photo as a reference around which Lightroom then straightens the image. In many cases, the Straighten tool's Auto button will successfully level a photo automatically, without the need to specify a reference with the tool.

4 In Clone mode, the Spot Removal tool replaces the target area with an exact copy of the source—ideal for dealing with regular patterns or textures. In Heal mode, the tool matches color and tone to blend the sample into the target area, instead of replacing it; best for areas with graduated color or fine, random textures.

5 A single click with the Spot Removal tool produces a circle spot. To create a brush spot you can either drag to "paint" an irregular-shaped spot freehand, or use the Shift key to connect two or more clicks to create a linear brush spot. All Spot Removal adjustments can be moved and made more or less soft-edged or opaque, but only circle spots can be scaled. Unlike brush spots, circle spots do not have marker pins.

PHOTOGRAPHY SHOWCASE
VIRAJ ANDREW BUNNAG

"The best thing about a picture is that it never changes, even when the people in it do." - Andy Warhol

My photographic journey started early, when I was given a book on photography and a well-used, second hand Nikon F2 film camera at the age of thirteen.

I continued to shoot film for many years, all the way up until college. By that time, the age of consumer digital photography was just beginning; I was encouraged to make the switch, and found that in transitioning from film to digital, I would also need to learn an entirely new skill set for the digital darkroom. Enter Photoshop 5.5.

My journey entered a new phase when I began working as a digital visual fx artist in the feature film industry, where I was fortunate enough to pick up yet another new set of skills, including lighting, cinematography, color grading, digital matte painting, and digital compositing—all of which would later help me immensely as a professional photographer and image retoucher.

Both Lightroom and Photoshop continue to play a huge role in my creative work, enabling me to recapture the richness and depth of traditional film looks and effects and create a sense of cinematic drama.

vbunnagphotography.com
instagram.com/vbunnagphotography/

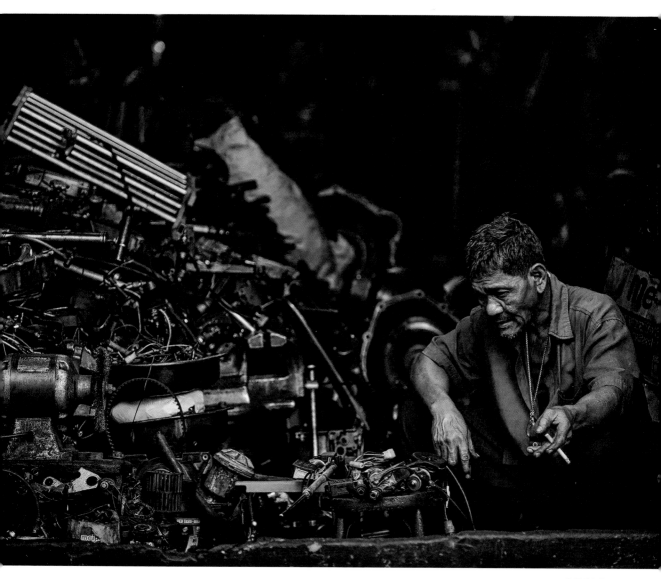

DAY'S END

FLAMER PORTRAIT

RUSH HOUR, SHIBUYA, TOKYO

UPPERCUT BEFORE THE KNOCKOUT

WING TSUN PORTRAIT

WHILE IT LASTS

6 ADVANCED EDITING

Lesson overview

Inadequate or artificial lighting, unusual shooting conditions, incorrect camera settings, and the idiosyncrasies of lenses can all lead to image faults. In the Develop module Lightroom delivers a suite of powerful developing controls to quickly rectify these problems, as well as an array of tools for creatively enhancing your photos.

In this lesson, you'll explore the Develop module in detail, gaining hands-on experience with most of these specialized tools as you practice some of the more advanced editing techniques:

- Correcting color problems and adjusting the tonal range
- Using the History and Snapshots panels
- Understanding the Histogram and the Tone Curve
- Adjusting specific areas in an image selectively
- Working with black and white and split tone effects
- Sharpening images and removing noise and distortion
- Creating your own Develop presets
- Merging photos to produce panoramas and HDR images

 You'll probably need around two hours to complete this lesson. If you haven't already done so, log in to your peachpit.com account to download the lesson files for this chapter, or follow the instructions under "Accessing the Lesson Files and Web Edition" in the Getting Started section at the beginning of this book.

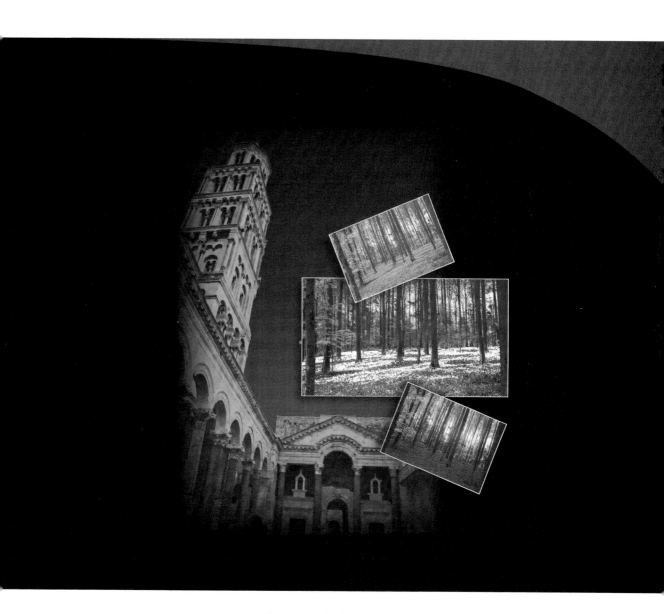

Fine-tune and polish your photographs with precise, easy-to-use tools, and then take your developing a step beyond just correcting your images; use the Develop module tools and controls creatively to customize your own special effects, and then save them as custom develop presets.

Getting started

Note: This lesson assumes that you already have a basic working familiarity with the Lightroom Classic CC workspace. If you need more background information, refer to Lightroom Classic CC Help, or review the previous lessons..

Before you begin, make sure you've set up the LRClassicCIB folder for your lesson files and created the LRClassicCIB Catalog file to manage them, as described in "Accessing the Lesson Files and Web Edition" and "Creating a catalog file for working with this book" in the Getting Started chapter at the start of this book.

If you haven't already done so, download the Lesson 6 folder from your Account page at www.peachpit.com to the LRClassicCIB \ Lessons folder, as detailed in "Accessing the Lesson Files and Web Edition" in the chapter "Getting Started."

1 Start Lightroom Classic CC. In the Adobe Photoshop Lightroom Classic CC - Select Catalog dialog box, make sure the file LRClassicCIB Catalog.lrcat is selected under Select A Recent Catalog To Open, and then click Open.

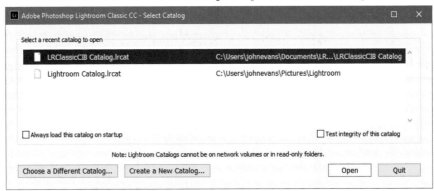

2 Lightroom Classic CC will open in the screen mode and workspace module that were active when you last quit. If necessary, switch to the Library module; then, click the Import button below the left panel group.

3 Under Source at the left of the Import dialog box, locate and select the LRClassicCIB \ Lessons \ Lesson 6 folder. Make sure that the Include Subfolders option at the top of the Source panel is disabled.

4 In the import options above the thumbnail previews, select Add. In the Keywords text box, type **Lesson 6, Develop**; then, click Import.

The six raw images are imported from the Lesson 6 folder and now appear in both the Library Grid view and in the Filmstrip across the bottom of the workspace.

Correcting color balance and tonal range

A light source with a deficient color spectrum can cause an overall color imbalance, or *color cast*, that typically appears as if the photo was viewed through a tinted overlay. Fluorescent lighting, for example, is notorious for a cold, blue-green tint, while images shot under Tungsten lights often have an overly warm, orange cast.

Tonal imbalances result from exposure problems. An underexposed photo appears too dark, while an overexposed shot looks pale and washed-out—and without a balanced spread of tones, both will lack contrast. Even for an expert, overcast or twilight lighting presents a challenge, and back-lit conditions can make it almost impossible to achieve a balanced exposure across the whole photograph.

In the Develop module, the basic tone and color corrections your photos are likely to need are generally best made in the following order:

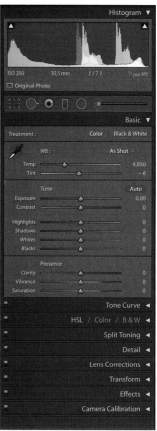

- Inspect the Histogram as an aid to understanding the photo's deficiencies. As you work on the image, the Histogram provides feedback on the effects of your adjustments.

- In the Basic panel, set the white point to correct the color balance.

- Maximize the image's tonal range using the Basic panel's tone controls.

- Tweak the contrast selectively using the Tone Curve panel.

- Adjust specific colors in the HSL / Color / B & W panel.

- Apply sharpening and noise reduction in the Detail panel.

- Correct lens effects such as distortion, color fringes, and vignetting in the Lens Corrections and Camera Calibration panels.

- Add special effects such as duo-tone treatments, simulated film grain, and decorative vignetting, using the Split Toning and Effects panels.

As you can see in the illustration at the right, this order is reflected in the layout of the panels in the right group; although you may often make only a handful of adjustments to any one image, you can work your way down the right panel group, using it as an image processing checklist.

1 If you're not already in the Develop module, press the D key. Show the Filmstrip, if necessary, and select the image DSC_5966.NEF, an inadequate exposure of a medieval courtyard enclosed by a brightly sunlit building on one side and deeply shadowed walls on the other.

2 Hide the Module picker (F5), the left panel group (F7), and the Filmstrip (F6). Make sure that both the Histogram panel and the Basic panel are expanded; then, drag the left edge of the right panel group to make it as wide as possible. Wider adjustment sliders give you finer control.

The controls in the Basic panel are also arranged from top to bottom in the order that's likely to produce the best results. This is certainly no hard-and-fast rule, but if you're new to image correction, you can let the layout guide you through the workflow.

3 Starting at the top of the Basic panel, try a few of the White Balance (WB) presets; then set the WB: Auto adjustment for this photo.

▶ **Tip:** If the colors you see on-screen differ significantly from those illustrated, consider calibrating your display. See Windows / macOS help for instructions. Slighter differences may be a result of the CMYK printing process.

4 Moving down the Basic panel to the Tone controls, click Auto Tone. Undo and redo the Auto Tone adjustment, noting the effect it has on the Histogram and the tone settings in the Basic panel, as well the changes in the image itself.

▶ **Tip:** Auto Tone may be all you need for some photos, but for others it may produce less satisfactory results. In such cases, you can use the Auto adjustment as a base for manual modification, or read the settings as a diagnosis of the photo's problems; then, undo and devise your own solutions.

The adjustment to the photo's tonal distribution has revealed color and detail that was almost invisible in the more deeply shadowed areas such as the cafe furniture and increased definition in mid-toned areas like the wall at the far side of the courtyard. Overall the image has far more color and depth, though the sunlit walls and the roofs above them still appear over-exposed.

Though the result is less than optimal, Auto Tone has improved the photo's tonal range markedly. The Histogram curve is still far from ideal, but the dominant peak of information clumped in the Blacks and Shadows ranges has become much broader and shifted to the right to fill out the mid-tones a little.

Undoing, redoing, and remembering changes

Lightroom offers several options for undoing and redoing changes and recalling key stages in the develop process. The Edit > Undo command (Ctrl+Z / Command+Z) lets you undo the last command executed; pressing Ctrl+Y / Command+Shift+Z will redo the last command undone. To jump backward and forward in the editing history by more than one step at a time, you'll use the History panel instead.

The History panel

1 Press F7 or click the triangle at the left edge of the workspace to show the left panel group. If necessary, collapse any other panels that are open (except the Navigator) to see the History panel.

2 Expand the History panel; you'll see a list of every operation that has already been performed; with the most recent command at the top.

3 Watch the Navigator panel as you move the pointer slowly up the list of commands in the History panel. The Navigator preview shows how the image looked at each stage of its developing history.

4 Click the top entry—Auto Settings—to return the image to its most recent edited state.

Note: If you return an image to a previous state by clicking an entry in the History panel, and then make any new adjustment, all of the entries above your current position will be replaced by the new command.

Creating snapshots

The History list can quickly become long and unwieldy, so it's a good idea to save key steps in an image's developing history as Snapshots for quick and easy recovery. In this case, you'll use a snapshot as a reference to guide you as you work.

1 In the History panel, right-click / Control-click the Auto Tone entry and choose Create Snapshot from the context menu.

2 In the New Snapshot dialog box, type **Auto WB & Tone** to name the snapshot; then, click Create. Your new snapshot appears in the Snapshots panel.

Getting more from the Before & After view

By default, the un-edited photo as imported is displayed as the Before image in the Before & After view. However, this is not always helpful; it may be more meaningful to compare the results of your latest adjustments to a more recent state.

You can designate any stage in the developing history—or any saved snapshot—as the Before image. Change the Before image when you're happy with your work thus far, then work beside it so that you can see exactly what gains you're making.

1 Click the Before & After view button in the Toolbar, repeatedly if necessary, until the two states of the photo are displayed one above the other.

▶ **Tip:** If you don't see the Toolbar below the work area, press T.

2 Right-click / Control-click your saved snapshot in the Snapshots panel and choose Copy Snapshot Settings To Before. Both sides of the view should now be showing the photo as it appears with the Auto Tone adjustment.

3 In the Basic panel, double-click the name of each of the six adjustment controls in the Tone pane to zero the current settings.

Each of these six actions is listed as a new entry in the History panel. The Auto Tone adjustment hasn't really been undone—it merely became history, superseded by more recent events. Once you've zeroed all six controls, the After view is identical to the history state just before you applied the Auto Tone adjustment.

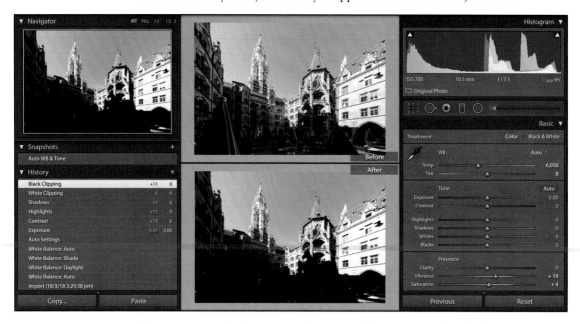

▶ **Tip:** In the Loupe view, you can quickly toggle between the most recent state of an image and the designated Before state by pressing the Backslash key (\) on your keyboard.

Now you can go back to your exploration of the Basic panel, with the snapshot Auto WB & Tone serving as a benchmark to which you can compare your efforts.

Working with the Tone controls

As with the panels in the right panel group, you'll start at the top.

The first step is to use the Exposure control to set the overall image brightness by correcting the midtones range; then, you can retrieve detail from the lightest and darkest areas with the Highlights and Shadows controls and correct clipping at the ends of the curve by tweaking the Whites and Blacks settings.

1 Hide the left panel group to make more room for your working view.

2 In the Basic panel, drag the Exposure slider all the way to the left, and then back up through its range. Watch the effect on the curve in the Histogram as well as in the After image. When you're done, set the Exposure value to **1.75**.

● **Note:** In terms of camera f-stops, increasing the exposure by 1 is equivalent to opening the aperture one stop.

3 Experiment with the Contrast slider, and then set the contrast to **+25** (%).

4 Watch the Histogram, as well as the After image, as you drag the Highlights slider slowly, all the way to the left. Notice the dramatic effect on the lighter parts of the image, while very little changes elsewhere, even in the adjacent mid-tones. The peak in the Whites zone of the Histogram curve disappears, and the right end of the curve moves towards the center. Set the Highlights to **-75**.

5 Drag the Shadows slider slowly, all the way to the right. Watch how little effect this has on the mid-tones and highlights in the image, relative to the gain in the darkest areas. When you're done, leave the Shadows set to **+75**.

▶ **Tip:** To modify any of the settings, you can either drag the slider, scrub horizontally over the numerical value, or click the setting's name to activate it, and then use the Plus (+) and Minus (-) keys.

After WB, Exposure and Contrast Highlights -75 Shadows +75

These Highlights and Shadows settings are somewhat extreme; at these levels you'll notice a glowing halo effect where light and dark areas meet, giving the scene an unreal look—and there is also the risk of introducing noticeable noise. As a general rule, set values between -50 and +50 for image correction and use higher settings sparingly to rescue problem photos or to achieve creative effects.

6 Set the Blacks to **+10** and leave Whites at the zero setting—for this image, just short of levels that would result in clipping at the ends of the Histogram curve. In the Presence pane, set the Clarity to **30** to enhance image definition.

● **Note:** Clarity effects local contrast between small adjacent areas of light and dark.

The photo now has a little less detail in the brightest areas than the auto-toned Before image, but a great deal more detail through the mid-tones and shadows. Though the image is much improved, the problem now is that any attempt to further improve the brightly lit buildings using the Tone controls in the Basic panel will adversely affect the more predominant shadowed areas.

Tip: You can add to, or subtract from, the area affected by an active Radial Filter by setting the tool to Brush mode, and then painting onto the photo, or by constraining using the Range Mask feature.

This image is divided into light and dark loosely along a diagonal line, so you can use the Graduated Filter tool to create a straight-edged, feathered mask through which you can adjust the overexposed areas without adversely affecting the rest of the photo. First, you'll set the adjustments to be applied through the Radial Filter.

7 Click the Loupe view button (◼) in the Toolbar. Click the Graduated Filter tool, the fourth of the tools in the strip just below the Histogram, to activate it. Lower the Exposure setting for the local adjustment to **-0.6** and reduce the Highlights to **-50**. Set both the Clarity and Saturation values to **25**. Zero all the other settings. These adjustments will be applied at 100% outside the starting end of the gradient mask, fading to 0% at the line where it ends.

Tip: The Graduated Filter is being applied over global adjustments, so that the cumulative values add up to some fairly extreme settings. As a result, the effect you see on-screen may not look like the illustration at the right if your display is calibrated differently from ours. Try adjusting the filter's settings; if the problem is a color-cast, for example, tweak the Temperature and Tint.

9 Starting just below the roof on the closest face of the nearer tower, drag with the Graduated Filter tool to align the center line with the edge of the roof at the far side of the courtyard as shown in the illustration below.

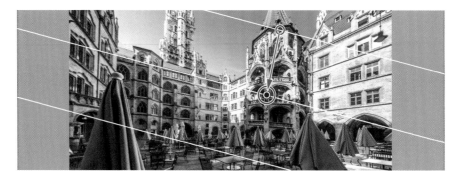

10 Press M to deactivate the Graduated Filter tool. The Histogram shows that this image now has some clipping in the blacks; hold down the Alt / Option key and drag the Blacks slider to the right until you see the last colored spots disappear on the white background of the clipping preview (we set a Blacks value of **20**).

11 Return to the Before & After view and show the left panel group (F7). In the History panel, right-click / Control-click the Import entry and choose Copy History Step Settings To Before; then, hide the left panels again.

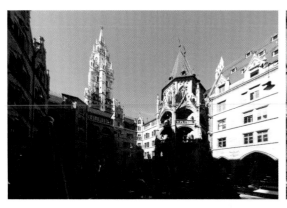

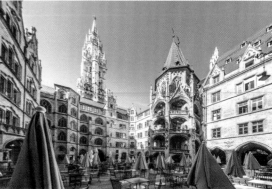

Beyond the Basic panel

Once you've adjusted the white balance and the tonal distribution in the Basic panel, you can move on to the rest of the panels in the right panel group.

1 In the Filmstrip, select the image DSC_6051.NEF, a photograph of the cliffs of Normandy; then, press D on your keyboard to switch to the Develop module.

2 You can make more space in the Loupe view for this portrait-format photo by hiding the top panel (F5) and the Filmstrip (F6). Press T to hide the Toolbar. Make sure that both side panel groups are visible.

3 Inspect the settings in the Basic panel; you can see that the settings for this Raw image have already been adjusted towards maximizing and balancing the overall tonal range. Expand the Histogram and Tone Curve panels. For a clearer view, collapse the Basic panel and any other panels that are currently expanded.

Adjusting contrast using the tone curve

Working with the Tone Curve enables you to adjust contrast in different parts of the tonal range selectively. Tone curve corrections should not be applied until after the imaged has been processed as necessary with the controls in the Basic panel.

The tone curve maps the distribution of tonal values in the input image along the x-axis to a new distribution of tonal values in the output image along the y-axis. The dark end of the range is at the lower left and the light at the upper right.

A linear tone curve at a 45° incline from the lower left corner to the upper right corner has no effect on the image; each tone value in the input image is mapped to the identical tone value in the output image. Raising the tone curve above this line maps tone values to a lighter value; lowering it darkens the tonal values.

A tone curve section that is flatter than 45° compresses a range of tone values from the input image (x axis) to a narrower range in the output image (y axis). Some tone values which were distinguishable in the input image become indistinguishable in the output image, resulting in a loss of image detail.

A tone curve section that is steeper than 45° expands tone values; the differences between tone values becomes more noticeable and therefore the image contrast is increased.

In Lightroom, the tone curve is constrained so that the curve is always ascending. This means that if you increase the incline of one section of the curve you'll end up with a decreased incline somewhere else; you'll have to make a compromise. When using the tone curve, the trick is to increase the contrast in the range where you have the most tonal information; recognizable by a peak in the histogram. At the same time, try to place the flatter parts of the tone curve in ranges where there is less information in the image (troughs in the histogram) or where a lack of contrast is not as disturbing or noticeable.

A typical tone curve intended to increase mid-range contrast starts flat in the lower left corner (less contrast in the shadows), is steep in the center (more contrast in the mid-tones), and ends flat in the upper right corner (less contrast in the highlights).

For the photo at hand we'll customize the tone curve to selectively increase the contrast in the brightly-lit portion of the cliff face, which dominates the image. For this substantial enhancement it will be worthwhile sacrificing a little tonal depth in the shadowed area at the lower right and in the sky.

1 In the header of the Navigator, set the Loupe view zoom level to FIT.

Note: The choice of point curve preset also constrains the amount of play in the adjustment controls.

2 From the Point Curve menu at the bottom of the Tone Curve panel, choose Linear, Medium Contrast, and Strong Contrast in turn and notice the effect each setting has on the image. You can use a tone curve preset as a starting point for your adjustments; for this image, set a Medium Contrast curve.

Note the silhouette of the histogram plotted in the background in the tone curve display. This gives you an indication of the tonal ranges where an increase in contrast might be most effective.

Tip: By default, the four tonal ranges are of equal width. You can change their width by dragging the controls below the tone curve to reposition the dividing lines between adjacent tonal ranges.

3 Position the pointer over the tone curve. As you move along the curve, you'll notice the name of the range currently under your pointer displayed at the bottom of the tone curve grid, while the corresponding slider is highlighted in the Region controls below.

Whether you use the sliders, enter numeric values, or drag directly in the tone curve grid, the tone curve controls raise or lower the curve by moving the center points of these four ranges: Shadows, Darks, Lights, and Highlights. The overall shape of the tone curve changes to accommodate your adjustments, becoming flatter in one place and steeper in another.

The extent to which you can adjust each section of the tone curve is indicated by the lighter gray area that appears when you position the pointer over that section.

4 To see which areas in the image correspond to the different tonal ranges, click the Target button (⊚) in the top left corner of the Tone Curve panel and move the pointer over the image in the Loupe view. As you move the pointer over the shadowed area in the lower part of the image you can see that these tones account for much of the first peak in the histogram around the 25% mark. Most of the tonal values in the blue sky are represented in the second peak in the histogram silhouette near the 50% input level. The tones in the well-lit parts of the cliff face are mostly spread between input levels of 60% to 90%. The third peak in the histogram corresponds to a mid-beige tone in the striated limestone.

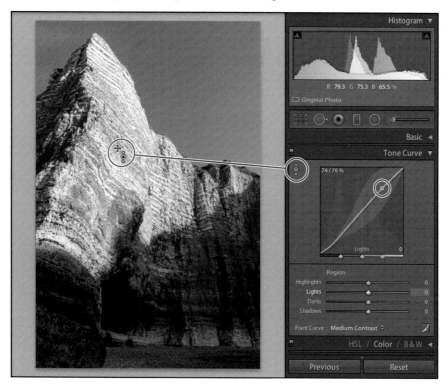

Lowering the Lights value in the curve should increase the contrast in the sunlit cliff face by steepening the curve for input values above 60%. The compromise will be a flattening of the curve for lower input values, which will reduce contrast in the shadowed areas and the sky where a loss of detail is less noticeable.

5 Watch the tone curve as you move the target cursor over the rock face. When you see the Lights adjustment control selected on the Tone Curve, click and drag downwards in the image. Release the mouse button when the Lights value is reduced to –55. Remember: you can only adjust the tone curve by dragging directly in the image when you are using the Tone Curve Target mode.

6 Click the Target button again to turn off target mode.

7 To compare your image with and without the tone curve adjustment, switch the tone curve controls off and on by clicking the On/Off switch at the left side of the Tone Curve panel's header. Review the effect in the image at 100% zoom level. Note how much your adjustment has enhanced the detail in the sunlit stone.

The image was also darkened as a whole because the tone curve was pushed below the diagonal. This works quite well for the photo at hand. In another case, you could lessen the effect, if you wished, by raising the Shadows value in the Tone Curve or by readjusting the levels using the controls in the Basic panel.

8 When you're done, set the zoom level to FIT and make sure the tone curve adjustment is turned on.

Overall, the photo's tonal balance now looks quite acceptable. To improve the image further, you'd need to increase definition in the darker areas selectively.

Making local corrections

The tone adjustment controls and the tone curve affect tones throughout a photo; you can't use them to lighten or darken one area more than another. For many photos, corrections applied across the entire image are sufficient, but for others you'll need to edit different areas separately. The local correction tools—the Graduated Filter, the Radial Filter, and the Adjustment Brush tool—enable you to do just that.

Using the Adjustment Brush tool

You can use the Adjustment Brush tool to edit different areas selectively by painting adjustments directly onto an image. In this exercise, you'll use three different techniques to help you paint inside the lines, limiting your edits to a defined target area.

1 In the Filmstrip, select the image DSC_0438.NEF, a photograph of the moon. And some buildings. If you're not in the Develop module from the previous exercise, press D on your keyboard to switch to the Develop module.

2 Click the Adjustment Brush tool (circled at right) below the Histogram panel, or press K. Controls for the Adjustment Brush tool appear below the tool strip. Make sure that Mask is set to New in the Adjustment Brush tool controls pane.

▶ **Tip:** You can apply multiple brush adjustments to a single image, each with its own effect. Try overlapping and layering adjustments.

3 From the Effect menu above the sliders, choose Temp: a preset that will zero all the controls other than the Temp (temperature) slider. Drag the Temp slider all the way to the left; making the initial adjustment easily noticeable will help you see what you're doing as you paint the mask.

4 Below the Effect pane, click brush A. Set the size to **20**, Feather amount to **0**, and activate the Auto Mask option. With Auto Mask on, the brush will detect the edges of the area you're painting, and mask the parts of the image outside those edges.

⬤ **Note:** You can set up two brushes to apply the adjustment and one that will erase it—each with a different size, softness, flow, and density.

5 Starting with the cursor cross-hairs just inside the right edge of the photo and a little above the top of the building, drag to trace around the roof line and the tower. As you drag, allow the cursor's circle to overlap the edge of the building, but make sure that the cross-hairs always remain over the sky area. When you get to the tower, reduce the brush size by half and try to minimize the overlap.

6 There are some small glimpses of sky visible under an arch below the tower; increase the brush size to **12** and click once in the largest of them.

7 Make sure that the brush adjustment is still selected and active; then, paint over the rest of the sky area, making sure to overlap your strokes for even coverage.

8 In the Toolbar, check Show Selected Mask Overlay. You may need to zoom in to see traces of the translucent red mask overlay around the arch, on the left side of the tower, and on the reflective windows at the right. Hold down the spacebar and drag to move around in the image while keeping the Adjustment Brush active. When you're done, zoom out tho the Fit view.

9 Activate Range Mask below the brush controls and choose Luminance from the menu. Drag the left marker to the right to set a luminance range of **60/100**, leaving the Smoothness set to the default **50**. The extraneous portions of the adjustment mask are removed, leaving only the sky affected.

10 At the top of the Adjustment Brush controls, click New to create a new mask. Your first mask becomes inactive and the colored overlay disappears. From the Effect menu at the top of the controls, choose Exposure. Set the Exposure to **0.5** and the Contrast to **30**. Set the Shadows to **100**, the Whites to **50**, Blacks to **25**, Clarity to **30** and Saturation to **20**. Disable the Auto Mask option and un-check Show Selected Mask Overlay in the Toolbar.

11 Starting on the wall just below the pin of your first brush adjustment, paint over the entire building, allowing your stroke to overlap the edges of the sky and cover the small window of light under the arch.

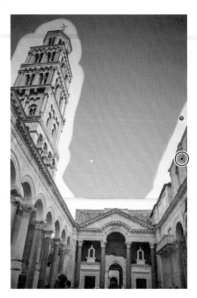

12 Activate Range Mask below the brush controls and choose Color from the menu. Pick up the color range mask eyedropper and click once on the stone wall at the right, not far from the pin at the point where you began painting this mask. In the Toolbar, check Show Selected Mask Overlay. Hold down the Shift key and click an area not yet covered (or not yet at full strength) by the mask. Each time you click, an eyedropper marker is left; you can delete any sample that introduces unwelcome effects by holding Alt / Option and clicking the marker.

13 Click to sample more colors to be included in the mask. You can designate up to five samples; then, each successive click will replace an existing marker, starting with the oldest. If you are unable to extend the mask to cover any small area, press Esc to drop the range mask eyedropper and paint it out with a small brush.

14 When you're done, disable the option Show Selected Mask Overlay in the Toolbar. Activate the mask for the sky by clicking its adjustment pin; then, increase both Temp and Tint settings to **100**. Set the Exposure to **-1**, and the Contrast to **100**. Decrease both the Shadows and Blacks to **-100**, and set the Saturation to **30**.

15 Press K to deactivate the Adjustment Brush, leaving all of the adjustments in force.

Using the two local adjustment masks you've established, you could create any number of treatments for this photo, from simple tonal corrections to surreal and other-worldly flights of fancy; why not create a few virtual copies and try your hand?

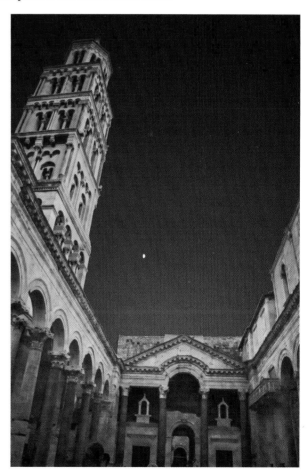

Using the Graduated Filter tool

With the Graduated Filter tool you can create a gradient mask through which you can apply an adjustment so that the effect is strongest in one area and fades off across the rest of the image, as you discovered earlier in this lesson.

1 You should still be in the Develop module from the previous exercise; in the Filmstrip select the image DSCN5366.NRW to see it in the Loupe view. Click to activate the Graduated Filter tool in the strip below the Histogram panel, or press M. Controls for the tool appear below the tool strip.

2 Your first mask will reduce the back-lit glare from of the sky behind the trees. At the top of the Gradient Filter tool controls, choose the Highlights preset from the Effect menu. Set the Temp control to -**15**, the Exposure to -**1.5**, the Highlights to -**100**, and both the Clarity and Dehaze values to **100**.

3 Hold down the Shift key as you drag downward from a point about halfway between the ground horizon and the top edge of the photo; stop dragging when the Gradient filter's center line and adjustment pin reach the forest floor; then, release the mouse button before the Shift key, which has constrained the new gradient mask to the horizontal axis. At the bottom of the controls pane, activate the Luminance Range Mask. Drag the left marker to the right to set a luminance range of **95/100**, and then set the Smoothness value to **70**.

4 Toggle the switch at the lower left of the Gradient Filter controls to assess the adjustments; the mask has effectively cut the glare, with very little effect on the tonal values of the trees or the forest floor, except a slight darkening due to the reduction of the back-lit haze. The brighter green of the tree foliage looks a little duller, having shifted a little toward blue.

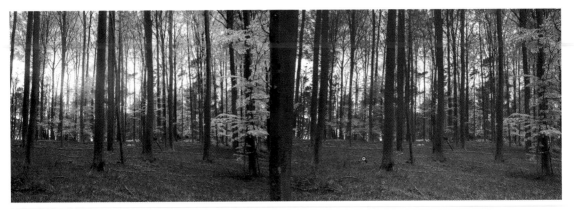

5 Press M to deactivate the Gradient Filter tool, leaving the adjustments in force. In the Tone pane of the Basic panel, click Auto; then press M to reactivate the Gradient Filter tool for a new mask. Choose the Clarity preset from the Effect menu to zero all the settings but Clarity. Increase the Exposure to **2.0**.

6 Hold the Shift key and drag upwards, starting from the base of the tree at center frame, until the lower of the three guide lines of the Gradient Filter tool is aligned with the ground horizon. Release the mouse button, and then the Shift key.

7 Double-click the word Exposure in the tool controls to zero the setting, and then activate the Color Range Mask.

8 Zoom in to the maximum ratio of 11:1 and drag the white rectangle in the Navigator preview to focus the view on a particularly dense patch of violets not far below the line of the ground horizon. Pick up the eyedropper

for the Color Range Mask and drag a marquee around as large a cluster of the flowers as you can manage, trying not to include any small areas of brown or green. Press Esc to drop the Color Range Mask eyedropper.

9 Zoom out to the Fit view, and then drag the Exposure slider to its maximum. In the Range Mask controls, drag the Amount slider all the way to the left to check the mask. Press M to deactivate the Gradient Filter tool, leaving the adjustments.

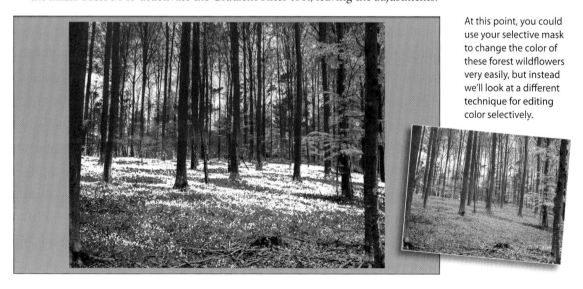

At this point, you could use your selective mask to change the color of these forest wildflowers very easily, but instead we'll look at a different technique for editing color selectively.

Making discrete color adjustments

Before you move on to complete your local adjustment project by selectively adjusting color, we'll take a quick look at some of the basic color theory concepts and terminology behind the HSL / Color / B & W panel.

You can use the color controls in the HSL / Color / B & W panel to adjust discrete shades of color in your image, changing the hue, saturation, or luminance values for specific color ranges independently.

When converting an image to black and white, you can fine-tune the way that each color in the image will contribute to the grayscale mix.

Understanding hue, saturation, and luminance

The color of each pixel in your image can be expressed either as a set of RGB values or as a combination of hue, saturation, and luminance values. Hue, saturation, and luminance values can be calculated from RGB values, and vice versa.

Once you understand hue, saturation, and luminance, defining color in these terms seems far more natural than using RGB values, especially when it comes to describing changes made to color.

For example; in RGB values, R: 42, G: 45, B: 63 describes a light blue, while a darker blue has the values R: 35, G: 38, B: 56. This is certainly not a very intuitive model for understanding color adjustments. In terms of hue, saturation and luminance, however, darkening the blues in your image can be expressed as simply reducing the luminance value for the blue color component.

When you describe a color by name—red, yellow, green, blue—you're referring to its *hue*. The full range of hues can be displayed as a color wheel. Changing the hue is equivalent to moving around the wheel in one direction or the other.

Saturation is the boldness or intensity of a hue, ranging from neutral and grayed to vivid and un-muted. Saturation can be visualized on a color wheel with fully saturated colors around the edge of the circle and less saturated colors closer to the center. As the saturation of a color is increased it moves from a neutral gray in the center of the wheel to a pure, vivid hue on the rim.

Luminance is the measure of brightness of a color, ranging from the minimum value for black to the maximum value for white. On the color wheel model, luminance can be represented by adding a third dimension, with a completely underexposed—or black—wheel below the color wheel and a completely overexposed—or white—wheel above it.

The terms tint, shade, and tone can all be expressed with reference to hue, saturation, and luminance.

A *tint* is a pure hue mixed with white; a hue with increased luminance and a reduced saturation. In our three-dimensional color wheel model the tints of a hue are found along the line from the pure hue on the rim of the wheel in the middle to the center point of the white wheel at the top.

A *shade* is a pure hue mixed with black; a hue with decreased luminance and saturation, located along a line from the pure hue on the rim of the wheel in the middle to the center point of the black wheel at the bottom.

A *tone* is a pure hue mixed with a neutral gray, located along a line from the pure hue on the rim of the wheel in the middle to the respective gray on the central axis.

Adjusting colors selectively

Understanding color in an image in terms of hue, saturation and luminance can help you both in identifying the changes you need to make to achieve the effect you want and in choosing the most effective way to make those changes. In this exercise you'll darken the blue of the sky in the photo of the sandstone cliffs. You can do this by reducing the luminance of the blue color range.

1 You should still be in the Develop module, with the image of the forest wild-flowers, DSCN5366.NRW, open in the Loupe view. Press M to activate the Gradient Filter tool; then click the adjustment pin on the preview image to activate the mask for the violets. Zero the Exposure and Clarity settings, and then deactivate the Gradient Filter tool.

2 In the right panel group, collapse the other panels, if necessary, and expand the HSL / Color / B & W panel. If it's not already selected, click the HSL (Hue, Saturation, Luminance) tab in the panel header, and then click the Luminance tab on the bar right below it.

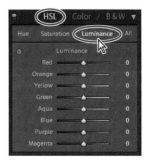

3 Click the Target tool button (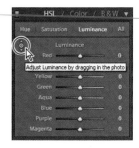) in the upper left corner of the Luminance pane.

4 In the Loupe view, click in a dense patch of violets and drag upwards to increase the luminance of the color range under the pointer. Release the mouse button when the Luminance values for Blue and Purple reach **+100**. The adjustment is lightening the sky too much, so drag the Blue slider down to **+50**.

5 While the target mode is still active, click the Saturation tab at the top of the HSL controls and repeat the process to set the Saturation value for Blue to **+30**. The more saturated purple is darkening the flowers; zero the Saturation for Purple.

6 Click the Hue tab and drag upwards in the flowers until the Purple value reaches **+40**. Drag the slider to reduce the Blue Hue shift to **+20**.

● **Note:** Hue, saturation, and luminance adjustments are not restricted to a single, discrete color but are applied across a range of colors related to the target hue.

7 Repeat the targeted hue, saturation and luminance adjustments for the greens in the image; work with a shaded green in the foreground tree foliage, rather than the brightest leaves. Use the Target tool to set both the Luminance and Saturation values to **+40** and the Hue to **- 15**. Don't be concerned with tweaking the Yellow values that have shifted together with the Green.

8 Press Esc to drop the Target button and disable target mode.

9 To compare the image with and without the hue, saturation and luminance adjustments, switch the HSL adjustment off and on by clicking the switch at the left of the HSL / Color / B & W panel header. When you're done, make sure the HSL adjustment is turned on.

10 Examine the All tab in the HSL pane. To check out the options in the Color pane, click Color on the header of the HSL / Color / B & W panel.

Converting an image to black and white

Lightroom converts a photo to black and white by mapping each color value to a default tone of gray. You can create very different grayscale looks for the same photo by adjusting the way that each color contributes to the mix.

1 In the Filmstrip, select the Raw image DSC_0132.NEF; then, click B & W in the header of the HSL / Color / B & W panel. You can see the result of the default black and white mix in the Loupe view and in the settings of the control sliders in the B & W pane. You can tweak the slider for each color manually or adjust the black and white mix visually using the adjustment target tool.

2 Click the Target button (⊙) at the upper left of the B & W tab. In the Loupe view, click a sun-lit brick at the left edge of the image; then, drag upwards to set the Orange value to +100. You'll notice that the Red value increases at the same time; double-click the word Red to zero that value, deepening the shade on the bricks and restoring some definition in the mortar lines in the brighter areas.

3 Move the target cursor over a lighter area in the cornice at the top of the image; then, drag downwards to decrease the Aqua value to -75. The Blue value is also reduced; double-click the word Blue to zero the setting. Click the Black And White Mix Target button (⊙) again to turn target mode off. As a final touch, set the Clarity value at the bottom of the Basic panel to +40 to increase definition.

4 To compare the image before and after your adjustments, toggle the On/Off switch at the left side of the HSL / Color / B & W panel header. When you're done, make sure to leave the Black And White Mix controls enabled.

Original, uncorrected photo

Default B & W conversion

Grayscale mix adjusted

Split toning

A split toning effect replaces the dark tones in an image with shades of one color and the lighter tones with tints of another. The effect can be quite subtle and restrained or very striking and unusual depending on your choice of colors.

1 In the right panel group, expand the Split Toning panel. Keep the HSL / Color / B & W panel open so you can see the settings for the grayscale mix.

2 In the left panel group, expand the Presets panel, if necessary, and then choose Split Tone 2 from the Lightroom B&W Toned Presets category. Note the changes in the Black & White Mix pane as well as the Split Toning panel. This effect uses a light olive for the highlights and a de-saturated French blue for the shadows.

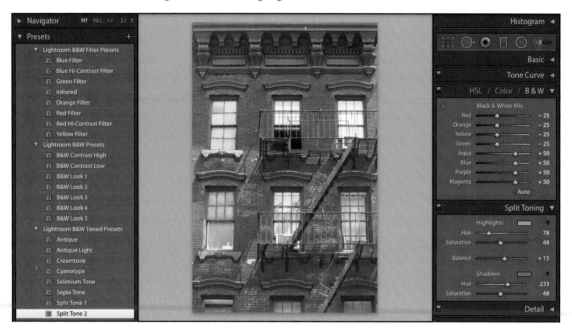

3 In the right panel group, expand the Basic and Tone Curve panels in turn, using Undo and Redo to see how the Split Tone 2 preset changes the settings. Collapse each panel when you're done with it.

This preset has built-in settings for the black and white mix, tone controls, and tone curve that override the look you created earlier. To counter this, you can copy just the color settings from the Split Toning panel, without the preset tone adjustments.

4 Right-click / Control-click the image and choose Settings > Copy Settings from the context menu. In the Copy Settings dialog box, first click the Check None button, and then activate only the Split Toning option. Click Copy.

5 Choose Edit > Undo Preset: Split Tone 2 to return to the black and white image with all your customized settings. Right-click / Control-click the image in the Loupe view and choose Settings > Paste Settings from the context menu.

Split Tone 2 preset applied Preset's Split Toning settings only applied

By checking the panels in the right panel group, you can confirm that this time, only the settings in the Split Toning panel have changed; there are no alterations to the tone and grayscale mix settings that make up the look you set up earlier.

Synchronizing settings

You can copy, or *synchronize*, the settings you've applied to one photo to a multiple selection of images by using the Synchronize Settings command.

This can be a real time-saver when you want the same look for all of the photos in a presentation such as a slideshow, web gallery, or print layout.

1 In the Filmstrip, Ctrl-click / Command-click to select all four of the Lesson 6 photos; then, click the photo with the split tone effect to make sure that it's the active (the most selected) image.

2 Click the Sync button below the right panel group. In the Synchronize Settings dialog box, click the Check None button, and then activate the Basic Tone, Treatment (Black & White) and Split Toning options. Click Synchronize.

All of the selected images have been converted to black and white and have had the duo-tone effect that you copied from the Split Tone 2 preset applied.

3 Undo the Synchronize operation to restore the images in your selection to the settings you applied in previous exercises.

▶ **Tip:** The Synchronize Settings command in the Develop module copies absolute values from one image to the others. To apply relative changes to a selection of images—such as increasing exposure by 1/3 step independent of the current exposure settings in each of the destination images— you can use the Quick Development panel in the Library module.

Removing camera-generated image artifacts

Before moving to the Detail panel to look at image noise and sharpening, you need to visit the Lens Corrections panel to deal with two unwelcome image artifacts.

1 Show the Filmstrip if it's hidden and select the photo of the medieval courtyard. Use the zoom picker and preview in the Navigator panel to set a 2:1 or 3:1 zoom and focus the view on the window and lamp just below the roof at the far right.

Our lesson photo exhibits *chromatic aberration*, an image artifact usually most noticeable near the edges of a photo shot with a wide-angle lens, resulting in color fringes (green/blue and magenta/purple) where the lens has been unable to correctly align the different wavelengths of incoming light on the sensor.

Tip: For information on using camera and lens profiles optimize corrections, please refer to Lightroom Help.

2 In the right panel group, expand the Lens Corrections panel. If it's not already active, click the Profile tab at the top of the panel. Note that profile-based corrections have already been enabled; lens correction operations work better if Lightroom can access the camera and lens profiles in the image's metadata.

Though you may not notice it until you zoom in closely to an image, chromatic aberration can cause even a well focused photo to look blurred, somewhat similar to the appearance of off-register printing in a cheap magazine.

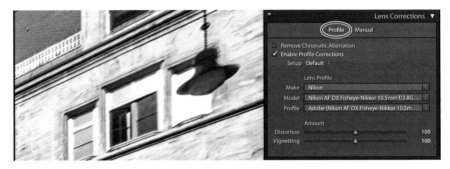

3 Watch the zoomed image as you activate the Remove Chromatic Aberration option. The operation was partly successful, but much of the magenta fringe remains at the edges where lighter-toned areas meet darker objects.

Note: If Lightroom can't detect the hues usually produced by chromatic aberration, you'll be asked to pick a different color.

4 In the Lens Corrections panel, click the Manual tab, and then pick up the Defringe eyedropper. Move the eyedropper over the image; a pixel-level preview gives you a clear view of the colors under the pointer. Click to sample a magenta/purple pixel from the lamps's left edge.

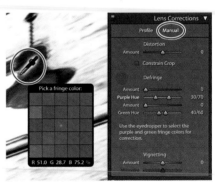

As you can see in the illustration above, the automatic chromatic aberration removal has successfully corrected the green fringes, but at the extreme left and right edges of the photo, their removal has left behind a pinkish "ghost."

5 Press the Esc key to release the Defringe eyedropper; an attempt to remove the pink ghosting with the eyedropper at this point would reinstate the magenta fringe. In the Lens Corrections panel, move the Purple Hue range markers from a setting of **35/60** to **40/80**. If there was any movement in the green Amount and Hue sliders, reset the values to **0** and **40/60**.

6 Zoom out to the FIT view.

Correcting lens distortion

As a final step, we'll look at the Transform controls that let you manually correct distortion caused by the camera lens. Our lesson photo was shot with a (very) wide-angled lens; it exhibits extreme *keystone distortion*, a classic effect of *fish-eye* lenses—but even "standard" lenses produce some degree of distortion.

Once again, it's important to start by enabling profile-based correction so that both automatic and manual adjustments are tailored to the idiosyncrasies of your lens.

1 Expand the Transform pane; note that the controls have pre-applied settings; toggle the switch in the Lens Corrections panel header to turn their effects off and on. In preparing the lesson image, we applied these settings to remove most of the keystone distortion. Make sure to return the switch to the on position.

2 Drag each of the Transform sliders back and forth to see its effect on the photo, making sure that you restore the original setting before moving on to the next.

Correcting perspective effects automatically

Even though a photo may not exhibit distortion as obvious as a fish-eye effect, objects in the image can be affected by perspective in ways that can diminish the impact of the image by distracting attention from the subject.

The Upright feature can correct perspective effects automatically by analyzing image content in the light of information from the lens profile, looking for elements affected in various ways by perspective. Every photo will perform differently with the Upright feature. For some photos, one or more of the Upright modes may produce no result at all if Lightroom can't find a viable correction; try all four modes for any image you wish to correct.

▶ **Tip:** For the best results, you should always enable the lens profile before applying Upright corrections; for some photos, Upright might work well without reference to a lens profile, but in many cases the results can be unpredictable.

1 In the Filmstrip, select the image DSC_0055.NEF. Set the zoom level to FIT.

2 Click the Profile tab at the top of the Lens Corrections panel, and then make sure that the Enable Profile Corrections option is still activated.

3 Expand the Transform panel. In the Upright controls, click the Auto, Level, Vertical, and Full buttons in turn.

Original image

Upright: Level mode

Upright: Vertical mode

● **Note:** An Upright correction will reset cropping and override any manual distortion transforms unless you hold Alt / Option when you apply the feature.

Level corrections are weighted in favor of horizontal elements in the image; you can use the Level tool to straighten a tilted image automatically, even when the horizon is hidden and all the so-called horizontal elements in the image are angled by perspective, as is the case with our lesson photo. Upright analyzes converging horizontals, calculates the hidden horizon, and straightens the image accordingly.

Vertical corrections are weighted towards vertical detail, but also level the image. The Vertical mode corrects *keystone distortion*, the perspective effect that causes vertical lines to converge when your camera is tilted upwards.

The Auto mode usually produces the most "realistic" results; intelligently blending level, vertical and perspective corrections in a way that makes the most of your image without forcing or favoring any particular aspect.

The Upright feature's Full mode combines the full effects of the Level, Vertical, and Auto perspective corrections; with the right photo, it can produce a striking result.

4 Click Off to clear the last Upright adjustment; then click the Guided button, or simply pick up the Guided Upright tool at the upper left of the Transformations panel.

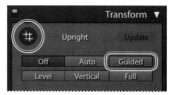

5 The tool icon hints at how the Guided Upright tool is to be used; drag lines along two converging horizontal references such as the roof line and the base of the iron fence to neutralize the horizontal perspective. Drag lines along two converging verticals to remove the keystone distortion.

Try to replicate what you see in the illustration at right: a completely frontal view, with no trace of perspective distortion. The guides remain "live" after the correction is applied; you can still move and rotate them to tweak the result.

Enable the Constrain Crop option to have Upright crop away areas left empty after a perspective correction. If the upright correction gives your photo a stretched or compressed look, adjust it with the Aspect slider in the manual Transform controls.

If you enable or disable profile corrections, or change the lens profile, after you've applied an Upright correction, you'll need to click Update in the Upright pane; Lightroom will re-calculate the existing correction accordingly.

Sharpening detail and reducing noise

The Detail panel hosts controls for sharpening image detail and reducing noise. Sharpening helps make edges more pronounced and gives the image a crisper look. Lightroom applies a slight amount of sharpening to your Raw images by default, so you should apply additional sharpening with caution.

1 In the Filmstrip, select the photo with the split tone effect. Set the zoom level to 1:1 (100%); sharpening and noise reduction edits are always best executed at 100%; the pixel-for-pixel view gives you the clearest appreciation of the results. Scroll down in the right panel group and expand the Detail panel.

2 To compare the image with and without the default 25% sharpening, switch the Detail controls off and on by clicking the switch at the left of the panel header. Review the effect in several areas of the image at 100% magnification. When you're done, make sure that the Detail settings are enabled.

▶ **Tip:** Depending on your intention, you may not always need to use four guides (the limit); the Upright tool will modify the perspective as soon as you have placed two. A pair of converging (not crossing) horizontal guides, for example, will modify the horizontal perspective, as in the exercise. A third guide can then be added to designate a single vertical for straightening, leaving the converging vertical perspective in place overall, but rearranging it around your reference. In the same way, a single horizontal guide, together with just one vertical, will establish references for both axes without correcting convergence.

Though the default sharpening has done a good job of emphasizing the edges in this image, you can still make it crisper. Before you apply extra sharpening, however, it's best to set up a mask that will restrict your adjustment to areas with edge detail: this will enable you to sharpen detail without accentuating image noise.

3 Focus the magnified Loupe view on part of the decorative cornice at the upper right. Hold down the Alt / Option key and drag the Masking slider to the right. Release the mouse button when most of the finer lines in the paint-work have disappeared, leaving the structural edges clearly outlined in white (we set a value of **70**). The black areas will be protected from sharpening.

4 To sharpen the image, drag the Amount slider to the right. With the mask in place, you can afford to increase the value significantly. We raised the Amount to **100**, the Radius to **3**, and the Detail to **50**. Compare several parts of the image with and without sharpening once again by clicking the switch at the left side of the panel's header. Make sure to return the switch to the on position.

▶ Tip: If you can't see the effect clearly, set a higher zoom ratio.

5 To assess the effect of the sharpening mask, drag the Masking slider back to its default setting of zero. Undo and Redo to see the effect of the sharpening with and without the mask. When you're done, return the Masking setting to **70**.

Most of the noise apparent in this image is *luminance noise*—variations in the brightness of pixels which should be equally bright. In general, Luminance noise is less of a problem than color noise, or *chrominance noise*—blue, red and purple spots in areas that should be a uniform hue. In the Noise Reduction pane, you can see that a little Color noise reduction has been applied to this image by default.

6 In the Filmstrip, select the photo of the courtyard cafe. Set the zoom level to 2:1 and focus the view on the lower right corner of the image.

7 To assess the effect of the default reduction in color noise, drag the Color slider all the way to the left. Undo and Redo to see the image with and without the noise reduction. When you're done, set the Color noise reduction value to **100**.

▶ Tip: You should use Noise Reduction with caution; both forms can blur image detail. You can use the Detail sliders for the Noise Reduction controls to help maintain the sharpness of the image, despite this effect.

8 Position the photo so that you can see the Closest table umbrella at the left of the photo. Drag the Luminance slider all the way to the right. The luminance noise has now disappeared; however, there is marked blurring of the detail in the background. You'll need to find a compromise between reducing noise and maintaining the sharpness. Drag the Luminance slider back to 0, and then slowly to the right until you notice that the noise is improved with only slight blurring image details. We set a value of **55**.

9 Use the Detail and Contrast controls below the Luminance slider to reduce the blurring effect. Try Detail and Contrast values of **75** and **50** respectively.

Creating your own developing presets

When you've spent time tweaking controls to create a look you'd like to use again, you can save your settings as a custom preset that will be listed in the Presets menu.

In Lesson 5, you trimmed a video clip in the Library module, where your editing options were limited to those offered in the Quick Develop panel. You can't bring video into the Develop module, but by working on a captured frame, and then saving your settings as a custom preset, you can effectively bring the power and subtlety of Develop module editing back to your video in the Library module.

1 In the header of the Filmstrip, click the white arrow to the right of the selected image's name and choose the Lesson 5 folder from the list of recent sources. Select the frame that you captured from the video in Lesson 5 in the Filmstrip.

The colors in our still frame are cold and de-saturated, and the tone is flat and dull; you'll use the White Balance (WB) controls to make the color warmer, and then add depth and definition by boosting the Contrast, Vibrance, and Saturation.

2 Starting at the top of the Basic panel, set both the Temperature to **+15** and the Tint to **+5**; then, set a Contrast value of **25**. Reduce the Whites setting to **-100**, and the Blacks to **-40**. Set the Vibrance to **25**, and the Saturation to **5**.

3 Choose Develop > New Preset. Name your custom preset **WarmMemories** and accept the User Presets folder as the destination to which it will be saved.

4 Inspect the Settings pane in the lower half of the New Develop Preset dialog box for an overview of just how many separate developing adjustments you can build into a single preset. The illustration below shows the default options; make sure you have the same set activated, and then click Create.

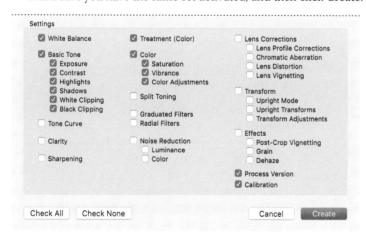

If you apply your custom preset to the lesson video now, you'll overwrite the video preset and manual adjustments you applied earlier. In the next exercise, you'll create a *virtual copy* of the video file, so that you can compare the two edited versions.

> ▶ **Tip:** You might set up a preset to achieve a unified look for every image in a photo book or web gallery, to add a romantic glow to wedding shots, or to correct the color in underwater photos. Develop presets streamline your workflow, enabling you to apply multiple settings with a single click.

> ◖ **Note:** Because this preset is intended for use with our lesson video, we avoided modification to the Highlights, Shadows, and Clarity settings, as those adjustments are amongst several not supported for video. If you choose a Develop preset that includes un-supported operations, you'll see an alert listing the adjustments that *can* be applied to video. For any given clip, some Lightroom presets not specifically intended for use with video may produce very little effect. Some other presets, including the Lightroom Effect Presets category, will not work at all for video.

Working with virtual copies

● **Note:** In fact, *every* photo or video in your catalog is a virtual copy of the master file.

When you wish to explore different treatments for a photo or video, without losing the work you've already done, you can create *virtual* copies of your image or clip, and edit each one independently, just as if they were separate master files.

If a particular photo is included in more than one collection, any changes you make to that image while you're working in one collection will be applied in all the others. If you wish to modify an image for a specific collection without affecting the way the photo appears elsewhere in your catalog, you should use a virtual copy.

You might include a full-frame, full-color version of your photo in a collection that you've assembled for a slideshow—and a tightly cropped, sepia-toned virtual copy in another collection intended for a print layout. You can apply a unifying special effect to an entire collection of virtual copies for a photo book without affecting the way the same images appear in any of your other projects and presentations.

Another advantage of working with virtual copies is that you save a lot of disk space by keeping only one master file for each photo; a virtual copy is actually no more than an additional catalog reference for the master file; changes you make to the virtual copy are recorded without affecting the original, or other virtual copies.

1 Switch to the Grid view in the Library. In the Grid view or the Filmstrip, right-click / control click the video file Venice.MP4 and choose Create Virtual Copy from the context menu. If necessary, press F6 to show the Filmstrip. You can see that there are now two copies of the video side by side in the Filmstrip.

▶ **Tip:** If you don't see the virtual copy dog-ear markers in the Grid view or the Filmstrip, choose View Options from any thumbnail's context menu, and then activate thumbnail badges.

In both the Grid view and the Filmstrip, virtual copies are identified by a page peel (or dog-ear) icon in the lower left corner of the thumbnail, though this is difficult to see on video thumbnails, as it appears behind the duration indicator.

By default, Lightroom will automatically stack the virtual copy with the original video. In this case, the original video was already stacked with the still frame you captured, so Lightroom has added the virtual copy to the existing stack. The original video at the top of the stack is marked with a stack badge.

2 Move the pointer over either of the stacked videos to see a file count indicating the position of that copy in the stack.

▶ **Tip:** To unstack photos or videos, select one of the thumbnails in the stack in the Grid view; then, right-click / Control-click the stack icon on the selected thumbnail and choose Unstack from the menu.

You can use the Kind filter—one of the Attribute filters in the Filter bar—to filter your library by file kind, isolating master images, virtual copies, or video files.

3 If you don't see the Filter bar above the Grid view, press Backslash (\) . Click Attribute in the filter picker; then click the third of the Kind filters—the button with a film-strip icon—at the right of the Filter bar. The Grid view displays the original video. Click to disable the video filter; then, click the next Kind filter to the left—the button with a turned-up corner—to isolate the virtual copy.

4 Click None in the filter picker; then, press Backslash (\) to hide the Filter bar.

5 Double-click the virtual copy, Venice.MP4 / Copy 1, in the Grid view or the Filmstrip, to open the clip in the Loupe view. Expand the Quick Develop panel, if necessary, and click the Reset All button at the bottom of the panel to clear all of the current settings and revert the copy to the video's un-edited state.

6 Click the Saved Preset menu and choose your WarmMemories preset from the User Presets category. Scrub or play through the clip to see the effect. Your custom preset has increased definition, boosted the dull de-saturated color, producing something of the nostalgic look of old home movies.

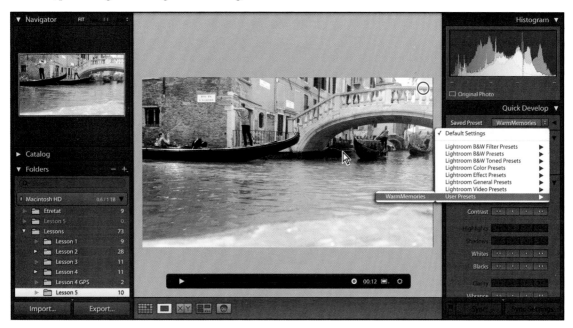

7 Choose Edit > Select None. In the Filmstrip, select the original video; then, hold down the Ctrl / Command key and click the virtual copy. Press the C key to switch to Compare view where you can see the two treatments side by side.

Combining photos as a panorama

The Photo Merge Panorama tool makes it easy to create striking panoramas.

1 In the Library module, switch to the Grid view; then, click the Import button. In the Import dialog box, navigate to and select the Lesson 6 > Photo Merge folder. In the Keywords box, type **Lesson 6, Develop, Merge**; then, click Import.

2 Shift-click to select the five photos, DSC_0072.jpg through DSC_0076.jpg; then, press Control+M or choose Photo Merge > Panorama from the Photo menu.

3 Resize the panorama preview window to see the preview at its maximum size. In the options pane at the right, toggle the *projection* (the method used to align and merge the source images) between the auto-selected Spherical and the Cylindrical method. When you're done, set the latter option for this exercise.

Note: If Lightroom can't detect overlapping detail or matching perspectives, you'll see an "Unable To Merge The Photos" message; try another projection mode, or click Cancel. You'll also see an error message if your source images are of different sizes, or were shot at different focal lengths.

For our lesson photos, the Perspective projection would be unable to merge the images; it usually works best with smaller selections of photos that share well-defined lines of perspective, in contrast to the clutter of chaotic angles in this street scene from Monschau, Germany. The Perspective projection designates the middle photo as the reference image, and then transforms the images at either side to match the perspective in that photo, while aligning overlapping content.

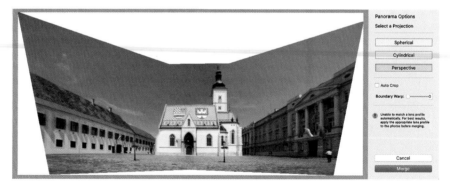

Tip: Once you've set the options you prefer, you can launch the merge process without opening the preview dialog box by pressing Shift+Control+M, or by holding down the Shift key as you choose Photo Merge > Panorama. Lightroom performs the merge as a background task while you work with your other images.

The Cylindrical and Spherical projections avoid the "bow-tie" distortion of the Perspective layout, and therefore, usually minimize the amount of the merged panorama that needs to be cropped away. The Cylindrical setting is best suited to wide views, while the Spherical projection is perfect for sets that make up full, 360-degree panoramas. The Auto Select Projection setting lets Lightroom choose the projection method that is most likely to work best for the selected images.

4 In the Panorama Options pane, activate Auto Crop; then, watch the preview as you drag the Boundary Warp slider to the maximum setting. Click Merge.

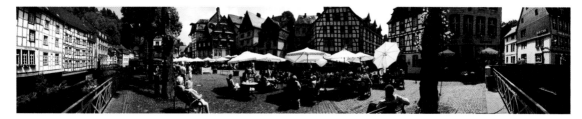

Lightroom calculates the optimum crop and saves the merged panorama in DNG format, to the same folder (and collection) as the source photos. Like all Lightroom edits, the crop remains "live;" you can tweak the crop area in the Develop module.

5 In the Grid view, select the image DSC_0072.jpg. In the Quick Develop panel, set the White Balance to Auto, and then click three times on the right-most button for Shadows. Shift-click the image DSC_0076.jpg to select all five photos, and then repeat the merge; develop settings from the active image (the "most selected" image) are applied to the merged panorama.

Note: As the merge to panorama changes geometric attributes when aligning photos, settings such as cropping and perspective corrections will not be copied to the panorama from the active image.

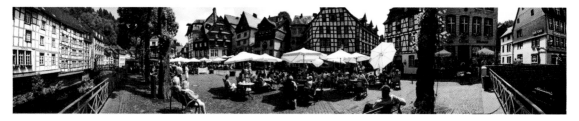

Merging photos into an HDR image

For harshly-lit subjects with deep shadows, back-lit scenes, and landscape photos, choosing an exposure level always involves a compromise. A setting that produces a good exposure in the darker areas will "burn out" the highlights, an exposure set to capture detail behind a back-lit subject, or the colors in a sunset sky, will make a silhouette of the subject in the foreground or leave the landscape in shadow.

The new Photo Merge HDR tool lets you combine different exposures of the same subject to produce a *High Dynamic Range* image—a photo with a broader and deeper range of color and tone than can be captured in a single shot. The first step is to capture multiple photos at different exposures using exposure bracketing. For this exercise, you'll work with a pair of images from a fishing village in Thailand.

1 In the Library module, click the Lesson 6 > Photo Merge folder in the Folders panel; then select the photos DSC05637.jpg and DSC05639.jpg.

Both of our lesson photos, shot in the glare of a hazy, tropical mid-morning, have dull, flat colors and a deficient distribution of tonal values; however, the lighter

Tip: Although we use relatively small JPEG images for this exercise, Photo Merge HDR will produce the best results with information-rich raw files. With raw source photos the merged DNG image has all the depth, detail and editing versatility of the originals—with even more dynamic range!

Tip: Although some other HDR tools require three exposure-bracketed photos (the base exposure together with the extremes), Photo Merge HDR usually performs just as well, and in some cases even better, with two.

exposure has color and shadow detail that is absent in the darker image, while the lower exposure does not have the same problem with burned-out highlights.

2 Press Control+H or choose Photo Merge > HDR from the Photo menu. Resize the merge preview window to see the preview at its maximum size. In the options pane at the right, Auto Align is enabled by default; unless you're using a tripod, you'll want to keep it that way. Disable the Auto Settings option; for this exercise, you can make your own tonal adjustments. By default, the Deghost Amount is set to None; for this exercise, set it to Medium. Toggle the Show Deghost Overlay option to see where deghosting has been applied; then, click Merge.

Even with automatic alignment, camera shake and the movement of elements such as waves (and boats) or foliage can result in *ghosting* in the merged image, usually noticeable as an offset double image, or sometimes as an unnatural smearing, especially on water. Deghosting detects these problems and resolves them by making one or other of the source images predominant when blending the affected areas.

Note: As for the panoramic merge, some develop settings from the active photo will be copied to the merged image; however, as the merge to HDR modifies tonal range, Exposure, Contrast, Highlights, Shadows, Whites, Blacks and Tone Curve settings will not be applied.

Lightroom saves the merged HDR image in DNG format, to the same folder (and collection) as the source photos. In the majority of cases, the HDR merge will not be your finished product, but an information-enhanced version of your source images that will be far more responsive to further editing.

3 Select the merged image and switch to the Develop module. Decrease the Contrast to **-10**, and the Highlights to **-50**. Set a value of **80** for Shadows, **35** for Whites and Clarity, and increase the Vibrance to **25**.

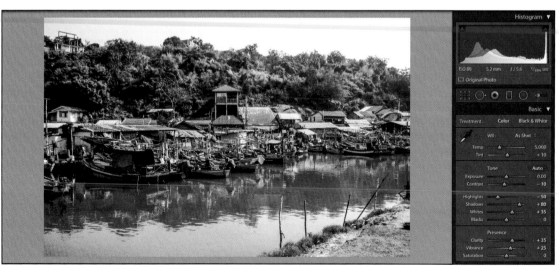

Review questions

1 How do you undo changes or return quickly to a previous develop state?

2 What does a tone curve represent and what is it used for?

3 What kinds of noise might be found in a digital image and what can you do about them?

4 Which tools are used to perform local corrections?

5 How can you apply a preset effect without overriding your image corrections?

6 What are the five Upright modes and what do they do?

Review answers

1 You can undo one modification at a time using the Undo command. You can jump back multiple steps at once in the History panel. You can create snapshots of important develop states so that you can return to them quickly.

2 A tone curve adjusts the distribution of the tonal ranges in an image. The curve shows the way tonal information from the original image will be mapped to the adjusted image. It can be used to increase or decrease the contrast in specific tonal ranges.

3 Digital images may contain luminance noise, which is a result of variation in the brightness of pixels which should be of the same luminance, and color (chrominance) noise: bright blue, red and purple spots in an area that should be a uniform hue. Both types can be reduced using the sliders in the Detail panel.

4 You can restrict adjustments to selected areas of your image with the Radial Filter tool, the Graduated Filter tool and the Adjustment Brush tool.

5 Apply a preset, and then right-click / Control-click the image and choose Settings > Copy Settings from the context menu. In the Copy Settings dialog box, disable those settings you wish to preserve; then undo the preset, right-click / Control-click the image and choose Settings > Paste Settings from the context menu..

6 The five Upright perspective correction modes are Auto, Guided, Level, Vertical, and Full. Level mode straightens tilted images, Vertical mode corrects converging verticals, Auto mode blends Level, Vertical, and aspect corrections intelligently to produce a natural-looking correction, and Full mode combines the effects of the previous three. Guided mode lets you designate prominent features in the image that should be horizontal or vertical and corrects the perspective accordingly.

PHOTOGRAPHY SHOWCASE
SETH RESNICK

"I am stimulated by color, design, light, texture, spontaneity and gesture. I try to bring back images that another photographer would not visualize from my minds eye."

My visual philosophy is to produce images nobody else envisions. I try to bring back images that another photographer would not visualize from my "mind's eye". Ideally, someone standing next to me won't see what I see.

I am stimulated by color, design, light, texture, spontaneity and gesture. These qualities make photography spectacularly rewarding for me. Like anything in life practice helps to make perfection and photography requires practice, which brings me to one of the reasons for my success. I always carry a camera because without the camera there can be no perfection. Photography is an expression of what I see around me, and how it makes me feel. I want to re-create the beauty that I see, and ignite an emotional response in my audience.

Photography is a highly creative art form of art and communication that draws me to its challenges. I photograph because it is like capturing a moment in time you know you will never be able to go back to. And capturing strong graphic images of those moments in time gives me a feeling of fulfillment and a passion to continue learning and sharing. I hope that my images foster a sense of intellectual curiosity and spark imagination.

www.sethresnick.com
www.d-65.com
www.digitalphotodestinations.com

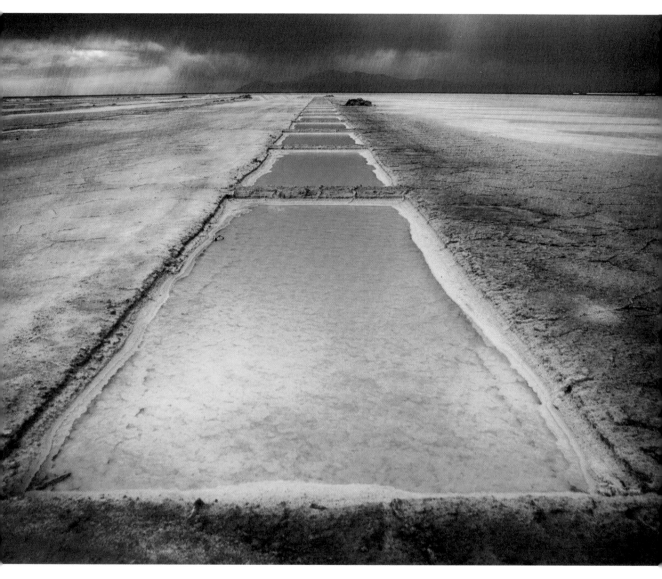

SALINAS GRANDE

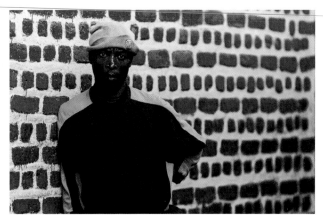

RED & GREEN WALL- RWANDA

GOING TO WORK- RWANDA

SOUSSUSVIEI- NAMIBIA

CIERVA COVE- ANTARCTICA

NEKO HARBOR

7 CREATING A PHOTO BOOK

Lesson overview

Whether it's produced for a client or as a professional portfolio, designed as a gift or as a way to preserve precious memories, a photo book makes a stylish way to share and showcase your images. The Book module makes it easy to design beautiful, sophisticated book layouts, and then publish them without leaving Lightroom.

In this lesson, you'll learn the skills you need to create your own professional-looking photo book:

- Modifying page layout templates
- Setting a page background
- Placing and arranging images in a layout
- Adding text to a book design
- Working with text cells and photo cells
- Using the Text Adjustment Tool
- Saving a photo book
- Exporting your creation

 You'll probably need between one and two hours to complete this lesson. If you haven't already done so, log in to your peachpit.com account to download the lesson files for this chapter, or follow the instructions under "Accessing the Lesson Files and Web Edition" in the Getting Started section at the beginning of this book.

The Book module delivers everything you need to create polished book designs that can be uploaded directly from Lightroom Classic CC for printing through the on-demand book vendor Blurb, or exported to PDF and output on your own printer. Template-based page layout, an intuitive editing environment, and state-of-the-art text tools make it easy to present your photographs in their best light.

Getting started

Note: This lesson assumes that you already have a basic working familiarity with the Lightroom Classic CC workspace. If you need more background information, refer to Lightroom Classic CC Help, or review the previous lessons.

Before you begin, make sure you've set up the LRClassicCIB folder for your lesson files and created the LRClassicCIB Catalog file to manage them, as described in "Accessing the Lesson Files and Web Edition" and "Creating a catalog file for working with this book" in the Getting Started chapter at the start of this book.

If you haven't already done so, download the Lesson 7 folder from your Account page at www.peachpit.com to the LRClassicCIB \ Lessons folder, as detailed in "Accessing the Lesson Files and Web Edition" in the chapter "Getting Started."

1 Start Lightroom Classic CC.

2 In the Adobe Photoshop Lightroom Classic CC - Select Catalog dialog box, make sure the file LRClassicCIB Catalog.lrcat is selected under Select A Recent Catalog To Open, and then click Open.

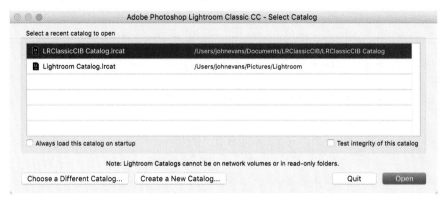

▶ **Tip:** If you can't see the Module Picker, choose Window > Panels > Show Module Picker, or press the F5 key. If you're working on macOS, you may need to press the fn key together with the F5 key, or change the function key behavior in the system preferences.

3 Lightroom Classic CC will open in the screen mode and workspace module that were active when you last quit. If necessary, switch to the Library module by clicking Library in the Module Picker at the top of the workspace.

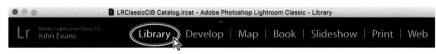

Importing images into the library

The first step is to import the images for this lesson into the Lightroom library.

1 In the Library module, click the Import button below the left panel group.

2 If the Import dialog box appears in compact mode, click the Show More Options button at the lower left of the dialog box to see all the options in the expanded Import dialog box.

3 Under Source at the left of the expanded Import dialog box, locate and select your LRClassicCIB \ Lessons \ Lesson 7 folder. Ensure that all of the images in the Lesson 7 folder are checked for import.

4 In the import options above the thumbnail previews, select Add so that the imported photos will be added to your catalog without being moved or copied. Under File Handling at the right of the expanded Import dialog box, choose Minimal from the Build Previews menu and ensure that the Don't Import Suspected Duplicates option is activated. Under Apply During Import, choose None from both the Develop Settings menu and the Metadata menu and type **Lesson 7, Architecture** in the Keywords text box. Make sure that the Import dialog box is set up as shown in the illustration below, and then click Import.

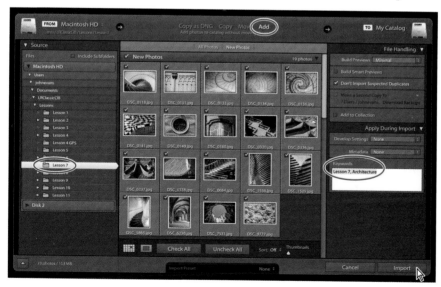

The nineteen images are imported from the Lesson 7 folder and now appear in the Grid view of the Library module and also in the Filmstrip across the bottom of the Lightroom workspace.

Assembling photos for a book

The first step in creating a book is to gather the photos you wish to include. Having just been imported, the images for this lesson are already isolated from the rest of your catalog; in the Catalog panel, the Previous Import folder is selected as the active image source.

The Previous Import folder is merely a temporary grouping and, as an image source, it is not flexible—you can't rearrange the images inside it, or exclude a photo from your project without removing it from the catalog entirely.

You should always use either a collection or a single folder without subfolders as the source for the images in your book; both will let you reorder photos in the Grid view or the Filmstrip. For this exercise, you'll create a collection—a virtual grouping from which you can also exclude an image without deleting it from your catalog.

1 Make sure that either the Previous Import folder in the Catalog panel, or the Lesson 7 folder in the Folders panel, is selected as the image source; then, press Ctrl+A / Command+A or choose Edit > Select All.

2 Click the New Collection button (⊕) in the header of the Collections panel and choose Create Collection. In the Create Collection dialog box, type **Details** as the name for the collection. Make sure that the option Include Selected Photos is activated and all the other options are disabled; then, click Create.

Your new collection appears in the Collections panel, where it is automatically selected.

3 Choose Edit > Select None. In the Toolbar, set the Sort order to Capture Time; then, click Book in the Module Picker at the top of the workspace.

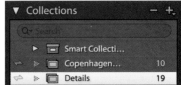

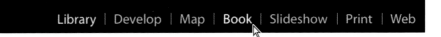

Working in the Book module

Whether you want to commemorate a family milestone, frame your memories from a special trip, or put together a photographic package for a client, a photo book is an attractive and sophisticated way to showcase your work.
The Book module delivers everything you need to create stylish book designs that can be uploaded directly from Lightroom for printing through the on-demand book vendor Blurb, or exported to PDF and printed on your own printer.

Setting up a photo book

In the work area, you may or may not see photos already placed in page layouts, depending on whether you've already experimented with the Book module's tools and controls. You can start this project by clearing the layout and setting up the workspace so that we're all on the same page.

1 Click the Clear Book button in the header bar across the top of the work area. If you don't see the header bar, choose View > Show Header Bar.

2 In the Book Settings panel at the top of the right panel group, Make sure that Blurb is selected from the Book menu and that the Size, Cover, Paper Type, and Logo Page are set to Standard Landscape, Hardcover Image Wrap, Premium Lustre, and On, respectively. The estimated price of printing the book at the current settings is displayed at the bottom of the panel.

3 If it's not already selected, click the Multi-Page View button at the far left of the Toolbar at the bottom of the work area. In the View menu, disable Show Info Overlay.

4 Choose Book > Book Preferences. Examine the options; you can choose whether photos are zoomed to fit their image cells or cropped to fill them, toggle the Autofill feature for new books, and set your preferences for text behaviors. Leave the settings at the defaults and close the Book Preferences dialog box.

The Autofill feature is activated by default; if you just entered the Book module for the first time, you would have seen the images from the Details collection already placed in the default book layout. An automatically generated layout can be a great starting point for a new book design, especially if you're beginning without a clear idea of exactly what you want.

● **Note:** If you're publishing to Blurb.com, auto-layout is limited to books of 240 pages. There is no auto-layout page limit for books published to PDF.

5 Expand the Auto Layout panel, if necessary. From the Auto Layout Preset menu, choose the Left Blank, Right One Photo, With Photo Text layout; then, click the Auto Layout button. Scroll in the work area, if necessary, to see all the page thumbnails. Click the Clear Layout button and repeat the procedure for the auto-layout preset One Photo Per Page.

6 Examine the result in the work area; scroll, if necessary, to see all the page thumbnails arranged as two-page spreads in the Multi-Page view. Hide the module picker and the left panel group by pressing F5, and then F7, or by clicking the triangles at the top and left edges of the Lightroom workspace. Drag the Thumbnails slider in the Toolbar to reduce or enlarge the thumbnails.

Note: Blurb offers a discounted price for photo books that incorporate the Blurb logo on the last page.

Lightroom generates a book with a cover, a separate page for each of the nineteen lesson photos—placed in the order in which they appear in the Filmstrip—and a twentieth page reserved for the Blurb logo. You can't place a photo on the Blurb logo page, but you can disable it in the Book Settings panel, if you wish.

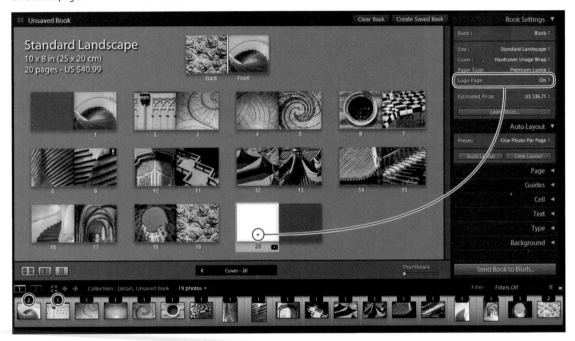

Tip: If you want to rearrange the order of images in the Filmstrip before you click Auto Layout, you'll first need to save your book.

The first image in the Filmstrip is placed on the front cover; the last photo in the series becomes the back cover image. The number above each photo in the Filmstrip indicates how many times it has been used in the book; the first and last images have each been used twice—on the cover and also on pages 1 and 19.

Changing page layouts

Using an auto-layout preset can help you get started on your book; you can then focus on individual spreads and pages to introduce subtlety and variety to the design. For this project, however, you'll build your book layout from scratch.

1 In the Auto Layout panel, click the Clear Layout button.

2 Right-click / Control-click the header of the Page panel and choose Solo Mode from the menu. If you see the overlay with the book's layout, size, page count, and estimated price, disable the Show Info Overlay option in the View menu.

3 In the Multi-Page view, double-click the front cover: the right side of the spread.

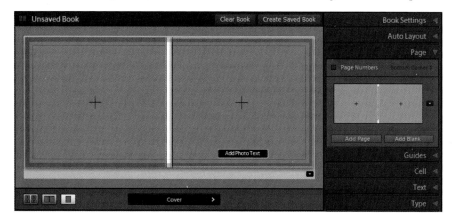

The cover layout fills the work area in the Single Page view, with the front cover's photo cell selected, as indicated by the yellow border. The Page panel shows a diagrammatic preview of the default cover template: two image cells (identifiable by central cross-hairs) and a narrow text cell positioned along the book's spine.

4 Click the Change Page Layout button () to the right of the layout preview thumbnail in the Page panel, or in the lower right corner of the cover spread displayed in the work area.

5 Scroll down in the page template picker to see all of the available cover layout templates. Grey areas with central cross-hairs indicate image cells; rectangles filled with horizontal lines represent text cells. Click to select the third template in the list. The single cross-hairs at the center of the spread shows that this template has a single image cell that extends across both covers, and three text cells: one on the back cover, one on the spine, and one on the front cover.

6 Expand the Guides panel. Make sure that the Show Guides option is activated; then, watch the layout in the work area as you toggle each of the four guides in turn. Move the pointer over the layout to see the borders of the text cells.

The Page Bleed guide's wide gray border shows the area to be cut off after printing. A thin gray line borders the Text Safe Area, where your text will be well clear of accidental trimming. The Filler Text guide shows filler text (here, the word "Title") to mark the position of text cells. Filler text disappears when you click a text cell.

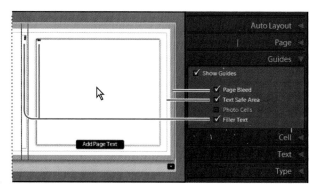

7 Disable Photo Cells, leaving the other three guides options activated; then, click the Multi-Page View button (▦) in the Toolbar.

The first page in a photo book is always on the right side of the first spread; the grayed-out left side represents the inside of the front cover, which is not printed. Likewise, the last page in a photo book to be published to Blurb must always occupy the left side of the final spread. At this stage, your book consists of a cover and a single, double-sided page, the back of which is the Blurb logo page.

8 Right-click / Control-click page 1 and choose Add Page from the context menu. A second spread appears in the Multi-Page view. Right-click / Control-click page 2 and choose Add Page to copy the same page layout to page 3.

9 Click to select page 2, and then click the Change Page Layout button () below the lower right corner of the page.

For inside pages, unlike the cover, the page template picker groups layout templates in categories according to style, project type, or by the number of photos per page.

▶ **Tip:** To add a page layout to the Favorites category in the template picker, click the circle that appears in the top right corner of the template's thumbnail when you move the pointer over it.

10 Click "2 Photos" to see all the templates with two image cells. Select the fourth template: a layout without text cells that fills the page with two portrait-format images, side by side. In the Guides panel, activate Photo Cells so that you can see the changed page layout.

Adding page numbers to a photo book

● **Note:** The context menu of a page number cell also lists commands that enable you to hide the page number on a selected page, or set the page numbering to start from a page other than page 1.

1 Double-click page 1 to shift to single page view; then, check the box at the top of the Page panel to activate page numbers. From the adjacent positioning menu, choose Bottom Corner. Right-click / Control-click page 1 and make sure that the option Apply Page Number Style Globally is activated in the context menu.

2 Click the new page number cell in the page preview; then, expand the Type panel and inspect the default font, style, size, and opacity settings. With the option Apply Page Number Style Globally activated, any changes to these type style settings would be made throughout the book; for now, leave them unchanged.

Placing photos in a book layout

You can add photos to a page layout in any of the three Book Editor views.

1 Click the Multi-Page view button at the left of the Toolbar; then, drag the seventh thumbnail in the Filmstrip, the image DSC_0141.jpg, onto the cover spread.

2 Drag the image DSC_6230.jpg from the Filmstrip to page 1 in the Multi-Page view. Place the photos DSC_0180.jpg and DSC_5865.jpg in the left and right image cells on page 2, respectively, and the sixth image DSC_0149.jpg on page 3.

● **Note:** An exclamation mark badge in the upper right corner of an image cell indicates that the image may not be of a high enough resolution to print well at the current size. You can either reduce the size of the image in your layout, or ignore the alert if you are prepared to accept a lower print resolution.

Changing the images in a photo book

You can remove a photo from a page layout by right-clicking / Control-clicking the image in the Book Editor and choosing Remove Photo from the context menu. If you simply want to replace a photo, you needn't remove it first.

1 Drag the photo DSC_0131.jpg—the second image in the Filmstrip—onto the right-hand image on page 2. DSC_0131.jpg replaces the original image.

2 In the Multi-Page view, drag the image on page 1—DSC_6230.jpg—onto the photo on page 3; the photos on pages 1 and 3 swap places.

▶ **Tip:** You should see the image thumbnail move as you drag, not the page itself. If you move the page instead, drag it back into place and try again, making sure to drag from well inside the photo cell.

▶ **Tip:** You can easily rearrange the order of the pages in your photo book—or even shuffle entire spreads—in the same way; simply drag them to new positions in the Multi-Page view.

Working with photo cells

The photo cells in a page layout template are fixed in place; you can't delete them, resize them, or move them on the page. Instead, you can use the *cell padding*—the adjustable space around a photo within its cell—to position the images in your page layout exactly as you want them.

1 Double-click page 3. The Book Editor switches from Multi-Page view to Single Page view; in the Toolbar, the Single Page View button is highlighted.

2 Click the photo to select it, and then experiment with the Zoom slider. When you enlarge the image too much (for this photo, above 43%), an exclamation-point badge appears in the upper right corner to alert you that the photo may not print well. Right-click / Control-click the photo and choose Zoom Photo To Fill Cell; the image is scaled so that its shortest edge fills the cell (at a zoom value of 29%, for this photo). Drag the photo to position it vertically within the cell. Drag the slider all the way to the left; the minimum setting reduces the image so that its longest edge fits within the image cell. Click well within the borders of the photo and drag it to the right side of the cell.

Tip: If you don't see the Amount slider, click the triangle above the padding values.

3 Leave the photo at the 0% zoom setting. Expand the Cell panel and increase the padding by dragging the Padding Amount slider or typing a new value of **150** pt.

4 Click the black triangle above the Padding value to expand the padding controls. By default, the four controls are linked; the adjustment you made in the previous step changed all four values. Disable the Link All option (the checkbox darkens); then, set both the Right and Top padding to **0** pt and the Bottom value to **300** pt.

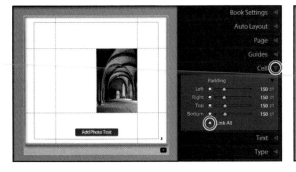

5 Set the Left and Right padding to **250** pt, and the Top and Bottom padding to **205** pt. Click the photo in the Single Page view to select it; then, use the slider to set the zoom level to 22% and drag the image to position it within its cell padding as shown in the illustration at the right.

By starting with the right template, and then setting the photo cell padding, you can position an image anywhere on the page, cropped however you wish.

6 In the Cell panel, activate Link All, and then drag any of the sliders to set all of the padding settings to zero. Right-click / Control-click the photo in the Single Image view and choose Zoom Photo To Fill Cell from the context menu. Drag the image vertically inside its cell to find a pleasing crop.

7 Click the Spread View button in the Toolbar to see pages 2 and 3 as a spread.

8 Select the image on the left of page 2. Set the linked padding controls to **50** pt, then unlink them and reduce the Right padding to **15** pt. Repeat the process for the photo on the right side of page 2, but this time, reduce the Left padding to 15, rather than the Right.

9 Double-click the yellow frame below page 2 to see it enlarged in the Single Image view. Zoom the photo on the left to 70%; then, drag the image inside its cell padding to position it as shown in the illustration at the right. Zoom the photo on the right to 45%; then, reposition it as shown in the illustration. For a clearer view, click the gray space outside the page to deselect it.

10 In the Toolbar below the Single Image view, click the left navigation arrow to jump to page 1. The circular grille is slightly off-center; zoom the photo to 20% and drag in the photo cell to center the image on the page.

11 Click away from the page to deselect it, and then click the Multi-Page View button (⊞⊞) in the Toolbar for an overview of the changes you've made.

Setting a page background

By default, all the pages in a new book share a plain white background. You can change the background color, set up a partially transparent backdrop image, or choose from a library of graphic motifs, applying your background design to the entire book, or just a selected page.

You can start by adding two more spreads to your book layout.

1 Right-click / Control-click page 4 and choose Add Page from the context menu. To apply the default layout to page 5, right-click / Control-click page 5 and choose Add Page. Right-click / Control-click page 6 and choose Add Blank Page.

2 Click to select page 6 in the Multi-Page view, and then click the Spread View button (▮▮) in the Toolbar.

> **Tip:** You can also apply a background image to a selected page (or pages) by dragging a photo directly onto the page background area from the Filmstrip, making sure not to drop the image into a photo cell.

3 Expand the Background panel. Disable the option Apply Background Globally; then, drag the last photo in the Filmstrip, DSC_9777.jpg, to the preview pane in the Background panel. Drag the slider to set the opacity of the image to 50%.

4 Activate the Background Color option, and then click the adjacent color swatch to open the color picker. Drag the saturation slider at the right of the color picker about two thirds of the way up its range; then, drag the eyedropper cursor in the picker to find a muted tone; we chose a color with R, G, and B values of 70, 55, and 90, respectively. Press Enter / Return to close the picker.

5 In the Background panel, activate the Apply Background Globally option, and then click the Multi-Page View button (▦) in the Toolbar.

Your background is applied to every page (except the Blurb logo page, where only the color is applied); it can be seen on page 7 and behind the images on page 2. On other pages, the background design is hidden behind photo cells.

6 Disable the Background Color option; then, right-click / Control-click the image in the background preview pane and choose Remove Photo. Disable Apply Background Globally.

7 Select page 2 in the Multi-Page view, and then reactivate the Background Color option. Click the color swatch to open the color picker, and then click the black swatch at the top of the picker. Press Enter / Return to close the color picker.

8 Refresh the skills you've learned in this lesson by replicating the pages in the illustration below. You'll need to adjust photo cell padding on pages 5, 6, and 7.

Adding text to a photo book

There are several ways to add text to your pages in the Book module, each useful in different situations:

* Text cells that are built into page layout templates are fixed in position; they can't be deleted, moved, or resized, but you can use the adjustable cell padding to position text anywhere on a page.

* A *photo caption* is a text cell that is linked to a single image in the layout; a photo caption can be positioned above or below an image, or overlaid on the photo, and can be moved vertically on the page.

* A *page caption* is a text cell that is linked to the page as a whole, rather than any particular image. Page captions span the full width of the page; you can move them vertically, and then adjust the cell padding to position text horizontally, enabling you to place custom text anywhere in your layout.

On a single page, you can add a page caption, and a separate photo caption for each image—even if the page is based on a layout template that has no fixed text cells. Fixed text cells and photo captions can be configured for custom text, or set to display captions or titles extracted automatically from your photos' metadata.

The Book module incorporates state-of-the-art text tools that give you total control over every aspect of the text styling. Type attributes can be adjusted using sliders or numerical input, or tweaked visually with the Text Adjustment Tool.

Working with text cells

Text cells incorporated in a page layout template are fixed in place; you can't delete them, resize them, or move them on the page. Instead, you can use the adjustable cell padding—the space surrounding the text within its cell—to position text in your page layout exactly as you want it.

▶ **Tip:** To select a page or a spread, rather than the text and image cells in the layout, click near the edge of the thumbnail, or just below it.

1 Click the Multi-Page View button (⊞) to see your entire book layout; then, double-click below the cover spread to zoom in on the layout. Click in the center of the front cover to select the fixed text cell.

2 Expand the Type panel. Make sure that the Text Style Preset is set to Custom, to accommodate manually entered text, rather than metadata from the image.

3 Choose a font and type style from the menus below the preset setting. We chose American Typewriter, Regular. Click the Character color swatch to open the color picker; click the white swatch at the left of the row at the top of the picker; then, press Enter / Return to close the color picker.. Set the type size to 70 pt, and leave the opacity set to 100%. Click the Align Center button at the lower left of the Type panel.

4 Type the words **in the**; then, press Enter / Return and type **detail**. Swipe to select the word detail, and then type in the Size text box to increase the size of the selected text to **140** pt.

5 Keeping the text selected, click the black triangle to the right of the Character color swatch to see the type attribute controls. Reduce the Leading—the spacing between the selected text and the line above it—to **100** pt.

▶ **Tip:** Once you've changed the Leading value, the Auto Leading button becomes available below the text adjustment controls, making it easy for you to quickly reinstate the default setting. The Auto Kerning button works the same way.

6 Click inside the text cell, but away from the text, to keep the cell selected while deselecting the text; then, expand the Cell panel. Disable the Link All option, and then increase the Top padding to **320** pt.

Fine-tuning type

In The Type panel, Lightroom incorporates a suite of sophisticated yet easy-to-use type tools that allow you detailed control over the text styling. You can use the adjustment sliders and numerical input to set type attributes in the Type panel, or tweak your text visually in any view using the intuitive Text Adjustment Tool.

1 Expand the Type panel and examine the four controls below the Size and Opacity sliders: Be sure to undo any changes you make at this stage.

- **Tracking** adjusts the letter spacing throughout a text selection. You can use tracking to change the overall appearance and readability of your text, making it look either more open or more dense.

- **Baseline** adjusts the vertical position of selected text relative to the baseline—the imaginary line on which the text sits.

- **Leading** adjusts the space between selected text and the line above it.

- **Kerning** adjusts the letter spacing between specific pairs of letters. Some pairings produce optical effects that cause letter spacing to appear uneven; place the text insertion cursor between two letters to adjust the kerning.

2 Swipe across all of the text in the front cover text cell to select it, and then click to activate the Text Adjustment Tool, to the left of the Character color setting in the Type panel.

3 Drag horizontally across the selection to adjust the text size. The adjustment is applied relatively; the different sizes of text are changed by relative amounts. Choose Edit > Undo or press Ctrl+Z / Command+Z to undo the change.

4 Drag vertically over the selection to adjust the leading; then, choose Edit > Undo or press Ctrl+Z / Command+Z to reverse the change.

5 Hold down the Alt / Option key—to temporarily disable the Text Adjustment Tool—and drag to select the words **in the**, leaving the word **detail** deselected; then, release the Alt / Option key and the mouse button. Hold Ctrl / Command as you drag horizontally over the selected text to increase the tracking slightly. Watch the Tracking control in the Type panel as you drag to set a value of **5** em.

6 Hold down the Alt / Option key and drag to select the word **the**, leaving the rest of the text deselected. Release the Alt / Option key and the mouse button. Hold Ctrl / Command and drag vertically over the selected text to shift it in relation to its baseline. Undo the change and click away from the text to deselect it.

7 If necessary, press F7, or choose Window > Panels > Show Left Module Panels. In the zoom ratio picker in the header of the Preview panel, click 1:1. Drag the white rectangle in the preview to focus on the front cover text. Make sure that the Text Adjustment Tool is still active; then, click once to position the text insertion cursor to the left of the word **in**. Drag to the right over the insertion point. Watch the Type panel as you drag to set a Kerning value of **135** em.

At this large point size, the first three letters of the word **detail** appear to be more loosely spaced than the last four.

8 Click once to place the insertion point between the letters **e** and **t**, and then drag to the left over the insertion point to set the Kerning value to **-30**. Set the Kerning value to **-40** for the **d-e** pair.

9 Click the Text Adjustment Tool in the Type panel to disable it; then, click the Multi-Page View button (⊞) in the Toolbar to see your entire book layout. Double-click page 1 to zoom to the Single Page view.

Working with captions

Unlike the fixed text cells built into layout templates, page and photo caption cells can be moved vertically; horizontal placement of captions is achieved by adjusting padding. Each page can include one page caption text cell and one photo caption cell for each photo on the page, even if the page template has no built-in text cell.

1. Right-click / Control-click the header of the Type panel and disable Solo Mode; then, leaving the Type panel open, expand the Text panel.

2. Move the pointer over page 1. The template for this page has no fixed text cell; hence, nothing is highlighted. Click the photo; then click the Add Photo Text button. In the Text panel, the Photo Text controls become active. Press Ctrl+Z / Command+Z to undo the photo caption. Now click the yellow footer below the photo; the Add Photo Text button changes to read Add Page Text. Click the Add Page Text button; the Page Text controls are activated in the Text panel.

3. To anchor the page caption to the top of the page, click the Top button in the Page Text controls; then, drag the Offset slider to set a value of **110** pt.

4. With the page caption active, set up the Type panel as you did for steps 2 and 3 of the exercise "Working with text cells" earlier in this project, other than the size and leading. Set the size to **40** pt and click Auto Leading. Type whatever you like in the page caption, using the Enter/Return key to break the lines so that the text is shaped to fit the image, as in the illustration below.

> **Tip:** If you prefer, you can add a photo or page text caption by activating the respective option in the Text panel, rather than using the floating buttons.

> **Note:** Unlike fixed template text cells and photo captions, page captions can't be set to display information drawn from a photo's metadata; they can only be used for custom text.

5. Click the Multi-Page View button (⊞) in the Toolbar.

Creating a custom text preset

You can save your text settings as a custom text preset, so you can apply the same style elsewhere in your book or re-use it in a different project, by choosing Save Current Settings As New Preset from the Text Style Preset menu in the Type panel.

Saving and re-using custom book page layouts

Once you've used cell padding and caption text to modify a page layout, you can save your design as a custom template that will be listed in the Page Layout menus.

1 Expand the Page panel; then, watch the layout thumbnail as you right-click / Control-click the page 1 preview and choose Save As Custom Page.

The original single-photo layout is overlaid by a text cell with the proportions and position of our page caption.

2 Click the Change Page Layout button () below the lower right corner of the page preview, or to the right of the Page panel's layout thumbnail; the saved layout is listed in the Custom Pages category.

Another way to re-use the work you've put into a layout is to copy and paste it directly onto another page in your book, where you can use it as is, or make further modifications to the design. You'll find the Copy Layout and Paste Layout commands in the same context menu you used in step 1.

Creating a saved book

Since you entered the Book module, you've been working with an *unsaved book*, as is indicated in the bar across the top of the Book Editor work area.

Until you save your book layout, the Book module works like a scratch pad. You can move to another module, or even close Lightroom, and find your settings unchanged when you return, but if you need to clear the layout to begin another project, all your work will be lost.

Converting your project to a Saved Book not only preserves your work, but also links your book layout to the particular set of images for which it was designed.

Your photo book is saved as a special kind of collection—an *output collection*—with its own listing in the Collections panel. Clicking this listing will instantly retrieve the images you were working with, and reinstate all of your settings, no matter how many times the book layout scratch pad has been cleared.

1 Click the Create Saved Book button in the bar at the top of the preview pane, or click the New Collection button (⊕) in the header of the Collections panel and choose Create Book.

2 In the Create Book dialog box, type **Details Book** as the name for your saved layout. In the Location options, activate Inside and choose the collection Details from the menu; then, click Create.

Your saved book appears in the Collections panel, marked with a Saved Book icon () and nested inside the source collection. The image count shows that the output collection includes only ten of the photos in the source collection. The bar above the work area shows the name of the book.

Tip: Adding more images to your saved photo book is easy: simply drag photos to the book's listing in the Collections panel. To jump directly from the Library to your lay-out in the Book module, move the pointer over your saved book in the Collections panel and click the white arrow that appears to the right of the image count.

Depending on the way you like to work, you can save your book layout at any point in the process; you could create a Saved Book as soon as you enter the Book module with a selection of images, or wait until your design is finalized.

Once you've saved your book project, any further changes you make to the design are auto-saved as you work.

Copying a saved book

Your saved photo book design represents a lot of effort; if you want to go ahead and try something different, or add pages and photos without a clear idea of what you'd like to achieve, you can duplicate your output collection and make changes to the copy without the risk of losing your work thus far.

1 Right-click / Control-click your saved book in the Collections panel and choose Duplicate Book from the context menu.

If you're happy with your extended design, you can delete the original saved book, and then rename the duplicate.

2 Right-click / Control-click the original saved book in the Collections panel and choose Delete from the context menu; then, confirm the deletion.

3 Right-click / Control-click the duplicated book in the Collections panel and choose Rename from the context menu. In the Rename Book dialog box, delete the word Copy from the end of the book's name, and then click Rename.

Exporting a photo book

You can upload your book to Blurb.com, or export it to PDF and print it at home.

1 To publish your photo book to Blurb.com, click the Send Book To Blurb button below the right panel group.

2 In the Purchase Book dialog box, either sign in to Blurb.com with your email address and password, or click "Not A Member?" in the lower left corner and register to get started.

3 Enter a book title, subtitle, and author name. You'll see an alert at this stage warning that your book must contain at least twenty pages; the Upload button is disabled. Click Cancel, or sign out of Blurb.com first, and then cancel.

Books published to Blurb must have between 20 and 240 pages, not including the front and back covers. Blurb.com prints at 300 dpi; if a photo's resolution is less than 300 dpi, an exclamation point badge (!) appears in the upper-right corner of the image cell in the work area. Click the exclamation point to find out what print resolution can be achieved for that photo. Blurb.com recommends a minimum of 200 dpi for optimum quality.

For help with printing, pricing, ordering, and other Blurb.com issues, visit the Blurb.com Customer Support page.

4 To export your photo book as a PDF file, first choose PDF from the Book menu at the top of the Book Settings panel. Examine the controls that appear in the lower half of the Book Settings panel. You can leave the JPEG Quality, Color Profile, File Resolution, Sharpening, and Media Type settings unchanged for now. Click the Export Book To PDF button below the right panel group.

5 In the Save dialog box, type **InTheDetail** as the name for the exported book. Navigate to your LRClassicCIB \ Lessons \ Lesson 7 folder, and then click Save.

6 To export your Blurb photo book as a PDF file for proofing purposes, leave the Book selection set to Blurb and click the Export Book To PDF button below the left panel group.

Well done! You've successfully completed another Lightroom Classic CC lesson. In this lesson you learned how to put together an attractive photo book to showcase your images.

In the process, you've explored the Book module and used the control panels to customize page templates, refine the layout, set a backdrop, and add text.

In the next chapter you'll find out how to present your work in a dynamic slideshow, but before you move on, take a few moments to reinforce what you've learned by reading through the review questions and answers on the next page.

Review questions

1 How do you modify a photo book page layout?

2 What options are available for page numbering?

3 What is cell padding and how is it used?

4 What text attributes are affected by the Tracking, Baseline, Leading, and Kerning controls in the Type panel?

5 How can you use the Text Adjustment Tool to fine-tune text?

Review answers

1 Click the Change Page Layout button (⏷) to the right of the layout preview thumbnail in the Page panel, or in the lower right corner of a selected page or spread displayed in the work area. Choose a layout category, and then click a layout thumbnail to apply that template. Use cell padding to tweak the layout.

2 Page numbering can be activated in the Page panel, where you can also set the global position for the numbers. Use the Type panel to set text style attributes. Right-click / Control-click a page number to apply the style globally, hide the number on a given page, or have the page numbering start on a page other than page 1.

3 Cell padding is the adjustable space around an image or text within its cell; it can be used to position text or a photo anywhere on the page. In combination with the Zoom slider, photo cell padding can be used to crop an image any way you wish.

4 Tracking adjusts the letter spacing throughout a text selection. You can use tracking to change the overall appearance and readability of your text, making it look either more open or more dense. The Baseline setting shifts selected text vertically in relation to the baseline. The Leading control affects the space between selected text and the line above it. Kerning adjusts the letter spacing between specific pairs of letters.

5 Drag horizontally across selected text to adjust the text size. Drag vertically over the selection to increase or decrease the leading (line spacing). Hold down the Ctrl / Command key as you drag horizontally over selected text to adjust the tracking. Hold down the Ctrl / Command key and drag vertically over a text selection to shift it in relation to its baseline. Hold down the Alt / Option key to temporarily disable the Text Adjustment Tool when you wish to change the text selection. Click between a pair of letters to place the text insertion cursor, and then drag horizontally across the text insertion point to adjust kerning.

PHOTOGRAPHY SHOWCASE
PATRICK JACOBS

"The only way to learn is to go out and shoot lots and lots of pictures. I take photographs every day—always challenging myself to produce an image that improves on my last shoot, though I suspect that the day when I am fully satisfied with my photos will never come."

I live beside the sea in Thailand and start every morning with an early walk on the beach and a new sunrise picture—although the elements provide endless variation, shooting the same subject every day is a great way to sharpen skills and try new ideas and techniques. As the day continues, I find inspiration in documenting the details of daily life as it plays out around me.

My approach is to be patient, taking time to observe before I shoot. I watch for the play between light, shadow, and reflection, and wait for the right moment to come my way. I let my imagination run, and look for a story I can tell that will elicit an emotional response from the viewer.

Though I see myself as a hobbyist, occasionally I am offered a shoot or sell a print, which gives me the satisfaction of sharing my work. Meanwhile, I work to improve my camera skills and continue to explore Lightroom, and sometimes I can sit back and be happy with a picture—that is, until I learn something new and go back to re-edit it.

facebook.com/patrick.jacobs/
instagram.com/patje559/

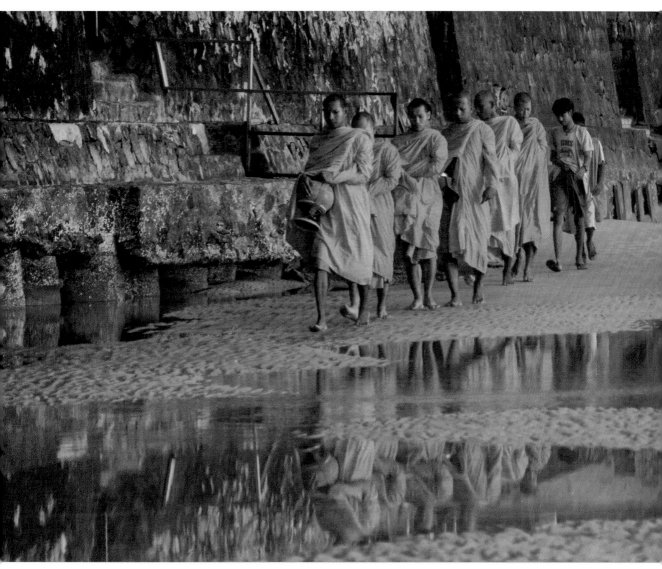

FOLLOW ME

BLUE HOUR

GIRL WITH HAT

SUNRISE PERFECTION

STAND-OFF

COMPANIONS

CONCENTRATION

8 CREATING A SLIDESHOW

Lesson overview

Once you've spent time bringing out the best in your images, showing them off in a slideshow is one of the easiest and most effective ways to share your photos with friends and family or to present them to a client. Choose a template as a starting point; then customize the layout, color scheme, and timing. Add backdrops, borders, text overlays—even music and video—to create a dynamic presentation that will complement your work and captivate your audience.

In this lesson, you'll create your own slideshow by following these easy steps:

- Grouping the images for your slideshow as a collection
- Choosing a slideshow template and adjusting the slide layout
- Setting a backdrop image and adding a text overlay
- Adding sound and motion to a slideshow
- Saving your slideshow and your customized template
- Exporting your presentation
- Viewing an impromptu slideshow

 You'll probably need between one and two hours to complete this lesson. If you haven't already done so, log in to your peachpit.com account to download the lesson files for this chapter, or follow the instructions under "Accessing the Lesson Files and Web Edition" in the Getting Started section at the beginning of this book.

In the Slideshow module you can quickly put together an impressive on-screen presentation complete with stylish graphic effects, transitions, text, music, and even video. Lightroom Classic CC makes it easier than ever to share your images with family and friends, clients, or the world at large by giving you the option of exporting your slideshow to PDF or video.

Getting started

Note: This lesson assumes that you already have a basic working familiarity with the Lightroom Classic CC workspace. If you need more background information, refer to Lightroom Classic CC Help, or review the previous lessons..

Before you begin, make sure you've set up the LRClassicCIB folder for your lesson files and created the LRClassicCIB Catalog file to manage them, as described in "Accessing the Lesson Files and Web Edition" and "Creating a catalog file for working with this book" in the Getting Started chapter at the start of this book.

If you haven't already done so, download the Lesson 8 folder from your Account page at www.peachpit.com to the LRClassicCIB \ Lessons folder, as detailed in "Accessing the Lesson Files and Web Edition" in the chapter "Getting Started."

1 Start Lightroom Classic CC.

2 In the Adobe Photoshop Lightroom Classic CC - Select Catalog dialog box, make sure the file LRClassicCIB Catalog.lrcat is selected under Select A Recent Catalog To Open, and then click Open.

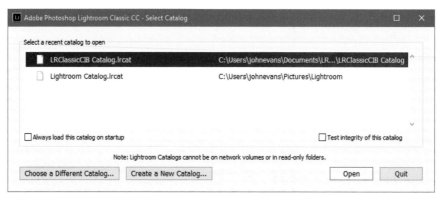

Tip: If you can't see the Module Picker, choose Window > Panels > Show Module Picker, or press the F5 key. If you're working on macOS, you may need to press the fn key together with the F5 key, or change the function key behavior in the system preferences.

3 Lightroom Classic CC will open in the screen mode and workspace module that were active when you last quit. If necessary, switch to the Library module by clicking Library in the Module Picker at the top of the workspace.

Importing images into the library

The first step is to import the images for this lesson into the Lightroom library.

1 In the Library module, click the Import button below the left panel group.

2 If the Import dialog box appears in compact mode, click the Show More Options button at the lower left of the dialog box to see all the options in the expanded Import dialog box.

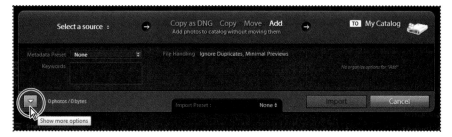

3 In the Source panel, locate and select the LRClassicCIB \ Lessons \ Lesson 8 folder; then, activate the Include Subfolders option. Ensure that all twelve images from the Lesson 8 folder are checked for import.

4 In the import options above the thumbnail previews, select Add so that the imported photos will be added to your catalog without being moved or copied. Under File Handling at the right of the expanded Import dialog box, choose Minimal from the Build Previews menu and ensure that the Don't Import Suspected Duplicates option is activated. Under Apply During Import, choose None from both the Develop Settings menu and the Metadata menu and type **Lesson 8, New York** in the Keywords text box. Make sure that your import is set up as shown in the illustration below, and then click Import.

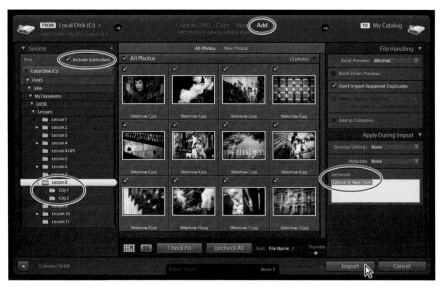

The twelve images are imported from the City 1 and City 2 subfolders inside the Lesson 8 folder and now appear in the Grid view of the Library module and also in the Filmstrip across the bottom of the Lightroom Classic CC workspace.

Assembling photos for a slideshow

▶ **Tip:** Your slideshow can include video as well as still images.

The first step is to assemble the images you wish to include. Having just been imported, the images for this lesson are already isolated from the rest of your catalog. In the Catalog panel, the Previous Import folder is selected as the active image source.

Although you could move to the Slideshow module now, the result would be less than ideal. The Previous Import folder is merely a temporary grouping and, as an image source, it is not flexible—you can't rearrange the images inside it, or exclude a photo from your slideshow without removing it from the catalog entirely.

1 In the Folders panel, click to select the Lesson 8 folder. If you don't see twelve lesson images in the Grid view and the Filmstrip, activate the option Show Photos In Subfolders in the Library menu; then, choose View > Sort > File Name.

2 In the Grid view or the Filmstrip, drag any of the lesson images to a new position in the group. An alert message appears to let you know that you can't reorder the images in a folder that contains subfolders; click OK to dismiss it.

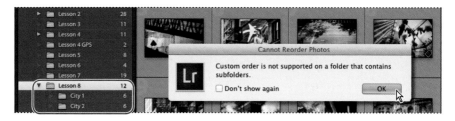

If the selected image source for your slideshow was a folder without subfolders, you *would* be able to rearrange photos in the Grid view or the Filmstrip to create a custom order for your slideshow, but you would still not be able to exclude an image without removing it from the catalog.

▶ **Tip:** You can reorder photos in a collection by simply dragging the thumbnails in the Grid view or the Filmstrip. Your custom display order will be saved with the collection.

The solution is to create a collection to group the photos for your project, where you can rearrange the image order—just as you can with a single folder—and also remove an image from the virtual grouping, without deleting it from your catalog. A collection has a permanent listing in the Collections panel, making it easy to retrieve the set of images you've assembled at any time, even if they're stored across multiple folders, as is often the case for the results of a complex search.

3 Check that the Lesson 8 folder is still selected in the Folders panel; then, press Ctrl+A / Command+A or choose Edit > Select All. Click the New Collection button (⊕) in the header of the Collections panel and choose Create Collection from the menu. In the Create Collection dialog box, type **City** as the name for the new collection, and make sure that the option Inside A Collection Set is disabled under Location. Activate the Include Selected Photos option and disable Make New Virtual Copies and Set As Target Collection; then, click Create.

Your new collection appears in the Collections panel, where it is automatically selected as the active image source. The image count indicates that the City collection contains twelve photos.

4 Choose Edit > Select None; then, press Ctrl+Alt+5 / Option+Command+5, or click Slideshow in the Module Picker to switch to the Slideshow module.

Working in the Slideshow module

At center stage in the Slideshow module is the Slide Editor view where you'll work on your slide layouts and preview your slideshow in operation.

In the left panel group, the Preview panel displays a thumbnail preview of whichever layout template is currently selected (or under the pointer) in the Template Browser panel, while the Collections panel provides easy access to your photos.

▶ **Tip:** The first time you enter any of the Lightroom modules, you'll see tips that help you identify the components of the workspace and understand the workflow order. You can dismiss the tips by clicking the Close button. To reactivate the tips for any module, choose [*Module name*] Tips from the Help menu.

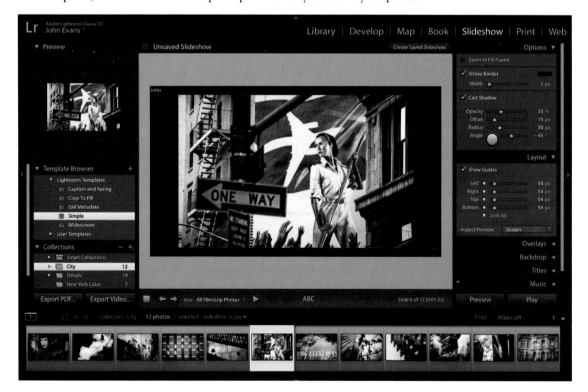

The Toolbar below the Slide Editor view offers controls for navigating through the images in your collection, previewing the slideshow, and adding text to your slides.

The settings and controls in the right panel group enable you to customize the selected template by tweaking the layout, adding borders, shadows, and overlays, changing the backdrop, adding title screens, and adjusting the playback settings.

● **Note:** Your preview may look slightly different from the illustration, depending on the size and proportions of your computer display.

Choosing a slideshow template

Each of the preset Lightroom slideshow templates incorporates a different combination of layout settings, such as image size, borders, backgrounds, shadows, and text overlays that can be customized to create your own slide designs.

▶ **Tip:** The default template will be used when you launch the Impromptu Slideshow from another module. To designate a different template for this purpose, right-click / Control-click its name in the Template Browser and choose Use For Impromptu Slideshow; a Plus sign (+) appears after the name of the new default template.

1 In the Template Browser panel, expand the Lightroom Templates folder, if necessary; then, move the pointer slowly up and down the list of Lightroom templates. The Preview panel shows you how the selected image looks in each template layout. Select a different image in the Filmstrip, and then preview the templates again.

2 When you're done previewing the options in the Template Browser, click to select the Widescreen template.

3 In the Toolbar, right below the slide preview, choose All Filmstrip Photos from the Use menu. In the Filmstrip, select the first image, Slideshow-1.jpg.

4 Click the Preview button at the bottom of the right panel group to preview your presentation in the Slide Editor view. When you're done, press the Esc key on your keyboard, or click in the Slide Editor view to stop the preview.

Template options for slideshows

As a convenient starting-point for creating your own slide layouts, you can choose from these customizable Lightroom templates:

Caption And Rating This template centers the images on a grey background and displays the photo's star rating and caption metadata on each slide.

Crop To Fill Your photos fill the screen and may be cropped to fit the screen's aspect ratio, so this is probably not a good option for images in portrait format.

EXIF Metadata The slides are centered on a black background and include star ratings, EXIF (Exchangeable Image Format) information, and your identity plate.

Simple This template centers your photographs on a black background and incorporates your custom identity plate.

Widescreen Your images are centered and sized to fit the screen without being cropped: any empty space outside the image is filled with black.

Customizing your slideshow template

For the purposes of this lesson, you won't be adding an identity plate or metadata information to your slides, so the Widescreen template will serve as a good basis for setting up a customized layout.

Adjusting the slide layout

Once you've chosen a slide template, you can use the controls in the right panel group to customize it. For this project you'll start by modifying the layout, and then change the background to set up the overall look of the design before you make decisions about the style and color of borders and overlaid text. The Layout panel enables you to change the size and position of the photo in the slide layout by setting the margins that define the image cell.

1 If the Layout panel in the right panel group is currently collapsed, expand it by clicking the triangle beside its name. Make sure that the Show Guides and Link All options are activated. If your screen has an aspect ratio other than 16:9, choose 16:9 from the Aspect Preview.

> **Tip:** Video clips in a slideshow are placed in your slide layout in the same way as still images, complete with borders and shadows.

2 Move the pointer over the lower edge of the image in the Slide Editor view. When the pointer changes to a double-arrow cursor, drag the edge of the image upwards. As you drag, grey layout guide lines appear against the black background around the scaled-down image. All four guides move at the same time because the Link All option is activated in the Layout panel. As you drag upwards, watch the linked sliders and numerical values change in the Layout panel and release the mouse button when the values reach 60 px (pixels).

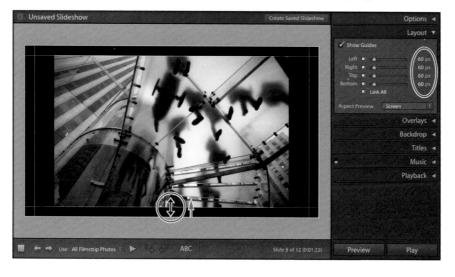

> **Tip:** You could also drag the sliders in the Layout panel, or click the pixel values and type new numbers, to adjust the size of the image in the slide layout. With the settings linked, you only need to drag one slider or enter one value. Remember that the proportions of your slides may differ from what you see in the illustrations in this lesson, depending on the aspect ratio of your computer display.

Now you can increase the width of the slide's top margin to create a space where you can add text later in the lesson.

3 In the Layout panel, disable the Link All option, and then either drag the Top slider to the right, type over the adjacent pixel value, or drag the top guide in the Slide Editor, to set a value of 135 px (pixels). Disable the Show Guides option, and then collapse the Layout panel.

Setting up the slide background

Note: When all three of the backdrop options are disabled, the slide background is black.

In the Backdrop panel you can set a flat background color for your slides, apply a graduated color wash, or place a background image—you can even mix all three elements to create an atmospheric frame for your photos.

1 In the Filmstrip, select any image other than the third photo in the series.

Tip: You can also drag an image from the Filmstrip directly onto the slide background in the Slide Editor view.

2 If necessary, expand the Backdrop panel in the right panel group. Activate the Background Image option, and then drag the third image, Slideshow-3.jpg, from the Filmstrip into the Background Image pane. Drag the Opacity slider to the left to reduce the value to 80%, or click the Opacity value and type **80**.

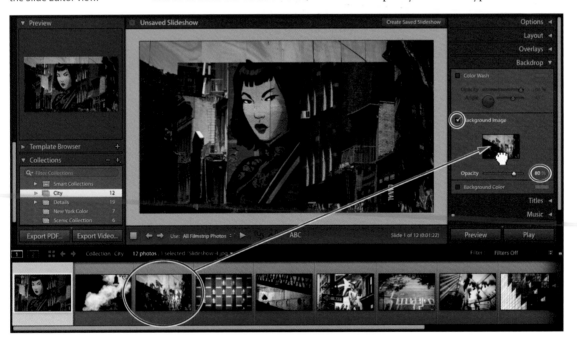

With the Background Color option disabled, the default black background shows through the partially transparent image, effectively darkening it. However, the background is still competing too much with the featured photos. You can use the Color Wash feature to darken the backdrop a little more. Color Wash applies a graduated wash that fades from whatever color is set in the Color Wash swatch to the background image (or color).

3 Activate the Color Wash option. Click the Color Wash swatch, and then click the black swatch in the row at the upper right of the Color Picker.

4 Click the Close button at the upper left of the Color Picker, and then use the Opacity slider to set the color wash opacity to **50**%. Set the Angle of the wash to **45**. When you're done, collapse the Backdrop panel.

With the background photo set to partial transparency, your backdrop design is now a composite of all three optional elements: a graduated color wash, an image, and the default background color.

▶ **Tip:** A sophisticated backdrop design that includes a related background image can be a stylish and effective way to create an overall theme or atmosphere for your slideshow.

Adjusting stroke borders and shadows

Now that you've established the overall layout and feel for your slides, you can "lift" the images to make them stand out more against the background by adding a thin stroke border and a drop shadow. We'll choose a border color that will provide a contrast to the predominately blue backdrop.

1 In the right panel group, expand the Options panel. Activate the Stroke Border option, and then click the color swatch beside it to open the Color Picker.

2 To set a pale blue color for the stroke border, click to select the R, G, and B percentages at the lower right of the Color Picker in turn and type values of **70**, **85**, and **90** respectively. Click outside the Color Picker to close it.

3 Use the Width slider to set a width of 1 pixel or type **1** in the text box.

4 Activate the Cast Shadow option in the Options panel and experiment with the controls. You can adjust the opacity of the shadow, the distance the shadow is offset from the image, the angle at which it is cast, and the Radius setting, which affects the softness of the shadow's edge. When you're done, set the controls as in the illustration at the right, and then collapse the Options panel.

Adding a text overlay

Note: For this exercise, you won't incorporate an identity plate or watermark in your slideshow. For more information on identity plates, refer to Lesson 2, Lesson 10, or the Lightroom Classic CC Help topic "Add your identity plate to a slideshow."

In the Overlays panel you can add text, an identity plate, or a watermark to your slides and have Lightroom display the rating stars you've assigned to your images or the captions that you've added to their metadata. In this exercise, you'll add a simple headline that will be overlaid on the background for every slide.

1 Expand the Overlays panel and activate the Text Overlays option. If the Toolbar is not visible just below the Slide Editor view, press the T key. In the Toolbar, click the Add Text To Slide button (ABC).

2 Type **SMALL SECRETS OF THE BIG CITY** in the Custom Text box.

3 Press Enter / Return. The text appears in the lower left corner of the slide, surrounded by a bounding box. The Text Overlays settings are updated to show the default font details (Myriad Web Pro is selected in the illustration below).

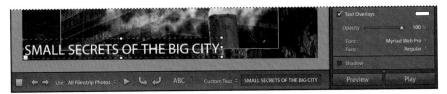

4 Click the double triangle beside the font name and choose a different font. We chose Rockwell Std for its suggestion of telegrams and typed reports; from the Face menu, we chose Light. Leave the text color set to the default white, but decrease the Opacity to 80% to soften the effect.

5 Drag the text upwards and allow it to attach itself to the anchor at the center of the slide's upper edge. Drag the handle at the bottom of the text bounding box upwards to scale the text to about 75% of the width of the photo; then, use the up and down arrow keys to position the title as shown in the illustration below.

As you drag text on a slide layout, Lightroom tethers the bounding box either to the nearest of various reference points around the edge of the slide, or to a point on the border of the image itself.

6 To see this in operation, drag the text around the slide, both inside and outside of the image, and watch the white tether-line jump from point to point. When you're done, return the text to its original position.

Throughout a slideshow, the tethered text will maintain the same position either relative to the slide as a whole, or to the border of each image, whatever its shape.

You can use this feature to ensure that photo-specific caption text, for instance, will always appear just below the left corner of each image no matter what its size or orientation, while a title that applies to the presentation as a whole—as does the text in our example—will remain in a constant position on the screen. In the latter case, the text is tethered to one of the anchors around the edge of the slide; in the former, the text would be tethered to an anchor on the border of the feature image.

The color and opacity controls in the Text Overlays operate just as they do for the Color Wash and Stroke Border. On macOS, you can also set up a drop shadow for your text.

7 Collapse the Overlays panel and deselect the text box in the Slideshow Editor.

8 Select the first slide in the Filmstrip and click the Preview button at the bottom of the right panel group to preview your slideshow in the Slideshow Editor view. When you're done, press Esc to stop playback.

Using the Text Template Editor

In the Slideshow module, you can use the Text Template Editor to access and edit the metadata that is stored in your photos and set up text overlays to be displayed on each slide, drawn from that information. You can add custom text and choose from titles, captions, image size, camera info, and a wide range of other options; then, save your choices as a text template preset that will help you streamline and automate your workflow for similar projects in the future.

To call up the Text Template Editor, first click the Add Text To Slide button (ABC) in the Toolbar and type to add a text overlay in the Slide Editor; then, with your new overlay selected, click the double triangle beside the Custom Text box in the Toolbar and choose Edit from the menu.

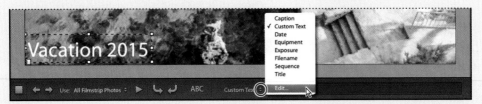

In the Text Template Editor, you can set up a string of one or more *text tokens*: placeholders that represent the information items to be drawn from each photo's metadata for display in your slideshow.

In the Preset menu at the top of the editor you can apply, save, and manage text overlay presets: saved sets of info tokens that are customized for different purposes.

Use the Image Name menu to set up a text string with the filename, copy name, folder name, or custom text.

Use the Numbering menu to number the images in your slideshow and display image capture dates in a variety of formats.

Choose from EXIF metadata including image dimensions, exposure, flash settings and many other attributes.

IPTC metadata includes copyright, creator details and numerous other options.

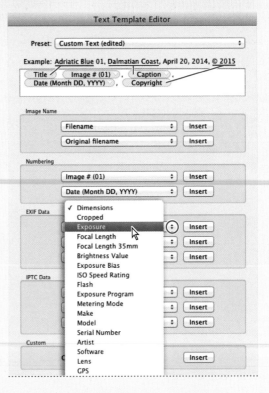

Creating a Saved Slideshow

Since you entered the Slideshow module, you've been working with an *unsaved slideshow*, as is indicated in the bar across the top of the Slideshow Editor view.

> ▶ Unsaved Slideshow Create Saved Slideshow

Until you save your slideshow, the Slideshow module works like a scratch pad. You can move to another module, or even close Lightroom Classic CC, and find your settings unchanged when you return, but if you click a new slideshow template—or even the one you started with—in the Template Browser, the "scratch pad" will be cleared and all your work will be lost.

Converting your project to a Saved Slideshow not only preserves your layout and playback settings, but also links your design to the particular set of images for which it was designed. Your slideshow is saved as a special kind of collection—an *output collection*—with its own listing in the Collections panel. Clicking this listing will instantly retrieve the images you were working with, and reinstate all of your settings, no matter how many times the slideshow scratch pad has been cleared.

1 Click the Create Saved Slideshow button in the bar at the top of the Slideshow Editor view, or click the New Collection button (⊕) in the header of the Collections panel and choose Create Slideshow.

2 In the Create Slideshow dialog box, type Secret City as the name for your saved presentation. In the Location options, activate Inside and choose the collection City from the associated menu; then, click Create.

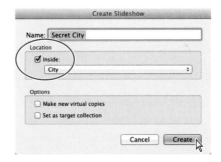

▶ **Tip:** The Make New Virtual Copies option is useful if you wish to apply a particular treatment, such as a developing preset, to all the pictures in your slideshow, without affecting the photos in the source collection.

The title bar above the Slide Editor now displays the name of your saved slideshow, and no longer presents the Create Saved Slideshow button.

Your saved slideshow appears in the Collections panel, marked with a Saved Slideshow icon (▣), and nested inside the original source collection, City. The image count shows that the new output collection, like the source, contains twelve photos.

You can save your slideshow at any point in the process; you could create a Saved Slideshow as soon as you enter the Slideshow module with a selection of images or wait until your presentation is polished. Once you've saved your slideshow, any changes you make to the layout or playback settings are auto-saved as you work.

For the purposes of this lesson, saving the project at this stage enables you to delete and rearrange slides to refine your presentation, without affecting the source collection—any image you exclude from the slideshow now will be removed from the Secret City output collection, but will remain a part of your City collection.

This could be useful if you also intended to use the photos in the City collection to produce a print layout and a web gallery, for instance—your original collection will remain intact, while the output collection for each project might contain a different subset of images, arranged in a different order.

Refining the content of a slideshow

Tip: Adding more photos to your saved slideshow is easy: simply drag images to the slideshow's listing in the Collections panel. Click the white arrow that appears to the right of the image count when you move the pointer over your saved slideshow in the Collections panel to jump from the Library to your presentation in the Slideshow module.

It's a good idea to finalize the photo set for your slideshow at this point, before you go on to specify playback settings—if you remove an image later, you might need to readjust the time allocated for each slide and transition, especially if your slideshow is timed to match the duration of a sound file.

1 In the Filmstrip, right-click / Control-click the image Slideshow-3.jpg—the photo you used as a background image—and choose Remove From Collection.

Note that although the photo disappears from the Filmstrip, and will not feature on any slide in the presentation it is not removed from the slide background in the Slide Editor view. The background image has become part of the slide layout, rather than merely one of the selection photos to be displayed.

Even if you "re-fill" your slideshow with a different set of photos entirely, the background image will remain in place. Your saved slideshow includes a link to the photo that is independent of the output collection or its parent collection.

In the Collections panel, the nested Secret City output collection now shows an image count of eleven photos, while its parent collection still contains the original count of twelve.

2 In the Filmstrip, drag the photo Slideshow-7 to a new position between the images Slideshow-5 and Slideshow-6, releasing the mouse button when the black insertion bar appears.

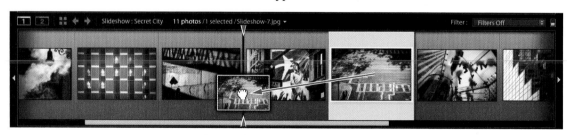

Adding sound and motion to your slideshow

One way to make your presentation more dynamic is to add video clips, which are placed on their own slides according to your layout, just like your photos—complete with stroke borders, shadows, and overlays.

Even for a slideshow composed entirely of still images, you can easily create atmosphere and generate emotional impact by adding music, and bring your photos to life with filmic pan and zoom effects.

You'll find a sound file named Backslider.m4a in your Lesson 8 folder. This piece of music will underline the moody, urban theme of the slideshow. However, feel free to choose any other file from your music library that you'd like to audition; with only eleven images in the slideshow, a fairly short piece will probably work best.

1 Expand the Music and Playback panels in the right panel group. Make sure the soundtrack is enabled for your slideshow by clicking the switch at the left of the Music panel's header. Click the Add Music button (⊕); then, navigate to your LRClassicCIB > Lessons > Lesson 8 folder, select the file Backslider.m4a, and click Open / Choose.

The name of the sound file and its duration are displayed in Music panel. As this piece includes a sound-effect intro and ending, you can start by adding a "blank slide" at both ends of the slideshow so that the music comes in at the right time.

2 Expand the Titles panel and activate both the Intro Screen and Ending Screen options. Disable the Add Identity Plate option for both screens.

The next step is to fine-tune the timing of the slideshow by setting the duration of the slides and the transitions between them to match the length of the music file.

3 In the Playback panel, watch the Slide Length and Crossfades values change as you click the Fit To Music button below the sliders.

The timing is adjusted to fit the eleven images and two title screens to the duration of the music file.

4 Drag the Crossfades slider to the right to increase the duration of the fade transitions to 4 seconds, and then click the Fit To Music button once more, keeping an eye on the Slide Length value as you do so.

Lightroom re-calculates the slide duration so that the slideshow fits the music file despite the lengthened fades.

5 Disable the Repeat Slideshow and Random Order options, further down in the Playback panel. In the Filmstrip, select the first image; then, click the Preview button at the bottom of the right panel group to preview the slideshow in the Slideshow Editor view. When you're done, press Esc to stop playback.

Adding music has created a sense of narrative for the presentation; now it's time to add some movement that will help to make it not just a story, but a journey.

6 Activate the Pan And Zoom option in the Playback panel. Drag the slider to set the level for the effect about one third of the way between Low and High.

The higher you set the Pan And Zoom slider, the faster and broader the movement; a low setting creates a slow drift that never moves too far from a full-frame view.

7 Make sure the first photo is selected in the Filmstrip, and then click the Play button at the bottom of the right panel group to see the slideshow in full-screen mode. If you wish, you can press the spacebar to pause and resume playback. When you're done press the Esc key to end the slideshow.

▶ **Tip:** You can add up to ten music files to your slideshow soundtrack; to change the order in which they'll play, drag files to new positions in the Music panel list.

For a slideshow that contains more images than our lesson project, use the Add Music button (⊕) to attach more sound files. If your slideshow includes multiple sound files, clicking the Fit To Music button will fit your slides and transitions to the combined duration of the music tracks.

The Sync Slides To Music option disables the Slide Length and Crossfades controls and the Fit To Music button. Lightroom analyzes the sound file and sets the timing of the slideshow not only to match the tempo, but also to respond to prominent sounds in the music.

The Playback panel also incorporates an Audio Balance slider that enables you to mix your soundtrack music with the audio from video clips in your slideshow.

If you have a second display attached to your computer, you'll see the Playback Screen pane in the Playback panel, where you can choose which screen will be used when you play your slideshow at full screen, and whether the other screen will be blanked during playback.

Saving a customized slideshow template

Having spent so much time customizing your slideshow template, you should now save it so that it becomes available as a new choice in the Template Browser menu.

This is not the same as saving your slideshow, as you did earlier. A saved *slideshow* is actually an output collection—an arranged grouping of images, saved together with a slide layout, text overlays, and playback settings. In contrast, a saved *custom template* records only your slide layout and playback settings—it is an empty container that is not linked to any particular set of images.

Modifying and organizing user templates

The Template Browser offers numerous options for organizing your templates and template folders:

Renaming a template or template folder
You cannot rename the Lightroom Templates folder, any of the Lightroom templates, or the default User Templates folder. To rename any of the templates or template folders that you have created, right-click / Control-click the template or folder in the Template Browser and choose Rename from the context menu.

Moving a template
If you wish to move a template into another folder in the Template Browser, simply drag the template to that folder. If you wish to move a template into a new folder, right-click / Control-click the template and choose New Folder from the context menu. The selected template will be moved into the new folder as it is created. If you try to move one of the Lightroom templates, the template will be copied to the new folder but will still remain in the Lightroom Templates folder.

Updating a custom template's settings
If you wish to modify one of your own custom templates select it in the Template Browser and make your changes using any of the controls in the right panel group. To save your changes, right-click / Control-click the template in the Template Browser and choose Update with Current Settings.

Creating a copy of a template
You may wish to create a copy of a template so that you can safely make modifications without affecting the original. If you wish to create a copy of the currently selected template in an existing template folder, click the Create New Preset button (+) in the Template Browser panel header. In the New Template dialog box, type a name for the copy, choose the destination folder from the Folder menu, and click Create. If you wish to create a copy of the currently selected template in a new folder, click the Create New Preset button (+) in the Template Browser panel header. In the New Template dialog box, type a name for the copy and choose New Folder from the Folder menu. In the New Folder dialog box, type a name for the new folder and click Create. The new folder appears in the Template Browser. Click Create in the New Template dialog box to dismiss it. The copied template will be created in the new folder.

Exporting a custom template
To export your custom slideshow template so that you can use it in Lightroom on another computer, right-click / Control-click the template name in the Template Browser menu and choose Export from the context menu.

Importing a custom template
To import a custom template that has been created in Lightroom on another computer, right-click / Control-click the User Templates header or any of the templates in the User Templates menu and choose Import from the context menu. In the Import Template dialog box, locate the template file and click Import.

(continues on next page)

Modifying and organizing
user templates (continued)

Deleting a template

To delete a custom template, right-click / Control-click the template name in the Template Browser and choose Delete from the context menu. You can also select the template and click the Delete Selected Preset button in the header of the Template Browser. You cannot delete the templates in the Lightroom Templates folder.

Creating a new templates folder

To create a new empty folder in the Templates Browser, right-click / Control-click the header of any other folder and choose New Folder from the context menu. You can drag templates into the new folder.

Deleting a templates folder

To delete a template folder, you'll first need to delete all the templates within that folder—or drag them to another folder. Right-click / Control-click the empty folder, and choose Delete Folder from the context menu.

Saving your customized slideshow template will save you a lot of time later should you wish to put together a related presentation, or simply use the template as a starting point for creating a new design.

By default, your customized template will be listed with the User Templates in the Template Browser panel.

1 With your slideshow still open, click the Create New Preset button (⊕) in the header of the Template Browser panel, or choose Slideshow > New Template.

▶ **Tip:** When saving a customized template it's a good idea to give it a descriptive name. This will make it easier to find as you add more choices to the Template Browser menu.

2 In the New Template dialog box, type **Centered Title** as the new template name. Leaving the default User Templates folder selected as the destination folder in the Folder menu, click Create.

Your new customized template is now listed under User Templates in the Template Browser panel.

Exporting a slideshow

To send your slideshow to a friend or client, play it on another computer, or share it on the Web, you can export it as a PDF file or as a high-quality video file.

1 In the Slideshow module, click the Export PDF button at the bottom of the left panel group.

2 Review the options available in the Export Slideshow To PDF dialog box, noting the settings for size and quality, and then click Cancel.

Note: PDF slideshow transitions work when viewed using the free Adobe Reader® or Adobe Acrobat®. However, slideshows exported to PDF will not include music, randomized playback order, or your customized slide duration settings.

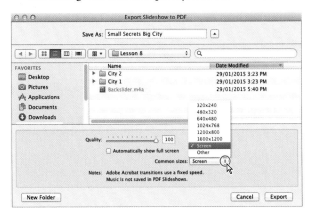

3 Repeat the process for the Export Video button. Review the Export Slideshow To Video dialog box, noting the range of options available in the Video Preset menu. Select each export option in turn to see a brief description below the Video Preset menu.

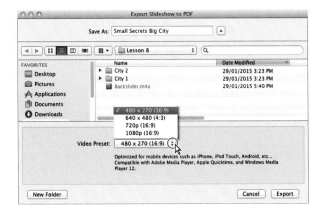

Lightroom Classic CC exports slideshows in the mp4 movie format so that you can share your slideshow movies on video sharing sites or optimize them for playback on mobile devices. Preset size and quality settings range from 480 x 270, optimized for personal media players and email, to 1080p, optimized for high quality HD video.

4 In the Export Slideshow To Video dialog box, type a name for your exported video and specify a destination folder. Choose an option from the Video Preset menu, and then click Export.

A progress bar in the upper left corner of the workspace shows the status of the export process.

Playing an impromptu slideshow

Even outside the Slideshow module you can play an impromptu slideshow. In the Library module, for instance, this makes a convenient way to see a full-screen preview of the photos you've just imported.

> **Tip:** To change the slideshow template used for the impromptu slideshow, right-click / Control-click a template in the Slideshow module Template Browser and choose Use For Impromptu Slideshow.

The Impromptu Slideshow can be launched from any of the Lightroom Classic CC modules. The slide layout, timing, and transitions for the Impromptu Slideshow will depend on the template currently set in the Slideshow module for use with the Impromptu Slideshow.

1 Switch to the Library module. In the Catalog panel, select Previous Import. Use the Sort menu in the Grid view Toolbar to set the sorting order to either Capture Time or File Name. Choose View > Sort > Ascending, or click the Sort Direction button (![icon]) beside the Sort menu, if necessary, to set an ascending sort direction (the Sort Direction button should show an "A" above a "Z").

2 Select the first photo in the Grid view; then, press Ctrl+A / Command+A or choose Edit > Select All to select all of the images from the previous import.

> **Tip:** In the Library and Develop modules, you can also use the Impromptu Slideshow button in the Toolbar. If you don't see the Impromptu Slideshow button in the Toolbar, choose Slideshow from the content menu at the right end of the Toolbar.

3 Choose Window > Impromptu Slideshow or press Ctrl+Enter / Command+Return to start the impromptu slideshow.

4 Use the spacebar to pause and resume playback. The slideshow will repeat, cycling through the selected images until you either press the Esc key on your keyboard or click the screen to stop playback.

Well done! You have successfully completed another Lightroom Classic CC lesson. In this lesson you learned how to create your own stylish slideshow presentation. In the process, you've explored the Slideshow module and used the control panels to customize a slideshow template—refining the layout and playback settings and adding a backdrop, text, borders, and a soundtrack.

In the next chapter you'll find out how to present your work in printed format, but before you move on, take a few moments to reinforce what you've learned by reading through the review questions and answers on the next page.

Review questions

1 How can you change which template is used for the Impromptu Slideshow?

2 Which Lightroom slideshow template would you pick if you wished to display metadata for your images?

3 What options do you have when customizing a slideshow template?

4 What are the four Cast Shadow controls and what are their effects?

5 What is the difference between saving your customized slideshow template and saving the slideshow you've created?

Review answers

1 In the Slideshow module, right-click / Control-click the name of a slideshow template in the Template Browser and choose Use For Impromptu Slideshow.

2 The EXIF Metadata template, which centers photos on a black background and displays star ratings and EXIF information for the images, as well as an identity plate.

3 In the right panel group you can modify the slide layout, add borders and text overlays, create shadow effects for images or text, change the background color or add a backdrop image, adjust the durations of slides and fades, and add a soundtrack.

4 The four Cast Shadow controls have the following effects:

- Opacity: Controls the opacity of the shadow ranging from 0% (invisible) to 100% (fully opaque).

- Offset: Affects the distance that the shadow is offset from the slide. As the offset is increased, more shadow becomes visible.

- Radius: Controls how sharp (lower settings) or soft (higher settings) the edges of the shadow appear.

- Angle: Sets the direction of the light source, which affects the angle at which the shadow is cast.

5 A saved custom template records only your layout and playback settings—it is like an empty container that is not linked to any particular set of images, whereas a saved slideshow is actually an output collection—an arranged grouping of images, saved together with a slide layout, text overlays, and playback settings.

PHOTOGRAPHY SHOWCASE
COLBY BROWN

"I hope that my images resonate with others, giving me the opportunity to share the world I love and hopefully helping others to learn to appreciate the beauty found all around us."

As a photographer I believe that the artistic process of an image doesn't stop once the shutter has been released, but continues into the digital darkroom. By blending various exposures together and increasing the dynamic range of details that I can preserve in a given scene, I am able to more accurately recreate and showcase moments frozen in time as I witnessed them, rather than limit myself based on current camera technology.

One of the most prolific aspects of the digital revolution of photography is the sheer fact that more people today, have the ability to digitally express themselves than ever before. Billions of people, all across this planet, are capturing the world around them and sharing those experiences with others. This is helping to push the boundaries of what we think is artistically possible as individuals begin to test the limits of their own creativity and passion.

As human beings I feel that we are all looking for inspiration as we move through life. We all want to be inspired to be more then we are, see more of the world, and experience more with the limited time that we have. I hope that my images resonate with others, giving me the opportunity to share the world I love and hopefully help others to learn to appreciate the beauty found all around us.

www.colbybrownphotography.com

PETRA BY NIGHT

FOCUSED

MIRRORED REFLECTIONS

YOSEMITE FALLS AMIDST THE STORM

THE SUBWAY

LOST INNOCENCE

9 PRINTING IMAGES

Lesson overview

The Lightroom Classic CC Print module offers all the tools you'll need to quickly prepare any selection of images for printing. You can print a single photo, repeat one image at different sizes on the same sheet, or create an attractive layout for multiple images. Add borders, text, and graphics, and then adjust print resolution, sharpening, paper type, and color management with just a few clicks.

In this lesson, you'll explore the Print module as you become familiar with the steps in the printing workflow:

- Choosing and customizing a print template
- Creating a Custom Package print layout
- Adding an identity plate, borders and a background color
- Captioning photos with information from their metadata
- Saving a custom print template
- Specifying print settings and printer driver options
- Choosing appropriate color management options
- Saving a print job as an output collection

 You'll probably need between one and two hours to complete this lesson. If you haven't already done so, log in to your peachpit.com account to download the lesson files for this chapter, or follow the instructions under "Accessing the Lesson Files and Web Edition" in the Getting Started section at the beginning of this book.

The Print module in Lightroom Classic CC makes it easy to achieve professional printed results, with device-specific soft proofing to help you produce prints that match the color and depth you see on screen, and customizable layout templates for anything from a contact sheet to a fine art mat.

Getting started

Note: This lesson assumes that you already have a basic working familiarity with the Lightroom Classic CC workspace. If you need more background information, refer to Lightroom Classic CC Help, or review the previous lessons.

Before you begin, make sure you've set up the LRClassicCIB folder for your lesson files and created the LRClassicCIB Catalog file to manage them, as described in "Accessing the Lesson Files and Web Edition" and "Creating a catalog file for working with this book" in the Getting Started chapter at the start of this book.

If you haven't already done so, download the Lesson 9 folder from your Account page at www.peachpit.com to the LRClassicCIB \ Lessons folder, as detailed in "Accessing the Lesson Files and Web Edition" in the chapter "Getting Started."

1 Start Lightroom Classic CC.

2 In the Adobe Photoshop Lightroom Classic CC - Select Catalog dialog box, make sure the file LRClassicCIB Catalog.lrcat is selected under Select A Recent Catalog To Open, and then click Open.

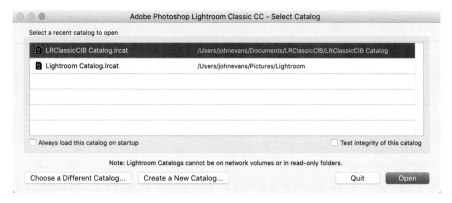

Tip: If you can't see the Module Picker, choose Window > Panels > Show Module Picker, or press the F5 key. If you're working on Mac OS, you may need to press the fn key together with the F5 key, or change the function key behavior in the system preferences.

3 Lightroom Classic CC will open in the screen mode and workspace module that were active when you last quit. If necessary, switch to the Library module by clicking Library in the Module Picker at the top of the workspace.

Importing images into the library

The first step is to import the images for this lesson into the Lightroom library.

1 In the Library module, click the Import button below the left panel group.

2 If the Import dialog box appears in compact mode, click the Show More Options button at the lower left to expand it.

3 Under Source at the left of the Import dialog box, navigate to and select the Lesson 9 folder (inside the LRClassicCIB \ Lessons folder). Make sure that all six images in the Lesson 9 folder are checked for import.

4 In the import options picker above the thumbnail previews, select Add so that the imported photos will be added to your catalog without being moved or copied. Under File Handling at the right of the Import dialog box, choose Minimal from the Build Previews menu and ensure that the Don't Import Suspected Duplicates option is activated. Under Apply During Import, choose None from both the Develop Settings menu and the Metadata menu, and type **Lesson 9** in the Keywords text box. Make sure that your import is set up as shown in the illustration below, and then click Import.

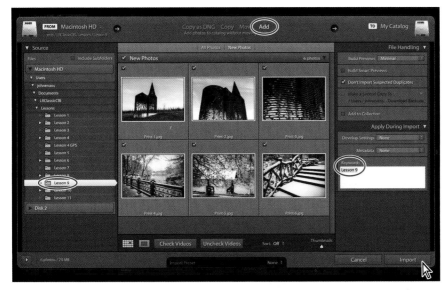

The six images from the Lesson 9 folder appear in both the Library module Grid view and the Filmstrip across the bottom of the Lightroom Classic CC workspace.

5 You won't be able to rearrange the images for your print job as long as Previous Import is selected as the image source in the Catalog panel. In the Folders panel, click the Lesson 9 folder to change the image source. In the Toolbar, set the Sort order to File Name; then, click Print in the Module Picker at the top of the workspace to switch to the Print Module.

▶ **Tip:** The first time you enter any of the Lightroom modules, you'll see module tips that will help you get started by identifying the components of the workspace and stepping you through the workflow. Dismiss the tips by clicking the Close button.
To reactivate the tips for any module, choose [*Module name*] Tips from the Help menu.

About the Lightroom Classic CC Print module

In the Print module you'll find tools and controls for each step in the printing workflow. Change the order of your photos, choose a print template and refine the layout, add borders, text, and graphics, and then adjust the output settings; everything you need to produce professional-looking prints is at your fingertips.

The left panel group contains the Preview, Template Browser, and Collections panels. Move the pointer over the list in the Template Browser to see a thumbnail preview of each layout template displayed in the Preview panel. When you choose a new template from the list, the Print Editor view—at center-stage in the workspace—is updated to show how the selected photos look in the new layout.

You can quickly select and rearrange the photos for your print job in the Filmstrip, where the source menu provides easy access to the images in your library, listing your favorites and recently used source folders and collections.

You'll use the controls in the right panel group to customize your layout template and to specify output settings.

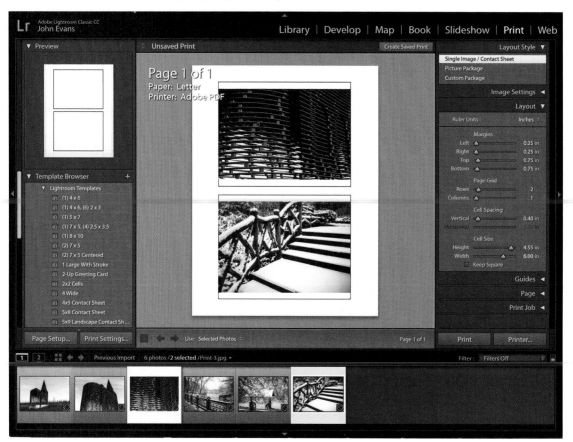

The Template Browser contains templates of three distinct types: Single Image / Contact Sheet layouts, Picture Package layouts, and Custom Package layouts.

Four of the first fifteen preset Lightroom templates in the menu are Picture Package layouts, which repeat a single image at a variety of sizes on the same page. The other eleven are Single Image / Contact Sheet layouts, which can be used to print multiple photos at the same size on a single sheet. Single Image / Contact Sheet layouts are based on an adjustable grid of image cells. They range from contact sheets with many cells to single-cell layouts such as the Fine Art Mat and Maximize Size templates. The Custom layout templates further down the menu enable you to print multiple images at any size on the same page. All of the templates can be customized; you can save your modified layouts as user-defined templates, which will be listed in the Template Browser.

Once you've chosen a layout from the Template Browser, the Layout Style panel at the top of the right panel group indicates which type of template you're working with. The suite of panels you see below the Layout Style panel will vary slightly, depending on which type of template you have chosen.

The controls in the Image Settings panel enable you to add photo borders and to specify the way your pictures are fitted to their image cells.

For a Single Image / Contact Sheet template, you can use the Layout panel to adjust margins, cell size and spacing, and to change the number of rows and columns that make up the grid. For a Picture Package or Custom package template, you'll modify your layout with the Rulers, Grid & Guides panel and the Cells panel. Use the Guides panel to show or hide a selection of layout guides. The Page panel has controls for watermarking your images and adding text, graphics, or a background color to your print layout. In the Print Job panel you can set the print resolution, print sharpening, paper type, and color management options.

About layout styles and print templates

The Template Browser offers a wide choice of preset Lightroom print templates that differ not only in basic layout but may also include a variety of design features such as borders and overlaid text or graphics.

Templates may also differ in their output settings: the preset print resolution setting for a contact sheet, for example, will be lower than the resolution set for a template designed for producing finished prints.

You can save time and effort setting up your print job by selecting the print template that most closely suits your purpose. In this exercise you'll be introduced to the different types of templates and use the panels in the right panel group to examine the characteristics of each layout.

1 In the left panel group, make sure that the Preview and Template Browser panels are expanded. If necessary, drag the top border of the Filmstrip down so that you can see as many of the templates in the Template Browser as possible. In the right panel group, expand the Layout Style panel and collapse the others.

2 Choose Edit > Select None, and then select any one of the images in the Filmstrip. The Print Editor view at the center of the workspace is updated to display the selected photo in the current layout.

3 If necessary, expand the Lightroom Templates folder in the Template Browser panel. Move the pointer slowly over the list of preset templates to see a preview of each layout in the Preview panel.

4 Click the second template in the Template Browser: "(1) 4 × 6, (6) 2 × 3." The new template is applied to the image in the Print Editor view. Scroll up in the right panel group, if necessary, and inspect the Layout Style panel. You'll see that the Layout Style panel indicates that this template is a Picture Package layout. In the Template Browser, click the sixth Lightroom template "(2) 7 × 5." The Layout Style panel indicates that this is also a Picture Package layout.

5 Now choose the ninth preset template in the Template Browser: "2-Up Greeting Card." The Layout Style panel indicates that the template "2-Up Greeting Card" is a Single Image / Contact Sheet layout, and the Print Editor view at the center of the workspace displays the new template.

6 In the Layout Style panel, click Picture Package. The Print Editor is updated to display the last selected Picture Package layout: "(2) 7 × 5." Click Single Image / Contact Sheet in the Layout Style panel and the Print Editor view returns to the last selected Single Image / Contact Sheet layout: "2-Up Greeting Card."

You'll notice that different control panels become available in the right panel group as you move between the Single Image / Contact Sheet and Picture Package layout styles. Panels common to both layout styles may differ in content for each.

7 In the right panel group, expand the Image Settings panel. In the Layout Style panel, click Picture Package and expand the Image Settings panel again. Toggle between the Picture Package and Single Image / Contact Sheet layouts and notice how the options available in the Image Settings panel change.

You can see that the selected photo fits to the image cell differently for each of these templates. In the Picture Package layout "(2) 7 × 5," the Zoom To Fill option is activated in the Image Settings panel so that the photo is zoomed and cropped to fill the image cell. In the Single Image / Contact Sheet "2-Up Greeting Card," the Zoom to Fill option is disabled and the photo is not cropped. Take a moment to examine the other differences in the Image Settings panel.

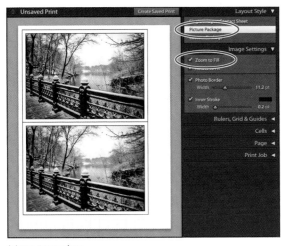

(2) 7 × 5 template

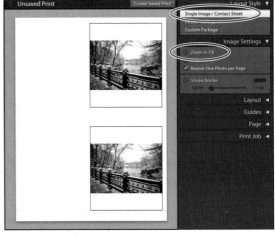

2-Up Greeting Card template

8 Select the Single Image / Contact Sheet layout style. Look at the page count at the right of the Toolbar below the Print Editor view: it reads "Page 1 of 1." Press Ctrl+A / Command+A or choose Edit > Select All to select all six images in the Filmstrip. The page count in the Toolbar now reads "Page x of 6." The template "2-Up Greeting Card" is now applied to all six photos, resulting in a print job of six pages. Use the navigation buttons at the left the Toolbar to move between the pages and see the layout applied to each image in turn.

Tip: You can also navigate your multi-page print document by using the Home, End, Page Up, Page Down, and left and right arrow keys on your keyboard, or choosing from the navigation commands in the Print menu.

9 For the last step in this exercise, collapse the Image Settings panel and expand the Print Job panel. You'll notice that in the Print Job panel, the Print Resolution for the "2-Up Greeting Card" template is set to 240 ppi. Select the template "4×5 Contact Sheet" in the Template Browser. The Print Resolution option in the Print Job panel is disabled and the Draft Mode Printing option is activated.

Selecting a print template

Now that you've explored the Template Browser, it's time to choose the template that you'll customize in the next exercise.

1 In the Template Browser, click the template "4 Wide." Later in this lesson you'll customize your identity plate, but for now, uncheck the Identity Plate option in the Page panel to hide the default design.

2 Choose Edit > Select None. In the Filmstrip, select the images Print-1.jpg, Print-2.jpg, and Print-3.jpg. The images will be arranged in the template in the same order in which they appear in the Filmstrip. Drag the images inside their grid cells to reposition them as shown in the illustration below.

Tip: By default, each photo will be centered in its own image cell. To expose a different portion of an image that is cropped by the boundaries of its cell, simply drag the photo to reposition it within its image cell.

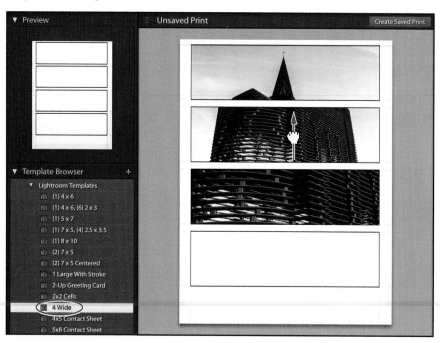

Specifying the printer and paper size

Tip: Lightroom automatically scales your photos in the print layout template to fit the paper size you have specified. In the Print Setup / Page Setup dialog box, leave the scale setting at the default 100% and let Lightroom fit the template to the page—that way, what you see in the Print Editor view will be what you'll get from your printer.

Before you customize the template, you'll need to specify the paper size and page orientation for your print job. Doing this now may save you the time and effort of readjusting the layout later.

1 Choose File > Page Setup.

2 In the Print Setup / Page Setup dialog box, choose the desired printer from the Name / Format For menu. From the Paper Size menu, choose Letter (Windows) / US Letter > US Letter (macOS). Under Orientation, choose the portrait format (vertical) thumbnail, and then click OK.

Customizing print templates

Having established the overall layout of your print job, you can use the controls in the Layout panel to fine-tune the template so that the images fit better to the page.

Changing the number of cells

For the purposes of this exercise, we need only three of the four preset image cells.

1 If necessary, expand the Layout panel in the right panel group. Under Page Grid, drag the Rows slider to the left or type **3** in the text box to the right of the slider.

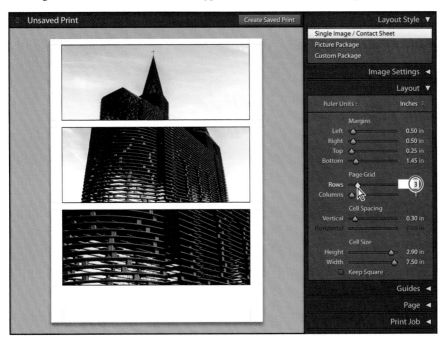

2 Experiment with the Margins, Cell Spacing, and Cell Size sliders—making sure to undo (Ctrl+Z / Command+Z) after each change. Activate the Keep Square option below the Cell Size sliders. The Cell Width and Cell Height sliders are locked together at the same value. Disable the Keep Square option.

3 The black lines you might see around the photos are merely guides indicating the image cell boundaries; they will not appear on your printed page. These guides are helpful while you're adjusting the cell size and spacing but they'll be distracting when you add printable borders to your layout in the next exercise.

> **Tip:** If you don't see the guides referred to in this step, activate the Show Guides check box at the top of the Guides panel and toggle each option to see the effect.

If necessary, expand the Guides panel below the Layout panel and disable the Image Cells option; then collapse the Layout and Guides panels.

Modifying the page layout of a print template

Layout controls for Single Image / Contact Sheet and Picture Package templates

Depending on which type of print template you are working with, you'll find a slightly different suite of panels in the right panel group. The Image Settings, Page, and Print Job panels are available for all template types but the controls for modifying the page layout differ. If you've chosen a Single Image / Contact Sheet template, you'll customize your layout using the Layout and Guides panels. For a Picture Package template, you'll use the Rulers, Grid & Guides panel and the Cells panel. For Custom Package layouts you'll also use the Rulers, Grid & Guides panel and the Cells panel—where you'll find a few minor differences from the options offered in the same panels for a Picture Package.

Picture Package templates and Custom Package layouts and are not grid-based so they are very flexible to work with; you can arrange the image cells on the page either by simply dragging them in the Print Editor view or by using the controls in the Cells panel. You can resize a cell using the width and height sliders or simply drag the handles of its bounding box. Add more photos to your layout with the Cells panel controls or Alt-drag / Option-drag a cell to duplicate it and resize it as you wish.

Lightroom Classic CC provides a variety of guides to help you adjust your layout. Guides are not printed: they appear only in the Print Editor view. To show or hide the guides, activate Show Guides in the Guides or Rulers, Grid & Guides panel, or choose View > Show Guides (Ctrl+Shift+G / Command+Shift+G). In the Guides panel you can specify which types of guides will be displayed in the Print Editor view.

Note: The Margins and Gutters guides and Image Cells guides—available only for Single Image / Contact Sheet layouts—are interactive; you can adjust your layout directly by dragging the guides themselves in the Print Editor view. When you move these guides, the Margins, Cell Spacing and Cell Size sliders in the Layout panel will move with them.

Using the Layout panel to modify a Contact Sheet / Grid layout

Ruler Units sets the units of measurement for most of the other controls in the Layout panel and for the Rulers guide in the Guides panel. Click the Ruler Units setting and choose Inches, Centimeters, Millimeters, Points or Picas from the menu. The default setting is Inches.

Margins sets the boundaries for the grid of image cells in your layout. Most printers don't support borderless printing, so the minimum value for the margins is dependent on the capabilities of your printer. Even if your printer does support borderless printing, you may first need to activate this feature in the printer settings before you can set the margins to zero.

Page Grid specifies the number of rows and columns of image cells in the layout. The grid can contain anything from one image cell (Rows: 1, Columns: 1) to 225 image cells (Rows: 15, Columns: 15).

Cell Spacing and Cell Size settings are linked so that changes you make to one will affect the other. The Cell Spacing sliders set the vertical and horizontal spaces between the image cells in the grid; the Cell Size controls change the height and width of the cells. The Keep Square option links the height and width settings so that the image cells remain square.

Using the Guides panel to modify a Contact Sheet / Grid layout

Rulers are displayed across the top and at the left of the Print Editor view. If Show Guides is activated, you can also show the rulers by choosing View > Show Rulers (Ctrl+R / Command+R). To change the ruler units, click the setting in the Layout panel.

Page Bleed shades the non-printable edges of the page, as defined by your printer settings.

Margins and Gutters guides reflect the Margins settings in the Layout panel; in fact, dragging these guides in the Print Editor view will move the respective sliders in the Layout panel.

Image Cells shows a black border around each image cell. When the Margins and Gutters guides are not visible, dragging the Image Cells guides in the Print Editor view will change the Margins, Cell Spacing, and Cell Size settings in the Layout panel.

Dimensions displays the measurements of each image cell in its top left corner, expressed in whatever units of measurement you have chosen for the Ruler Units.

Using the Rulers, Grid & Guides panel to modify a Picture Package layout

Ruler Units lets you set the units of measurement just as you would in the Layout panel when you're working with a Contact Sheet / Grid template.

Grid Snap helps you to position the image cells accurately on the page in the Print Editor view. As you drag the cells, you can have them snap to each other or to the grid (or turn the snap behavior off) by choosing Cells, Grid, or Off from the Snap menu options. The grid divisions are affected by your choice of ruler units.

Note: If you accidentally overlap your image cells, Lightroom will let you know by showing a warning icon (!) in the top right corner of the page.

Page Bleed and **Dimensions** work just as they do in the Guides panel for a Single Image / Contact Sheet layout.

Using the Cells panel to modify a Picture Package layout

Add To Package offers six preset image cell sizes that can be placed in your layout at the click of a button. You can change which of the presets is assigned to each button by clicking its menu triangle. The default presets are standard photo sizes but you can edit them if you wish.

New Page adds a page to your layout, though Lightroom automatically adds pages if you use the Add to Package buttons to add more photos than fit on a page. To delete a page from your layout, click the red X in its upper left corner of the page in the Print Editor view.

Auto Layout optimizes the arrangement of the photos on the page for the fewest cuts.

Clear Layout removes all the image cells from the layout.

Adjust Selected Cell lets you change the height and width of an image cell using sliders or numerical input.

Rearranging the photos in a print layout

Lightroom places your photos in the cells of a multiple-image print layout in the order in which they appear in the Filmstrip (and the Library module Grid view).

If your image source is a Collection, or a folder without subfolders nested inside it, you can change the placement of your images in the print job by simply dragging their thumbnails to new positions in the Filmstrip. Rearranging photos in this way is not possible if either the All Photographs folder or Previous Import folder is the selected image source.

1 In the header bar of the Filmstrip, the Lesson 9 folder is listed as the source of the images displayed. Click the white triangle to the right of the image source information in the header bar of the Filmstrip to see the source menu options.

If you enter the Print module with the Previous Import folder selected as the image source, making it impossible to reorder the photos for your print job, you can choose from recently opened folders and collections in the Filmstrip source menu.

2 Choose Edit > Select None, or press Ctrl+D / Command+D on your keyboard; then, drag the thumbnails in the Filmstrip to reverse the order of the first two photos, Print-1 and Print-2.

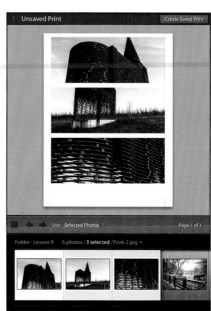

3 Ctrl-click / Command-click to group-select the first three photos in the Filmstrip.

The photos are rearranged in your modified layout template to reflect their new order in the Filmstrip.

4 Drag the images inside their grid cells to reposition them to suit the new layout.

For a Picture Package layout, which repeats a single photo at various sizes on the same page, a new page is added to the print job for each selected photo; reordering the photos in the Filmstrip will affect only the page order.

Creating stroke and photo borders

For our Single Image / Contact Sheet layout, the Image Settings panel offers options that affect the way your photos are placed in the image cells, and a control for adding borders. In this exercise you'll add a stroke border around each of the three images and adjust the width of the stroke.

1 Expand the Image Settings panel. For the 4 Wide template, the Zoom To Fill option is activated. This means that our photos are cropped in height to fit the proportions of the image cells.

▶ **Tip:** You can change the color of the border by clicking the Stroke Border color swatch and choosing a color from the Color Picker.

2 Click the check box to activate the Stroke Border option, and then drag the Width slider to the right or type **2.0** in the text box to the right of the slider. For your reference, one inch is equivalent to 72 points (pt).

3 In the Layout Style panel, click Picture Package. In the Rulers, Grid & Guides panel, activate the Image Cells option to see the borders of the cells. For a Picture Package template, the Image Settings panel offers two controls for borders. An Inner Stroke border is the Picture Package equivalent of a Stroke Border. The Photo Border control lets you set the width of a blank frame between the edge of each photo and the boundary of its image cell.

4 Experiment with the Inner Stroke and Photo Border settings.

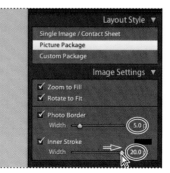

5 Disable the Image Cell guides. In the Layout Style panel, click Single Image / Contact Sheet to return to your modified 4 Wide template.

Using the Rotate To Fit option

By default, Lightroom will place photos so that they are upright within their image cells. The Rotate To Fit option in the Image Settings panel will override this behavior so that your photos are rotated to match the orientation of the image cells. For presentation layouts you would not wish to have images displayed in different orientations on the same page but in some situations this feature can be very helpful and save on expensive photo paper too! The Rotate To Fit option is particularly useful when you wish to print photos in both portrait and landscape formats on the same sheet, as large as possible and without wasting paper, as shown in the illustration on the right.

Another situation where you might choose to use the Rotate To Fit setting is when you are printing contact sheets. As you can see in the next illustration, Rotate To Fit enables you to see all the photos at the same size regardless of the image orientation.

Customizing your identity plate

In the Page panel you'll find controls for adding an identity plate, crop marks, page numbers, and text information from your photos' metadata to your layout. To begin with, you'll edit the identity plate to suit your layout.

1. Expand the Page panel; then click the check box to activate the Identity Plate option. The illustration at the right shows a preview of the default Identity Plate on macOS (your macOS user name); on Windows, the default is the text "Lightroom." Click the triangle in the lower right corner of the identity plate preview pane and choose Edit from the menu.

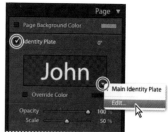

2. In the Identity Plate Editor dialog box, activate the Use A Styled Text Identity Plate option. Choose Arial, Regular, and 36 point from the font menus. To change the text color, swipe over the text in the text box to select it, and then click the color swatch to the right of the font size menu; we chose a slightly darker gray than the default. Swipe to select the text again, if necessary, and type **Manneken Photography** (or a name of your own choice); then click OK.

> **Tip:** If your text is too long to be fully visible in the text box, either resize the dialog box or reduce the font size until you've finished editing.

3. In the Page panel, drag the Scale slider to the right so that the identity plate text is the same width as the image. You can also scale the identity plate by clicking it in the Print Editor view and dragging the handles of its bounding box.

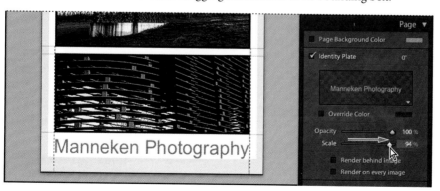

> **Tip:** By default the identity plate will be oriented horizontally. This setting (0°) is indicated at the top right of the Identity Plate pane in the Page panel. To re-orient your identity plate on the page, click on the 0° indicator and choose 90°, 180°, or −90° from the menu. To move your identity plate, simply drag it in the Print Editor view.

4 Now you'll change the color of the identity plate. Click the Override Color check box to set the color of the identity plate for this layout only—without affecting the defined color settings for the identity plate.

5 Click the Override Color swatch to open the Color Picker. Set the RGB values: R: **55%**, G: **15%**, B: **5%**, and then close the Color Picker. The color of the text identity plate is now a deep, slightly de-saturated rust red.

▶ **Tip:** If you see a hexadecimal value displayed in the lower right corner of the Color Picker rather than RGB values, click RGB below the color slider.

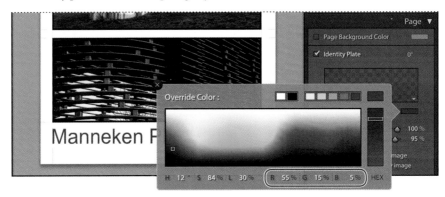

6 In the Identity Plate pane, use the Opacity slider or type **75** in the text box beside it to set an opacity value of 75% for the identity plate. This feature can be particularly effective if you wish to position your identity plate over an image.

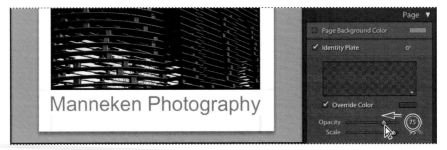

Printing captions and metadata information

In this exercise, you will add a caption and metadata information—in this case, titles for the images—to your print layout using the Page panel and the Text Template Editor.

1 At the bottom of the Page panel, click the check box to activate the Photo Info overlay option, and then choose Edit from the menu to the right. Most of the other options in the Photo Info menu are drawn from the images' existing metadata.

The Text Template Editor enables you to combine custom text with the metadata embedded in your image files, and then save your edited template as a new preset, making it easy to add the same items of text information to future print jobs.

Descriptions of our lesson photos have been pre-entered in the Caption field of the images' metadata; you'll base your text captions on this metadata.

▶ **Tip:** You'll find more detailed information on the Text Template Editor in the section "Using the Text Template Editor" in Lesson 8.

2 Choose Caption from the Preset menu at the top of the Text Template Editor dialog box.

3 Click to place the insertion cursor before the Caption token in the Example text box. Type **Print Portfolio :** (including the colon); then, add a space between your text and the token.

4 Click to place the cursor after the Caption token in the Example box. Type a comma, and then a space; then, choose Date (Month) from the second Numbering menu. If the Date (Month) token does not appear in the Example box, click the Insert button to the right of the Date menu.

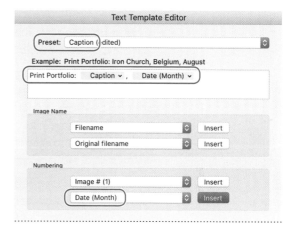

5 Add a space after the Date (Month) token; then, choose Date (YYYY) from the second Numbering menu and click the Insert button if necessary. Click Done to close the Text Template Editor dialog box. The images in the Print Editor view are now captioned and dated.

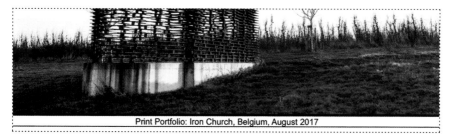

6 Click the triangle beside the Font Size menu at the bottom of the Page panel and choose 12 pt; then collapse the Page panel.

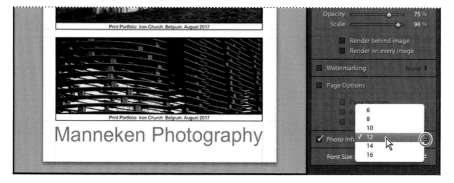

Saving your customized print template

Having started with a preset print template, you've created your own page design by modifying the layout and adding borders, an identity plate, and caption text to the images. You can now save your customized layout for future use.

1 Click the Create New Preset button (+) in the header of the Template Browser panel header, or choose Print > New Template.

2 In the New Template dialog box, type **My Wide Triptych** in the Template Name text box. By default, new templates are saved to the User Templates folder. For this exercise, accept the default User Templates as the destination folder and click Create.

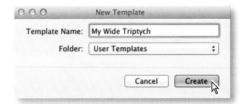

3 Your saved template appears in the User Templates folder in the Template Browser panel where you can access it quickly for use with a new set of images. With your new template selected in the Template Browser, select the last three images in the Filmstrip, Print-4.jpg, Print-5.jpg, and Print-6.jpg.

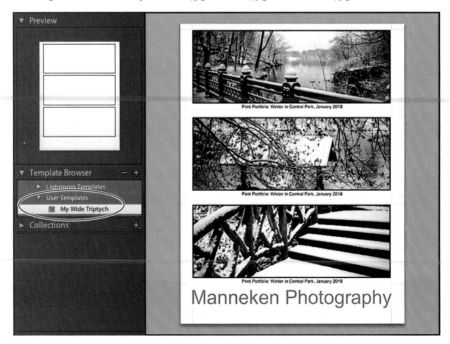

Creating a Custom Package print layout

Every Single Image / Contact Sheet template is based on a grid of image cells that are all the same size. If you want a more free-form layout, or you prefer to create your own page layout from scratch, without using any of the preset templates as a starting point, you can use the Custom Package option in the Layout Style panel.

1 Choose Edit > Select None, or press Ctrl+D / Command+D on your keyboard. In the Template Browser, select the layout Custom Overlap × 3 Landscape from the list of Lightroom templates.

2 In the Rulers, Grid & Guides panel, activate the Show Guides option, if necessary; then, disable all but the Page Bleed and Page Grid guides.

> **Tip:** If you'd prefer to work without using a template, start by clicking Custom Package in the Layout Style panel; then, click Clear Layout in the Cells panel and drag photos from the Filmstrip directly onto the page preview.

The images in a Custom Package layout can be arranged so that they overlap. The selected template includes three overlapping image cells spread diagonally over a fourth that occupies most of the printable page area.

3 Click to select the central image cell in the layout, and then right-click / Control-click inside the selected cell. Note the options in the context menu; the first four commands enable you to move an image forwards or backwards in the stacking order.

4 For now, choose Delete Cell from the context menu; then, delete the small cell at the lower left.

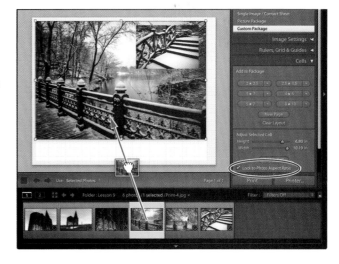

5 At the bottom of the Cells panel, activate the Lock To Photo Aspect Ratio option. Drag the image Print-6.jpg from the Filmstrip into the smaller image cell; then, drag the photo Print-4.jpg into the larger cell behind it.

6 Click away from the large photo cell to deselect it; then, re-select the image and use the controls in the Cells panel to set the Width to **9.5** inches. The Height value is adjusted automatically, maintaining the photo's original proportions.

7 In the Cells panel, disable the Lock To Photo Aspect Ratio control; then, drag the handle at the top of the large cell's bounding box downwards to set the Height to **2.45** inches. With the Lock To Photo Aspect Ratio option disabled, the image is cropped to fill the altered proportions of its cell.

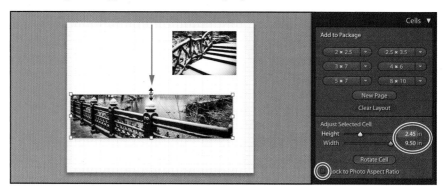

8 Select the smaller image on the page and set both the Width and Height values to **4.6** inches. Hold down the Alt / Option key and drag the square-cropped image to produce a copy; then, replace the photo in the copied cell by dragging the image Print-5.jpg from the Filmstrip.

● **Note:** Depending on your printer, the printable (non-bleed) area may not be centered on the page, as is the case in these illustrations.

9 Drag the three images to arrange them on the page as shown in the illustration below. Be sure to center the arrangement within the printable area of the page; that is, inside the area defined by the gray border of the Page Bleed guide. To refine the way each image is cropped, hold down the Ctrl / Command key as you drag to reposition the photo within the frame of its image cell.

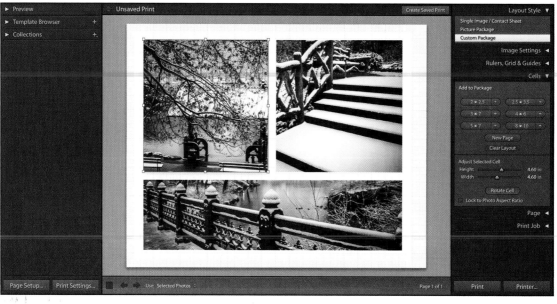

Changing the page background color

1 In the Image Settings panel, activate the Inner Stroke option. Use the slider or type over the current value to set the width of the stroke to **1.0** pt. Leave the stroke color set to the default white; the white stroke borders will become visible when you set a background color in step 4.

2 In the Rulers, Grid & Guides panel, disable Show Guides.

3 In the Page panel, click the check box to activate the Page Background Color option. Click the Page Background Color color swatch to open the Color Picker.

4 In the Color Picker, Click the black swatch at the top of the Page Background Color picker to sample it with the eyedropper cursor, and then click the Close button (x) or click outside the Color Picker to close it.

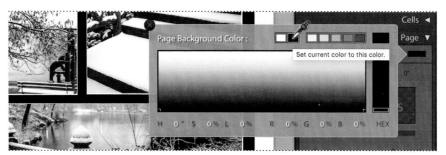

▶ **Tip:** To save on printer ink, you may prefer not to print a page with large areas of bold color or black in the background on your home printer, but when you're ordering professional prints this can be a striking choice.

The new color appears in the Page Background Color color swatch and in the page preview in the Print Editor view.

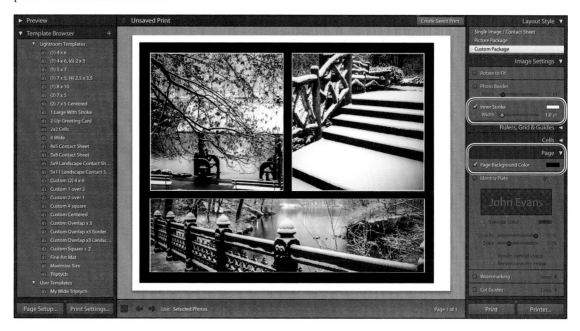

Soft proofing photos before printing

Each type of monitor and printer operates within its own *color gamut* or *color space*, which defines the range of colors that can be reproduced accurately by that device. By default, Lightroom uses your monitor's *color profile*—a mathematical description of its color space—to make your photos look as good as possible on screen. When you print an image, the image data must be reinterpreted for the printer's color space, which can sometimes result in unexpected shifts in color and tone.

You can avoid such unpleasant surprises by soft proofing your photos in the Develop module before you bring them into the Print module. Soft proofing lets you preview how your photos will look when they're printed; you can have Lightroom simulate the color space of your printer, and even the inks and paper you're using, giving you the opportunity to optimize your photos before printing them. To activate soft proofing, open a photo in the Develop module and click the Soft Proofing check box in the Toolbar, or press the S key on your keyboard. The background surrounding the image changes to white "paper" and a Proof Preview label appears in the corner of the work area. Use the view button in the Toolbar to switch between the Loupe view and a choice of before and after views.

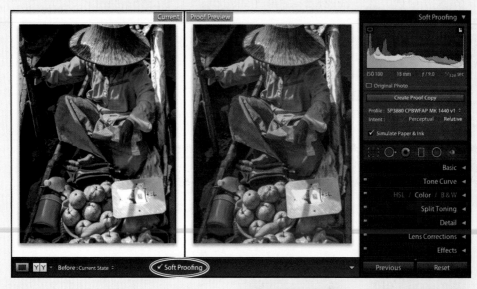

When you activate soft proofing, the Histogram panel changes to the Soft Proofing panel, which provides access to proofing options. The tonal distribution graph is updated according to the currently selected color profile. In the illustration at the right, the graph in the Histogram panel

corresponds to the Before image in the illustration above. The graph in the Soft Proofing panel reflects the comparative flatness of the Proof Preview.

To soft proof your photo for a different printer, choose another color profile from the Profile menu in the Soft Proofing panel. If you don't see the profile you want in the menu, choose Other, and then select from the list of installed color profiles in the Choose Profiles dialog box.

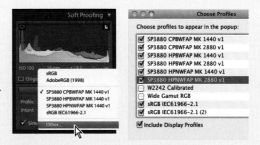

The Intent setting determines the rendering intent, which affects how colors are converted from one color space to another. The Perceptual rendering intent aims to preserve the visual relationship between colors so they look natural, though the color values may change. Relative rendering prints in-gamut colors as they are and shifts out-of-gamut colors to the closest printable approximations, retaining more of the original colors, though the relationships between some of them may be altered.

Once you've chosen a printer profile, you can activate the Simulate Paper & Ink option to simulate the off-white of real paper and the dark gray of real black ink. This option is not available for all profiles.

To check if your colors are in-gamut for the selected profile and rendering intent, use the buttons in the upper corners of the histogram in the Soft Proofing panel. Move the pointer over the Show /Hide Monitor Gamut Warning button on the left; colors that are outside your display's capabilities turn blue in the Proof Preview. Move the pointer over the Show/Hide Destination Gamut Warning button on the right; colors that cannot be rendered by your printer turn red in the preview. Colors that are out-of-gamut for both the monitor and the printer turn pink. Click the buttons to show the gamut warning colors permanently; click again to hide them.

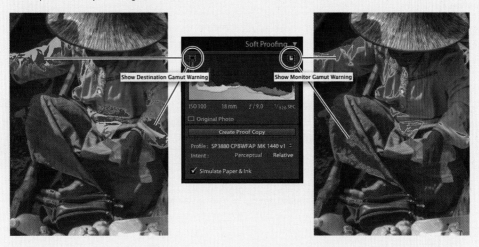

Click Create Proof Copy to generate a virtual copy that you can adjust without affecting your master settings. If you start adjusting a photo while soft proofing is on without first creating a proof copy, Lightroom asks if you want to create a virtual copy for soft proofing or make the master image a proof.

Configuring the output settings

The final step before you're ready to print your layout is to adjust the output settings in the Print Job panel.

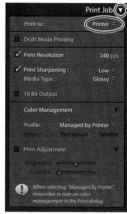

1 Expand the Print Job panel in the right panel group.

From the Print To menu at the top of the Print Job panel you can choose to send the job directly to your printer or generate a JPEG file, which you can print later or send out for professional printing. The controls in the Print Job panel vary slightly depending on which option is selected in the Print To menu.

2 Choose Printer from the Print To menu at the top of the Print Job panel.

Note: The terms "print resolution" and "printer resolution" have different meanings. "Print resolution" refers to the number of printed pixels per inch (ppi); "printer resolution" refers to the capability of the printer, called dots per inch (dpi). A printed pixel of a particular color is created by patterns of tiny dots of the few ink colors available.

Activating the Draft Mode Printing option will disable the other options in the Print Job panel. Draft Mode Printing results in high speed output at a relatively low quality, which is an efficient option for printing contact sheets or for assessing your layout before you commit it to high quality photo paper. The 4 × 5 Contact Sheet and the 5 × 8 Contact Sheet templates are preset for Draft Mode Printing.

The Print Resolution setting that is appropriate for your print job depends on the intended print size, the resolution of your image files, the capabilities of your printer, and the quality of your paper stock. The default print resolution is 240 ppi, which generally produces good results. As a rule of thumb, use a higher resolution for smaller, high quality prints (around 360 ppi for letter size). You can use a lower resolution setting for larger prints (around 180 ppi for 16″ × 20″) without compromising too much on quality.

3 The Print Resolution control has a range of 72 ppi to 1440 ppi. For this exercise, type **200** in the Print Resolution text box.

Note: The purpose of the Sharpening feature in the Develop module is to compensate for blurriness in the original photo, while Print Sharpening improves the crispness of printed output on a particular paper type.

Images tend to look less sharp on paper than they do on screen. The Print Sharpening options can help to compensate for this by increasing the crispness of your printed output. You can choose between Low, Standard, and High Print Sharpening settings, and specify a Matte or Glossy Media Type. You won't notice the effects of these settings on screen so it's useful to experiment by printing at different settings to familiarize yourself with the results.

4 If it's not already selected, choose Low from the Print Sharpening menu.

Working with 16 Bit Output on macOS

If you are running macOS and are using a 16-bit printer, you can activate the 16 Bit Output setting in the Print Job panel. This will result in less image degradation and color artifacts in files that have been extensively edited.

Note: If you select 16 Bit Output and print to a printer that does not support it, print performance is slowed, but quality is not affected.

For detailed information on working with 16-bit output, consult the documentation for your printer or check with your output center.

Using color management

Printing your digital images can be challenging: what you see on screen is not always what you get on paper. Lightroom Classic CC is able to handle a very large color space but your printer may operate within a much more limited gamut.

In the Print Job panel, you can choose whether to have Lightroom handle color management or leave it up to your printer.

Color managed by your printer

The default Color Management setting in the Print Job panel is Managed By Printer. This can be the easiest option and, given the continuing improvement of printing technology, will generally produce satisfactory results. In the Print Setup / Print dialog box (File > Print Settings), you can specify the paper type, color handling, and other print settings. On Windows, click Properties in the Print Setup dialog box to access additional printer specific settings.

● **Note:** For Draft Mode Printing, color management is automatically assigned to the printer.

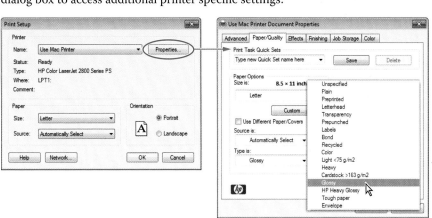

● **Note:** The options available in the Print Setup / Print dialog box may vary depending on your printer.

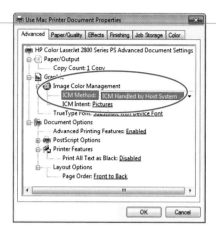

If you choose Managed By Printer, enable the ICM Method for Image Color Management (Windows) or activate the ColorSync option in the Color Management settings for the printer driver software (macOS) so that the correct profile is applied before printing. Depending on the printer driver software, you can usually find the color settings in the Print Document dialog box under Setup / Properties / Advanced (Windows), or in the menu below the Presets in the Print dialog box (macOS).

Color management controlled by Lightroom

Letting your printer manage color may be acceptable for general printing purposes but to achieve really high quality results it's best to have Lightroom do it. If you choose this option you can specify a printing profile tailored to a particular type of paper or custom inks.

1 In the Print Job panel, choose Other from the Color Management Profile menu.

You can choose this option when the profile you want isn't listed in the Profile menu. Lightroom searches your computer for custom printer profiles, which are usually installed by the software that came with your printer. If Lightroom is unable to locate any profiles, choose Managed By Printer and let the printer driver handle the color management.

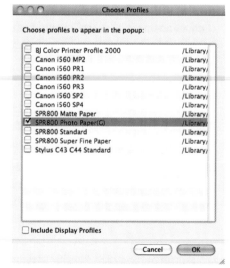

2 Depending on your printer and paper stock, choose one or more printer profiles. In this illustration a profile for the Epson Stylus Pro R800 using glossy photo paper has been selected. Each profile you choose will be added to the Profile menu under Color Management in the Print Job panel for easy access next time you print.

Once you've chosen a printer profile from the Profile menu, the Rendering Intent options become available in the Print Job panel. The color space of an image is usually much larger than that within which most printers operate, which means that your printer may not be able to accurately reproduce the colors you see on screen. This may result in

printing artifacts such as posterization or banding in color gradients as the printer attempts to deal with out-of-gamut colors. The Rendering Intent options help to minimize these problems. You can choose between two settings:

- **Perceptual** rendering aims at preserving the visual relationship between colors. The entire range of colors in the image will be re-mapped to fit within the color gamut your printer is able to reproduce. In this way, the relationships between all the colors are preserved but in the process even colors that were already in-gamut may be shifted as the out-of-gamut colors are moved into the printable range. This may mean that your printed image will be less vivid than it appeared on screen.

- **Relative** rendering prints all the in-gamut colors as they are and shifts out-of-gamut colors to the closest printable colors. Using this option means that more of the original color of the image is retained but some of the relationships between colors may be altered.

In most cases the differences between the two rendering methods are quite subtle. As a general rule, perceptual rendering is the best option for an image with many out-of-gamut colors and relative rendering works better for an image with only a few. However, unless you are very experienced it may be hard to tell which is which. The best policy is to do some testing with your printer. Print a very colorful, vivid photo at both settings and then do the same with a more muted image.

3 For the purposes of this exercise, choose Relative rendering.

Tweaking printed color manually

Printed results don't always match the bright and saturated look of the colors you see on-screen in Lightroom Classic CC—even when you've spent time setting up the color management for your print job.

The problem may be related to your printer, the inks or paper stock you're using, or an incorrectly calibrated monitor; whatever the cause, you can make quick and easy adjustments with the Brightness and Contrast sliders in the Color Management pane of the Print Job panel.

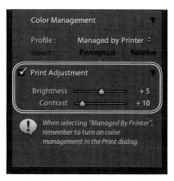

Tip: The tone curve adjustments produced by the Print Adjustment sliders do not appear in the on-screen preview. You may need to experiment a little to find the settings that work best for your printer.

Your Print Adjustment settings are specific to the combination of printer, paper, and ink that you're using—they'll stay in place as long as you're working with the same output settings, and will be saved in the Lightroom catalog file with your custom template or saved print job.

Saving print settings as an output collection

Since you entered the Print module, you've been working with an *unsaved print*, as is indicated in the bar across the top of the Print Editor view.

> **Unsaved Print** Create Saved Print

Until you save your print job, the Print module works like a scratch pad. You can move to another module, or even close Lightroom Classic CC, and find your settings unchanged when you return, but if you select a new layout template, or even the one you started with, in the Template Browser, the "scratch pad" will be cleared and all your work will be lost.

Tip: Once you've saved your print job, any changes you make to the layout or output settings are auto-saved as you work.

Converting your print job to a Saved Print not only preserves your layout and output settings, but also links your layout to the particular set of images for which it was designed. Your print job is saved as a special kind of collection—an *output collection*—with its own listing in the Collections panel. Clicking this listing will instantly retrieve the images you were working with, and reinstate all of your settings, no matter how many times the print layout scratch pad has been cleared.

Depending on the way you like to work, you can save your print job at any point in the process; you could create a Saved Print as soon as you enter the Print module with a selection of images or wait until your layout is polished.

A print output collection is different from a normal photo collection. A photo collection is merely a grouping of images to which you can apply any template or output settings you wish. An output collection links a photo collection (or a selection of images from that collection) to a particular template and specific output settings.

For the sake of clarity: an output collection also differs from a custom template. A template includes all your settings but no images; you can apply the template to any selection of images. An output collection links the template and all its settings to a particular selection of images.

1 Click the Create Saved Print button in the bar at the top of the Slideshow Editor view, or click the New Collection button (➕) in the header of the Collections panel and choose Create Print.

Tip: The Make New Virtual Copies option (Windows only) is useful if you wish to apply a particular treatment, such as a developing preset, to all the pictures in your print job, without affecting the photos in the source folder or collection.

2 In the Create Print dialog box, type **Print Portfolio** in the Name box to name your saved print job. Make sure that the Location option is disabled, and then click Create.

Your saved print output collection appears in the Collections panel, marked with a Saved Print icon (🖨) to differentiate it from an image collection, which has a stacked photos icon. The image count shows that the new output collection contains three photos. The title bar above the Print Editor now displays the name of your saved print job, and no longer presents the Create Saved Print button.

Tip: To add more photos to a saved print job, drag images to the print output collection in the Collections panel.

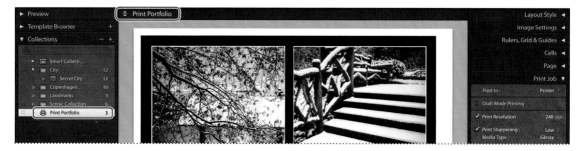

Printing your job

1 Click the Printer button at the bottom of the right panel group.

2 Verify the settings in the Print dialog box and click OK / Print to print your page, or click Cancel to close the Print dialog box without printing.

Tip: If you don't need to verify your printer settings, click the Print button at the bottom of the right panel group or choose File > Print.

Clicking the Print button will send your print job to the printer queue without opening the Print dialog box. This is useful if you print repeatedly using the same settings and don't need to confirm or change any settings in the Print dialog.

To achieve the best results when you print, calibrate and profile your monitor regularly, always verify that print settings are specified correctly, and use quality papers. However, there is no substitute for experience. Experiment with a variety of settings and options—and if at first you do succeed, consider yourself very lucky!

Congratulations! You've completed another Lightroom Classic CC lesson. In this lesson you learned how to set up your own sophisticated print layouts.

In the process, you've explored the Print module and used the control panels to customize a print template—refining the layout and output settings and adding a background color, text, borders, and an identity plate to your printed page.

In the next chapter you'll look at ways to publish and share your photos, but before you move on, take a few moments to refresh your new skills by reading through the review questions and answers on the following pages.

Review questions

1 How can you quickly preview the preset print templates, and how can you see how your photos will look in each layout?

2 What are the three print template layout styles, and how can you check which type of template you have chosen?

3 When you're working with the Print Setup / Page Setup dialog box, why is it better to leave the Scale setting at 100%?

4 For what purposes is Draft Mode Printing appropriate?

5 What is the difference between a Saved Print collection, a photo collection, and a saved custom print template?

6 What is Soft Proofing?

Review answers

1 Move the pointer over the list of templates in the Template Browser to see a thumbnail preview of each layout displayed in the Preview panel. Select your images in the Filmstrip and choose a template from the list; the Print Editor view shows how your photos look in the new layout.

2 Single Image / Contact Sheet layouts can be used to print multiple photos at the same size on a single sheet. Based on an adjustable grid of image cells that are all the same size, they range from contact sheets with many cells to single-cell layouts such as the Fine Art Mat and Maximize Size templates. Picture Package layouts repeat a single image at a variety of sizes on the same page in cells that can be moved and resized. Custom Package layouts are not based on a grid; they enable you to print multiple images at any size on the same page, and even to arrange them so that they overlap.

The Layout Style panel indicates whether a layout selected in the Template Browser is a Custom Package, Picture Package, or Single Image / Contact Sheet template.

3 Lightroom automatically scales your photos in the print layout template to fit the specified paper size. Changing the scale in the Print Setup / Page Setup dialog will result in the layout being scaled twice so your photos may not print at the desired size.

4 Draft Mode Printing results in high speed output at a relatively low quality, which is an efficient option for printing contact sheets or for assessing your layout before you commit it to high quality photo paper. The contact sheet templates are preset for Draft Mode Printing.

5 A photo collection is merely a virtual grouping of images to which you can apply any template or output settings you wish, whereas a Saved Print output collection links a selection of images to a particular template and specific layout and output settings. A saved print template preserves your customized layout and output settings but includes no images; you can apply the template to any selection of images. A Saved Print collection links the template and all its settings to a particular set of images.

6 Soft Proofing is a way to check on-screen how your photos will look when printed, or perhaps output for use on the Web. Lightroom Classic CC uses color profiles to simulate the result of printing to specific printers with particular types of ink and paper—or of saving your images to a different color space as you might do with pictures intended for the Internet—enabling you to make the appropriate adjustments to your photos before exporting copies or committing to printing.

PHOTOGRAPHY SHOWCASE
CHRIS ORWIG

"Photography is a means to express deeper ideas, to convey quiet moments, and to savor life before it slips away."

I became a photographer because I was in a major slump. I was wrestling with some significant identity and health issues, and I was losing my grip. Then, suddenly, my father gave me a camera. And that camera was my ticket to a new life.

By holding the camera up to my eye, the world no longer revolved in the same way. My own pain and sorrows drifted away. The camera slowed time down and taught me about the value of life. Soon it became a passport to a whole new way to live.

Photography enriches, enlivens, and expands how we think. It heightens what we see and deepens who we are. It's so easy to drift through life and to neglect the small details. Photography is a wake up call to not let any of it pass us by.

While I enjoy and appreciate many types of photography, I like to photograph people who excel in life and are intensely committed to what they do.

In this set of photographs, you will find some legends in the surfing world. And rather than photograph their mythic stature, my aim was to capture something more real. These pictures have a quiet, subtle, and maybe a poetic voice. Photography is similar to poetry in many ways. What the novelist says in 10,000 words a poet says in 10. The poet not only says less, but sometimes uses less to even say more.

http://chrisorwig.com

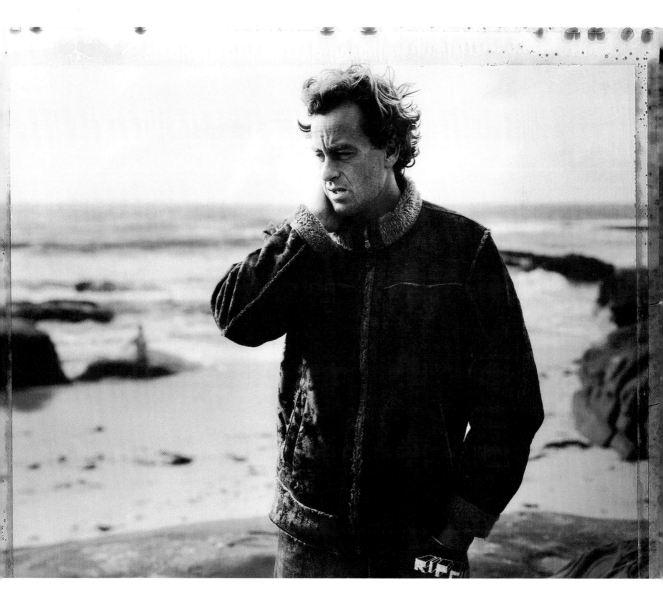

TOM

ROB

ANTON

SHAUN

KELLY

TAYLOR

10 PUBLISHING YOUR PHOTOS

Lesson overview

Lightroom Classic CC offers several easy-to-use options for sharing your photos. Publish Services enable you to share images directly from the Library module. You can create a Publish Collection to manage the files you've handed off to a client, to sync photos to your phone, or to upload images directly to a photo sharing website. The Web module provides a range of customizable gallery templates and all the tools you'll need to build a striking website and upload it to your web server.

In this lesson, you'll learn the techniques and skills that you'll use to publish photos from the Library and to create your own web gallery:

- Publishing images to a photo sharing website
- Using Publish Collections and republishing updated images
- Sharing from Lightroom CC for Mobile
- Choosing and customizing a gallery layout template
- Specifying output settings and adding a watermark
- Saving your customized templates and presets
- Uploading your gallery to a web server

You'll probably need between one and two hours to complete this lesson. If you haven't already done so, log in to your peachpit.com account to download the lesson files for this chapter, or follow the instructions under "Accessing the Lesson Files and Web Edition" in the Getting Started section at the beginning of this book.

Use integrated Publish Services to share your photos online, directly from the Lightroom Classic CC Library module, or choose from HTML templates in the Web module to quickly generate sophisticated interactive web galleries. Post images to photo sharing sites, share from Lightroom CC for Mobile via Lightroom CC Web, or upload an interactive gallery directly to a web server—and all without leaving Lightroom Classic CC.

331

Getting started

Note: This lesson assumes that you already have a basic working familiarity with the Lightroom Classic CC workspace. If you need more background information, refer to Lightroom Classic CC Help, or review the previous lessons..

Before you begin, make sure you've set up the LRClassicCIB folder for your lesson files and created the LRClassicCIB Catalog file to manage them, as described in "Accessing the Lesson Files and Web Edition" and "Creating a catalog file for working with this book" in the Getting Started chapter at the start of this book.

If you haven't already done so, download the Lesson 10 folder from your Account page at www.peachpit.com to the LRClassicCIB \ Lessons folder, as detailed in "Accessing the Lesson Files and Web Edition" in the chapter "Getting Started."

1 Start Lightroom Classic CC.

2 In the Adobe Photoshop Lightroom Classic CC - Select Catalog dialog box, make sure the file LRClassicCIB Catalog.lrcat is selected under Select A Recent Catalog To Open, and then click Open.

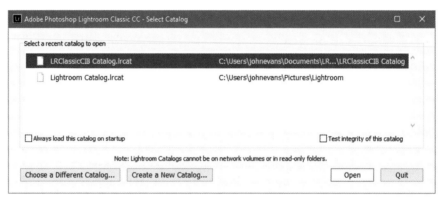

Tip: If you can't see the Module Picker, choose Window > Panels > Show Module Picker, or press the F5 key. If you're working on macOS, you may need to press the fn key together with the F5 key, or change the function key behavior in the system preferences.

3 Lightroom Classic CC will open in the screen mode and workspace module that were active when you last quit. If necessary, switch to the Library module by clicking Library in the Module Picker at the top of the workspace.

Importing images into the library

The first step is to import the images for this lesson into the Lightroom library.

1 In the Library module, click the Import button below the left panel group.

2 If the Import dialog box appears in compact mode, click the Show More Options button at the lower left of the dialog box to see all the options in the expanded Import dialog box.

3 In the Source panel, locate and select the LRClassicCIB \ Lessons \ Lesson 10 folder; then, activate the Include Subfolders option. Ensure that all the images from the Lesson 10 folder are checked for import.

4 In the import options above the thumbnail previews, select Add so that the imported photos will be added to your catalog without being moved or copied. Under File Handling at the right of the expanded Import dialog box, choose Minimal from the Build Previews menu and ensure that the Don't Import Suspected Duplicates option is activated. Under Apply During Import, choose None from both the Develop Settings menu and the Metadata menu and type **Lesson 10** in the Keywords text box. Make sure that your import is set up as shown in the illustration below, and then click Import.

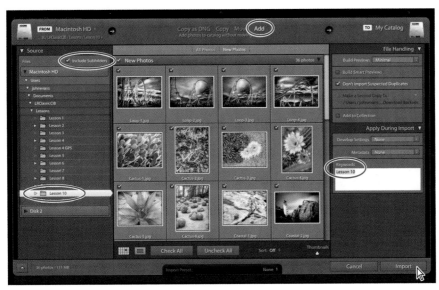

The images are imported from the five subfolders nested inside the Lesson 10 folder, and now appear in the Library module, in both the Grid view and the Filmstrip across the bottom of the Lightroom Classic CC workspace.

Publishing photos from the Library

We live in a connected world where, for many of us, posting images to photo sharing websites, or handing off photos online to a client are daily occurrences.

The Publish Services panel enables you to publish your images directly from the Library module, providing integrated connections to Facebook, Flickr, and Adobe Stock—as well as a link to Adobe Add-ons where you can download third-party Publish Services plug-ins that will give you direct access to other sharing websites.

Use the Publish Services panel to create Publish Collections that will not only make sharing photos to your favorite website as simple as drag and drop, but also help you manage your shared images by keeping track of whether or not they've been updated to the most recent versions. You can use a Publish Collection to manage and update images you've handed off to a client or shared online, or to keep the photos on your phone in sync with your Lightroom Classic CC library.

Setting up a Flickr account

In this exercise, you'll set up a Flickr account and publish a selection of photos.

Tip: At the Adobe Add-ons page, click the link at the left for Lightroom add-ons, then try searching the terms "publish," "sharing," and "upload."

Tip: If you don't see the Publish Services panel, richt-click / Control-click the header of any panel in the left group and choose its name from the menu.

1 Expand the Publish Services panel, if necessary, by clicking the triangle to the left of the panel's name; then, click Set Up in the Flickr header.

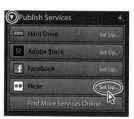

The Lightroom Publishing Manager dialog box opens .

2 Under Publish Service, type your name in the Description text box; then, click the Authorize button in the Flickr Account pane.

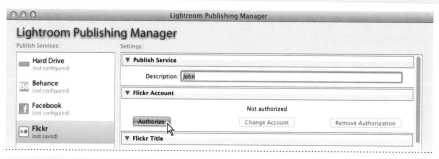

Tip: If you don't see the Yahoo sign-in page, try using a different web browser.

3 Lightroom asks your permission to upload images to Flickr; click Authorize.

Your default web browser opens. You will be asked to sign in through Yahoo (you may need to sign up, first), and then your browser will open the Flickr sign-in page.

4 Type a screen name for your Flickr account and click Create A New Account.

5 Flicker asks you to confirm the request from Lightroom Classic CC to link to your Flickr account. Click "OK, I'll Authorize It" to authorize Lightroom to access all content in your Flickr account, to upload, edit, replace, and delete photos in your account, and to interact with other Flickr members.

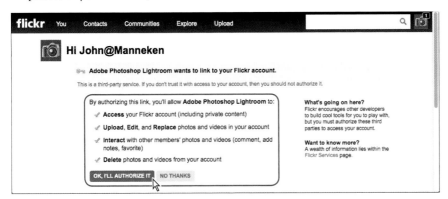

6 Click OK / Allow to establish the link with Lightroom Classic CC; then, click Done to return to the Lightroom Publishing Manager. In the Flickr Account pane, the Authorize button is now disabled.

7 In the Lightroom Publishing Manager dialog box, set the Flickr Title to use the images' existing file names. Under File Settings, drag the Quality slider to set a value of 75. Scroll down, if necessary, to see the Output Sharpening options. Click the check box to enable sharpening, and then choose Screen from the Sharpen For menu and Standard from the Amount menu.

8 Make sure that Watermarking is disabled. Under Privacy and Safety, activate the Public setting, so that access to your photos will be unrestricted. Leave the options for renaming, resizing, video and metadata unchanged.

9 Click Save to close the Lightroom Publishing Manager dialog box.

In the Publish Services panel, your activated Flickr service displays the name you assigned in step 2. The service now contains a single Photostream; an image count of 0 at the right indicates that the new Photostream does not yet contain any photos.

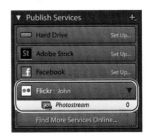

Publishing photos to Flickr

In this exercise you'll add a selection of images to your Flickr Photostream.

1 In the left panel group, expand the Folders panel. Collapse other panels, if necessary, so that you can see the expanded Folders panel and the Publish Services panel at the same time, without scrolling.

2 In the Folders panel, expand the Lesson 10 folder and click to select the nested subfolder named Batch1.

3 Press Ctrl+A / Command+A to select all four images, and then drag the selected photos to your newly created Photostream in the Publish Services panel.

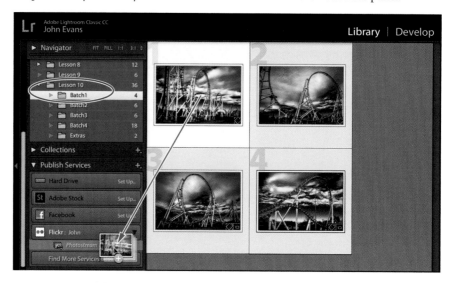

4 In the Publish Services panel, click the Photostream to see its contents; the four images are displayed in the work area under the header New Photos To Publish.

5 Click the Publish button at the bottom of the left panel group.

A progress bar appears in the upper left of the workspace as the images are uploaded to Flickr. While the upload is in progress, the work area is split horizontally, showing which images have been published and which have yet to be uploaded.

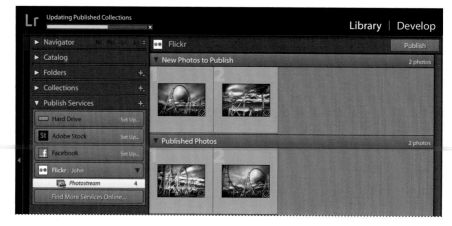

6 Wait until the publish process is complete and all four photos are listed as published; then, right-click / Control-click the entry for your new Photostream in the Publish Services panel and choose Show In Flickr from the menu.

Publishing photo comments

Your Publish Services connection allows for two-way interaction between Flickr and Lightroom, so you can keep up to date with—and respond to—any comments that are posted on your images.

1 On your Flickr web page, click the photo Loop-3.jpg to see the image enlarged. Type a comment in the text box, at the left below the enlarged image, and then click Comment.

2 Switch back to Lightroom Classic CC. With your Flickr Photostream still selected in the Publish Services panel, click to select the image Loop-3.jpg under the Published Photos header in the work area; then, click the Refresh Comments button () at the left of the header of the Comments panel in the right panel group. Watch the progress bar at the top left of the workspace as Lightroom Classic CC connects to Flickr and updates your Publish Collection.

3 Expand the Comments panel, if necessary, to confirm that the comment you posted on your Flickr page has been downloaded to Lightroom Classic CC.

► **Tip:** To post a comment in your Flickr Photostream from within Lightroom Classic CC, click the Flickr service in the Publish Services panel, select a published photo, type your comment in the Comments panel, and then press Enter / Return.

Republishing a photo

Publish Services helps you keep track of images that have been modified since they were published, so you can easily make sure that you are sharing the latest versions.

1 With your Flickr Photostream selected in the Publish Services panel, and the image Loop-3.jpg selected in the work area, expand the Quick Develop panel in the right panel group.

2 In the Quick Develop panel, click the right-most button for Exposure three times. Click five times each on the left-most buttons for Contrast and Highlights and the right-most buttons for Shadows, Clarity, and Vibrance. The edited image is now displayed under the header Modified Photos To Re-Publish.

3 Click the Publish button in the bar at the top of the work area to re-publish the modified photo. A dialog box appears asking if you wish to replace the original photo published on Flickr; click Replace.

4 Right-click / Control-click your Photostream under Flickr in the Publish Services panel and choose Show In Flickr from the menu. If you don't see the re-published version of the photo, try reloading the page in your browser.

5 Click the re-published photo to see it in single image view. Scroll down to see the comment you posted earlier. Move the pointer over the comment; then, click the trash icon at the right to delete it.

6 In the Library, select the image Loop-3.jpg and click the Refresh Comments button (🔄) in the Comments panel. Watch the progress bar at the top left of the workspace as Lightroom connects to Flickr and updates your Publish Collection.

Creating a new Album on Flickr

The Publish Services panel offers several options for working with your Flickr account from within Lightroom Classic CC; let's look at another one of them.

1 In the Folders panel in the left panel group, expand the Lesson 10 folder, if necessary, and then click to select the subfolder named Batch2.

2 Choose Edit > Select All or press Ctrl+A / Command+A to select all six images in the Batch2 folder.

3 Right-click / Control-click your new Photostream in the Publish Services panel and choose Create Album from the context menu.

4 In the Create Album dialog box, type **Cactus Garden** as the name for the new album. Ensure that the Include Selected Photos option is activated and the other options are disabled, and then click Create.

Tip: The context menu for your Flickr Photostream also offers the option to create a Smart Album: a publish collection which will update itself to include any new photos you import to Lightroom that match the saved search criteria.

A listing for your new Album appears, nested inside the Flickr service in the Publish Services panel, and the central work area displays the six images from the Batch 2 folder under the header New Photos To Publish.

5 Click the Publish button below the left panel group, or in the bar above the work area, and then wait while the new set of images is uploaded to Flickr.

6 To view the newly published images online, right-click / Control-click your new album in the Publish Services panel and choose Show In Flickr from the menu. When you're done, return to Lightroom Classic CC.

Sharing images to Facebook

The Publish services panel also incorporates a direct connection to Facebook.

1 In the Publish Services panel, click the Facebook connection Set Up button.

2 Under Facebook Account in the Lightroom Publishing Manager dialog box, click Authorize On Facebook. Click OK.

Your web browser opens. If you are not already logged in to Facebook, you'll see the Facebook Login page. If you don't have a Facebook account, get started by clicking the Sign Up For Facebook link at the bottom of the login page. If you are already logged in, the Connect Adobe Photoshop Lightroom with Facebook page opens.

3 Sign up or log in to Facebook, if necessary, and then follow the prompts to allow Facebook to communicate with Lightroom. When you're done, return to the Lightroom Publishing Manager.

4 Type **Albums** in the Description text box under Publish Service. Under the Facebook Album header, click Create New Album. Type **Scotland Trip** as the name of the new album; then, click OK. Choose the new album from the pop-out Album menu. Leave the rest of the default settings as they are and click Save to dismiss the Lightroom Publishing Manager.

5 In the Folders panel, click to select the subfolder Batch3, nested inside the Lesson 10 folder. Choose Edit > Select All, or Ctrl-click / Command-click the images in the Grid view or Filmstrip to select all six. Drag the selected photos to your newly created Scotland Trip album, listed under the Facebook connection in the Publish Services panel.

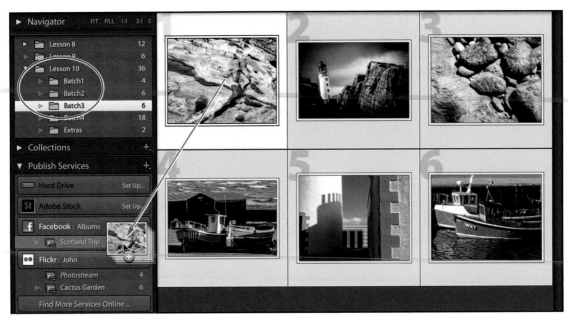

6 Click the Scotland Trip album under Facebook in the Publish Services panel; then, click the Publish button below the left panel group, or in the header bar.

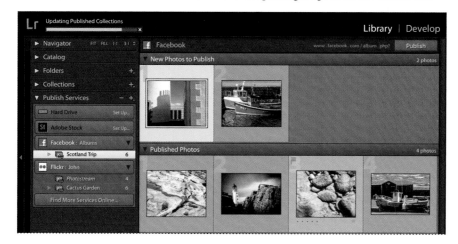

A progress bar appears in the upper left of the workspace as the files are uploaded to your Facebook page and the work area becomes a split screen that shows which images have already been published and which have yet to be uploaded.

7 Wait until the publish process is complete and all six photos are listed as published; then, right-click / Control-click your new album in the Publish Services panel and choose Show Album In Facebook from the menu.

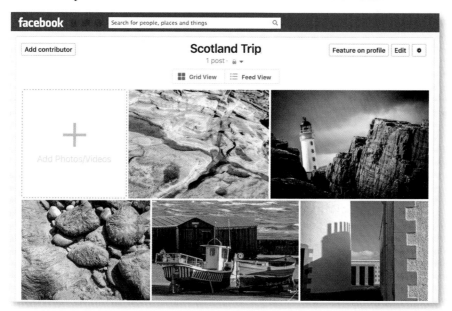

Your new publish service allows two-way communication between Lightroom and Facebook. In Lightroom, you can select a published image in your Facebook collection and click the Refresh Comments button (⟳) in the header of the Comments panel to download any viewer comments—or type in the Comments panel to post a comment to your album.

8 When you're done, return to Lightroom Classic CC.

Publishing photos to Adobe Stock

The latest addition to the integrated services in the Publish Services panel, Adobe Stock is a service that provides designers and businesses with access to curated, high-quality photos and other assets for use in creative projects.

The Adobe Stock service is integrated with other Adobe desktop apps, such as Photoshop CC, Illustrator CC, and InDesign CC, so that creative professionals can search and browse photographic assets from Adobe Stock as they work.

Through the Publish Services panel, you can use your existing Creative Cloud account credentials to establish a connection between Lightroom Classic CC and the Adobe Stock Contributor portal (https://contributor.stock.adobe.com/) where you can set up a contributor account.

As a contributor, Adobe Stock offers you unparalleled exposure, licensing photographic assets to stock content buyers directly through Adobe Creative Cloud apps and also via the web. By contributing to Adobe Stock, your work can reach these global buyers and you can start to earn money doing what you love.

Your photos remain your own; you are not signing your rights away when you work with Adobe Stock. Instead, you enter a non-exclusive agreement that allows Adobe to promote and license your content.

Contributing to Adobe Stock allows you to be part of an amazing community of creative content providers, whose efforts and input ensure that Adobe Stock is constantly evolving and building even more ways for you to be involved. Keep an eye on the Adobe Stock page at the Adobe Creative Cloud Blog for more information and ideas: https://theblog.adobe.com/creative-cloud/adobe-stock/

Simply drag photos from the Grid view to your activated Adobe Stock photoset in the Publish Services panel to publish the photos from Lightroom Classic CC and submit them to Adobe Stock for moderation.. The Adobe Stock Contributor portal automatically extracts the Lightroom Classic CC Keywords associated with your images and displays them as tagged Keywords; you can visit the contributor portal to add more tags and organize your uploaded images.

Publishing photos to your hard disk

The Publish services panel also enables you to create publish collections on your hard disk; then, Lightroom will keep track of which images have been updated since the collection was published, just as it does for a collection published online.

You can create a new publish collection for each of your clients, making it easy to check whether they have the most current versions of the photos you hand off, or set up a publish collection that will enable you to publish images to your phone's sync folder with drag and drop convenience, even without Lightroom CC for Mobile.

1 In the Publish Services panel, click Set Up at the right of the Hard Drive header. Type **Sync to Phone** in the Description text box under Publish Service in the Lightroom Publishing Manager dialog box.

2 Under Export Location, choose Specific Folder from the Export To menu; then, click Choose and specify your My Pictures Folder / Pictures Folder as the destination. Activate the Put In Subfolder option and name the new subfolder **Phone**.

3 Under File Settings, set a Quality value of 50. Review the other options in the Lightroom Publishing Manager dialog box, leaving the settings unchanged for the moment, and then click Save.

A listing for your new Phone publish collection appears under the Hard Drive header; the image count shows that the collection does not yet contain any photos.

4 In the Folders panel in the left panel group, Ctrl-click / Command-click to select the four "Batch" subfolders nested inside the Lesson 10 folder, leaving the Extras folder unselected. Choose Edit > Select All to select all thirty-four images in the four subfolders, and then drag the selected photos to your newly created Phone entry in the Publish Services panel.

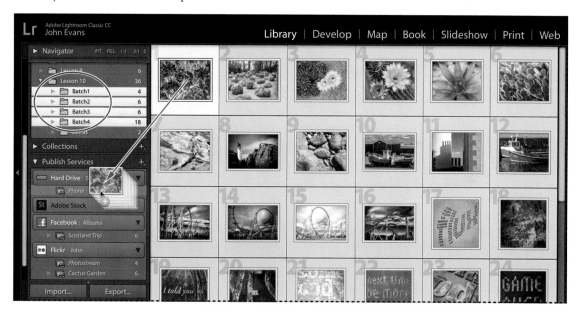

5 Click the Phone entry in the Publish Services panel. The Lesson 10 photos in the new publish collection are displayed in the work area under the header New Photos To Publish. Click the Publish button at the bottom of the left panel group or in the header bar and wait while Lightroom processes the images.

6 Right-click / Control-click Phone collection in the Publish Services panel and choose Go To Published Folder from the context menu. An Explorer / Finder window opens showing the thirty-four published images in your new Phone folder. Close the Explorer / Finder window and return to Lightroom Classic CC.

Sharing via Lightroom CC on the web

Lightroom CC for mobile makes it just as easy to share your photos from your handheld device as it is from your desktop. From your mobile device, you can view or present your synced collections wherever you are—and share them with friends or clients—online at Lightroom CC on the web.

There are no Lesson images provided for this exercise; you'll share your own photos from the synced collections that you established in Lesson 4.

1 On your mobile device, tap the Lightroom CC app icon, and then sign in to Lightroom CC with your Adobe ID.

2 In Lightroom Classic CC, choose File > Open Recent and launch the personal catalog for which you enabled syncing in Lesson 4; then, check the upper left corner of the workspace to make sure that syncing is still turned on.

3 In the Collections panel, click one of your synced collections to see the photos in that collection displayed in the Grid view. Right-click / Control-click the collection and choose Lightroom CC Links > View On Web.

4 Your browser opens to the expanded view of the selected synced album, though you may first land at the Lightroom CC sign-in page, where you can sign in with your Adobe ID. Click any album in the list at the left to see its contents.

In the expanded view, the photos in your album are arranged in a tiled grid. At the upper left above the grid are several controls for working with your photos online.

5 Click the Slideshow button to view (or present) the album as a slideshow. When you're done, press Esc to exit the slideshow; then, click the Share button (▣).

Collections synced to Lightroom CC are private by default; until you make a Lightroom CC album public, only you can see it in Lightroom CC on the web. The sharing options pane presents several options:

• **Share This Album** lets you specify settings for sharing the album as a stand-alone collection at Lightroom CC on the web. To a viewer the album will look much the same as what you see in the Albums view.

• **Add Album To Gallery** steps you through setting up an online Lightroom CC Gallery, where you can share multiple albums at a single URL.

• **Create A New Share** lets you add text and customize a shared album layout.

6 In the sharing options pane, click Share This Album to open the Album Settings controls. Click the General tab to title the shared album and set a cover photo, and then click the Slideshow tab to set playback options. Click the Share tab, and then click Share This Album.

7 Press Ctrl+C / Command+C to copy the pre-selected sharing URL to the clipboard. Check the boxes to activate your preferred sharing options; then, make sure that the flag status filter is set to Share All Photos. If you wish to post a link to your album on Facebook, Twitter, or Google+, click the appropriate button.

8 Click Done. To invite a friend or client to view your collection in Lightroom CC on the web, paste the copied URL into an e-mail or social networking message.

Sharing from your handheld device

1 In the Albums view on your mobile device, tap the three dots (...) beside the synced collection that you enabled for sharing from Lightroom CC on the web. In the album options, tap Share Web Gallery; a notification shows that the album is already set to Public. Options give you the opportunity to view the album online,
share a link to the public album, or stop sharing and make it private again.

2 To enable sharing for another of your synced collections, tap the three dots beside its listing in the Albums view, and then tap Share Web Gallery in the album options. Tap Share to confirm that you wish to make your private collection public, and then specify whether you wish to be notified about likes and comments from viewers.

Note: Viewers of the photos you've shared can comment on or "like" your work. Tap a photo in the expanded album contents view to access the comments button () at the lower right of the single image view. On your desktop, photos with comments are marked with a badge.

 Photo has comments
Click to see them

3 Tap Share Link and choose from the sharing options. To view the public collection on Lightroom CC on the web as an invited guest will see it, tap View On Web.

4 In the Albums view on your handheld device, click either of your public albums to display the photos inside. In the expanded album contents view, tap the Share button (■) at the upper right and choose Share from the menu.

5 Touch the photos you wish to share; then, click the check mark at the upper right.

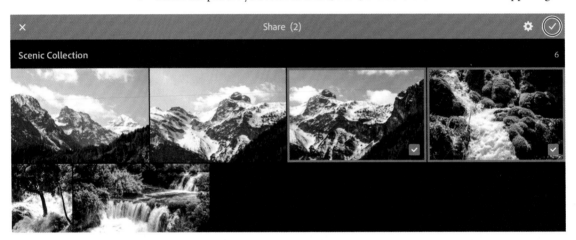

6 In the Image Size dialog, tap Small; then tap Facebook in the sharing options.
Type a descriptive message to accompany your post.
Use the buttons at the lower left to choose a destination album on Facebook, specify the audience for your shared photos, and add a status message and location, and then tap Post.

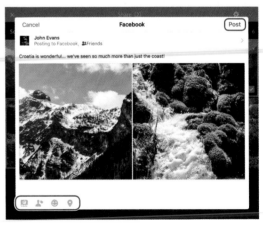

7 Return to Lightroom Classic CC on your desktop. In the Collections panel, right-click / Control-click one of your shared collections and familiarize yourself with the menu options; then, choose File > Open Recent > LRClassicCIB Catalog.lrcat to re-load your Classroom in a Book catalog.

The Lightroom Classic CC Web module

Another great way to share and showcase your photos is to use the Lightroom Classic CC Web module to design, preview, and upload your own web gallery.

In the Web module, you'll start by using the Template Browser in the left panel group to preview the wide range of gallery layout templates. When you've made your choice from the Template Browser, the Gallery Editor view in the central work area shows how your images look in the selected gallery layout.

In the Gallery Editor view, your gallery is fully interactive, performing exactly as it will on the web.

You'll use the panels in the right group to customize the gallery template. You can tweak the layout, change the color scheme, and add text, borders, and effects. With a single click, you can preview your gallery in a web browser or upload it to your web server—all without leaving Lightroom Classic CC.

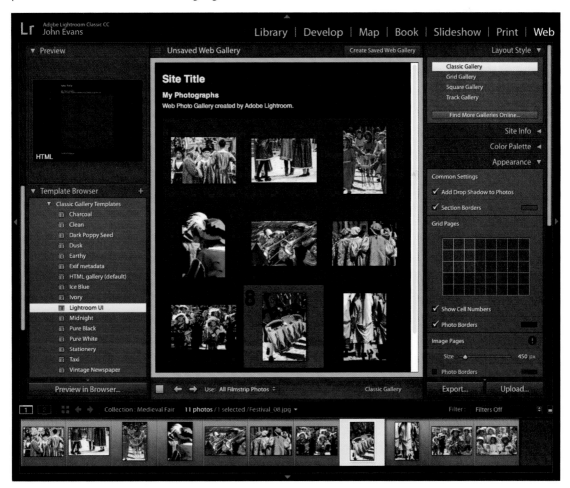

Assembling photos for an online gallery

In the exercises to follow, you'll customize a Lightroom template to showcase some photographs of paintings in an interactive web portfolio. The first step in creating a web gallery is to isolate the images you want to use from the rest of your catalog.

1 In the Folders panel, select the folder Batch4, nested inside the Lesson 10 folder.

The fact that the selected image source is a folder without subfolders means that you'll be able to rearrange photos in the Grid view or the Filmstrip to create a custom order for your gallery, but you won't be able to exclude an image from the selection without moving it from the folder, or removing it from your catalog.

Tip: You can reorder photos in a collection by simply dragging the thumbnails in the Grid view or in the Filmstrip. Your custom display order will be saved with the collection.

The solution is to create a collection to group the photos for your project, where you can rearrange the image order—just as you can with a single folder—but also remove an image from the virtual grouping, without moving it from the source folder, or deleting it from the catalog.

A collection has a permanent listing in the Collections panel, making it easy to retrieve a set of images at any time, even if they're stored across multiple folders, as could have been the case had you assembled the images for your gallery using a multiple-criteria search of your library.

2 Check that the Lesson 10 / Batch4 folder is still selected in the Folders panel. In the Toolbar, set the Sort method to Capture Time or File Name; then, press Ctrl+A / Command+A or choose Edit > Select All.

3 Click the New Collection button () in the header of the Collections panel and choose Create Collection from the menu. In the Create Collection dialog box, type **Paintings** as the name for the collection, and make sure that the Location option is disabled. In the Collection Options, activate Include Selected Photos and disable the other options; then, click Create.

In the Collections panel, your new collection automatically becomes the active image source; the image count to the right shows that it contains eighteen photos.

Rearranging the order of your images

Either before or after you see how your photos look in a gallery layout, you may wish to change the order in which the images will appear on screen.

You might rearrange your photos to enhance the flow of a pictorial narrative, or to establish contrast within the sequence by mixing high- and low-toned images, which will help the photos to stand apart from each other, especially on the index page of a Square or Track gallery, where there is no space between adjacent images.

In this exercise, you'll move two of the lesson images to tweak the order of warm and cool colors in the first half of the series.

1　Make sure that the Paintings collection is still selected in the Collections panel; then, choose Edit > Select None.

2　In the Grid view, drag the image Painting-4.jpg to position it between the images Painting-8.jpg and Painting-9.jpg. Release the mouse button when the black insertion point line appears between the eighth and ninth thumbnails.

Note: The order of the images in the Grid view and the Filmstrip determines their display order in a Web gallery.

Note: Dragging an image that is part of a multiple selection will move all the selected images. If all images in a collection are selected you will not be able to rearrange their order.

3　In the Filmstrip, drag the image Painting-9.jpg to the left. Release the mouse button when the black insertion point line appears between the fourth and fifth images (Painting-5.jpg and Painting-6.jpg).

You can rearrange the order of images in the Filmstrip while you're working in any of the Lightroom Classic CC modules, as long as your image source is a collection or a folder without subfolders. When you re-order photos in the Filmstrip in the Web module, the Gallery Editor view in the work area may be slow to reflect the changes. If necessary, you can refresh the Gallery Editor view by choosing Web > Reload.

4　Keeping the Paintings collection selected in the Collections panel, choose Edit > Select None; then, press Ctrl+Alt+7 / Option+Command+7, or click Web in the Module Picker to switch to the Web module.

Choosing a template in the Web module

Tip: The first time you enter any of the Lightroom Classic CC modules, you'll see tips that will help you get started by identifying the components of the workspace and stepping you through the workflow. You can dismiss the tips by clicking the Close button. To reactivate the tips for any module, choose [*Module name*] Tips from the Help menu.

The first step in creating your own gallery is to choose one of the twenty-four customizable HTML 5 gallery designs in the Template browser. Once you've tweaked and personalized the layout to suit your needs, you can save it, ready for re-use or further modification the next time you need to generate a similar presentation.

The Lightroom gallery templates differ not only in basic layout and color scheme, but also in the use of design elements such as image borders and drop shadows, and in the options available for displaying text information on your gallery pages.

1 In the Layout Style panel at the right, select the Classic Gallery style. In the Template Browser at the left, the default HTML gallery template is activated. Click the Lightroom UI template a little further down the list; the Preview panel shows a thumbnail of the selected design, and the Gallery Editor view shows how your images will look in that layout. From the Use menu in the Toolbar below the Gallery Editor, choose All Filmstrip Photos.

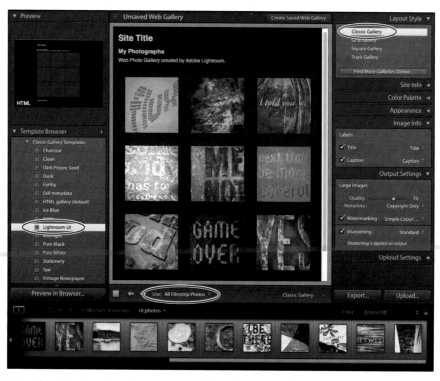

2 Hide the Filmstrip, if necessary, so that you can see the Preview panel and as much as possible of the list of templates in the Template Browser. Watch the Preview panel as you move the pointer down the list of templates.

3 Click on one or two templates from each category and inspect the layout in the Gallery Editor. For each design you preview, mouse over the thumbnails in the Gallery Editor view; some layouts include interactive highlighting.

4 In the right panel group, collapse all but the Layout Style and Site Info panels. In the Layout Style panel, click Classic Gallery; then, examine the options available in the Site Info panel. In the Layout Style panel, select each of the other three styles in turn, noting the different options in the Site Info panel.

Note: The Grid and Track Gallery styles share the same options in the Site Info panel.

The Classic Gallery styles offer the most options for adding descriptive text to your gallery, and also the opportunity to personalize the page with your own identity plate. You can use a simple text identity plate, as in the illustration at the left, or place a graphic such as your business logo or signature, or even your photo.

5 Collapse the Site Info panel, and then expand the Color Palette panel. Compare the options for each of the four gallery styles. When you're done, collapse the Color Palette panel and move down to the Appearance Panel.

Square Gallery options

Track Gallery options

Grid Gallery options

Just as for the Site Info panel, the Classic Gallery styles also provide more specific and comprehensive controls in the Color Palette and Appearance panels, including the option to specify a fixed number of rows and columns of image cells (the illustration at the left shows the default 3 x 3 grid).

In the Grid Pages pane of the Appearance panel, you can set the number of images that will be displayed on each index page of a Classic Gallery. A page indicator and navigation controls below the index grid enable the viewer to move between pages.

For a Grid Gallery template, you can choose either a scrolling, single-page index or a navigable, multiple-page layout from the Pagination Style menu in the Appearance panel. For a multiple-page index, you must specify the number of images per page.

The Square and Track Gallery styles have scrolling, single-page index layouts that will flow to fill the browser window; there are no pagination or navigation controls.

For a Classic gallery, you can set the size of the single image that you'll see when you click a thumbnail in the index by using the Size slider in the Image Pages pane at the bottom of the Appearance panel; for the other gallery styles, the image will be automatically scaled to fit the browser window (*below, right*).

The options and controls that are presented in the last three panels in the right panel group—the Image Info, Output Settings, and Upload Settings panels—are common to all four gallery styles.

It's a good idea to make sure you're familiar with the differences between the four gallery layout styles and the characteristics of their preset variations, so that you can choose the template that's closest to the design you have in mind. For even more choices, explore the third-party gallery plugins available at Adobe Add-ons.

▶ **Tip:** The Grid, Square and Track Gallery styles, have been optimized to work well with both desktop and mobile web browsers.

6 In the Layout Style panel, click Find More Galleries Online.

7 On the Adobe Exchange page, click the magnifying glass icon at the upper right and type **Lightroom plug-ins** in the search box; then, click Enter / Return.

8 Click the link to Lightroom Plug-ins And Free Presets; then, choose Web Galleries from the links at the right.

In the Web Galleries category on the "In depth: Plug-ins" page, you'll find links to web gallery creation plug-ins that enable you to create a range of scrolling galleries and slide show presentations, including specialized galleries for large images, blog-themed templates, and password-protected galleries with features including e-commerce and client proofing.

There are also add-ons for uploading your photos and existing albums to online gallery hosting services, and for generating an entire website to showcase your work, where instead of a single gallery, you can create a complete web presence that includes a structured hierarchy of galleries.

Customizing your web gallery

You can save time when creating your web gallery by starting with the layout template closest to the design you have in mind. Once you've made your choice, you can use the Site Info, Color Palette, Appearance, Image Info, and Output Settings panels in the right panel group to customize the template.

You can add text, choose a color scheme, and tweak the layout to change the look and feel of your gallery. In the following exercises, you'll place a logo, customize the text in your gallery template, adjust the layout, and add a watermark to the images.

Personalizing a Classic gallery

If you've chosen one of the Classic Gallery templates, you have the opportunity to personalize your gallery by placing your name, signature, photo, or business logo in the header, which is particularly effective if you're presenting photos to a client.

1 In the Template Browser, select the Charcoal gallery template, the first layout in the Classic Gallery Templates category.

2 Click the checkbox to activate the Identity Plate option in the Site Info panel; then click the white triangle at the lower right of the identity plate preview pane and choose Edit from the menu.

> **Tip:** For best results, use an image that is no more than 60 pixels high so that Lightroom will not need to scale it to fit your layout. Although the file supplied for this exercise is 60 pixels in height, it includes 12 pixels of transparency along the bottom edge, which serves as a spacer to separate it from the preset gallery text.

3 In the Identity Plate Editor dialog box, activate the option Use A Graphical Identity Plate, and then click Locate File.

4 In the Locate File dialog box, navigate to the Extras folder inside the Lesson 10 folder and select the file Web_Identityplate.png. Click Choose; then, click OK. The new identity plate appears in the Gallery Editor view and in the Identity Plate preview in the Site Info panel.

Working with identity plates

You can personalize your slideshows and print layouts—just as you've done with your web presentation—by adding your own identity plate.

A **Styled Text Identity Plate** will display whatever text you enter in the Identity Plate Editor dialog box. You can choose font characteristics from the menus below the text box and change the text color by clicking the swatch.

A **Graphical Identity Plate** uses a graphic that is no more than 60 pixels high, in any of the following file formats: PDF, JPG, GIF, PNG, TIFF, or PSD (Windows) and JPG, GIF, PNG, TIFF, or PSD (Macintosh). The resolution of graphical identity plates may be too low for printed output. Choose Save As from the Enable Identity Plate menu, and give your identity plate a name.

Tweaking the layout of a web gallery

You can adjust your gallery layout using the Appearance panel. The options available in the Appearance panel differ for each layout style.

For a Classic gallery, the Appearance panel offers the options shown in the illustration to the right. You can add borders or drop shadows to your images and display an index number in the background of each image cell. Change the number of rows and columns used on the index page with the Grid Pages controls, which will indirectly determine the size of the thumbnail images in the grid. The minimum grid is three by three—if your gallery contains more than nine images additional index pages will be generated. You can also set the size of the single-image page and the width of a photo border for the enlarged view of an image.

Together with the controls in the Color Palette panel, these options give you great flexibility in customizing the look and feel of your Classic gallery layout.

1 We'll look at the color controls in another exercise; for now, work your way down the controls in the Appearance panel, toggling the controls by clicking the checkboxes as you watch the effects in the gallery preview. Experiment with setting different proportions for the index page layout in the Grid Pages pane.

2 In the Template Browser, click the Grid Gallery variants in turn, noting the differences in the Appearance panel settings for each of the three templates; then, choose the Grid Gallery (default) template and experiment with the controls. Change the Pagination Style to Multiple Pages and experiment with the Items Per Page setting. Enable the Floating Header option, and then scroll down the index page in the Gallery Editor view to see the result.

3 Repeat the process for the three Square Gallery variants.

4 Select the default Track Gallery template. Set the Row Spacing to Large and enable Floating Header; then, expand the Site Info and Color Palette panels.

Working with Site Info text

For all four gallery styles, you can add a gallery title, an author name, and a website or e-mail link in the Site Info panel. The Classic and Square galleries also allow for extra lines of descriptive text.

1 Click the default Gallery Title text in the Site Info panel and type a title for your site; then, press Enter / Return; your text replaces the placeholder text in the gallery header. In a web browser, your gallery title will also appear in the browser window title bar or tab.

2 Click the triangle beside Gallery Title and note the entries in the Site Title menu. Lightroom keeps track of your entries for each of the text boxes in the Site Info panel. Instead of retyping information each time you create a new web gallery, you can choose previously entered details from this list.

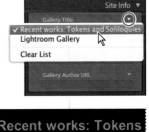

▶ **Tip:** In a Classic Gallery layout, you can also edit text directly in the Gallery Editor view; simply click the text you wish to change, and then type over it. Press Enter / Return to update both the gallery preview and the corresponding entry in the Site Info panel.

3 Click the Gallery Author text box in the Site Info panel and type your name. Press Enter / Return; your name appears in a by-line below the title in the gallery header.

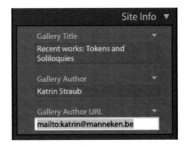

The third item in the Track Gallery Site Info panel, Gallery Author URL, will not be visible on-screen in its own right, but is attached to the Gallery Author text, making it an interactive web or mail link.

4 Click the Gallery Author URL text box in the Site Info panel; then, enter your e-mail address like this: **mailto:user@domain.com**. Press Enter / Return; in the work area preview, the Gallery Author text is now underlined to indicate a live link. Click the by-line; your default mail application to a new, pre-addressed e-mail message.

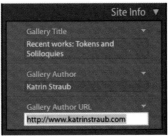

If you have a personal web page, you can use the Gallery Author URL entry to set up a link to your Home page, where you can offer the viewer links to other galleries that you've created in Lightroom.

5 Click the Gallery Author URL text box in the Site Info panel and enter your Home page URL like this: **http://www.domain.com**; then, press Enter / Return. In the work area preview, click the by-line; your default web browser will open to the specified web page.

Changing colors

The controls in the Color Palette panel enable you to change the color scheme for your website. You can set the color for every element in the layout: background, text, navigation icons—and, for Classic and Grid galleries, image cells and borders.

Choosing colors that work well together and look good on any system may seem a challenge, but keeping just a few simple rules in mind should help you to stay within a safe palette. Text that stands out from the background only because of its hue, rather than by tonal contrast, may be hard to see if the colors are shifted on the viewer's browser; use dark text on a light background and vice versa.

For base elements such as the background, image borders, and header text, neutral, muted colors will compete less with your images.

If you want to get serious about designing color schemes (and have some fun along the way), Adobe Color CC can be an invaluable reference. Explore the interactive color wheel and browse palettes created by other users at color.adobe.com.

1 In the Color Palette panel, click the Background color swatch to open the Lightroom Color Picker.

2 Move the pointer over the central pane in the Color Picker; the cursor becomes an eyedropper. Click anywhere in the central pane and drag the eyedropper across the gallery preview to sample a deep viridian hue from the second image in the top row. Watch the HSL values at the bottom of the Color Picker to make sure that the luminance (L) value of the color you sample is no higher than 15%. You can see the result in the template preview at the left as you drag; the new color is not applied in the Gallery Editor until you release the mouse button.

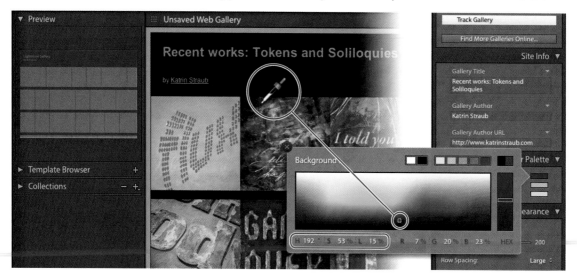

3 In the Color Palette panel, click the Text color swatch and drag upwards to sample the color you just set in the Background swatch. In the Color Picker, click the Luminance (L) value and type **40**; then, press Enter / Return.

4 Click the Icons color swatch and drag upwards to sample the color you just set in the Text swatch; then, press Enter / Return to dismiss the Color Picker.

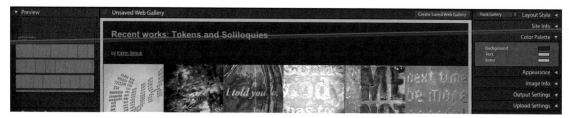

Adding information about your photos

In the Image Info panel, you can choose from a range of options in the Title and Caption menus to specify the information you'd like to display about each of the images in your web gallery. The lesson images have already had titles added to their metadata. In this exercise, you'll add a common caption to the entire collection.

1. Expand the Image Info panel in the right panel group. Make sure that both the Title and Caption options are activated, and that the Title label option is set to display the title embedded in the images' metadata.

2. Click on the double triangle beside Caption to see the list of options. Most of the options display information items that are retrieved from an image's metadata. For the purposes of this exercise, choose Custom Text.

3. Click the Custom Text box to activate it for text insertion and type **mixed media on canvas**; then, press Enter / Return.

4. Click any of the images on the index page to see it enlarged in the single-image view, labeled with the title from its metadata and your custom text caption. Move the pointer to the sides of the image page to see the navigation buttons; then click the X icon at the upper right to return to the index page.

Specifying output settings

In the Output Settings panel you can control the image quality and the sharpness of the JPEG images generated for the single-image pages in your web gallery. You can also choose to add a watermark to your images, which gives you at least minimal protection when publishing your work.

▶ **Tip:** It's always worth experimenting with the image quality settings; for some images a lower setting might be sufficient, resulting in a website that loads faster.

1 In the right panel group, collapse the Image Info panel and expand the Output Settings panel. Drag the Quality slider to set the image quality to 70%, or alternatively, click the value to the right, type **70** and press Enter. In most cases, an image quality setting of 70% to 80% strikes a good balance between file size and image quality.

2 If they are currently disabled, activate the Watermarking and Sharpening options at the bottom of the Output Settings panel. Make sure that the amount of Sharpening to be applied is set to Standard.

You won't see the changes you've made to these settings reflected in the images in the gallery preview; both the image quality and sharpening settings will not be applied until Lightroom Classic CC exports the image files for your website.

Watermarking images

In the Watermark Editor dialog box, Lightroom makes it easy to watermark your images for export, printing, publishing, or for a web gallery.

You have the choice of applying a simple text watermark—ideal for a copyright message or your business name—or importing an image file such as your company logo to be applied as a graphic watermark.

For a text watermark you can specify a font and the text color, and for both watermark styles you can adjust the opacity and either use precise scaling and positioning controls or work directly with your watermark in the watermarking preview.

1 Press Ctrl+A / Command+A, or select all of the images in your web gallery manually by Shift-clicking the thumbnails at either end of the Filmstrip. Click the double arrow to open the Watermarking menu and choose Edit Watermarks to open the Watermark Editor dialog box.

The default watermark style is a simple text copyright watermark. In the Watermark Editor dialog box you have the opportunity to enter your own message and specify the font, style, alignment, and color of your text. On macOS, you can also set up a drop-shadow effect for your watermark text.

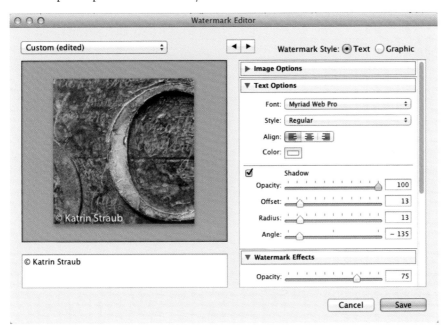

For both watermark styles you can use the Watermark Effects controls at the right of the dialog box to adjust the opacity, size, and placement of your watermark. Alternatively, you can move or resize the watermark directly; a bounding box and handles will appear when you move the pointer over the preview. Use the left and right arrows at the top of the dialog box to change the image in the preview pane.

2 Under Image Options at the upper right of the Watermark Editor dialog box, click Choose to select an image file to be used as a graphic watermark. In the Open / Choose A File dialog box, navigate to and open the Extras folder inside the Lesson 10 folder. Select the file watermark_K.png; then, click Choose.

At the upper right of the Watermark Editor dialog box, the Watermark Style has changed to Graphic and the Text Options are now disabled.

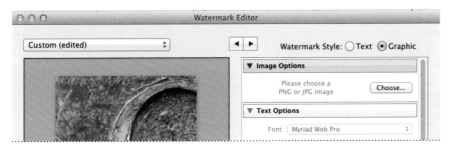

3 At the right of the Watermark Editor dialog box, scroll down if necessary and expand the Watermark Effects controls. Use the sliders or type new values to set the opacity value to **50**, proportional sizing value to **25**, and both the horizontal and vertical inset values to **3**. Use the Anchor setting at the lower left to position the watermark at the lower right of the image. For our purposes, you won't need to use the Rotate buttons to reorientate the watermark image.

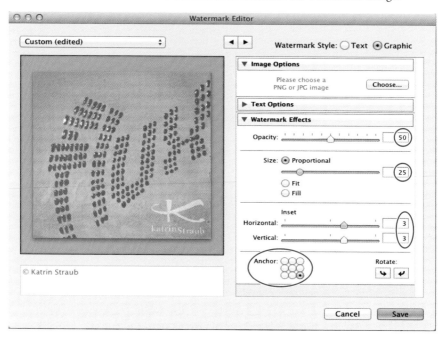

4 Use the left and right arrow buttons at the top of the Watermark Editor dialog box to cycle the image in the watermarking preview and decide whether the settings are effective for all the images in the collection. Make any adjustments you wish to make.

5 Choose Save Current Settings As New Preset from the Custom menu above the watermarking preview. In the New Preset dialog box, type **web portfolio** to name the new preset, and then click Create.

You could now apply the same watermark to another collection of images quickly and easily by choosing from the Watermarking menu in the Output Settings panel.

6 Click Done to close the Watermark Editor dialog box. The watermark appears on the images in the gallery preview and the web portfolio preset is indicated beside Watermarking in the Output Settings panel.

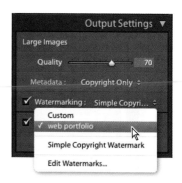

This concludes the section on customizing the look and feel of your web gallery. You've personalized a web page by placing a graphic identity plate, changed the site info text, added a live link, learned how to adjust the layout and color scheme, and finally added titles, captions and a watermark to the images.

It's time to test the way your gallery performs in a web browser before you save all these modifications as a custom template that you can use as a starting point the next time you create a web gallery.

Previewing the gallery

To enable you to preview your gallery as it will appear on the Web, Lightroom generates the web pages and all the necessary image files in a temporary folder on your hard disk, and then opens the index page of the gallery in your default web browser.

1 To preview the gallery in your default web browser, click the Preview In Browser button below the left panel group, or choose Web > Preview In Browser.

While Lightroom generates the necessary files, a progress bar appears in the upper left corner of the Lightroom Classic CC workspace. You can cancel the Preview In Browser command at any time by clicking the small cross icon (x) at the right end of the progress indicator—but for this exercise, let the process run its course.

Once Lightroom has finished generating the necessary files, your web gallery opens, fully functional, in your default browser.

Tip: You should always preview your gallery in this way before publishing it. Test the navigation controls, examine the image quality, and confirm that your photos appear in the correct order, with the right information.

2 To check how your web gallery performs in the browser, run these simple tests:

- If necessary, use the scroll bar to scroll down the index page.

- Click a thumbnail to view the enlarged image on the single-image page and examine the image quality.

- Click the left and right navigation arrows on either side of the image count above the enlarged photo to move between single-image pages. Move the pointer over the left and right edges of the page and test the arrow buttons.

- Make sure the titles, captions, and watermarks are displayed correctly; then, close the single-image page by clicking the X in the upper right corner.

- Resize your browser window to see how the gallery works at different sizes.

- Click the by-line below the gallery title to check if it links correctly to your home page or opens a new e-mail message.

3 If you'd like to check how your gallery will perform on a mobile device, skip ahead and work through the exercise "Uploading your gallery to a web server." At step 7, name the subfolder Test. When you're done, return to this exercise.

4 On your handheld device, enter the URL of your gallery in your web browser.

5 Check all of the same items that you tested when you previewed the gallery in your desktop web browser.

Saving your custom template

Having spent time and effort modifying the layout, you should save your design as a custom template. The new template will be listed in the Template Browser panel, where you can access it easily if you want to rework or extend your gallery, or use it as a starting point for designing a new layout. You can create additional folders in the Template Browser to help you manage your custom templates.

1 With your customized web gallery still open in the Web module, click the Create New Preset button (+) in the header of the Template Browser panel in the left panel group. Alternatively, choose Web > New Template.

2 In the New Template dialog box, type **My Track Web Portfolio**. Leave the default User Templates folder selected in the Folder menu and click Create.

Your customized web gallery template is now listed under User Templates at the bottom of the Template Browser panel.

3 In the Template Browser panel right-click / Control-click the User Templates folder and choose New Folder from the context menu. In the New Folder dialog box, type **Track Templates Customized** as the name for the new folder; then click Create.

4 In the Template Browser panel, drag the My Track Web Portfolio template from the User Templates folder into your new Track Templates Customized folder.

▶ **Tip:** To delete a selected template, click the Delete Selected Preset button (-) in the header of the Template Browser. You cannot delete the Lightroom templates. To delete a folder from the Template Browser, first delete all the templates inside it—or drag them into another folder; then right-click / Control-click the empty folder and choose Delete Folder from the context menu. You cannot delete the default templates folders.

Creating a Saved Web Gallery

Since you entered the Web module, you've been working with an *unsaved web gallery*, as is indicated in the bar across the top of the Gallery Editor view.

Until you save your gallery design, the Web module works like a scratch pad. You can move to another module, or even close Lightroom Classic CC, and find your settings unchanged when you return, but if you select a new gallery template, or even the one you started with, in the Template Browser, the "scratch pad" will be cleared and all your work will be lost.

● **Note:** Once you've saved your gallery, any changes you make to the layout or output settings are auto-saved as you work.

Saving your web gallery not only preserves your layout and output settings, but also links the layout to the particular set of images for which it was designed.

Your web gallery is saved as a special kind of collection—an *output collection*—with its own listing in the Collections panel. Clicking this listing will instantly retrieve the images you were working with, and reinstate all of your settings, no matter how many times the web gallery scratch pad has been cleared.

1 Click the Create Saved Web Gallery button in the bar at the top of the Gallery Editor view, or click the New Collection button (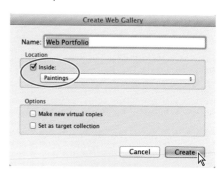) in the header of the Collections panel and choose Create Web Gallery.

2 In the Create Web Gallery dialog box, type **Web Portfolio** as the name for your saved presentation. In the Location options, activate Inside and choose the collection Paintings from the menu; then, click Create.

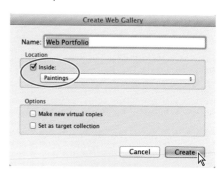

▶ **Tip:** Adding more photos to a saved gallery is easy: simply drag images to the gallery's listing in the Collections panel. To open your gallery in the Web module from the Library, click the white arrow that appears to the right of the image count when you move the pointer over your saved gallery in the Collections panel.

Your saved gallery appears in the Collections panel, marked with a Saved Web Gallery icon (▦), and nested inside the original source collection, Paintings. The image count shows that the new Web Portfolio output collection, like the source collection, contains eighteen photos. The title bar above the Gallery Editor view displays the name of your saved gallery.

Depending on the way you like to work, you can save your web gallery at any point in the process; you could create a Saved Web Gallery as soon as you enter the Web module with a selection of images or wait until your presentation is polished.

Exporting your gallery

Now that you're happy with your gallery and you've saved the template, you can export the website to your hard disk.

You can run the exported website from your laptop if you need to present your work without an Internet connection, or burn the exported files to a CD-ROM as a working backup or to send to a client.

1 Select My Track Web Portfolio from the Track Templates Customized folder in the Template Browser panel and click the Export button below the right panel group, or choose Web > Export Web Photo Gallery.

2 In the Save Web Gallery dialog box, navigate to your Lesson 10 folder. Type **My CIB Web Gallery** in the File Name / Save As text box, and then click Save.

Lightroom Classic CC will create a folder named My CIB Web Gallery inside the Lesson 10 folder and generate all the necessary image files, web pages, subfolders and support files within that folder.

If you have many images in your gallery, this operation might take a while—a progress bar at the upper left of the Lightroom Classic CC workspace provides feedback as Lightroom completes the process.

3 When the export is complete, double-click the file index.html in the folder My CIB Web Gallery inside your Lesson 10 folder. Your gallery opens in your default web browser. When you're finished reviewing the exported gallery, close the browser window and return to Lightroom Classic CC.

▶ **Tip:** Before burning your web gallery to a CD-ROM for a client, create an alias of the index.html file, place it beside the folder containing the files for the website, and rename it **Start here**. This will make it easy for your client to launch your presentation.

Uploading your gallery to a web server

In the last exercise of this lesson you'll learn how to upload your web gallery to a server from within Lightroom Classic CC. To do this, you'll need to know your FTP server access information. Your Internet service provider can provide these details.

1 In the Web module, expand the Upload Settings panel in the right panel group.

2 From the FTP Server menu in the Upload Settings panel, choose Edit.

3 In the Configure FTP File Transfer dialog box, enter the server address, your username and password, and the server path.

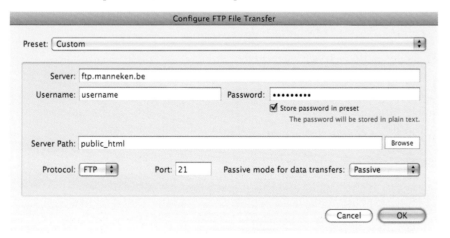

▶ **Tip:** For security reasons, don't activate the Store Password In Preset option unless you are the only person with access to the computer you're using.

4 From the Preset menu, choose Save Current Settings As New Preset.

5 In the New Preset dialog box, enter a name for your FTP server preset, and then click Create.

6 Click OK to close the Configure FTP File Transfer dialog box. You'll notice that the name of your new FTP server preset now appears in the Upload Settings panel, where you can access it at any time from the FTP Server Presets menu.

> **Tip:** To avoid possible compatibility issues with your web server, you should use only lowercase letters, the minus sign (-), and the underscore character (_) in the subfolder name. Avoid using spaces in the folder name.

7 To place the gallery inside a subfolder on your FTP server, activate the option Put In Subfolder and type a name for the subfolder that's relevant to the content of the gallery. This subfolder name will become part of the URL of your web gallery. For example, we used **tokens** as subfolder name, so the complete URL might look like this: http://www.katrinstraub.com/tokens.

8 Click the Upload button below the right panel group. If you didn't save your FTP server password in the Configure FTP File Transfer dialog box, you'll need to enter it now in the Enter Password dialog box, and then click Upload.

Uploading your web gallery to an FTP server generally takes much longer than exporting it to your local hard disk. You can watch the upload status in the progress bar at the upper left of the Lightroom Classic CC workspace.

Once the upload is complete, you can enter the URL of your gallery in your web browser and admire your site live on the Internet. Don't send the URL to a client or friends before you've confirmed that everything works as expected!

Congratulations—you've completed this lesson on publishing images. You've learned how to use the new Publish Services feature to publish images to a photo sharing website or to your hard disk, and how to share to social networking sites and Lightroom CC on the web via Lightroom CC for mobile. You've built your own web gallery, saved a custom gallery template and created new watermarking and FTP upload presets. Finally, you learned how to export your web gallery or upload it to a web server.

Before you move on to the next lesson, take a moment or two to review some of your new skills by reading through the questions and answers on the facing page.

Review questions

1 Why would you use Publish Services to publish images to your hard disk?

2 How do you view comments posted on the photos you've shared to social networking and photo sharing sites or Lightroom CC on the web?

3 Why is it useful to create a collection to group the images that you intend to use for a web gallery?

4 Which panels would you use to customize the Lightroom web templates?

5 How do you add a graphic watermark to the images in your web gallery?

Review answers

1 You can create a new publish collection on your hard disk for each client to whom you hand off photos, making it easy to check whether they have the most current versions, as Lightroom will keep track of which images have been updated since the collection was published. You can also set up a publish collection that will enable you to publish images to your iPhone sync folder with drag and drop convenience.

2 To see viewers' comments on shared photos in Lightroom CC on a mobile device, tap the comments button (▣), in the expanded collection view. On a desktop computer, photos with comments are marked with a badge (▣); click the badge to see the attached comments.

3 Grouping your images as a collection not only keeps them all in one place for easy reference—it will also make the process of updating and adjusting your web gallery much more efficient. Once a selection of photos has been saved as a collection it is possible not only to re-order images, as you can with a single-folder image source, but also to exclude an image without deleting it from the catalog.

4 The panels in the right panel group—the Site Info, Color Palette, Appearance, Image Info, Output Settings, and Upload Settings panels—contain controls for modifying the gallery layout templates from the Template Browser.

5 In the Web module, activate the Watermarking option in the Output Settings panel. Click the double arrow to open the Watermarking menu and choose Edit Watermarks to open the Watermark Editor dialog box. Under Image Options in the Watermark Editor dialog box, click Choose to select an image file to be used as a watermark.

11 MAKING BACKUPS AND EXPORTING PHOTOS

Lesson overview

Lightroom Classic CC makes it easy to back up and export all the data connected with your image library. You can create backup copies of your photos on external storage during import, make full or incremental backups of both your photos and develop settings, or have Lightroom back up automatically. Export files in a range of formats, from images optimized for on-screen viewing to archival copies.

In this lesson you'll learn a variety of techniques to help you stream-line your workflow and minimize the impact of accidental data loss:

- Backing up the catalog file

- Backing your entire image library

- Making incremental backups and exporting metadata

- Exporting photos for on-screen viewing

- Exporting photos to be edited in another application

- Exporting photos for archival purposes

- Using export presets

- Setting up automated post-export actions

 You'll probably need between one and two hours to complete this lesson. If you haven't already done so, log in to your peachpit.com account to download the lesson files for this chapter, or follow the instructions under "Accessing the Lesson Files and Web Edition" in the Getting Started section at the beginning of this book.

Safeguard your photographs and develop settings against loss using Lightroom Classic CC's built-in backup tools. Back up just your catalog file, or your entire photo library, complete with develop settings and copies of your master files. Export photos in different file formats for multimedia presentations or e-mail attachments, for further editing in an external editor, or to be stored for archival purposes.

Getting started

Note: This lesson assumes that you already have a basic working familiarity with the Lightroom Classic CC workspace. If you need more background information, refer to Lightroom Classic CC Help, or review the previous lessons..

Before you begin, make sure you've set up the LRClassicCIB folder for your lesson files and created the LRClassicCIB Catalog file to manage them, as described in "Accessing the Lesson Files and Web Edition" and "Creating a catalog file for working with this book" in the Getting Started chapter at the start of this book.

If you haven't already done so, download the Lesson 11 folder from your Account page at www.peachpit.com to the LRClassicCIB \ Lessons folder, as detailed in "Accessing the Lesson Files and Web Edition" in the chapter "Getting Started."

1 Start Lightroom Classic CC.

2 In the Adobe Photoshop Lightroom Classic CC - Select Catalog dialog box, make sure the file LRClassicCIB Catalog.lrcat is selected under Select A Recent Catalog To Open, and then click Open.

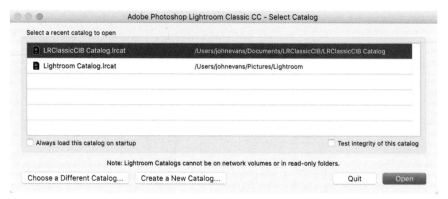

Tip: If you can't see the Module Picker, choose Window > Panels > Show Module Picker, or press the F5 key. If you're working on Mac OS, you may need to press the fn key together with the F5 key, or change the function key behavior in the system preferences.

3 Lightroom Classic CC will open in the screen mode and workspace module that were active when you last quit. If necessary, switch to the Library module by clicking Library in the Module Picker at the top of the workspace.

Importing images into the library

The first step is to import the images for this lesson into the Lightroom library.

1 In the Library module, click the Import button below the left panel group.

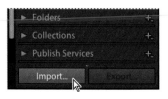

2 If the Import dialog box appears in compact mode, click the Show More Options button at the lower left of the dialog box to see all the options in the expanded Import dialog box.

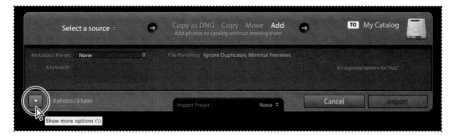

3 Under Source at the left of the expanded Import dialog box, locate and select your LRClassicCIB \ Lessons \ Lesson 11 folder. Ensure that all six images in the Lesson 11 folder are checked for import.

4 In the import options above the thumbnail previews, select Add so that the imported photos will be added to your catalog without being moved or copied. Under File Handling at the right of the expanded Import dialog box, choose Minimal from the Build Previews menu and ensure that the Don't Import Suspected Duplicates option is activated. Under Apply During Import, choose None from both the Develop Settings menu and the Metadata menu and type **Lesson 11** in the Keywords text box. Make sure that the Import dialog box is set up as shown in the illustration below, and then click Import.

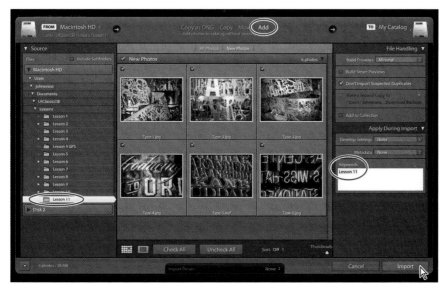

5 The six images are imported from the Lesson 11 folder, and now appear in both the Grid view of the Library module and in the Filmstrip across the bottom of the Lightroom Classic CC workspace. Choose View > Sort > File Name.

Preventing data loss

The importance of a good backup strategy is often only understood too late. How much damage would be done if your computer was stolen right now? How many files would be irrecoverably lost if your hard disk failed today? How much work and money would that cost you? You can't prevent a disaster from happening but it *is* in your power to reduce the risks and the cost of recovery. Backing up regularly will reduce the impact of a catastrophe and save you time, effort, and money.

Lightroom Classic CC delivers a range of options that make it easy to safeguard your photo library; as for the rest of the files on your computer, you really should have your own backup strategy in place.

Backing up the catalog file

The Lightroom catalog file stores a great deal of information for the photos in your library—not only the locations of the image files, but the metadata attached to them, including titles, captions, keyword tags, flags, labels, and ratings, together with all your developing and output settings. Every time you modify a photo in any way, from renaming the file during import to color correction, retouching, and cropping—all your work is saved to the catalog file. It records the way your images are grouped and ordered in collections, and records the publishing history, slideshow settings, web gallery designs, and print layouts associated with them as well as your customized templates and presets.

Unless you back up your catalog, you could lose hundreds of hours of work in the event of a hard disk failure, accidental deletion, or a corrupted library file—even if you do have copies of your original images stored safely on removable media. You can set Lightroom to initiate a regular backup of your catalog file automatically.

1 Choose Catalog Settings from the Edit / Lightroom menu. On the General tab, choose When Lightroom Next Exits from the Back Up Catalog menu.

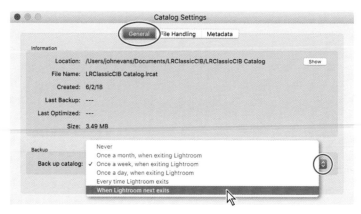

2 Click OK / the Close button (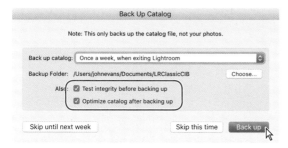) to close the Catalog Settings dialog box; then quit Lightroom Classic CC.

3 In the Back Up Catalog dialog box, click the Choose button to change the folder where the backed up catalog will be stored. Ideally the backup should be located on a different disk than your original catalog file; for the purpose of this exercise you can select the LRClassicCIB folder on your hard disk. In the Browse For Folder / Choose Folder dialog box, select the LRClassicCIB folder as the backup directory and click Select Folder / Choose.

4 Make sure the options Test Integrity Before Backing Up and Optimize Catalog After Backing Up are activated. It's a good idea to keep these options activated whenever you back up your catalog; it would defy the purpose of a backup if your original catalog file was not in good working order. Click Back Up.

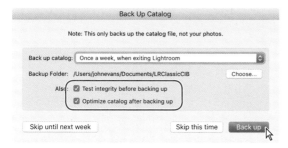

Each time you back up your catalog, Lightroom Classic CC will create a complete copy of the catalog file in the directory you specified, inside a new folder with a name composed from the date and time of the backup. To save space on your backup drive, you can either delete your older backup files or compress them. Catalog files compress very effectively; you can expect a compressed catalog to be as small as 10% of the size of the original. Make sure to decompress the file before attempting to restore your catalog from the backup.

Should your catalog be accidently deleted or become corrupted, you can now restore it either by copying the backup file to your catalog folder or by creating a new catalog and importing the contents of your backup file. To avoid inadvertently modifying your backup file, it's preferable not to open it directly from the Lightroom Classic CC File menu.

Note: Backing up the catalog file in this way does not make backup copies of the original image files or the preview images that Lightroom Classic CC displays in the workspace. The previews will be regenerated as your catalog file is restored from the backup, but you'll need to back up your original image files separately.

5 Start Lightroom Classic CC. In the Adobe Photoshop Lightroom - Select Catalog dialog box, make sure that the file LRClassicCIB Catalog.lrcat is selected under Select A Recent Catalog To Open, and then click Open.

6 Choose Edit > Catalog Settings / Lightroom > Catalog Settings.

7 In the Catalog Settings dialog box, click the General tab and set your preferred backup frequency by choosing from the Back Up Catalog menu.

8 Click OK / the Close button (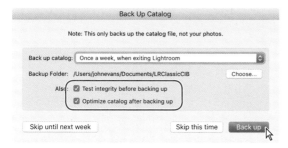) to close the Catalog Settings dialog box.

Exporting metadata

The catalog is a central storage location for all the information associated with every image in your library; exporting and distributing the catalog file's content is another strategy that will lessen the impact if your catalog file is lost or damaged. By saving the information from the catalog file that is specific to each photo to the respective image file on your hard disk—and keeping this exported information in sync with your catalog file, which can be done automatically—you have, in effect, a distributed backup of the metadata and develop settings for each of your photos.

When a photo has changes to its metadata that have not yet been saved to the original image file—such as the Lesson 11 keyword tag you applied to the images for this lesson during the import process—its image cell in the Grid view and the Filmstrip is marked with the Metadata File Needs To Be Updated icon (≡↓).

1 If you don't see the Metadata File Needs To Be Updated icon (≡↓) in the Grid view image cells, choose View > View Options. On the Grid View tab in the Library View Options dialog box, activate the Unsaved Metadata option under Cell Icons. Click the Close button to close the Library View Options dialog box.

2 Select the first image in the Grid view. Right-click / Control-click the thumbnail and choose Metadata > Save Metadata To File from the context menu. Click Continue to confirm the operation: after a brief processing time, the Metadata File Needs To Be Updated icon disappears from the thumbnail cell.

3 Ctrl-click / Command-click to select the other five photos, and then click the Metadata File Needs To Be Updated icon (≡↓) in the image cell of any of the selected images. Click Save to update the image files on your hard disk.

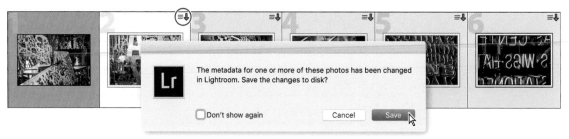

After a brief processing time, the Metadata File Needs To Be Updated badge disappears from each of the image cells.

If you edit or add to an image's metadata in another application, such as Adobe Bridge or the Photoshop Camera Raw plug-in, Lightroom Classic CC will show the Metadata Was Changed Externally icon (≡↑) above the thumbnail in the Grid view. To accept the changes and update your catalog file accordingly, choose Metadata > Read Metadata From Files. To reject the changed metadata and overwrite it with the information in your catalog file, choose Metadata > Save Metadata To Files.

You can update the metadata for a batch of modified images—or even for the entire catalog with all its folders and collections—by selecting the images or folders to be updated and choosing Metadata > Save Metadata To Files as you did in step 3.

You can use the Metadata Status filter in the Filter bar to quickly find those photos in your library with changes made externally to the master files on disk, any image with a metadata conflict—with unsaved changes made by both Lightroom and another application since the file's metadata was last updated, those with unsaved changes made in Lightroom, or images with metadata that is up to date.

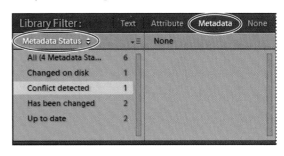

For DNG, JPEG, TIFF, and PSD file formats—which have defined spaces within the file structure where XMP information can be stored separately from the image data—Lightroom writes metadata into the image file itself. In contrast, changes made to camera raw images are written into a separate *XMP sidecar file* that records the metadata and develop settings exported to the image from Lightroom.

Many camera manufacturers use proprietary and undocumented formats for their Raw files, some of which become outdated as new ones appear. Because of this, storing the metadata in a separate file is the safest approach, avoiding the possibility of corruption in the Raw file or loss of the metadata exported from Lightroom.

4 From the Edit / Lightroom menu, choose Catalog Settings. On the Metadata tab activate Automatically Write Changes Into XMP so that metadata is exported automatically whenever a Raw image is modified; the sidecar file will always be up-to-date with your catalog.

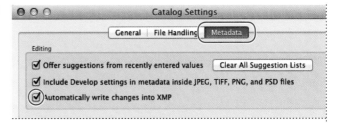

However, XMP information exported in this way contains only the metadata specific to the individual images: keywords, flags, labels, ratings, and develop settings. It does not include higher-level data relevant to the catalog as a whole such as information relating to stacks, virtual copies, and settings used in presentations.

Backing up the library

In the first exercise you backed up your catalog file without any images. In the second exercise, you updated your images files with metadata and develop information from the library catalog. This time, you'll export your entire Lightroom Classic CC library: images, catalog, stacks, collections—the works!

Exporting images as a catalog

When you export your photos as a catalog, Lightroom creates a copy of the catalog file and gives you the option to make copies of the master files and the image previews at the same time. You can choose to export the entire library, or just a selection of your images, as a catalog. Exporting images in this way is ideal for moving your photos together with all the associated Lightroom catalog information from one computer to another. You can use the same technique to restore your entire library from a backup after a data loss.

1 In the Catalog panel, click All Photographs; then, choose File > Export As Catalog.

Ideally, you should save your backup files to a hard disk other than the one that stores your catalog and the master image files—but for this exercise, you can save the backup files to the LRClassicCIB folder on your hard disk.

2 Type **Backup** in the File Name / Save As text box; then, navigate to your LRClassicCIB folder. Disable the option Build / Include Smart Previews, and make sure that Export Negative Files and Include Available Previews are activated. Click Save / Export Catalog.

Tip: Don't be concerned if you see a message saying that Lightroom could not find photo previews for the lesson files watermark_K.png and Web_Identityplate.png; simply click past the alert to continue.

A progress bar is displayed at the upper left as the new catalog is being created; for such a small catalog, backing up should take only a few seconds. Lightroom copies the image files associated with the catalog to their new location as a background task.

3 When the export process is complete, switch to Windows Explorer / the Finder and navigate to the LRClassicCIB folder. Open the new Backup folder.

● **Note:** You may see a different set of folders than is shown in the illustration, depending on which lessons you've already completed.

You can see that the folder structure nested inside the Backup folder replicates the arrangement of folders you see in the Folders panel. All the master images in your Lightroom Classic CC library have been copied into these new folders and the file Backup.lrcat is a fully functional copy of your original catalog.

4 In Lightroom Classic CC, choose File > Open Catalog. In the Open Catalog / Open dialog box, navigate to the new Backup folder inside the LRClassicCIB folder. Select the file Backup.lrcat, and then click Open. If the Open Catalog dialog box appears, click Relaunch. Lightroom will open the backup catalog.

5 Other than the filename in the title bar of the workspace, this catalog will be almost indistinguishable from your original work catalog. Only some temporary status information has been lost; for example, in the Catalog panel you can see that the Previous Import folder is now empty, as is the listing for All Synced Photographs. You can sync only one catalog from Lightroom Classic CC, so any synced collections in your work catalog will not be marked as synced here.

6 Some of your preferences have been reset to defaults which may differ from the choices you've made for your LRClassicCIB catalog. Choose Catalog Settings from the Edit / Lightroom menu. Click the General tab in the Catalog Settings dialog box. You can see that the backup frequency has been reset to the default. Click Cancel / the Close button (⊝) to close the Catalog Settings dialog box.

7 Choose File > Open Recent > LRClassicCIB Catalog.lrcat. In the Open Catalog dialog box, click Relaunch. If the Back Up Catalog dialog box appears, click Skip This Time.

Doing incremental backups

In the usual course of events, the majority of the images in your library will remain unchanged between backups. An incremental backup will save you time by replacing only the backup copies and catalog entries of images that have been modified since the last backup.

Although Lightroom Classic CC does not have an incremental backup command, you can achieve the same effect by regularly updating your existing backup with just those files in your main catalog that have been modified since the last backup.

1 In the Folders panel, select the Lesson 11 folder. Select the image Type-5.nef. In the Quick Develop panel, choose Auto from the White Balance menu; then, click the Auto Tone button. Click twice each on the right-most buttons for Whites and Clarity, and the left-most button for Blacks. This tonal adjustment will be the incremental change to your library for the purposes of this exercise.

2 Choose File > Open Recent > Backup.lrcat to switch to the Backup catalog. If the Open Catalog dialog box appears, click Relaunch. If a notification dialog appears asking if you wish to enable GPS address lookup, click disable to dismiss it.

3 Choose File > Import From Another Catalog. In the Import From Lightroom Catalog dialog box, navigate to the LRClassicCIB folder. Drill down to the LRClassicCIB/LRClassicCIB Catalog folder. Inside that folder, select LRClassicCIB Catalog.lrcat, and then click Open / Choose.

▶ **Tip:** If you see other files selected for import, it's likely that they are from the albums that you published to Flickr or Facebook, and that you have made changes (likes or comments) other than those detailed in the exercises. Go ahead and include those images.

4 In the Import From Catalog dialog box, make sure the Show Preview option is activated. Choose Metadata And Develop Settings Only from the Replace menu under Changed Existing Photos. Disable the option Preserve Old Settings As A Virtual Copy. Scroll down towards the bottom of the Preview panel display to confirm that only the image you edited in step 1 is selected for import.

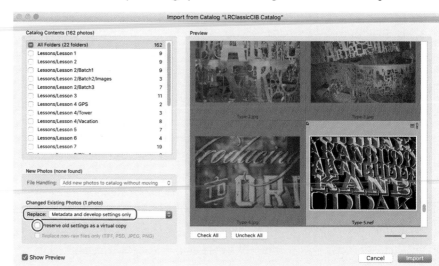

● **Note:** When you're adding new images to your backup library, choose Copy New Photos To A New Location And Import from the File Handling menu. Click the Choose button to specify your current Backup folder as the destination for the copied files.

5 Click Import. You can see that the image has been updated with the Quick Develop adjustments that you applied in the master catalog. You have just performed an incremental backup.

6 Click All Photographs in the Catalog panel, and then choose Edit > Select All or press Ctrl+A / Command+A. Choose Metadata > Save Metadata To Files or press Ctrl+S / Command+S; then, click Continue. This will export the metadata and develop settings for each photo in the backup library to the backup image file or its XMP sidecar, as an extra precaution against data loss.

7 Choose File > Open Recent > LRClassicCIB Catalog.lrcat to return to your original catalog. If the Open Catalog dialog box appears, click Relaunch.

8 If the Back Up Catalog dialog box appears, click Skip This Time.

▶ **Tip:** If you are asked whether Lightroom should overwrite the information embedded in the image files, click Overwrite Settings.

Exporting photos

The backup techniques that we've discussed so far all produce backup files that can be read only by Lightroom or another application that is capable of reading and interpreting the exported XMP metadata. If you wish to send your work to somebody who doesn't have Lightroom installed on their computer, you'll first need to convert the images to an appropriate file format. This is comparable to saving a Word document as plain text or as a PDF document for distribution; some of the functionality is lost but at least the recipient can see what you're working on. Your choice of file format will depend on the purpose for which the images are intended.

- To export a photo for use as an e-mail attachment intended to be viewed on screen, use the JPEG file format and minimize the file size by reducing the resolution and dimensions of the image.

- To export an image to be edited in another application, convert the photo to either the PSD or TIFF file format at full size.

- For archival purposes, export the images in their original file format or convert them to DNG.

Exporting JPEG files for on-screen viewing

For this exercise, you'll use a saved preset to edit the lesson images before you export them so that you'll be able to see at a glance that your develop settings have been applied to the exported copies.

1 In the Folders panel, select the Lesson 11 folder; then, choose Edit > Select All. From the Saved Preset menu at the top of the Quick Develop panel, choose Lightroom B&W Toned Presets > Split Tone 4.

2 With all six images still selected in the Grid view, choose File > Export.

3 Under Export Location in the Export dialog box, choose Specific Folder from the Export To menu, and then click the Choose button below it to specify a destination folder *(see illustration after step 4)*. Navigate to your Lessons folder, select the Lesson 11 folder, and click OK / Choose.

4 Activate the Put In Subfolder option and type **Export** as the name for the new subfolder. Disable the option Add To This Catalog.

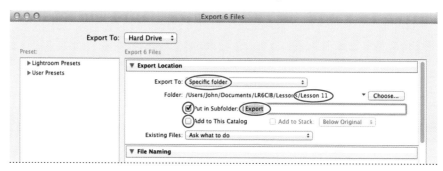

5 Under File Naming in the Export dialog box, click the checkbox to activate the Rename To option; then, choose Date - Filename from the menu.

6 Under File Settings, choose JPEG from the Image Format menu and set a Quality value of between 70% and 80%—a range that generally makes an acceptable compromise between image quality and file size. From the Color Space menu choose sRGB. The sRGB color space is a good choice for images intended to be viewed on the web—or in other circumstances where you are unsure what form of color management is used, if any at all.

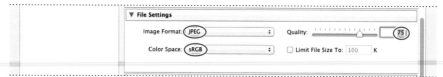

7 Scroll down in the Export dialog box, if necessary, so that you can see the Image Sizing controls. Activate the Resize To Fit option and choose Width & Height from the menu. Enter **750** for both width (W) and height (H) and choose Pixels from the units menu. This will proportionally scale each image so that its lon-gest side is 750 pixels. Our lesson images are all larger than this, so you won't need to activate Don't Enlarge to avoid smaller images being upsampled. Set the Resolution to **72** Pixels Per Inch—although resolution settings are in general ignored for on-screen display. The reduction in file size is the result of reducing the total number of pixels that make up the image.

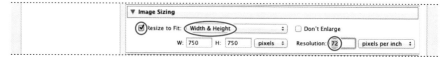

8 In the Output Sharpening settings, activate the Sharpen For Screen option and set the Amount to Standard. Under Metadata, choose the Copyright Only option. Note the other options available under Metadata; even with the All metadata option selected, you can still protect your privacy by removing GPS location information. Disable Watermarking. Choose Show In Explorer / Show In Finder from the After Export menu under Post-Processing.

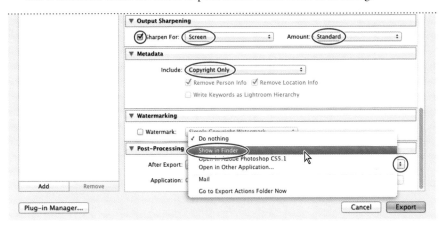

9 Click Export; then, watch the progress bar on the left side of the top panel in the workspace. When the export process is complete, your Export folder inside the Lesson 11 folder will open in Windows Explorer / the macOS Finder.

Note: To have Lightroom notify you by playing a sound when the export process is complete, choose a sound from the menu under Completion Sounds on the General tab in the Preferences dialog box.

Using export plug-ins

You can use third-party Lightroom plug-ins to extend almost any aspect of Lightroom Classic CC's functionality, including the export options.

There are export plug-ins that enable you to use the Lightroom export interface to send images to particular online photo sharing sites and social networking sites, or even other applications; for example a Gmail plug-in enables you to create an instant Gmail message and attach your photos as they are exported.

Other plug-ins add search criteria to the Filter bar, enable you to automate and compress backups, help you to create photo-collages or design and upload web galleries, give you access to professional effects and filters, or let you work with Photoshop-style layers in the Develop module.

Click the Plug-in Manager button in the lower left corner of the Export dialog box, and then click Adobe Add-Ons to browse online, where you'll find plug-ins from third-party developers offering additional functionality or helping you to automate tasks, customize workflows, and create stylish effects.

You can search the available Lightroom plug-ins by category, browsing for camera raw profiles, develop presets, export plug-ins, and even web gallery templates.

10 In Windows Explorer, show the Preview Pane or click Slideshow view to see a preview of the images in the folder. In the macOS Finder, select an image in Column view or in Cover Flow to see its preview. You can see that the duo-tone preset has been applied to these copies of the lesson photos during the export process. The copies are 750 pixels wide and have much reduced file sizes.

11 Delete the images from the Export folder; then, return to Lightroom Classic CC. With the six images still selected, choose Edit > Undo Split Tone 4 to revert all six images to their original colors.

Exporting as PSD or TIFF for further editing

1 In the Grid view, choose Edit > Select None, and then click to select the image Type-3.jpg. In the right panel group, expand the Quick Develop panel and choose Lightroom Color Presets > Cross Process 2 from the Saved Preset menu.

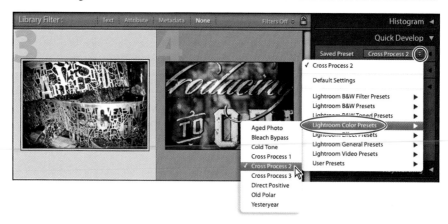

2 Choose File > Export. In the Export dialog box, you'll notice that all your settings from the previous exercise are still in place.

3 In File Settings, choose TIFF from the Image Format menu. When saving in TIFF format, you have the option to apply ZIP data compression—a lossless form of compression—to reduce the resulting file size. From the Color Space menu, choose AdobeRGB (1998).

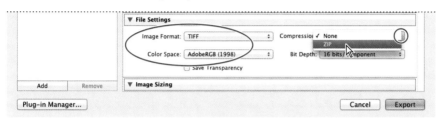

Tip: To export more images using the same settings that you used for the previous export (and without calling up the Export dialog box) choose File > Export With Previous.

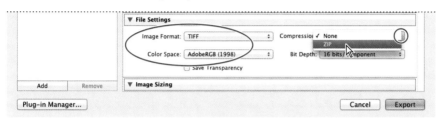

When you intend to edit an image in an external application after exporting it, you should use the AdobeRGB (1998) color profile rather than the sRGB color profile. The AdobeRGB (1998) color profile has a larger color gamut, which results in fewer colors being clipped and the original appearance of your images being better preserved. The ProPhoto RGB color gamut is even larger, capable of representing any color from the original raw image. However, to correctly display images using the AdobeRGB (1998) or ProPhoto RGB color profiles on screen you need an image editing application capable of reading these color profiles. You'll also need to turn color management on and calibrate your computer display. Without taking these measures, your images will look bad on screen with the AdobeRGB (1998) color profile—and even worse with ProPhoto RGB.

4 Change the image format to PSD. Choose 8 Bits/Component from the Bit Depth menu. Unless you have a particular need to output 16 bit files as part of your workflow, 8-bit files are smaller and compatible with more programs and plug-ins, but do not preserve fine tonal detail as well as 16-bit files. Lightroom actually operates in a 16 bit color space but by the time you're ready to export images you've usually already made any important corrections or adjustments that were necessary, so you won't lose much in terms of editing capability by converting the files to 8 bits for export.

Tip: Choose your preferred external editor, file format, color space, bit depth, compression settings, and file naming options on the External Editing tab of the Preferences dialog box. In the Lightroom Classic CC workspace, choose Photo > Edit In, and then choose your preferred external image editing application from the menu. Lightroom will automatically export an image in the appropriate file format, open it in the external editor, and add the converted file to the Lightroom library.

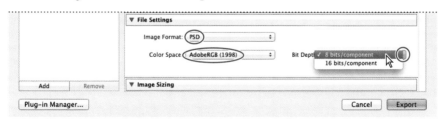

5 In Image Sizing, disable Resize To Fit and set the Resolution to 300 pixels per inch, to match the original image; to preserve all the image information for further editing, we wish to export every pixel of the source file.

6 Leave the Output Sharpening and Metadata settings unchanged. If you have Adobe Photoshop installed on your computer, choose that application from the After Export menu in the Post-Processing options. Alternatively, choose Open In Other Application, and then click Choose to select your preferred image editor. Click Export.

7 Wait until the export is complete and the photo has opened in the external editor. The image has been exported with the Color Presets - Cross Process 2 preset that you applied in the Quick Develop panel. Its dimensions are the same as those of the original image—3,000 by 2,000 pixels.

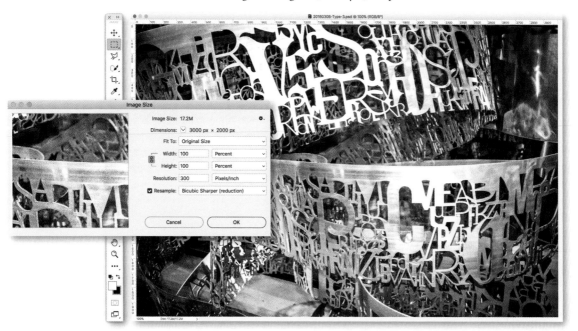

8 Quit the external editor, delete the file from the Export folder in Windows Explorer / the Finder, and then return to Lightroom Classic CC.

Exporting as Original or DNG for archiving

● **Note:** When you choose to export images in DNG file format you have additional options that affect the way the DNG files are created, but the original image data remains essentially unchanged.

1 Make sure the Lesson 11 folder is selected in the Folders panel. In the Grid view, select the Raw image Type-5.nef—the photo you edited earlier in this lesson.

2 Choose File > Export. In the Export dialog box, leave the Export Location unchanged, but disable the renaming option under File Naming.

3 In File Settings, choose Original from the Image Format menu. Note that there are now no other File Settings, Image Settings, or Output Sharpening options available; Lightroom will export the original image data unaltered.

4 In the Post-Processing options, choose Show In Explorer / Show In Finder from the After Export menu; then, click Export.

5 When the export process completes, the Lesson 11 \ Export folder opens in Windows Explorer / the Finder. In the Windows Explorer / Finder window, note that an XMP sidecar file has been saved together with the copy of the RAW image file, which was originally provided *without* an XMP file. The XMP file records changes to the image's metadata (the keyword you added at import) as well as its detailed editing history (the Quick Develop adjustments you made).

6 In Windows Explorer / the Finder, delete both files from the Export folder, and then return to Lightroom Classic CC.

Using export presets

Lightroom Classic CC provides presets for commonly performed export tasks. You can use any preset as is or as a starting point for setting up your own.

If you find yourself performing the same operations over and over again you should create your own presets to automate your workflow.

1 Click the Lesson 11 folder in the Folders panel. In the Grid view, select any of the images in the Lesson 11 folder and then choose File > Export.

2 In the list of presets on the left side of the Export dialog box, choose For Email from the Lightroom Presets.

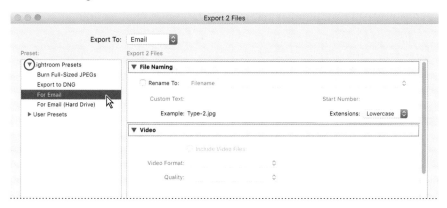

3 Examine the settings associated with this preset. With the current File Settings, an exported file will be an sRGB JPEG file with a Quality setting of 60 (%). Under Image Sizing, the exported image is set to be scaled down so that its longest side will be 500 pixels. Output Sharpening and Watermarking are disabled and the Metadata options are set to export copyright details only. Note that there are no export location or post-processing settings.

▶ **Tip:** For more detail on exporting photos as e-mail attachments, see "Sharing your work by e-mail" in Lesson 1.

Lightroom will export the image directly to an e-mail, so there are no export location settings associated with this preset. Post-processing options are also unnecessary; Lightroom automatically generates an e-mail and attaches the photo; your e-mail will be sent from within Lightroom, with no need to launch an e-mail client.

4 In the list of presets on the left side of the Export dialog box, click to select the Burn Full-Sized JPEGs export preset.

5 Note the changes in the export settings. CD / DVD is now selected in the Export To menu at the top of the Export dialog box, instead of Email (so, once again, export location settings are redundant). Under File Settings, the JPEG Quality setting has been set to 100 (%).

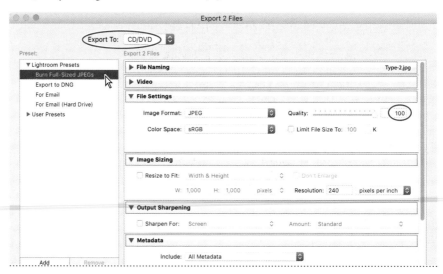

6 Scroll down to examine the rest of the preset options. Under Image Sizing, the Resize To Fit option is disabled, and the file will be exported with all of its metadata, except for People tags and GPS location information.

You can adjust any of the preset settings if you wish, and then save your custom configuration as a new preset by clicking the Add button below the Presets list. Once again, there are no post-processing options; if you go ahead and click the Export button, Lightroom will automatically open the Choose Burner / Burn Disc dialog box (if your computer is capable of burning a disc, or connected to a disc burner), where you can designate your disc burner and specify the burn speed before clicking Burn.

Setting up post-processing actions

You can streamline your export workflow by setting up automated post-processing actions. For example, if you prefer to set up an e-mail in your default e-mail client, you could have Lightroom Classic CC automatically launch your mail application and prepare a new message with the exported image attached.

1 Choose For Email (Hard Drive) from the Lightroom Presets. For this preset, Lightroom exports the file to disk at an appropriate file size for e-mailing.

2 Under Export Location in the Export dialog box, choose Specific Folder from the Export To menu, and then click the Choose button below it to select your Lesson 11 folder as the export destination. Activate the Put In Subfolder option and type **For Email** as the name for the new subfolder. Disable the option Add To This Catalog.

3 In the Post-Processing options, choose Go To Export Actions Folder Now from the After Export menu.

Lightroom Classic CC opens a Windows Explorer / Finder window with the Export Actions folder already selected. The next step in setting up your automated export is to place a shortcut or alias for your e-mail application into this folder.

4 Open a second Windows Explorer / Finder window and navigate to the folder containing your e-mail application. Right-click / Control-click the e-mail application, choose Create Shortcut / Make Alias from the context menu, and then drag the new shortcut or alias into the Export Actions folder. When you're done, return to the Export dialog box in Lightroom Classic CC.

5 In the Post-Processing settings, choose the new shortcut or alias to your e-mail application from the After Export menu.

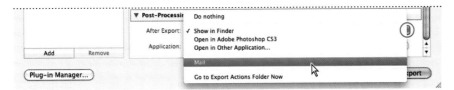

With the current settings you could export an image as a small JPEG file and Lightroom Classic CC would automatically launch your e-mail application and open a new message with the image already attached. But first, there's one more step that can help automate the process even further.

Creating user presets

You can save your customized export settings as a new user preset. Export presets are always available from the File menu (File > Export With Preset) where you can start your export without having to open the Export dialog first.

1 Click the Add button in the lower left corner of the Export dialog box. In the New Preset dialog box, type **To My Email and Attach** as the name for your new preset, choose User Presets from the Folder menu, and then click Create.

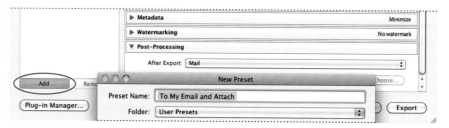

In the Export dialog box, your new preset is now listed under User Presets.

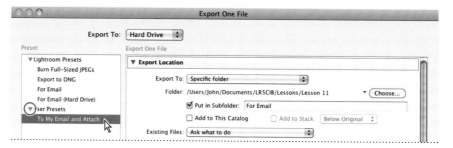

2 Click Cancel to close the Export dialog box without exporting any images.

3 Select one or more images in the Grid view and choose File > Export With Preset > To My Email And Attach.

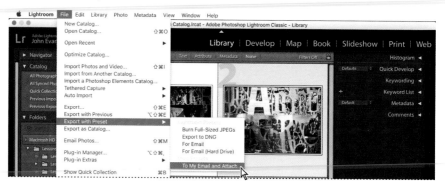

The export process will begin immediately. When exporting is complete, your e-mail application will be launched automatically and will open a new message with your exported photo or photos already attached; all you need to do is to enter the recipient's e-mail address and you're ready to send.

Review questions

1 What are the two basic components of your photo library that need to be backed up?

2 How can you move a selection of images or your entire image library with all the associated catalog information from one computer to another?

3 How can you do an incremental backup of your photo library?

4 How would you choose between file formats for exporting your photos?

5 What is a post-processing action?

Review answers

1 The two basic components of the image library are the original image files (or master files) and the library catalog file, which records all the metadata and the complete editing history for every image in the library as well as information about collections, user templates and presets, and output settings.

2 On one computer, use the Export As Catalog command to create a catalog file together with copies of the original images and the available previews. On the other computer, use the Import From Another Catalog command.

3 Once you have created a full backup of the library using Export As Catalog, you can switch to the backup catalog regularly and use the Import From Another Catalog command to update it. You can configure the import settings so only those images that have been modified since the last backup are imported from the main catalog. In this way, you can keep your existing backup catalog updated incrementally— avoiding the more time consuming process of making a full new backup.

4 The appropriate choice of a file format depends on the intended use of the exported images. To export images for on-screen viewing as e-mail attachments, you'd use the JPEG file format and minimize the file size. To export an image to an external image editing application you'd use PSD or TIFF and export the image at full size. For archival purposes, export the images in their original format or convert them to DNG.

5 A post-processing action is a preset that can help to automate your workflow. You can choose a preset that will automatically burn your images to a CD or DVD after export, or one that will launch your e-mail application and attach your exported images to a new message. You can save your own action presets, which will be listed beside the Lightroom presets in the Export dialog box.

INDEX

Production Notes

The *Adobe Photoshop Lightroom Classic CC Classroom in a Book* was created electronically using Adobe InDesign CC. Art was produced using Adobe InDesign CC, Adobe Illustrator CC, and Adobe Photoshop CC.

References to company names in the lessons are for demonstration purposes only and are not intended to refer to any actual organization or person.

Team credits

The following individuals contributed to the development of this edition of the *Adobe Photoshop Lightroom Classic CC Classroom in a Book*:

Project coordinators, technical writers: John Evans & Katrin Straub

Production: Manneken Pis Productions (www.manneken.be)

Copyediting & Proofreading: John Evans, Katrin Straub

Keystroker: Karyn Johnson

Designers: John Evans, Katrin Straub

Special thanks to Nancy Davis, Laura Norman, and Tracey Croom.

Typefaces used

Adobe Clean, Adobe Myriad Pro, and Adobe Warnock Pro are used throughout the lessons. For more information about OpenType and Adobe fonts, visit http://www.adobe.com/products/type/opentype.html.

Photo Credits

Photographic images and illustrations supplied by John Batdorff, Colby Brown, Torsten Buck, Andrew Viraj Bunnag, John Evans, David Frohlich, Patrick Jacobs, Julieanne Kost, Chris Orwig, Seth Resnick, Katrin Straub, and Adobe Systems Incorporated. Photos are for use only with the lessons in the book.

Contributors

 John Evans has worked in computer graphics and design for more than 30 years, initially as a graphic designer, and then since 1993 as a multimedia author, software interface designer, and technical writer. As a technical writer his work includes software design specifications, user manuals, and several editions of *Adobe Photoshop Elements Classroom in a Book* and *Adobe Photoshop Lightroom Classroom in a Book*.

 Katrin Straub is an artist, a graphic designer, and author. Her award-winning print, painting, and multimedia work has been exhibited worldwide. With more than 25 years' experience in design, Katrin has worked as Design Director for companies such as Landor Associates and Fontworks in the United States, Hong Kong, and Japan. Her work includes packaging, promotional campaigns, multimedia, website design, and internationally recognized corporate and retail identities. She holds degrees from the FH Augsburg, ISIA Urbino, and The New School University in New York. Katrin has authored many books, among them Adobe Creative Suite Idea Kit, Adobe Soundbooth and several editions of *Adobe Photoshop Elements Classroom in a Book*, *Adobe Premiere Elements Classroom in a Book*, and *Adobe Photoshop Lightroom Classroom in a Book*.